SMALL HOMES
The Right Size

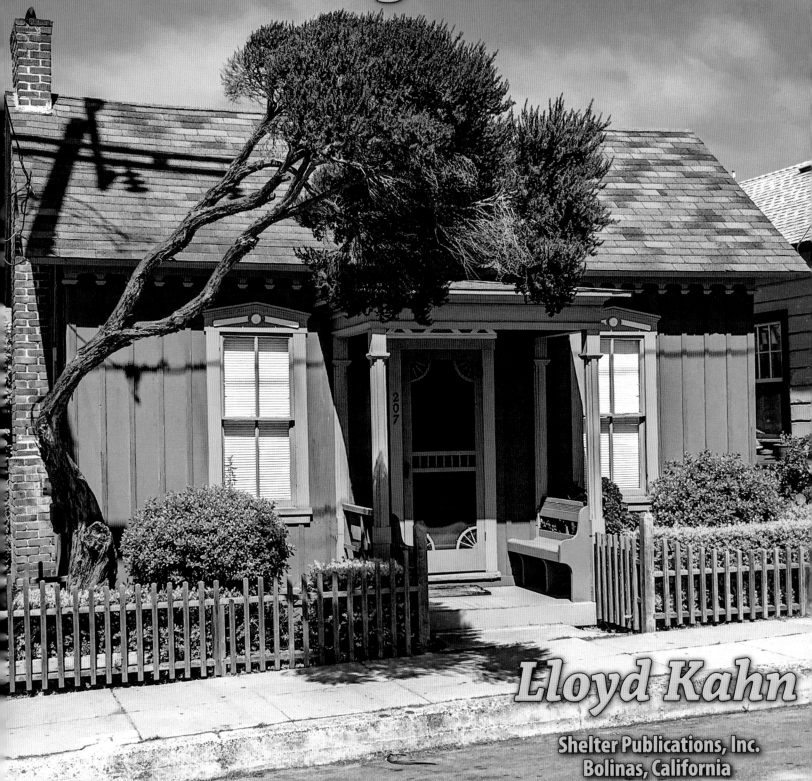

Lloyd Kahn

Shelter Publications, Inc.
Bolinas, California

Distributed in the United States by Publishers Group West
and in Canada by Publishers Group Canada

Library of Congress Cataloging-in-Publication Data

Names: Kahn, Lloyd, 1935– author.
Title: Small homes : the right size / Lloyd Kahn.
Description: Bolinas, California : Shelter Publications, 2017. |
 Series: The Shelter Library of Building Books ; 7
Identifiers: LCCN 2016049165 (print) |
 LCCN 2016049632 (ebook) |
 ISBN 9780936070681 (paperback) |
 ISBN 9780936070698 (Epub) |
 ISBN 9780936070704 (Kindle)
Subjects: LCSH: Small houses.
Classification: LCC NA7533 .K347 2017 (print) |
 LCC NA7533 (ebook) |
 DDC 728--dc23
LC record available at https://lccn.loc.gov/2016049165

5 4 3 2 1 — 18 17
(Lowest digits indicate number and year of latest printing.)

Printed and bound in Hong Kong

Shelter Publications, Inc.
P.O. Box 279
Bolinas, California 94924
415-868-0280

Email: shelter@shelterpub.com
Orders, toll-free: 1-800-307-0131

Shelter's Website: www.shelterpub.com
The Shelter Blog: www.TheShelterBlog.com
Lloyd on Instagram: www.instagram.com/lloyd.kahn
Lloyd's Blog: www.LloydKahn.com

> **Note:** We have a lifetime money-back guarantee on all our books.
> If you are in any way dissatisfied, call us, and we will reimburse you
> for the cost of the book plus postage. No need to return the book.

Shelter
Publications

Contents

How the book is organized: The only unifying factor here is floor area. The homes are organized in a loose* manner: artistic homes, timber frame, wooden structures, natural materials, recycled materials, off-the-grid, miscellaneous small homes, small homes in towns and cities, and a few "smaller-than-small" homes.

If you're thinking of building, buying, or fixing up a small home: Look through these pages for ideas. There's enough variety here to give you many choices.

Loose because many of the homes fit into multiple categories, like an off-the-grid, timber-frame home with natural and recycled materials.

In Praise of Small Homes

"U.S. Houses Are Still Getting Bigger" read a recent news article in *The Wall Street Journal*. *According* to the United States Census Bureau, the average size of a new single-family house in the U.S. in 2015 was 2,467 sq. ft., or 1,000 sq. ft. (61%) larger than in 1973.

Things are going in the wrong direction!

Tiny Homes In recent years, some people have opted out of a mortgage or high rent, and are living — for at least a time — in very small spaces, simplifying and rearranging their lives to do so.

The media calls this a "movement." Why? Not only is the concept radical (revolutionary), but — tiny homes are photogenic!

The media loves them: Witness a half dozen TV shows, thousands of YouTube videos, a plethora of books, blogs, newspaper and magazine articles, and social media postings on the subject.

There have been some great — and inspiring — stories of people scaling back, simplifying, and sometimes elegantly, living a different style of life.

But there's also been a lot of hype, like TV programs based on phony story lines, no relation to real life. Ah, me.

Our last two books were on tiny homes, so I'm familiar with the subject. After several years monitoring (and pondering) the movement, I've concluded that what's important is not that homes be "tiny," but that they be *smaller*. It's the direction that counts. Maybe the tiny house movement is a clarion call for a change in consciousness.

Small Homes This book is about homes that are larger than "tiny," but smaller than the national average. It's a logical step for Shelter Publications after our experiences with tiny homes.

Compared to the average American home, small homes are less expensive, use less resources, are more efficient to heat and cool, and cheaper to maintain and repair.

These are (but for a few) between 400–1200 square feet of floor area — less than half the size of the typical new American home. (By way of comparison, homes in our book, *Tiny Homes: Simple Shelter*, averaged 200–300 sq. ft.)

Types of homes The homes here — some 65 of them — vary from unique and artistic to simple and low-cost. Some are plain, ordinary buildings that provide owners shelter at a reasonable cost — and some are inspiring examples of design, carpentry, craftsmanship, imagination, creativity, and homemaking.

Some are built with "natural materials," such as cob or straw, some with recycled wood or lumber milled on-site, some are old homes that have been remodeled, and many are designed and built from scratch by the owners.

Many are in the country, some in small towns, and some in large cities.

In a sense, this is going back to earlier times, when people used less resources.

It's all in the hands The underlying theme with Shelter's books, which cover an over-40-year span, is that you can create your own home with your own hands, using mostly natural materials.

With most of these homes, the owners have done their own work. With others, they have hired builders to carry out their plans.

There's an old-school concept working here that's still relevant in this digital era: *A computer can't build your home for you.* You still need a hammer (or nail gun), a saw — and human hands.

The Shelter Library of Building Books — A Series This is the 7th in a series of interrelated books on homemade building. *(See p. 223 for details.)*

Online coverage of small homes We invite readers and builders to send us other homes in this size category. Contact us at ***smallhomes@shelterpub.com***. We'll publish these at ***www.theshelterblog.com*** in a subcategory titled "Small Homes."

Stay tuned. We manage a book like this every 2–3 years.

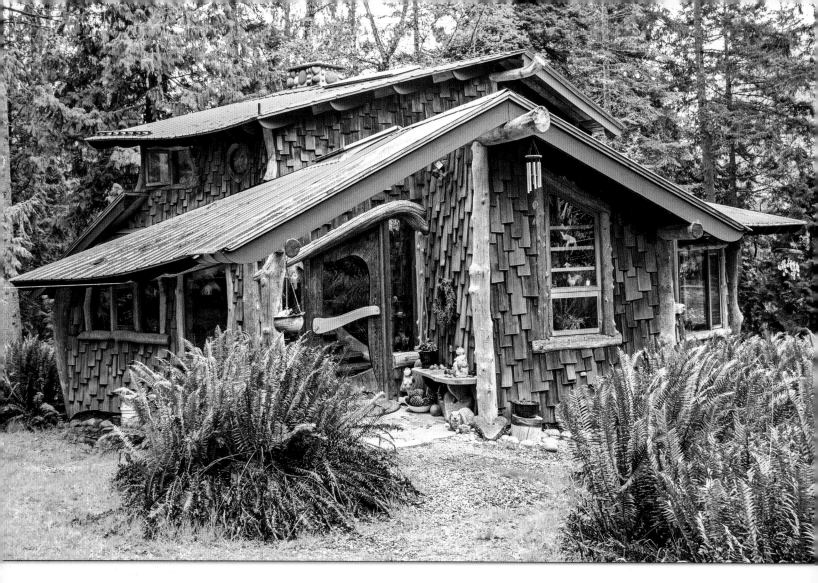

Island Home

It took them 19 months to build the house.

On a trip to a British Columbia island in April 2014, I was visiting Lloyd House, one of my favorite builders in the world (see Builders of the Pacific Coast). He said, "You know, there's a house nearby I think you should see. It might be the most beautiful home I've ever been in."

Boy, did that get my attention. So I drove over and met Graham and Gloria Herbert, and their home was, as described, exquisite — thoughtfully designed, finely crafted, artistic, colorful, and homey.

Graham and Gloria didn't want any publicity, but they knew our books and said it was OK for me to shoot photos as long as I didn't publish anything without their consent.

So now, a year-and-a-half later, I've told them about this book and they've given us the go-ahead to publish the photos. And you'll notice it's the first home in the book.

The following details are from phone conversations with Gloria.

–LK

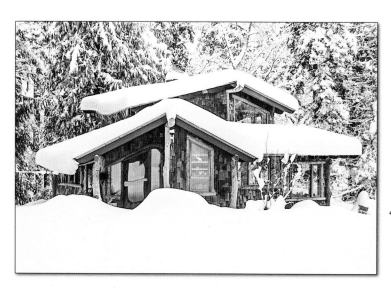

Graham was a second-generation boat builder, hence the curves in design.

GLORIA AND GRAHAM got together on this small island, and eventually decided they would build a house. "We're going to build a house and then have a party and get married," they told a friend.

The friend replied, "Get married first, then build the house" — which they did. There's a lot of stress in building a home, and being married meant they were committed to working things out.

When I was there, Gloria said they'd had hundreds of arguments while building — "lively discussions." When I asked her what these arguments were about, she laughed and said. "Well, they were the same arguments 100 times over — and we both won."

It felt really good there. Wood and stone, meticulous craftsmanship, vibrant colors, paintings, fabrics, stored food — all the things that make a beautiful home.

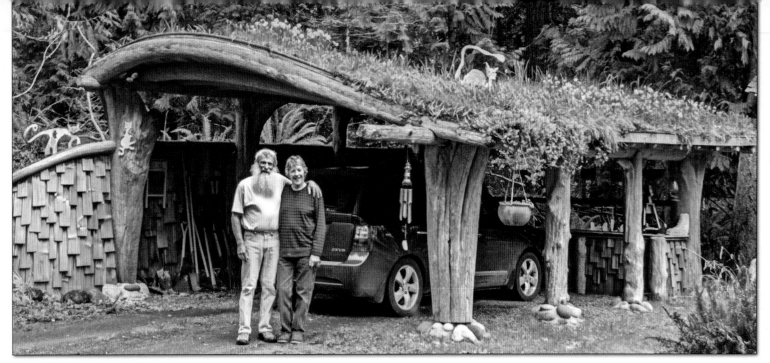

"*We would row out at night in search of logs, towing them back home.*"

It took them 19 months to build the house. First, Graham built a model; they wanted a low profile. Graham was a second-generation boat builder, hence the curves in design.

They purchased the framing lumber and got all the posts and beams off the beach. For all the other lumber — floors, walls, counters, ceilings — they milled lumber from trees cut down in clearing the building site: balsam fir and Douglas fir.

They got stones from a gravel pit on another island, and collected logs used for the stairway and window trim from nearby beaches. Graham had built an 18′ wooden rowboat and they would row out at night in search of logs, towing them back

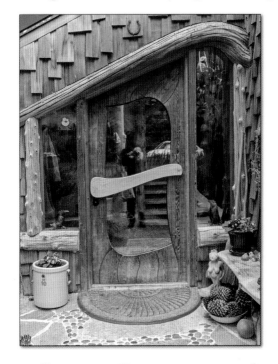

home. "We'd need, say, an 8′ log with a bend to the right, and go out looking for it."

Gloria: "Graham and I tackled trimming the first outside window; when we finished, he told me to find a carpenter to help me because I was way too fussy for his style."

They went through four local builders until they found one willing to do the window trim with driftwood logs; it took three weeks. There are 70 panes of glass, including the skylights, and, although surrounded by trees, the house is filled with light.

The house has radiant heating, with pipes in the floors.

Floor Area: 1200 sq. ft. / 111 m²

For all the other lumber — floors, walls, counters, ceilings — they milled lumber from trees cut down in clearing the building site: balsam fir and Douglas fir.

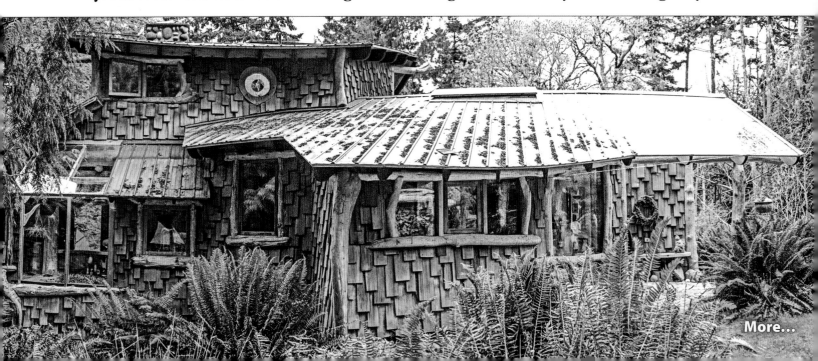

More...

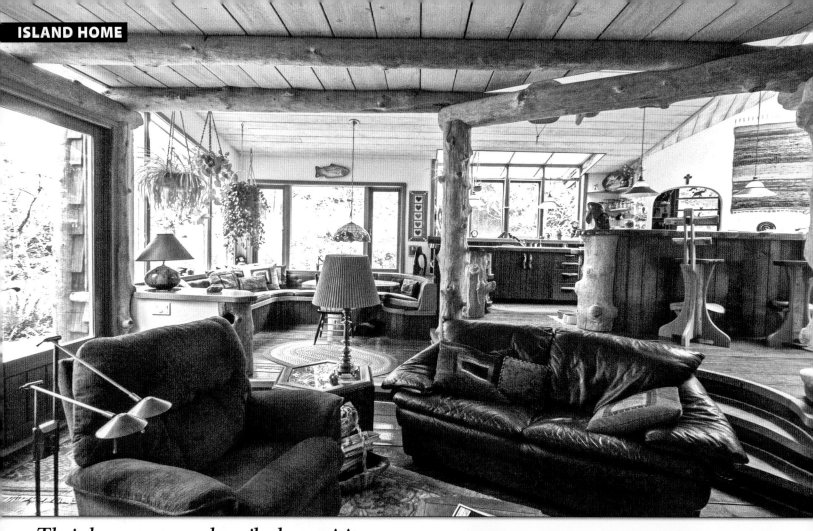

Their home was, as described, exquisite —
thoughtfully designed, finely crafted,
artistic, colorful, and homey.

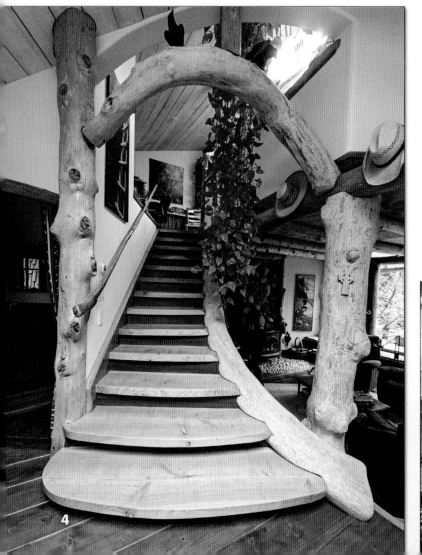

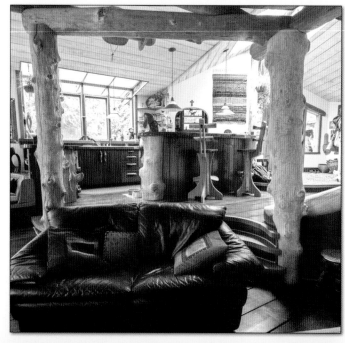

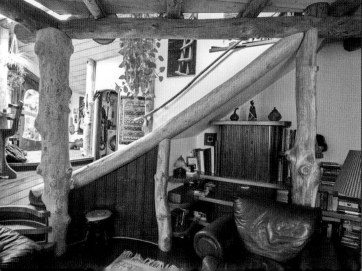

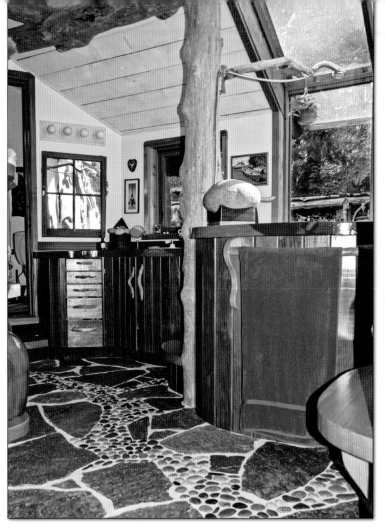

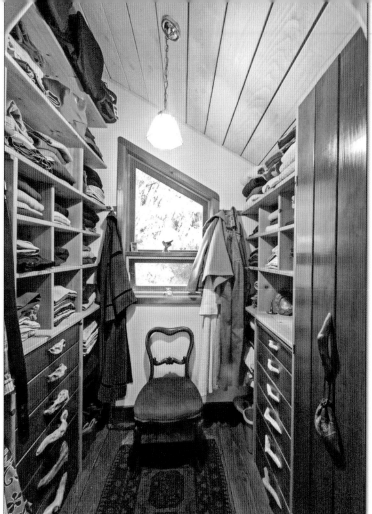

*...meticulous craftsmanship, vibrant colors,
paintings, fabrics, stored food—
all the things that make a beautiful home...*

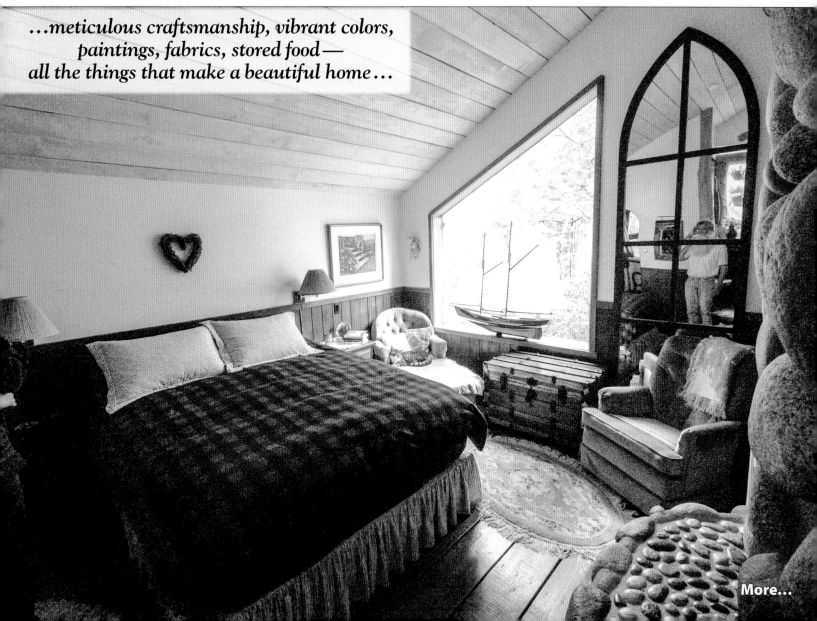

More...

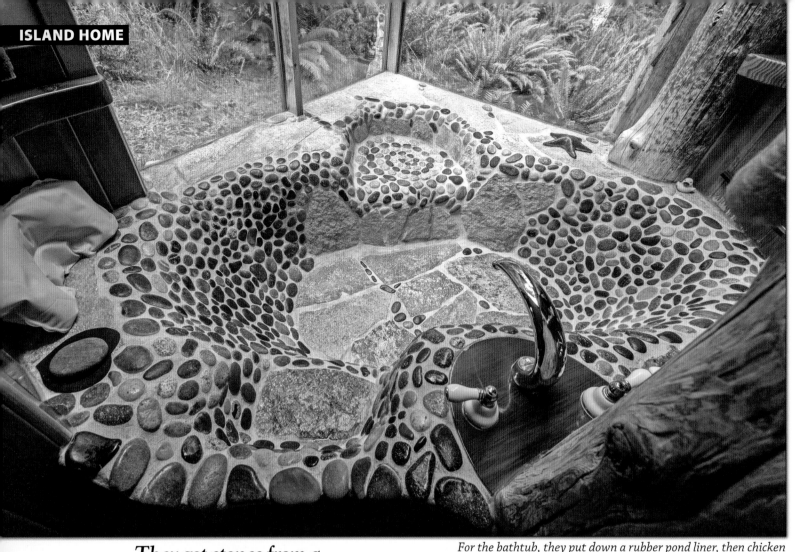

They got stones from a
gravel pit on another island.

For the bathtub, they put down a rubber pond liner, then chicken
wire plastered with ferro cement containing chopped fiberglass,
with smooth stones embedded.

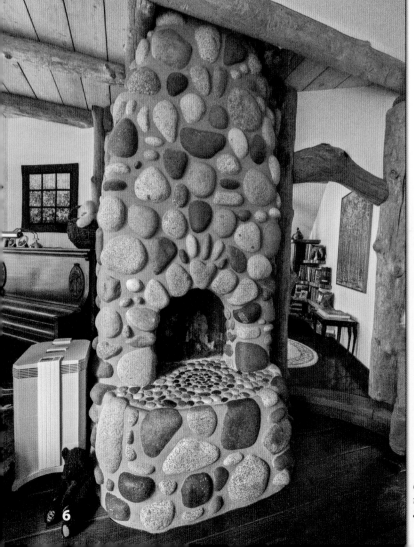

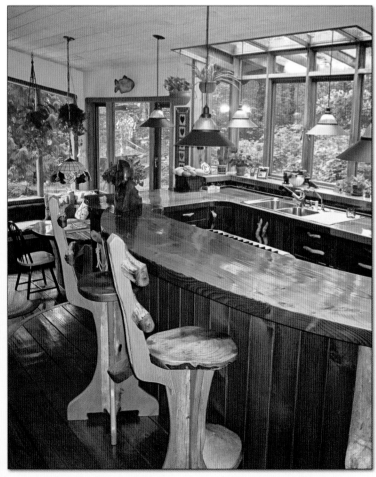

Gloria did all the stonework on the fireplace and chimney — it
took 7 months and — laughing — "it kept me out of Graham's hair."
She mixed the mortar in a wheelbarrow.

There are 70 panes of glass, including the skylights, and, although surrounded by trees, the house is filled with light.

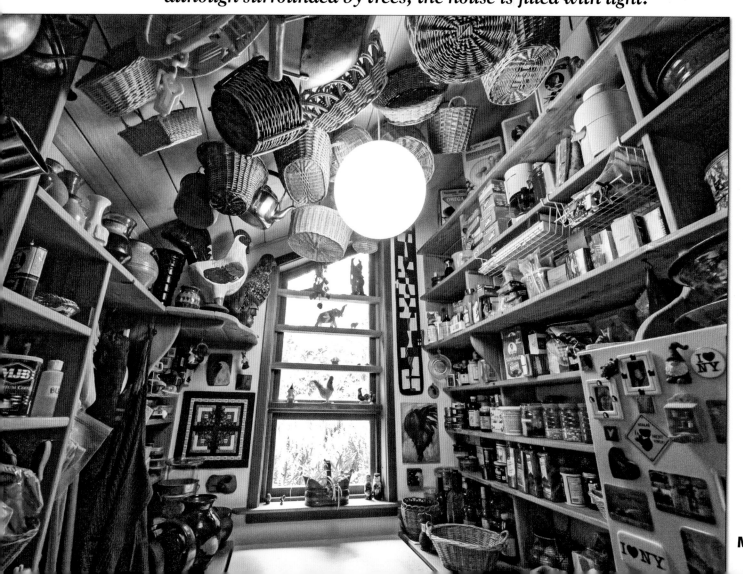

More...

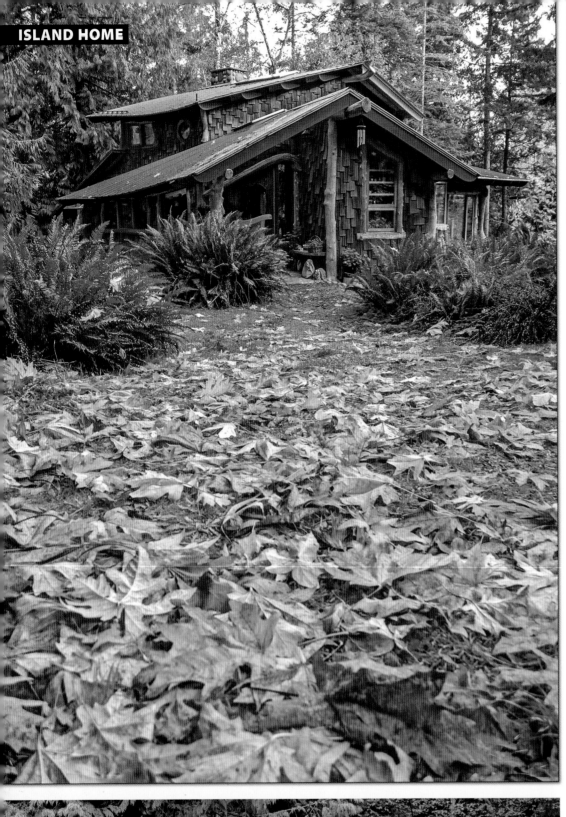

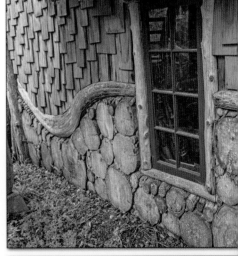

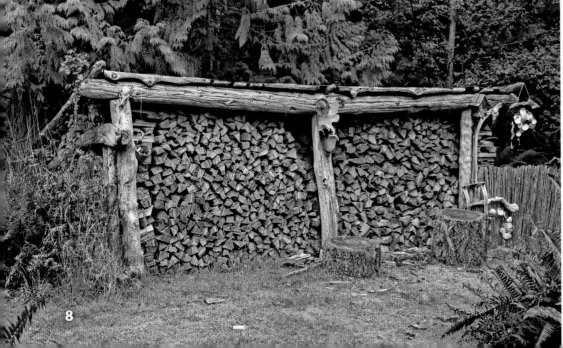

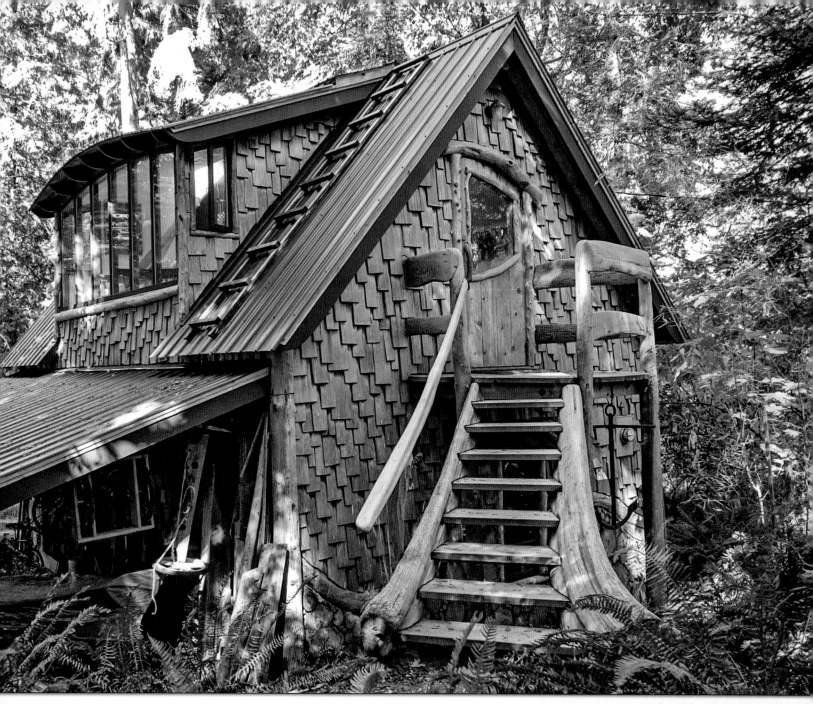

Graham's workshop/studio; he does his painting upstairs and builds boats, etc. downstairs. Photos, top left on opposite page, and above and below on this page, by Graham and Gloria.

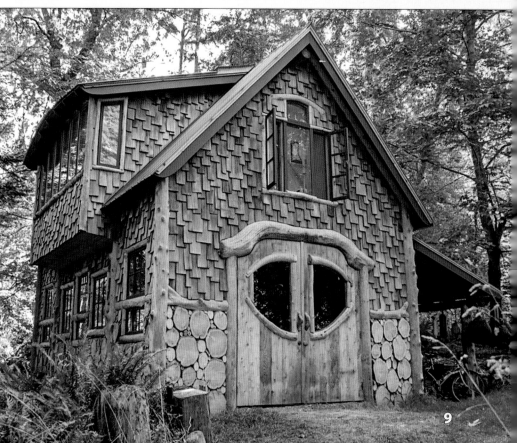

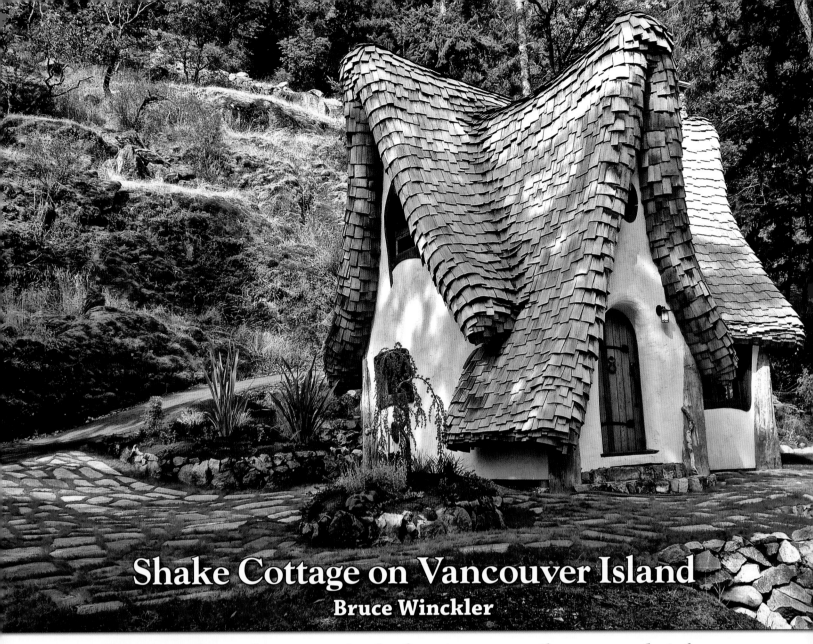

Shake Cottage on Vancouver Island
Bruce Winckler

When people see this cottage for the first time…a smile comes to their faces.

WHILE CRUISING THE Internet looking for a cottage design for a special location, I came across the Lindcroft Homes website. They had constructed a whimsical kids' treehouse that spoke to me.

I contacted them to ask if they could build a cottage here on Vancouver Island with similar lines. They had a design that they wanted to show me. We initially met in the summer of 2009.

They liked the location and I felt their design would fit perfectly into the building site. It's at the end of a kilometer-long, gated driveway and is only visible from the water.

Construction started in October 2009. Tim and Daniel* both lived on the mainland near Vancouver at the time, but rented a house here on the island during the construction.

All materials had to be packed to the difficult site manually. Nothing was easy with this build, but we all felt that the completed project would be well worth the effort. This was a labor of love. Great care went into all aspects of this cottage.

Builders: Tim Lindberg (left) and Daniel Huscroft (right)

The timbers, floorboards, front door, and windows were all made from wood milled locally from a friend's property. The shakes were sourced from a supplier on this island; the shakes for the top part of the building were steamed to achieve the curves and a curved froe was used for the rounded eaves. Lots of work!

After the timber frame was up, a level was no longer a useful tool. To achieve the right lines, almost each board was custom cut, making for a slow, tedious pace. The boys building it knew it wasn't for the faint of heart!

Local metal artist Jake James

made the front-door hardware and mushroom-shaped bathroom vent. The landscape materials are all local.

Tim and Daniel completed the basic structure in March 2010; the interior took another four months to finish.

When people see this cottage for the first time — almost without exception — a smile comes to their faces.

It was a pleasure to work with Tim and Daniel; we are considering doing another project of the same nature with them in the future.

Floor Area: 600 sq. ft. / 56 m²

www.lindcroft.com

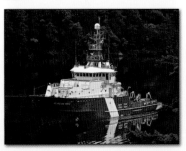

The Coast Guard came by for a look one day.

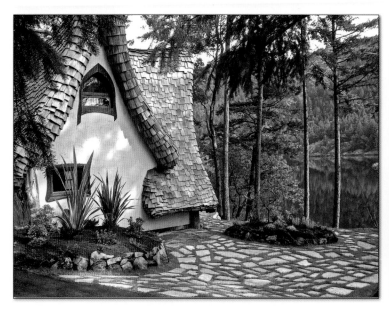

The shakes for the top
part of the building were
steamed to achieve the curves.

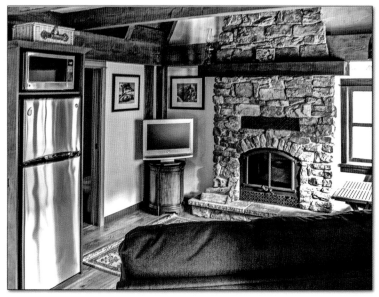

This was a labor of love.

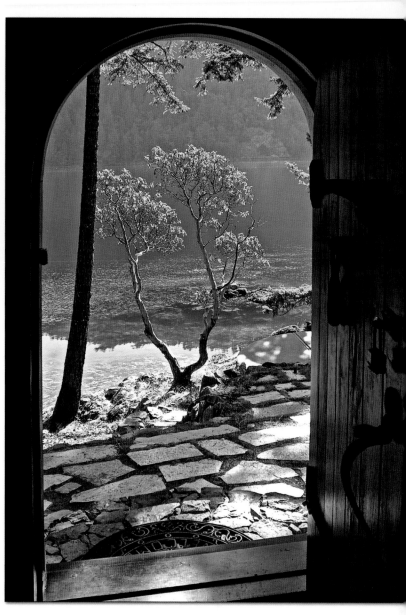

It's at the end of a
kilometer-long gated driveway
and is only visible from the water.

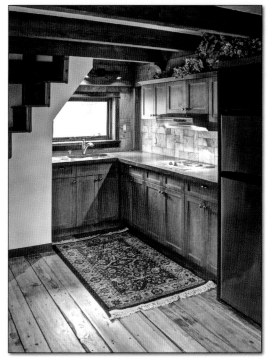

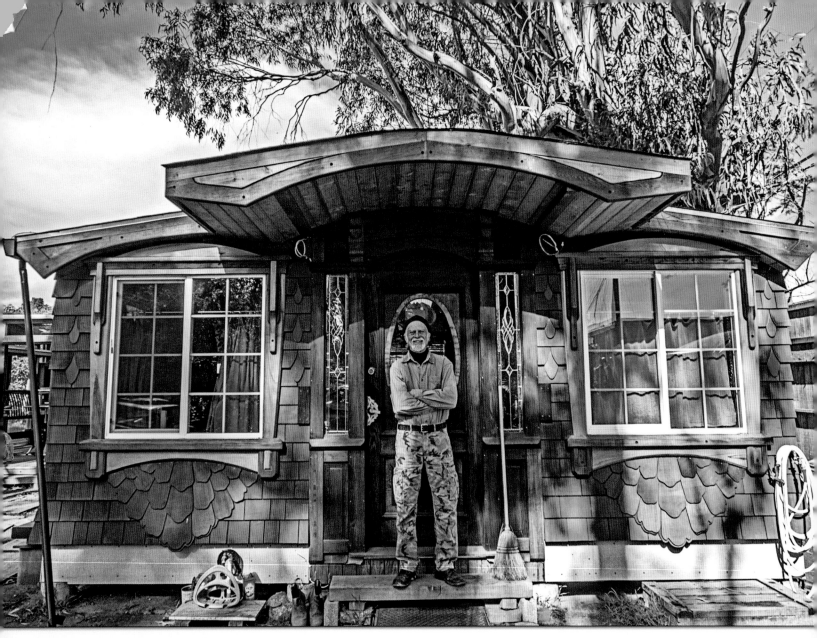

Vin's Small Home

Vin Jon Gorman

VIN STARTED DRAWING WHEN HE was very young. He grew up in New Jersey, and in high school he did portraits of his classmates for $5 each. "It'd take me 8–10 hours to do one," he said.

He came to California at age 18 and ended up designing and building his first home in the woods in Humboldt County, using local and salvaged materials.

We talked about the '60s and '70s, when a lot of young people were trying to figure out what to do with our lives. We didn't want to go into the business world or work for corporations. "People knew what they didn't want to do, but not so much what *to* do," he said.

"How do you get a house with no loan? How do you learn how to build? How do you grow food? Well, we got the *Shelter* book, and the *Whole Earth Catalog* — the do-it-yourself movement — and we went to work."

Vin is a talented artist and master carpenter — a fortunate combination. It means he can build whatever he designs.

"I've always wanted challenges — spiral stairways, complicated hip roofs, curves, with every rafter different."

He worked as a carpenter and then foreman in building about a dozen houses in the '80s and since then has done a number of artistic structures of various kinds, including the eucalyptus-pod-shaped sauna in *Builders of the Pacific Coast (pp. 204–205)*.

His present-day home, shown here, was built for about $35,000 — cash. He says it'll take about another $5000 to finish it. It's immaculately crafted, colorful, and has good vibes. He built it entirely himself, including plumbing and electrical work.

He's setting up a rainwater storage tank and will soon be off the grid via photovoltaic solar panels.

These days, Vin is looking for a unique project. "I don't have to make money. I'm looking for a project that will utilize my skills. Maybe I can help someone achieve their dream."

Vin says that he can travel. You can contact him at: ***shelter@shelterpub.com***.

Floor Area: 650 sq.ft. / 60 m²

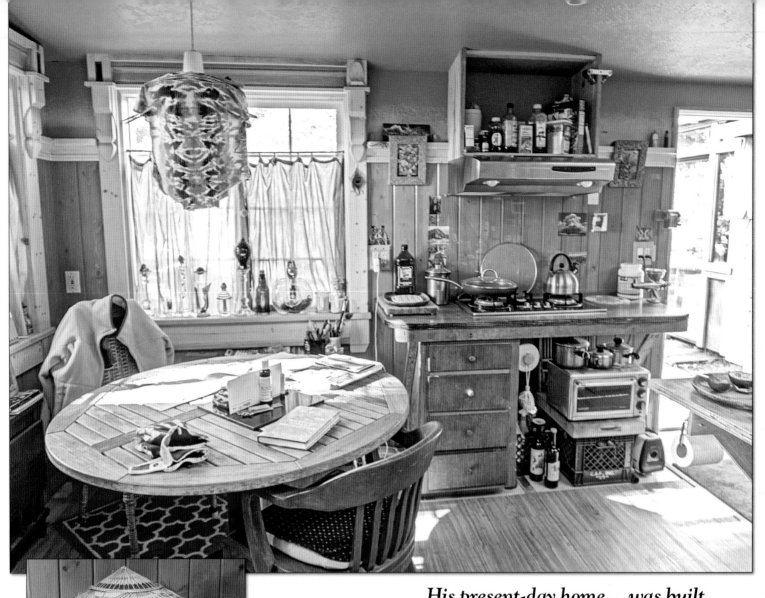

*His present-day home...was built
for about $35,000 — cash.*

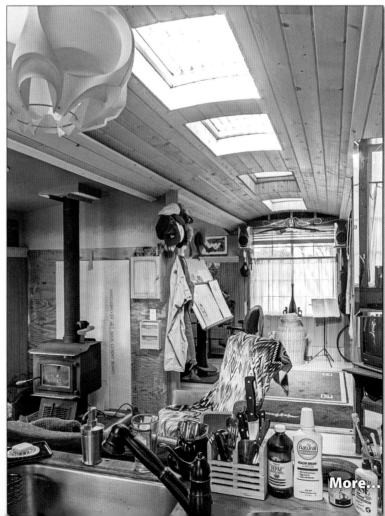

More...

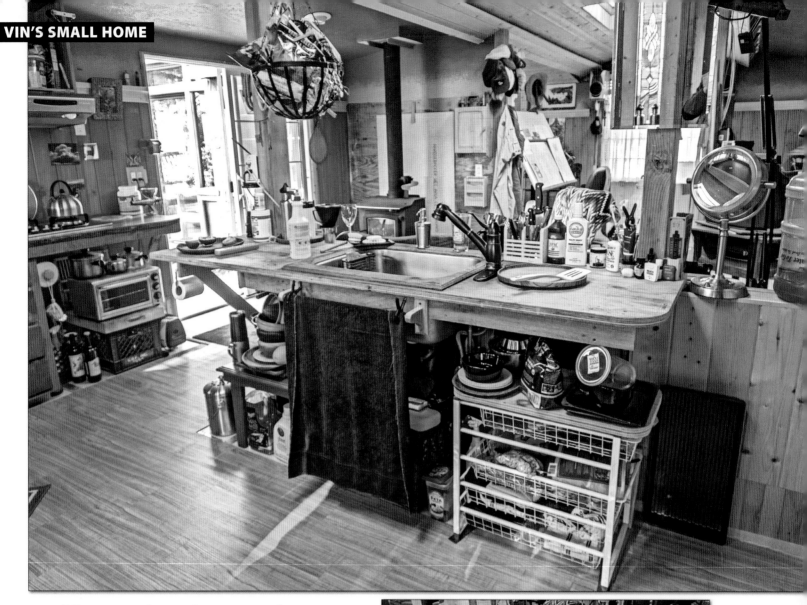

Vin is a talented artist and master carpenter — a fortunate combination.

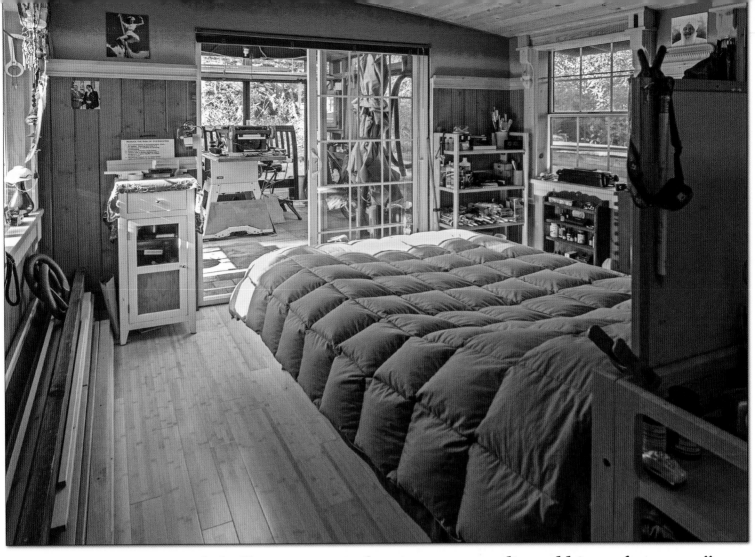

"I've always wanted challenges — spiral stairways, complicated hip roofs, curves."

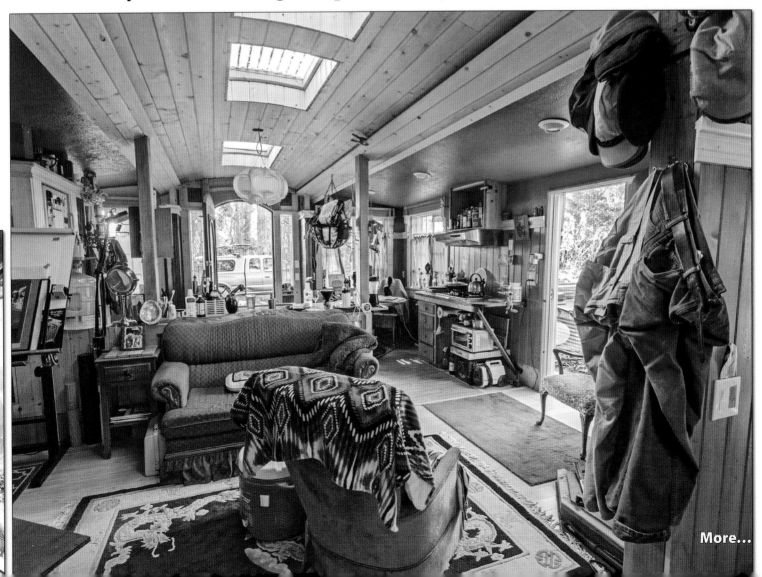

More...

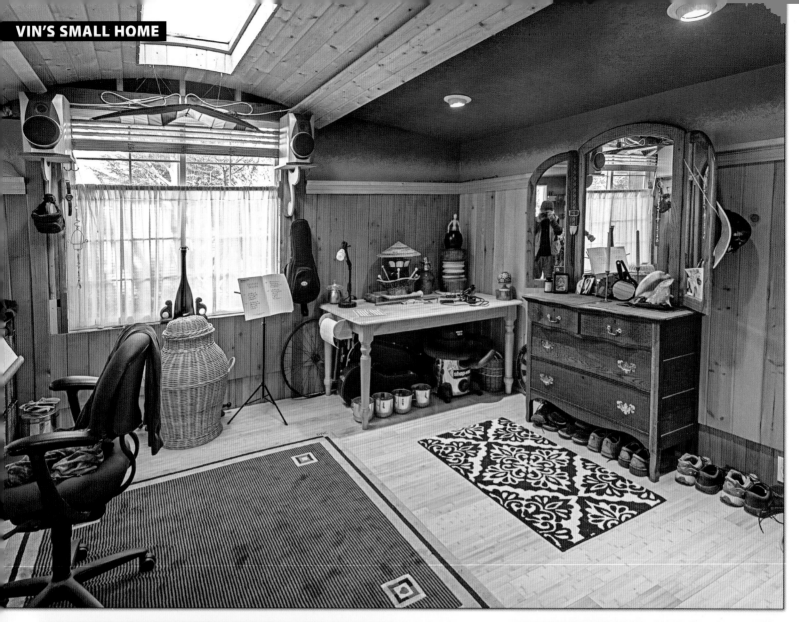

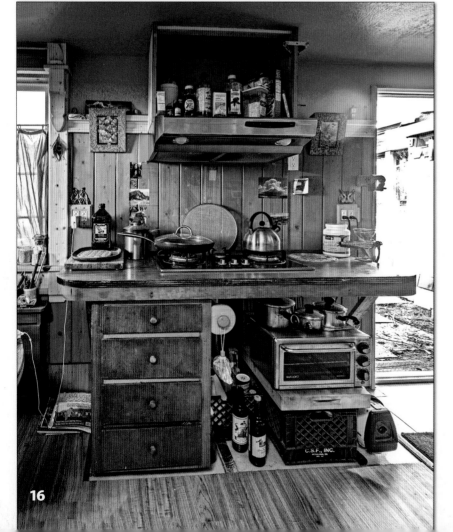

"Maybe I can help someone achieve their dream."

17

Mike & Sierra's Home in the California Foothills

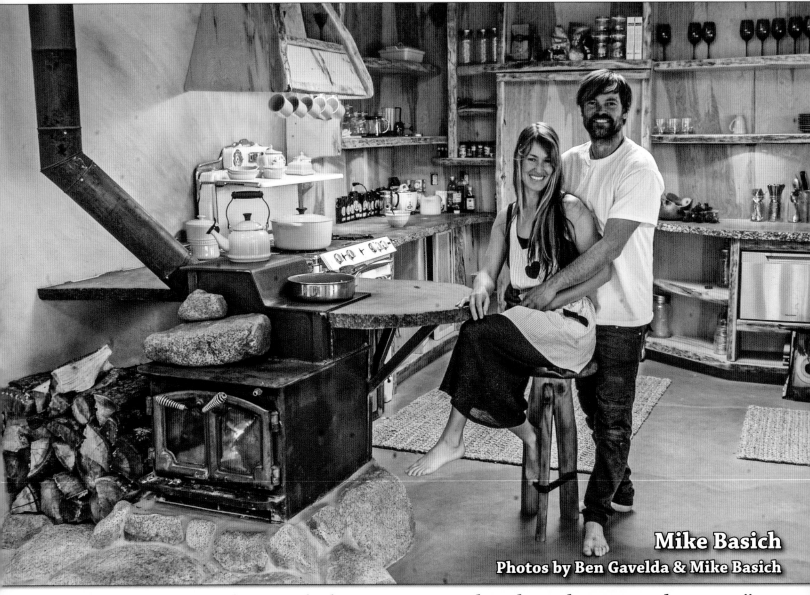

Mike Basich
Photos by Ben Gavelda & Mike Basich

"When the stove is heating the house, we can cook with two burners and an oven."

Mike Basich has been featured in our last two books. His solar-powered and solar-heated wood/stone/glass house was featured in Tiny Homes, *and his ingenious custom pickup truck/snowmobile transporter was included in* Tiny Homes on the Move.

Mike is a famed world-class snowboarder, who once jumped out of a helicopter with his snowboard at 100 feet above the ground. Mike is also a world-class builder, working with wood, stone, metal, and glass.

In January 2015, Mike and his girlfriend Sierra found a 2½-acre piece of land in a sunbelt area on the outskirts of Nevada City, California.

My son Evan (who discovered Mike about four years ago) and I asked Mike about the land, construction details, the garden, their cooking, and Mike's latest snowboard adventures: —LK

Could you describe the land, including structures, when you bought it?

We stumbled across it at dusk one evening. It was so peaceful — 2½ acres at the end of a gravel road — 2300 feet in elevation. It backs up to the woods, so there are a lot of wild animals coming through. At the moment, we have a fox living in the shrubs near the house, lots of deer every day, and birds everywhere.

There's a pond, a wonderful view of the valley, two barns for animals (which we hope to get this summer), and a garage, which we've turned into a dance studio.

All the buildings were built in the '60s and had been vacant for years (there were lots of mice), so we gutted the house. When we tore out the walls and ceilings, we discovered that the house

"We stumbled across it at dusk one evening. It was so peaceful."

18

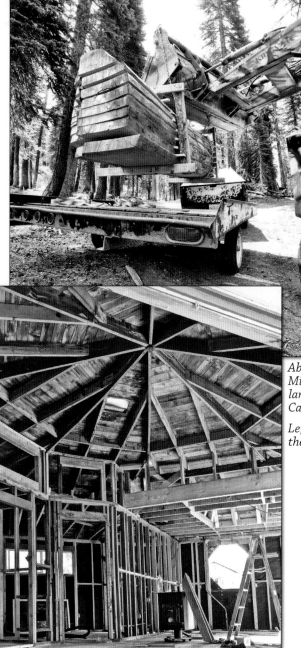

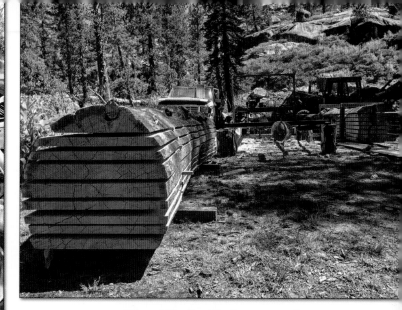

"I milled all the wood from standing dead trees."

Above and right above: Milling wood from Mike's land near Donner Lake, California

Left and right: Opening up the framing

"When we tore out the walls and ceilings, we discovered that the house was eight-sided —an octagon."

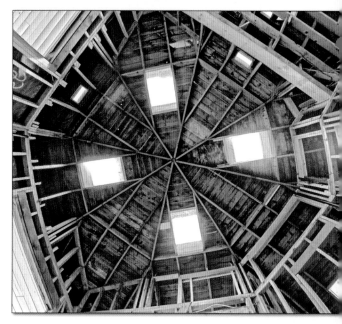

was eight-sided — an octagon. Which was so fitting for me, since my last small home was a pentagon. Now, with another person in my life, a somewhat larger home was the focus for new goals in life.

Before we started construction, we planted a lot of trees — 40 fruit trees and many redwoods along the property line. I've learned in the past to plant trees the first thing; time flies when you're remodeling, and trees take time.

The house is 825 square feet — perfect for us. I added a lot of skylights and sliding doors to help make it feel open. I milled all the wood from standing dead trees on the land where my cabin is (last project), including flooring, trim, and some nice slabs for the kitchen.

Insulating panels in place during remodel

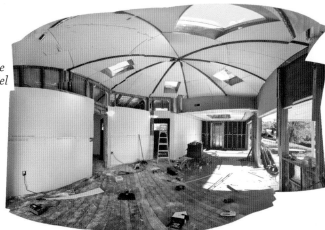

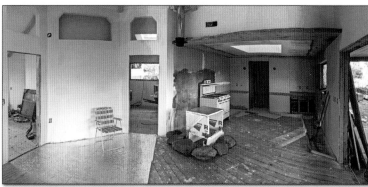

Kitchen before and after

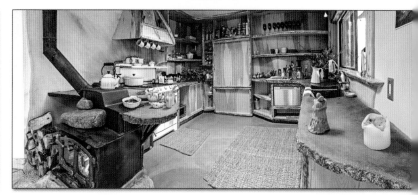

More...

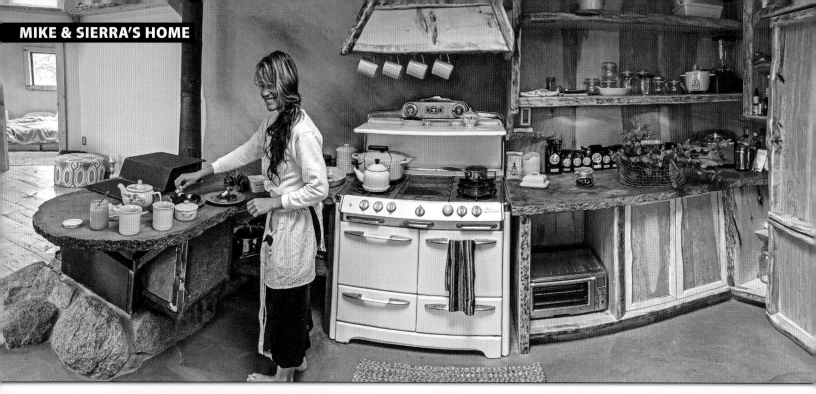

"We're growing lots of lettuce, beets, carrots, kale, and tomatoes, and parsley."

What are you growing in the garden?

We put in a garden right away. We built wood beds and yes, expensive compost, but well worth it! So many less weeds when you buy nice compost.

We're growing lots of lettuce, beets, carrots, kale, and tomatoes, and parsley. We've been blending stuff right in the garden with an electric blender and GoalZero solar panels — as fresh as it gets.

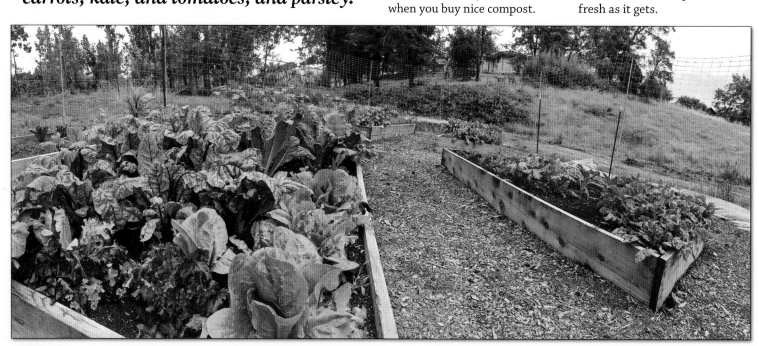

Sierra and I both like cooking over the fire, so I decided to incorporate cooking into our fireplace. When the stove is heating the house, we can cook with two burners and an oven. It's great to maximize the fireplace this way.

I have always focused on temperatures in the environment; for example, I made the backside of the refrigerator vent outside the house, so the motor doesn't have to work so hard in the winter, plus it keeps the noise down.

> *"I have always focused on temperatures in the environment."*

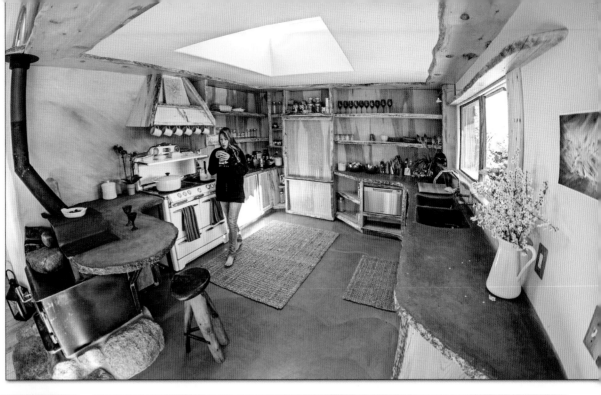

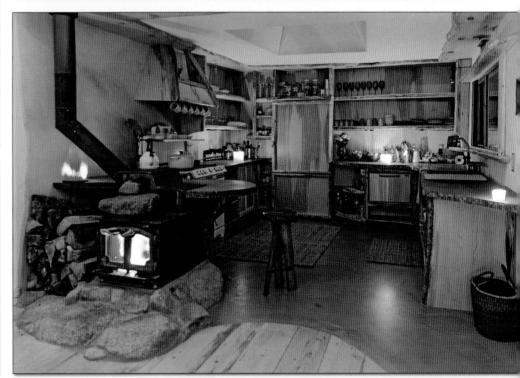

More...

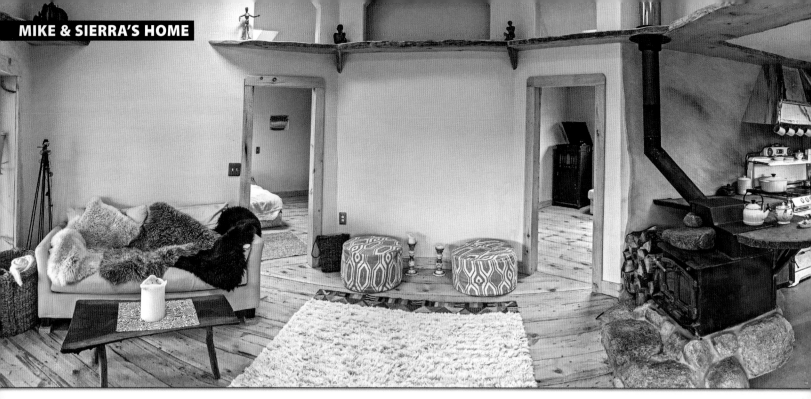

"I added a lot of skylights and sliding doors to help make it feel open."

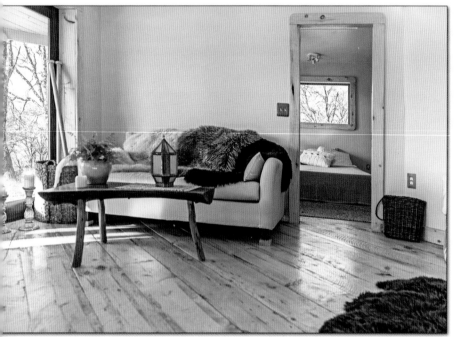

"The house is 825 square feet—perfect for us."

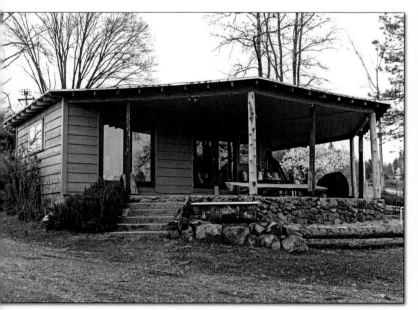

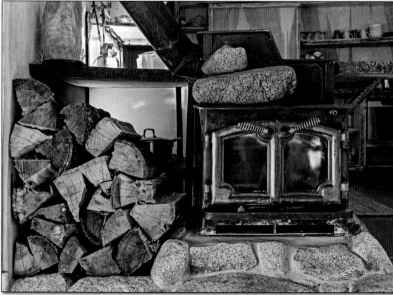

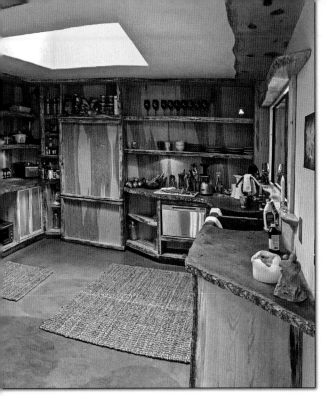

"We went through an amazing process in choosing colors."

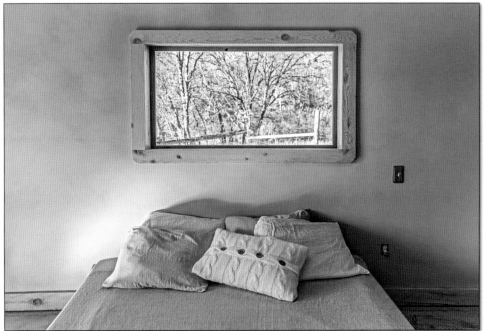

We went through an amazing process in choosing colors. Sierra mixed the colors into the spray gun as I moved my way through the house spraying the walls. Each room fades from one color to another as it goes from one side to the other. It's not only great color therapy, but represents a change in my life.

What are you doing in the snowboard world these days?

I recently did the stunt work in the latest remake of "Point Break." It was a nine-week project to capture 2½ minutes of footage used in the film. This level of production was new for me and intense and exciting. We filmed it all in Italy with helicopters.

I have been enjoying my homemade chairlift at my cabin up at Donner Summit. We finally had a good year for snow; it was amazing to use my lift finally. I towed my tiny house up there on skis behind my snowcat, and it was fun to journey this way with the tiny house and create a guest house over night up in the snow—had a lot of guests once the word got out. A tiny house next to a private chairlift can do that, I guess.

I did two shows on HGTV, one for "Tiny House – Giant Journey" and another one in Alaska for bush pilots.

Floor Area: 825 sq. ft. / 77 m²

 www.241-usa.com

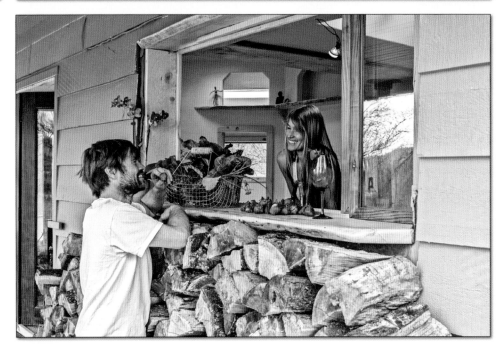

Surfer's Paradise

Dino Colombo

I HAD KNOWN DINO PERIPHERALLY for some years as a colorful character —surfer and artist—living in a small northern California beach town. One day while walking on the beach, I saw him with a kite surfer sail and a "Carveboard" skateboard. He said he was letting air out of the tires and sailing it on the beach. We were standing near his beachside home and I asked if I could take a look inside.

It was a surfer's dream, practically every square inch decorated with art related to the ocean, much of it humorous. A small bathroom and a small kitchen with what looked to be a 24-inch Wolf Range. He'd been living in this place for 19 years. "All the junk here was found by, or given, to me. Nothing purchased online or from fancy stores."

He said he came to the beach when he was 13 years old, after seeing a copy of *Shelter* in the surf shop where he was working; it inspired him to get out of the suburbs, where he was living, and head for the beach, and he's never left. "I just love it out here."

His home not only has good-feeling surfer vibes, but is colorful and immaculate.

–LK

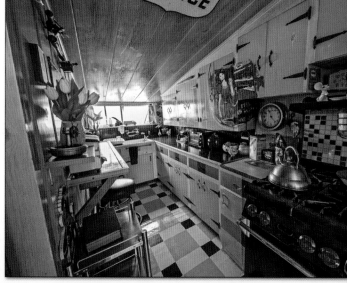

His home not only has good-feeling surfer vibes, but is colorful and immaculate.

Floor Area: 470 sq. ft / 44 m²

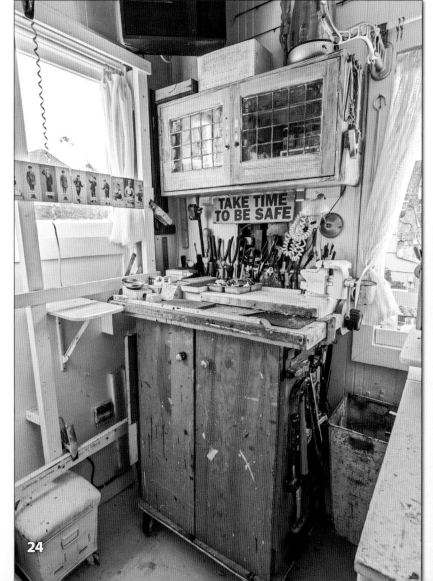

TAKE TIME
TO BE SAFE

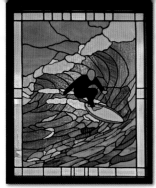

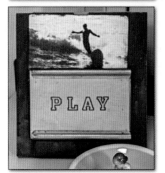

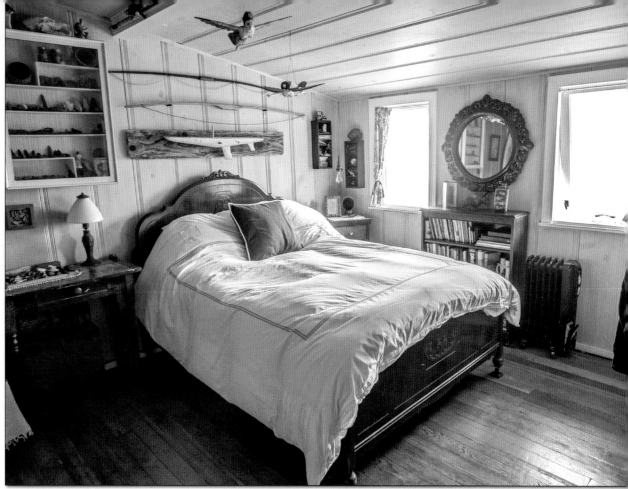

It was a surfer's dream.

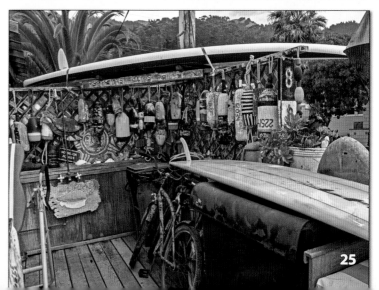

Wayne and Nancy's Hawaiian Island Cabin

Before I left for Hawaii in January 2015, my friend Louie Frazier said I had to look up Wayne and Nancy. He said Wayne was a native Hawaiian, an outdoorsman, hunter, hiker, carpenter, and musician, and that we had a lot in common.*

Louie was right. After driving out a long road to their remote cabin, I met Wayne and felt like I'd known him forever.

That afternoon, he and I went out in the countryside exploring other remote/vacation cabins.

Their home felt a lot like my own. That night we had a wonderful dinner prepared by Nancy: elk stew and a killer pie for dessert.

Wayne showed me an old tattered copy of our book Shelter *that Louie had given to him years ago, and that he said had influenced him in many ways.*

**Louie is the featured builder in* Home Work *(pp. 2–9).*

–LK

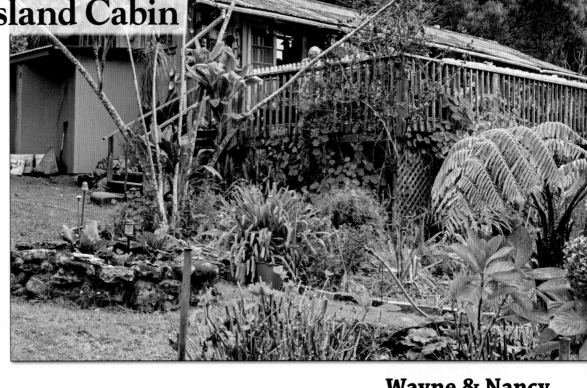

Old copy of Shelter *given to Wayne by Louie Frazier years ago*

Front seat of Wayne's truck

Wayne & Nancy

WAYNE AND NANCY have a small summer cabin on one of the Hawaiian Islands. Built in 1931, it had six or seven owners prior to Wayne. When he first got it, the interior was stained dark grey. "It was like living in a cave."

Wayne is a woodworker, photographer, builder, and a "jack of all trades," as he puts it, as well as a musician. Nancy is an artist, gardener, cook, and homemaker.

Wayne started by ripping out the flat ceiling in the kitchen and installing a 4″ × 6″ Monterey cypress beam at plate height across the kitchen. Wayne milled the beam out of a tree that had been planted on the property in 1936, and felled by the great hurricane of 1982.

The roof on the living room was corrugated metal and there was no insulation. The rafters were round (unmilled) pieces of ōhi'a lehua wood. Wayne installed four-inch batts of fiberglass insulation, and covered it with Canec panels (made in Hilo from the waste fiber of sugar cane production).

One day the roof started leaking and to track it down, Wayne removed one of the metal roofing sheets. "Oh my God!" Nancy said, as light poured into the room, changing the ambience completely. When the metal sheet was replaced with a sheet of polyethylene plastic roofing, the room was bathed in light.

Floor Area: 1900 sq. ft. / 176 m²

Wayne removed the low ceilings in the bedrooms; he then built a loft over the bathroom, reachable from either bedroom.

The old iron-pipe plumbing system was replaced with copper and there is a solar water heater.

Wayne says when they first got the house, it was surrounded by deep jungle — you couldn't see out of the windows. It took him 13 years to push back the jungle, using a machete, shovel, pick, and chainsaw.

The house is homey, bright, and colorful. I felt at home the moment I stepped inside. "The house looks the way it does mostly because of Nancy," says Wayne.

Wayne is a woodworker, photographer, builder, and a "jack of all trades."

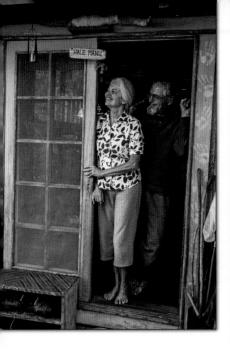

"When they first got the house, it was surrounded by deep jungle.

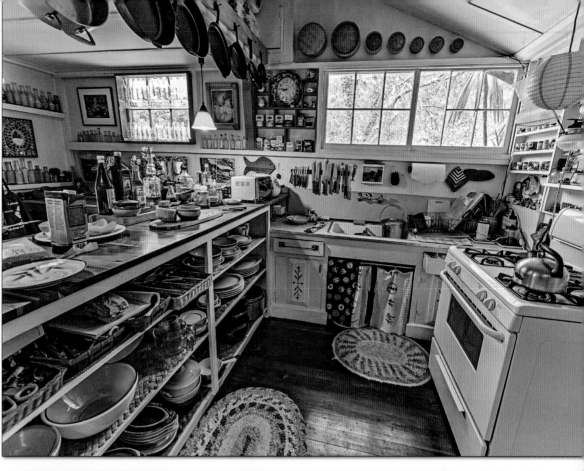

Storage area on shelf above cypress beam. The pots and pans hang on stainless steel bolts, which have had their heads cut off. A jig was used to drill the bolt holes at a uniform angle. Thin plates made of extremely hard ipe *(aka 'ironwood') decking keep the cookware from gouging the soft cypress.*

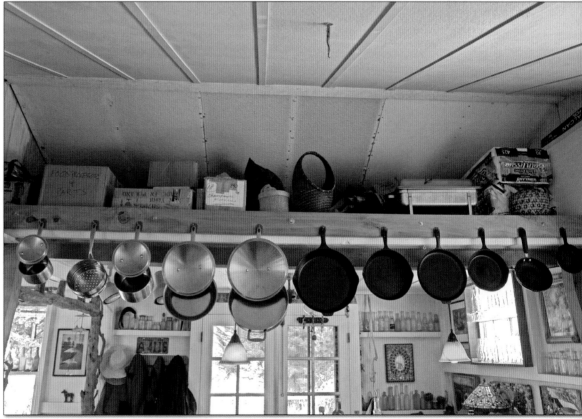

"Oh my God!" Nancy said, as light poured into the room.

More...

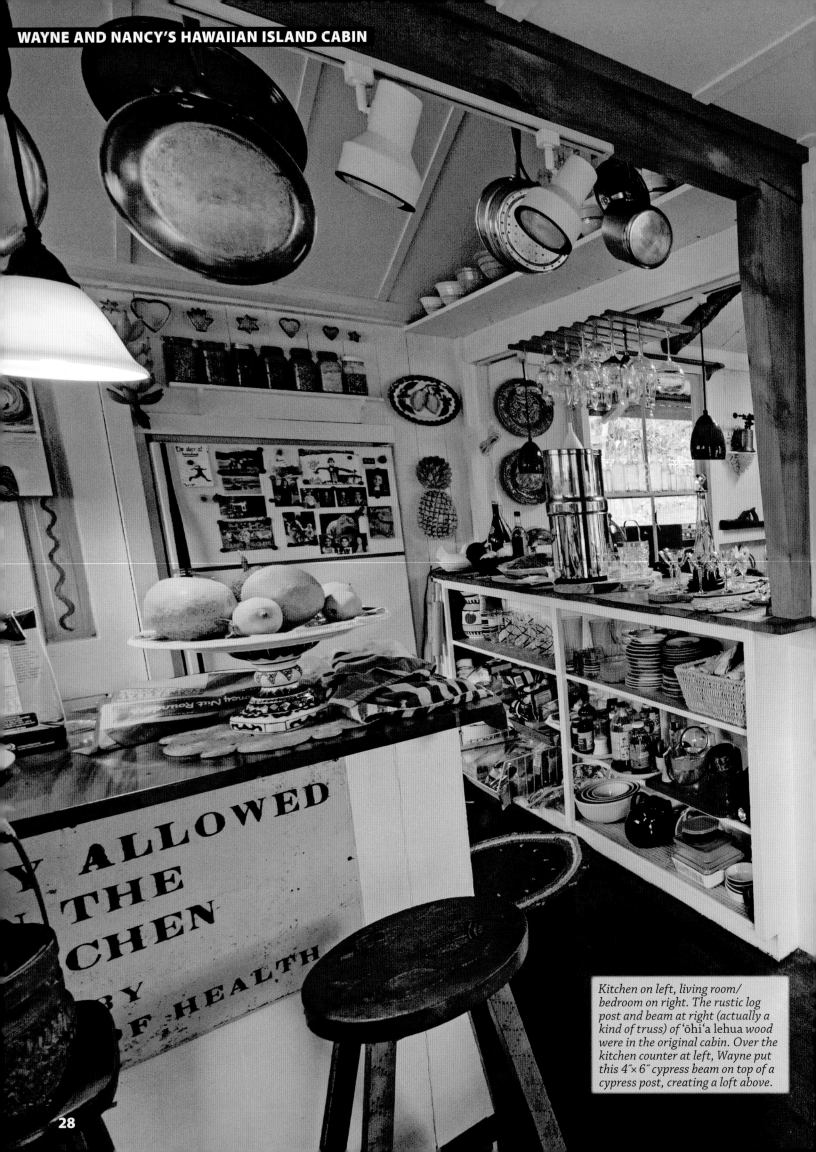

ALLOWED
THE
CHEN
BY
F HEALTH

Kitchen on left, living room/ bedroom on right. The rustic log post and beam at right (actually a kind of truss) of ʻōhiʻa lehua wood were in the original cabin. Over the kitchen counter at left, Wayne put this 4″× 6″ cypress beam on top of a cypress post, creating a loft above.

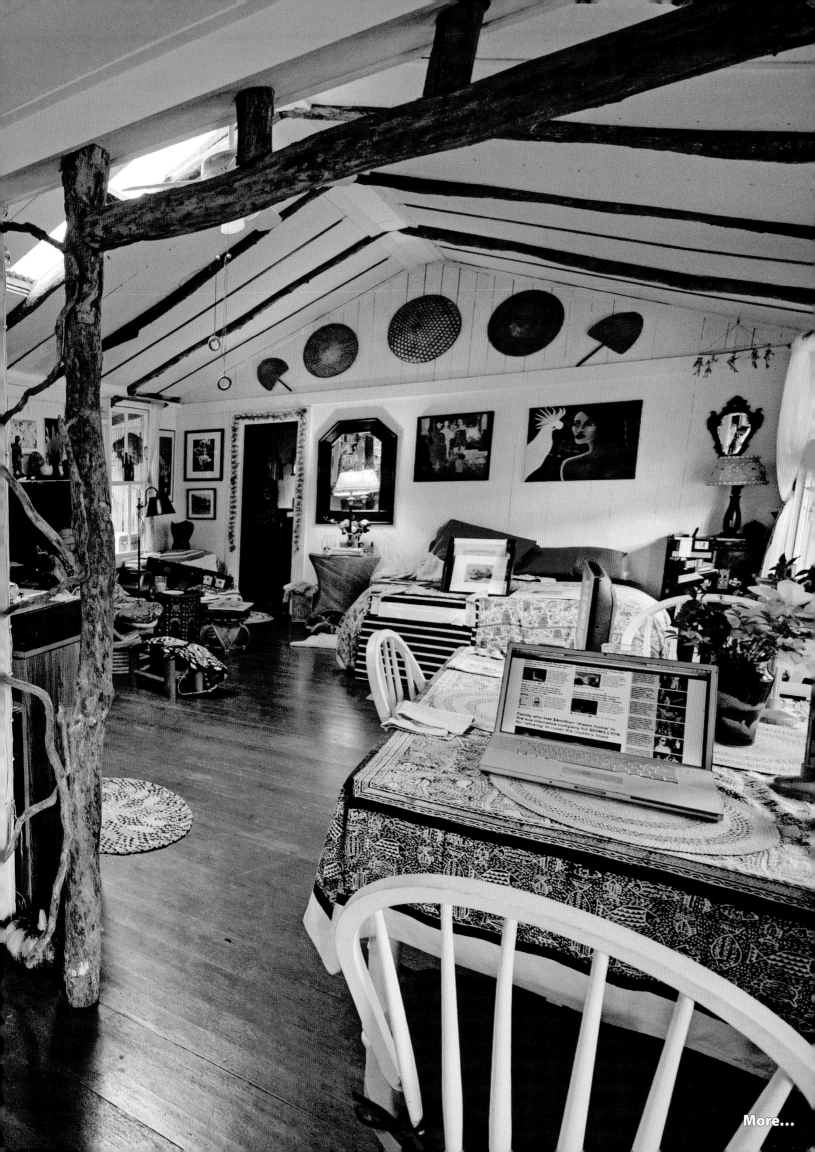

More...

Being single-wall construction (1″× 6″ tongue-and-groove, clear-heart Douglas fir), the walls were originally kept from bowing outward by crossties at plate level. When Wayne removed them so he could raise the roof, he made the double crossties shown here, notched into a kingpin, for lateral structural support. The Canex (building board) ceiling panels hide fiberglass insulation and help dampen the sound of rain on the corrugated metal roof. Screened aluminum vents let out moist air near the apex. On some single-wall houses, the wall stiffener is on the outside. On others, like this cabin, they are on the inside. These serve double duty, carrying casement windows repurposed to slide sideways to open.

The house is homey, bright, and colorful.

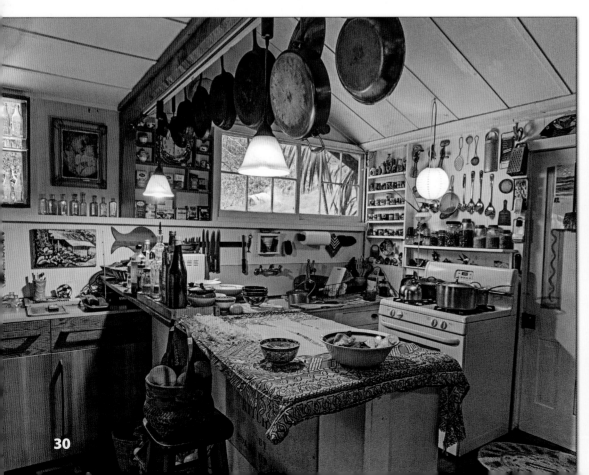

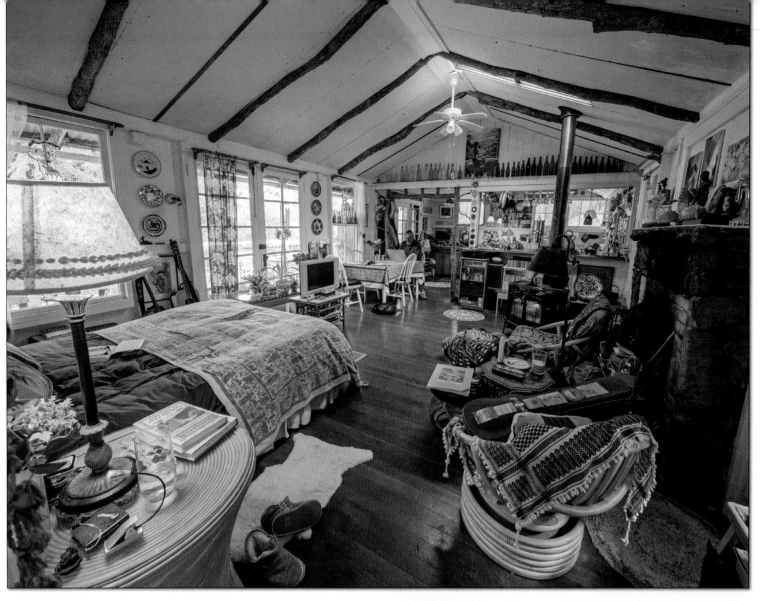

"*The house looks the way it does mostly because of Nancy.*"

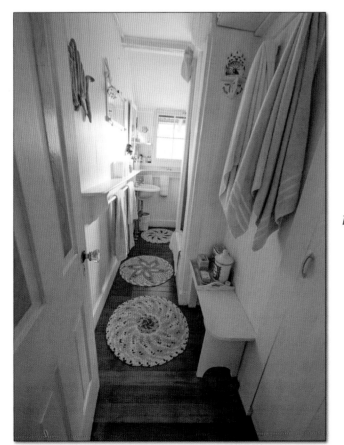

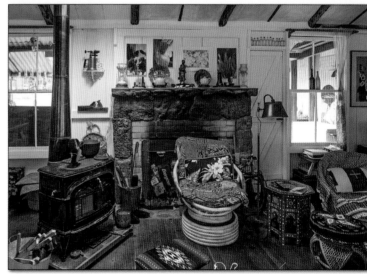

Guest bedroom

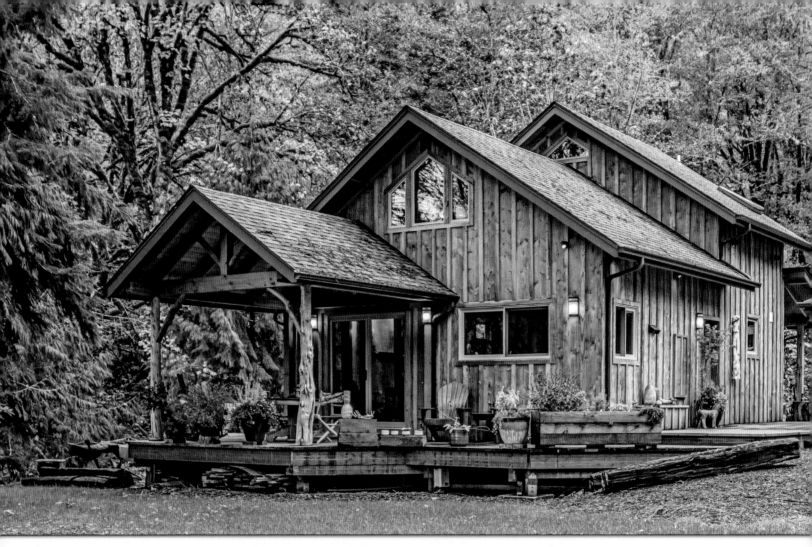

Digger Mountain Cabin
Scott McClure

Second-growth Douglas fir trees were selected and cut from the hill above the building site, milled on the landing, and trucked 35 miles to my shop for fabrication.

TWENTY-SEVEN ROAD MILES FROM the Pacific Ocean, my client bought his tree farm in the middle of the Oregon Coast Range in 1971. There was an old cabin (one of the two original homesteads on the property) right next to the present building site, slowly settling into the duff of the three-stemmed redwood tree now growing hard up against its south eave. The house is home to numerous small creatures; we rescued a lethargic bat while removing windows and other salvage before demolition. Some folks hopefully wondered if the demolition of the old cabin meant that many old stories were now safely put to rest, reaching a kind of statute of limitations.

An artist, potter, and teacher of pottery for many years, my client built a wood-fired anagama kiln on the property in 1990, the third wood-fired kiln constructed in the state. Fired twice a year, it is a four-day process and consumes more than four cords of wood to reach temperature.* It takes a fair-sized crew to do this efficiently and about six or seven years ago a ceramics studio was built, with a full bath, work sink, and a woodstove — the upstairs being used

as sleeping quarters. This worked well as a warm, dry place to hang out in during firings and occasional visits, but Jay and his partner wanted a space of their own they could retreat to during firings, as well as a place they could call home after his retirement.

The plans were drawn by my good friend Terry Johnson and we stayed with his basic space plan of just over 1100 sq. ft., though we did squeeze in a half-bath upstairs, thanks to my creative plumber friend Pat and a carefully placed skylight for headroom. We also added a 12´×12´ covered porch on the south end, framed using timber from the site as well as a couple of juniper posts that we scrounged from a pile we stumbled across out in the meadow. A smaller, covered porch shelters the laundry-room door to the north.

Second-growth Douglas fir trees were selected and cut from the hill above the building site, milled on the landing, and trucked 35 miles to my shop for fabrication. The board and batt siding is also Doug fir from the property. Bigleaf maple and Oregon white oak were also milled and eventually turned into siding, flooring,

stair parts, mantle, and other trim. Door and window casings were clear, western red cedar salvaged from the old cabin, topped with live edge pieces straight from the slash pile.

The rafters are covered in T&G pine, with 9½″ of EPS rigid foam above as insulation. The timber frame is wrapped with 2´×6´ walls filled with blown-in-place fiberglass. R-38 fiberglass batts insulate the floor. Heat is supplied by the soapstone woodstove, though there are three electric heaters (bath, living, and upstairs) installed to satisfy the building code. The lighting is all LED and really shows off the timber frame. Reports are that it's an easy place to keep comfortable with a minimum of effort; the owners are very pleased with the space.

This project was a joy. The clients are wonderful humans. I am a lucky builder.

Floor area: 1100 sq. ft. / 102 m²

 www.confluencebuilds.com

Info on anagama kilns:
www.jaywidmer.us

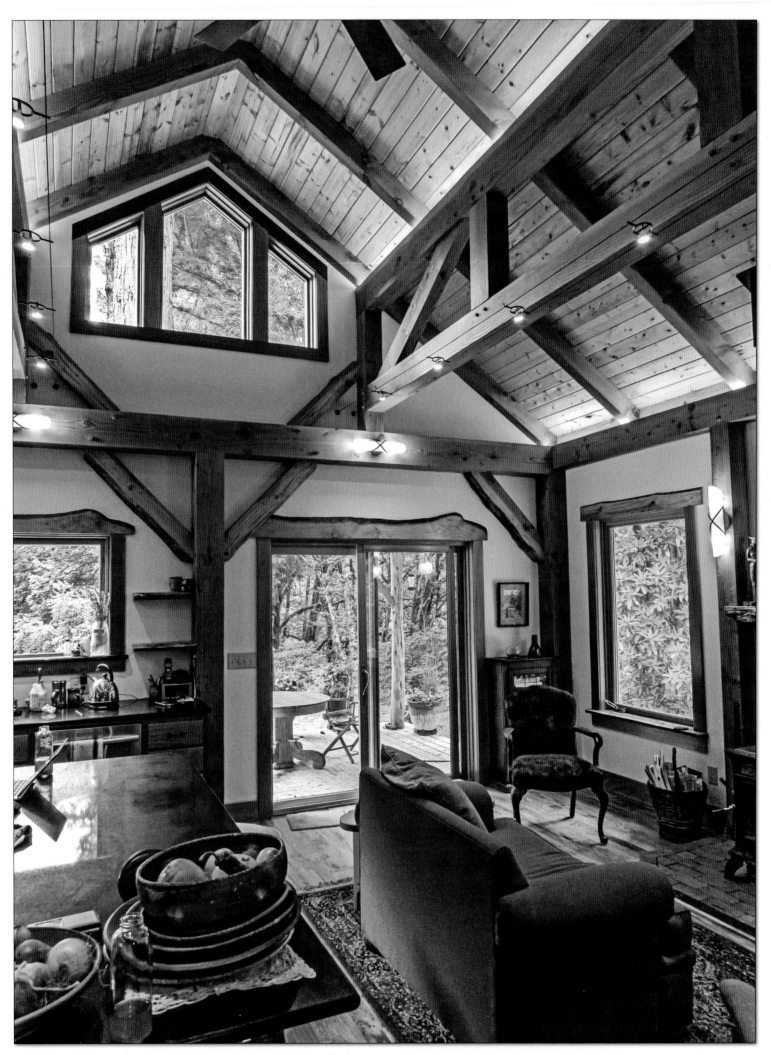

"We stayed with his basic space plan of just over 1100 sq. ft., though we did squeeze in a half-bath upstairs."

More...

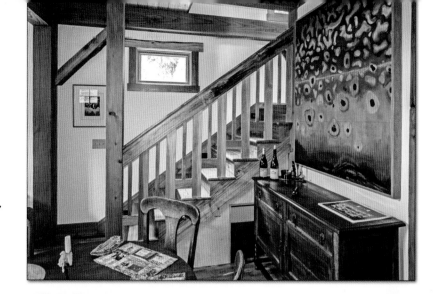

The framing plan became a complete joined timber frame, which fit the owners' aesthetic quite nicely and is a complement to the organic nature of their collection of pottery and other art.

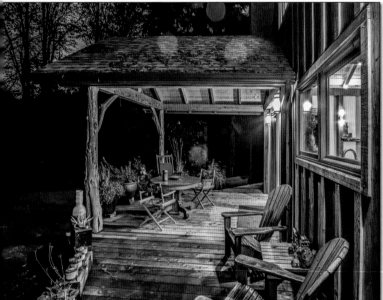

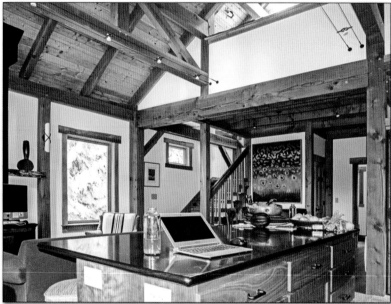

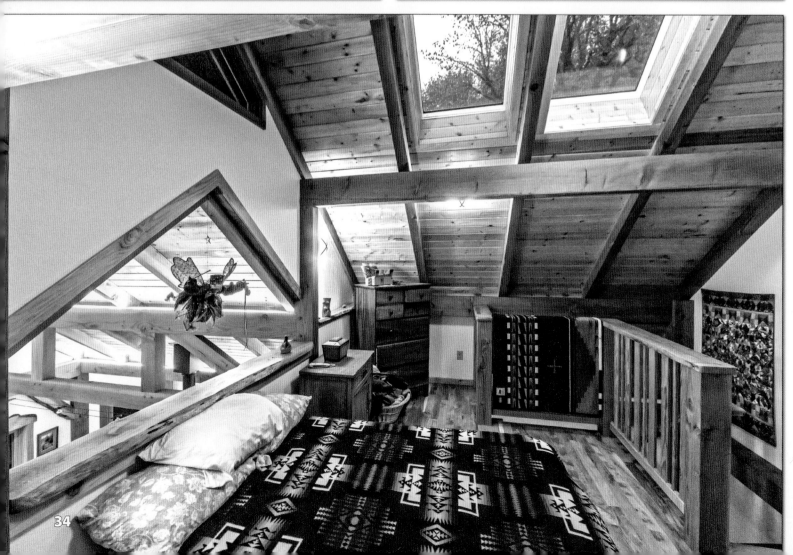

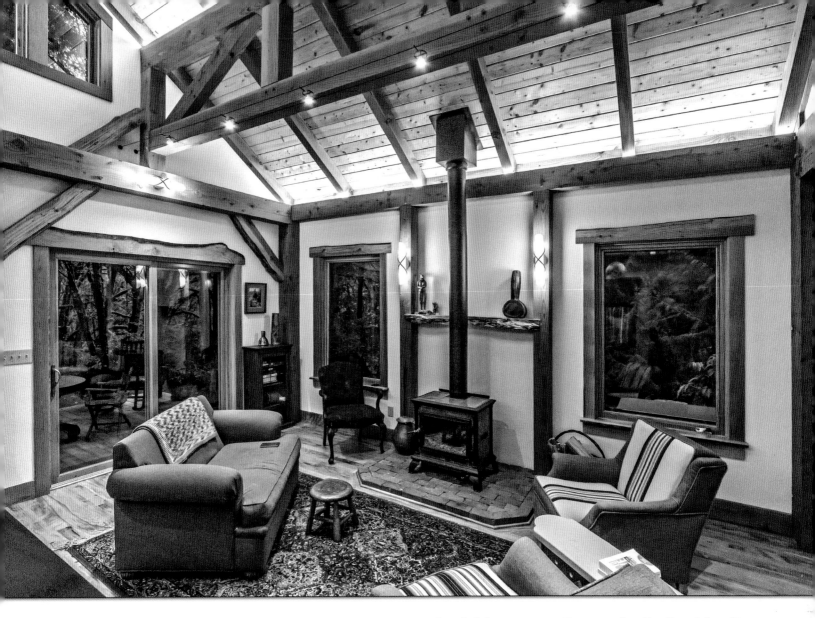

"This project was a joy. The clients are wonderful humans. I am a lucky builder."

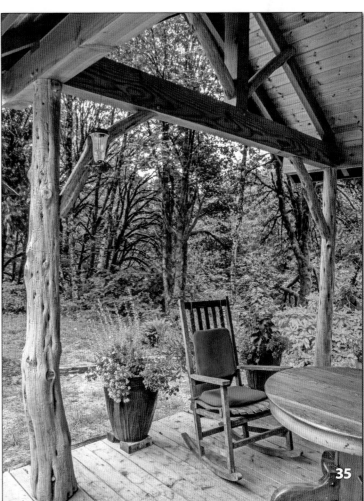

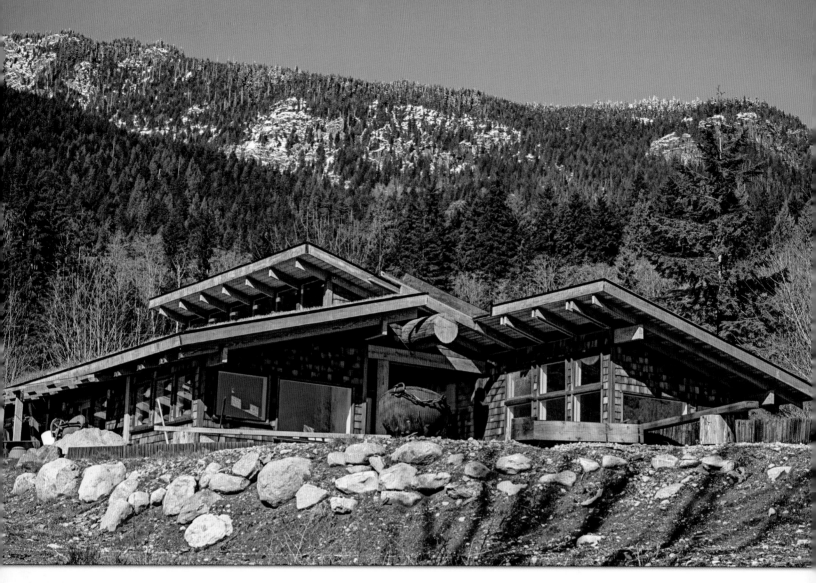

Timber Home Along Canada's Sunshine Coast
Marlin Hanson

AROUND EIGHT YEARS AGO, MY brother and I bought some land on the Sunshine Coast* in British Columbia. He planned to build a large shop and I planned on building a small house. At the same time, there was some logging going on behind the place, so we bought some logs — mostly second-growth Douglas fir.

Over the next year I worked slowly designing my house with a few scale models. I milled the timbers on our old Mobile Dimension sawmill, and let them dry for a couple years while I slowly got the site ready for building. I was working in marine construction and wanted to utilize the simple and strong construction methods we used under piers.

I built the house over three summers and picked away after work and on weekends during the winters.

The first summer was the most fun. My dad and I did all the timber work and framing together and got the roof decked before the rainy season started.

That winter I built a power- and pump-house and put in an apple orchard. The second summer, I worked at getting the green roof on and the outside of the house shingled.

I built the woodshed that winter as a staging zone to allow me to get the inside of the house finished the following summer. I built the shed with salvaged steel pipe for posts and wood left over from my house. The pipe had been off-cuts from pilings we had driven at work. I torched saddles into the tops and placed two large fir logs as beams across. I still haven't got around to bolting them on yet.

The third summer I buttoned up the inside of the house: plumbing, electrical, insulation, plaster, and kitchen.

That fall my daughter and I moved in. There is still a lot to do but the feeling of living in this space that has taken all these years and all this thought is amazing.

Floor Area: 1281 sq. ft. / 119 m²

 instagram.com/hanson_land_and_sea

*The Sunshine Coast refers to the land north of Vancouver, approximately 100 miles long on Highway 101, running along the southwest coast of mainland Canada.

"We bought some logs — mostly second-growth Douglas fir."

"I milled the timbers on our old Mobile Dimension sawmill."

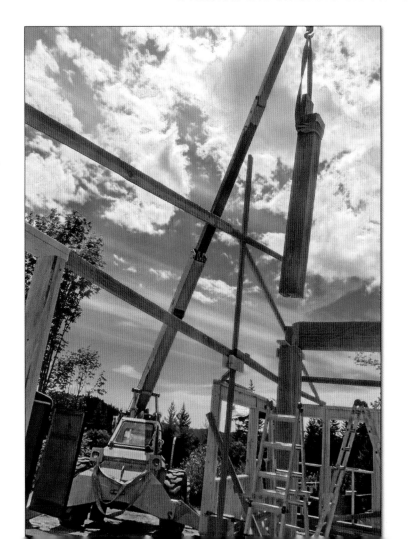
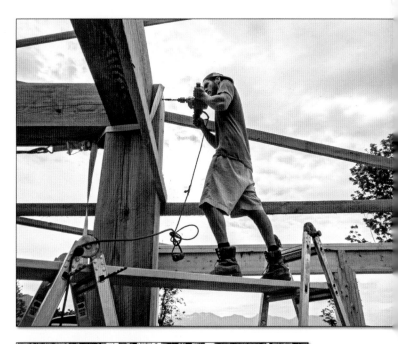

More...

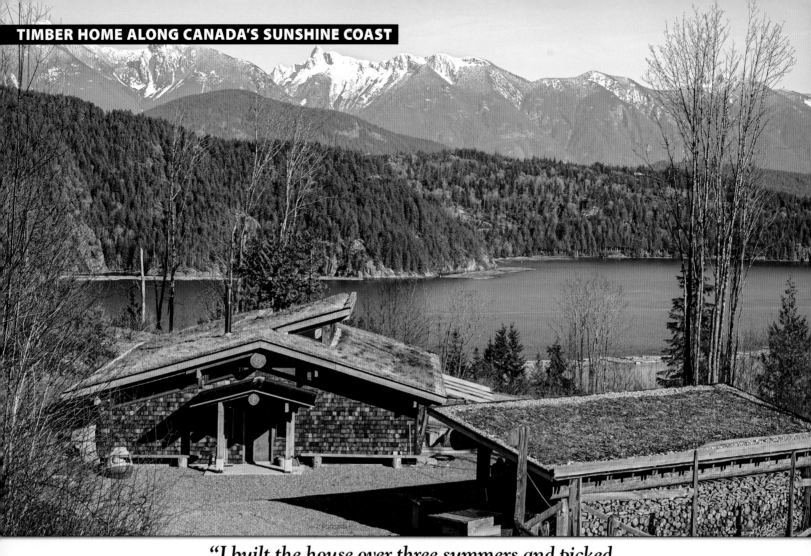

"I built the house over three summers and picked away after work and on weekends during the winters."

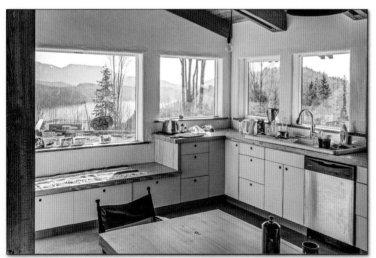

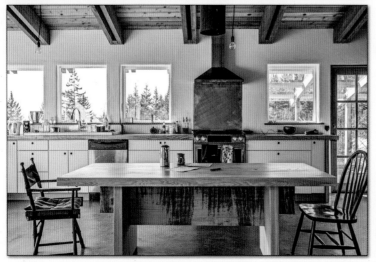

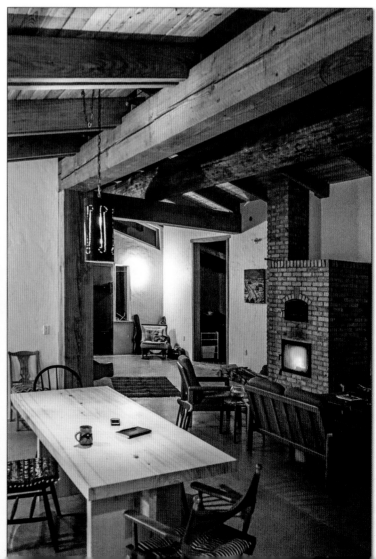

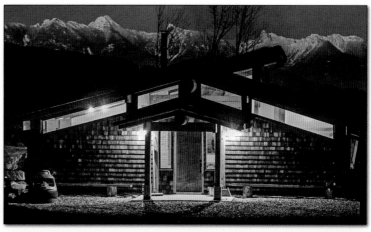
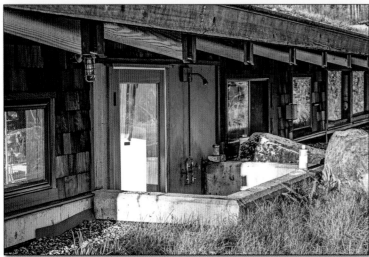
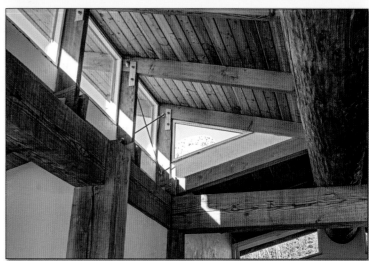

"There is still a lot to do but the feeling of living in this space that has taken all these years and all this thought is amazing."

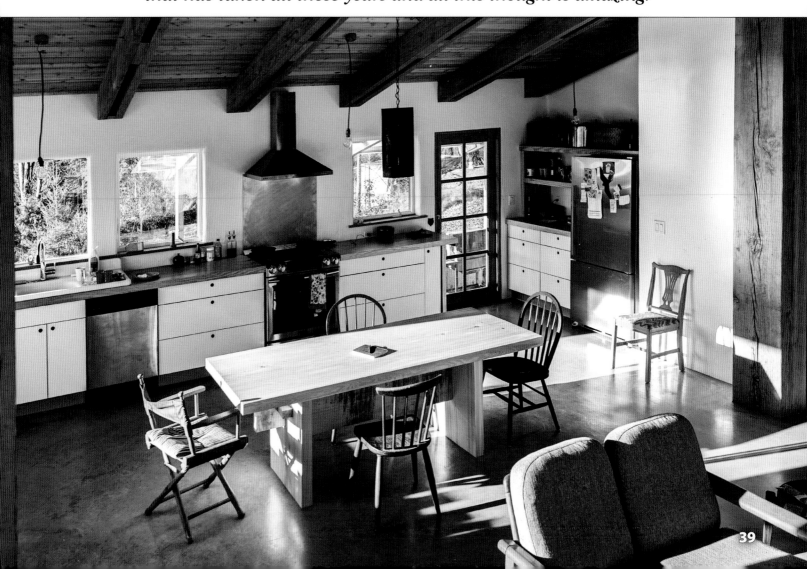

Small Timber Frame Home in German Forest

Marco Trauth

Photos: Shahab Gabriel Behzumi

WHILE WALKING ALONG THE WAY OF St. James (a pilgrimage trail from Germany to northwestern Spain), I had an inspiration on the very first day. After quitting school and traveling by bus, sailboat, and by foot, it seemed wrong to start another adventure without having a shelter to return to.

So I changed my direction and thought about where I could build, and what kind of house. My family owned a nice piece of land in the middle of a forest, so I decided to build a tree house there. A week later, I read a book, bought some wood, borrowed the most important tools, and started right away.

It was a nice time and very good example of "learning by doing." I was pretty proud of my accomplishment and for the next five years, the tree house was my home.

Then I started gardening and built a stone oven in a traditional way for baking bread and pizza. I shared my life with some friends, and a lot of visitors and WWOOFers (World Wide Opportunities on Organic Farms).

Two years ago I felt the need for more living space, so I decided to build a timber frame home. I felled trees on my site and had them milled on a portable sawmill. Last year, a friend and I started to prepare the timbers. We did 95 percent of the cutting with Japanese handsaws. Working in the sun with your very own body power and no noisy electrical appliances is a whole different way of building!

The house has power supplied by the sun and running water from a source nearby. Hot water is supplied by a Biomeiler: a specially designed compost heap with pipes inside *(see below)*. The rain gutter is carved out of one piece of larch. The roof is covered with 120-year-old handmade tiles and insulated by a mixture of clay, straw, hemp, and feathers.

Now that the house is finished, I would like to continue my mission of worldwide carpentry.

Floor Area: 250 sq. ft. / 23 m²

Contact: *ventura@mail.de*
 Biomeiler water heating compost piles:
 www.shltr.net/biomeiler

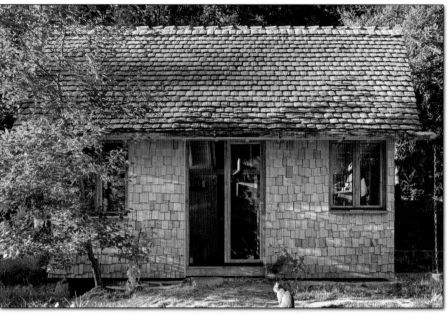

"The roof is covered with 120-year-old handmade tiles."

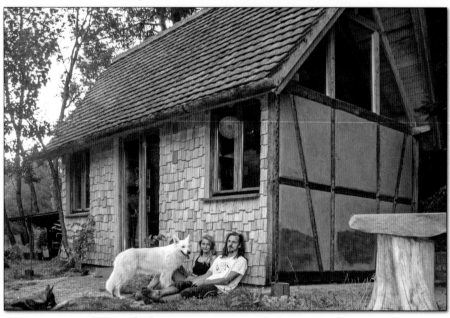

"We did 95 percent of the cutting with Japanese handsaws."

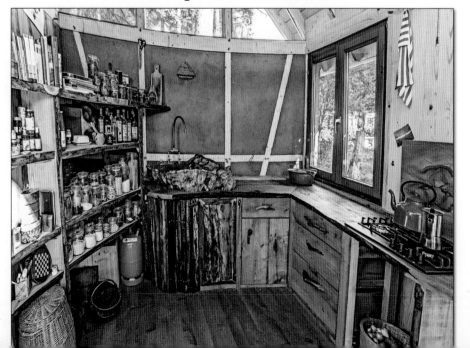

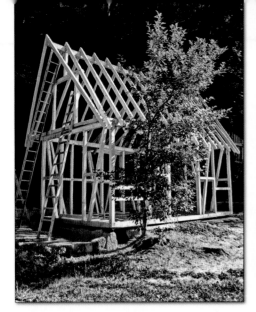

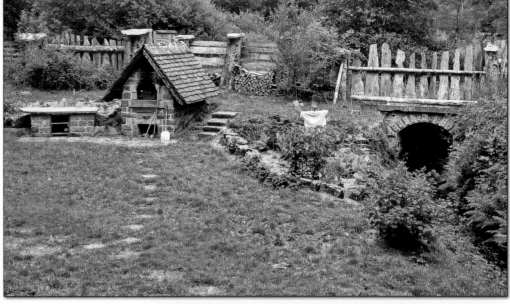

"Working in the sun with your very own body power and no noisy electrical appliances is a whole different way of building!"

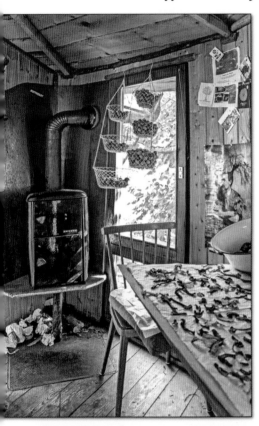

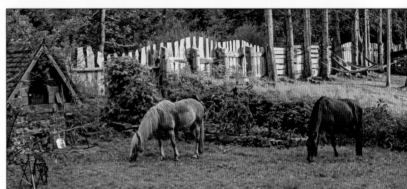

"For the next five years, the treehouse was my home."

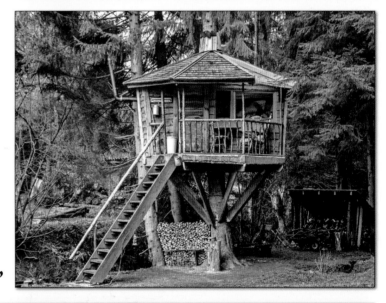

Small Home in Lithuania

Dan Combellick

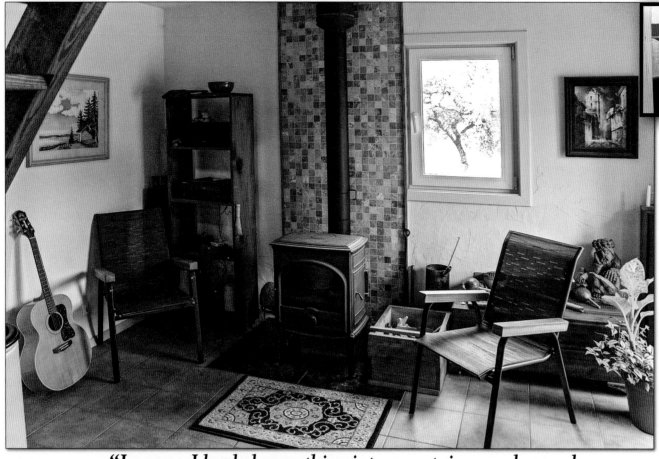

"In 2003 I loaded everything into a container and moved to a piece of land I had purchased in northern Lithuania."

I STARTED AS A CARPENTER when I was 16 in Montana. I was working as a dishwasher when a builder, who was a regular at the counter, liked the way I worked and offered me a job. During the next two years, we built houses, and I was exposed to the first printing of *Shelter*. This was in 1973.

Shelter had a significant influence on me and opened my eyes and mind to many paths, which I explored.

Having this background made me a rebel when I studied architecture at Iowa State University. I spent half my time in advanced classes in structural engineering, where the jokes about architects were frequent.

I could not comprehend how you could be an architect and not know how to build. Later in life, I experienced the ramifications of this ignorance as I easily took over control of projects (as the builder) from the architects — because they did not know how to build or what things cost.

After five years at the university, I worked as a carpenter, superintendent, project manager,

and then in 1992, I started building on my own, doing design work, and contracting expensive homes. Building expensive homes for rich folks was surprisingly unrewarding, but on the bright side, I was exposed to many fine craftsmen and I took care to watch, ask questions, and learn from them.

I did this until 2003 with the exception of three months in the summer of 1994, when I was sent to Lithuania to show a Lithuanian building contractor how to assemble an American technology house — the first in the then-recent breakaway from the Soviet Union. It took me about two weeks to decide I wanted to live there, and over the following years, I saved money in preparation for my move to Lithuania.

In 2003 I loaded everything into a container and moved to a piece of land I had purchased in northern Lithuania. I started by building a small shed, about 10′ × 16′. The frame was of handhewn logs — some of which I

bought and the rest cut down from my forest. Once I had a place to live — albeit without electricity and water — I started on my small home.

There was no electricity, so the entire home was built with hand tools. My saws were always perfectly sharp. I once counted 150 strokes for a cut on one of the rafters, so as you can imagine, I took the greatest care with my saws.

Thanks to my structural background I can make up my own construction methods as I go, without fear. This house could be described as a "timber/ stud" frame.

The design was shamelessly stolen from the local vernacular; I saw no reason to do anything different. Over hundreds of years, the inhabitants of a given region will evolve the best shapes and features for a home and it would have been foolish to do something unusual, "modern," or otherwise to insult the landscape or ignore the wisdom of regional builders.

Fortunately I got electricity toward the end of the project, a savior for installing trim, having hot water, lamps not fueled by kerosene, a clothes washer, and all those little things I had been living without.

I lived there for a few years and I can easily say that this house was the love of my life. Needless to say, there was no bank loan, and everything I could see was something I had done.

Memories remain strong. I recall a day so quiet the only sounds beyond those from my tools were the swish of stork's wings as they flew overhead; the first summer I was building, I saw 26 rainbows. But as sure as the Siberian winds can bear down upon Lithuania in the winter, a divorce was descending upon me, and I needed a new place to live.

I found 12 acres nearer the capital, Vilnius, which had a 70-year-old log home *with* electricity, 40 ancient apple trees, and no running water.

The first year I built an outhouse, started a garden, and rigged a summer water line

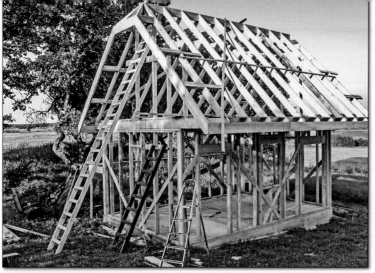
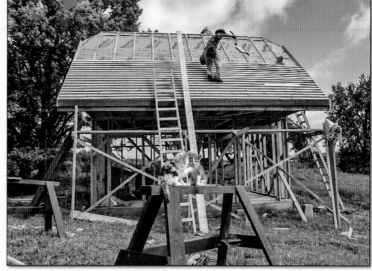
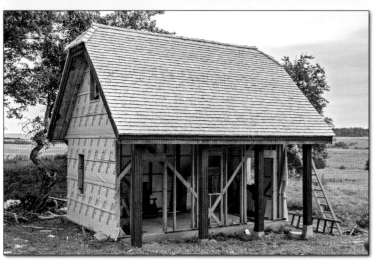
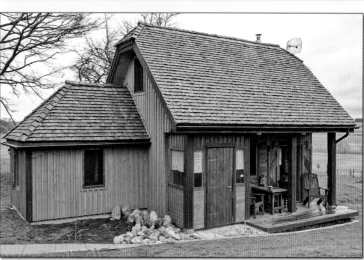

> "Herein lies another beauty of the small home:
> You don't need to spend so much, or work so long."

from the old hand-dug well, which would promptly freeze as soon as the temperature dropped below 32°F. I picked a location for my new small home *(photos shown here)* and began the foundations.

Having electricity sped the process up considerably, but it still took me three summers to make the house livable. Again I did all the work myself, and alone, except for the wood roof.

There is nothing out of the ordinary about this house except perhaps the insulation. I like heating a home with wood, but I tire of cutting and splitting large quantities of firewood. The insulation was expensive and very labor intensive, but herein lies another beauty of the small home: You don't need to spend so much, or work so long.

I constructed the exterior to address the three ways you can lose heat: conduction, convection, and radiation, and it has paid off. In the old log home I would use six armloads of wood in a day. In the new house: one. The windows are triple-paned; you take winters very seriously when living in Lithuania.

I was able to move in just three months after I lost my other home. It is 450 square feet and you know what? It is enough. I may add an east bedroom, which would have a gorgeous view, and this would give me a second bed in case someone is crazy enough to visit.

I want to thank Lloyd Kahn. He is perhaps responsible for sending me on this journey. I think there was never a publication that inspired me more than *Shelter* in 1973. Without it, I imagine I would have followed a very different path, and to paraphrase Gandalf (I think) "Not to honor one's teacher, not to cherish one's charge, is to be on the wrong path no matter how clever you may be."

I was sixteen then; I'm almost 60 now. My goals remain now as they were then. I live in a house I own, that I built myself, grow much of my own food, and am approaching sustainability. I am so far removed from the rat race that I cannot even hear the jeering crowds.

Thanks, Lloyd.

Floor Area: 450 sq. ft. / 42 m²

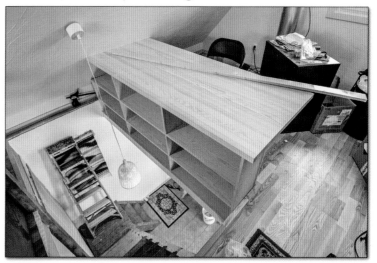
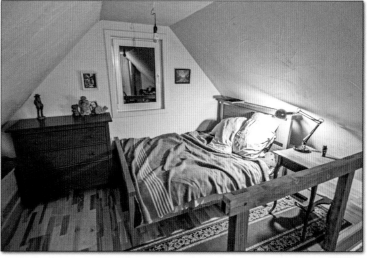

43

Cabin in the California Woods
Ed and Marilyn Stiles

On the property was an old chicken barn that had been converted into living quarters.

*Over the years,
Ed rebuilt just about everything.*

IN 1965, ED AND MARILYN Stiles got married in upstate New York and headed for California. Ed intended to be a woodworker, and they detoured through Tennessee so Ed could pick up some major woodworking tools (table saw, band saw, joiner, shaper, planer) at the Powermatic factory.

Ed and Marilyn arrived in the San Francisco area with a trailer full of tools and started looking for a place to set up shop. Through a series of fortuitous events, they first rented, then bought some land on a wooded hillside north of San Francisco.

"My dream place," said Ed. "To be able to live and work on the land, but with access to the city — my fantasy — go into the city, music, all that. Well, *(laughs)* I never did that."

On the property was an old chicken barn that had been converted into living quarters. Over the years, Ed rebuilt just about everything. First he strengthened a sagging roof with salvaged 4 × 6s, then built a

bedroom upstairs and a sunroom. He rebuilt the bathroom, adding a uniquely shaped wooden tub that he calls "the milkmaid's bucket."

Almost all the wood used was salvaged. "I'm a wood guy," says Ed. "Almost everything I do is with redwood."

"I love this house being so lightly built, with small dimensions. It's about as cheap as any structure you could build. You can use salvaged materials."

Over the years Ed has built custom furniture, five houses, a new shop, and remodeled small houses.

You can see his furniture at:
www.edstiles.com

Floor Area: 1248 sq. ft. / 116 m²

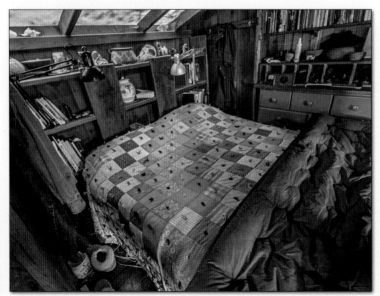

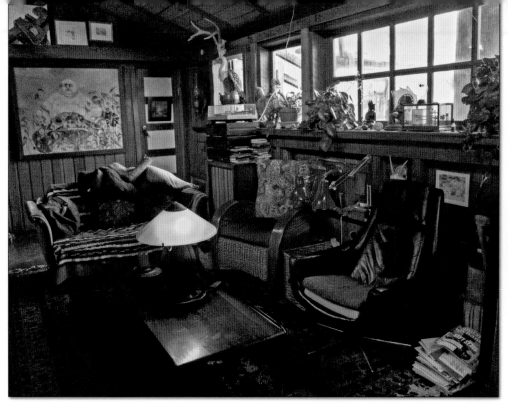

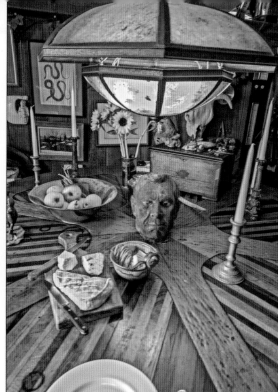

Almost all the wood used was salvaged.

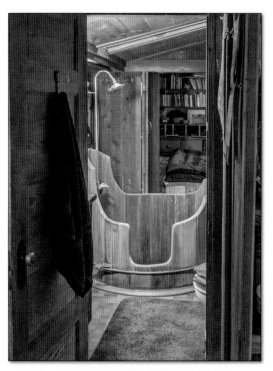

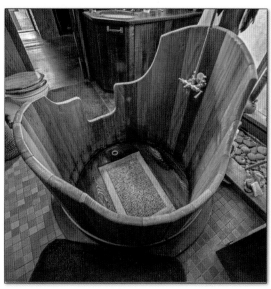

"I'm a wood guy," says Ed.

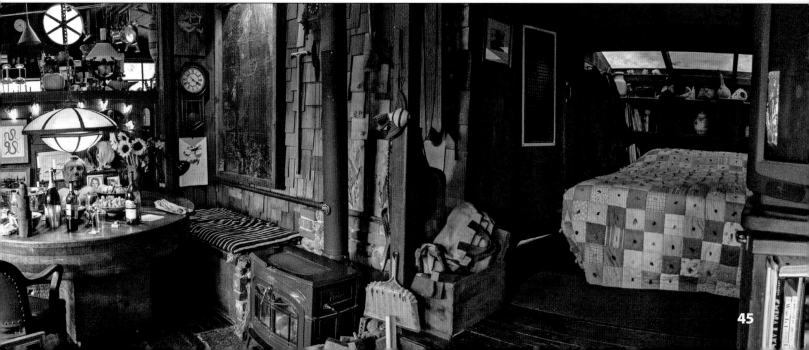

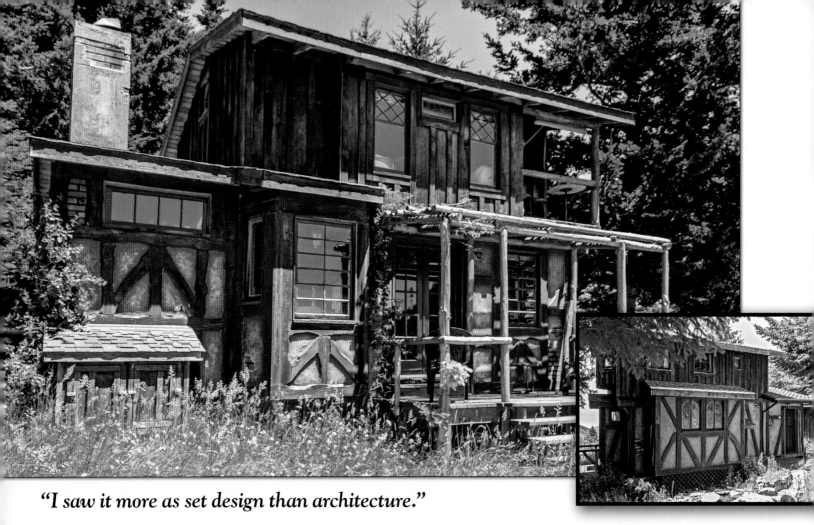

"I saw it more as set design than architecture."

Off-the-Grid Cabin in California Woods
Tony Anderson

WHEN MY BROTHER and I bought land in remote coastal Northern California in the '70s, our parents, Bob and Jean Anderson, jumped at the opportunity to build a small home on our place.

Bob was a retired filmmaker, and Jean a travel agent, so they had seen a lot of the world from which to get ideas for building.

"I saw it more as set design than architecture," Bob said about the 665-square-foot house.

Built with standard stud-wall framing and locally milled wood, he added a half-timbered facade on the exterior, complete with stucco peeling away to expose brick. My mom and dad were both meticulous about trying to make the place look instantly old, in a European way.

Interior posts and beams were cut and peeled on-site (by Jean, using a draw knife). In order not to have too

boxy a feeling and to add variation, there are several bay windows and entrance nooks.

There are two decks; one reached by a bridge over a small stream and wrapped around a large fir tree, the other shaded by a vine-covered ramada of fir poles.

An 8-foot slab of a tree was split in half to form a three-inch-thick, built-in dining table/bar. All the windows and doors are made of recycled materials.

Upstairs, there is a small, covered porch where you can sit and contemplate the canyon below. A couple of steps away is the bathhouse, with a bottle wall in the shower.

The overall feeling here is off-the-grid contemplative peacefulness; no Internet, no cell reception, just a snug, half-timbered cottage overlooking the ocean and forest.

Floor Area: 665 sq. ft. / 62 m²

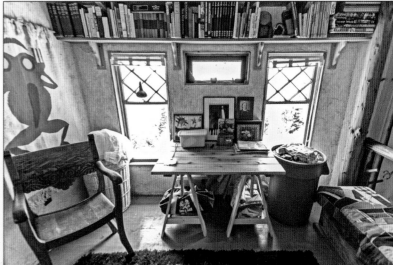

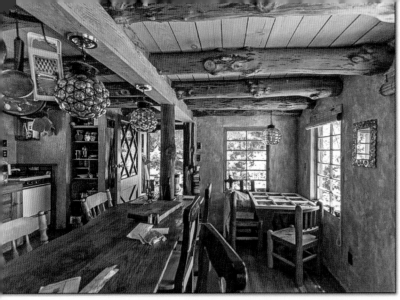
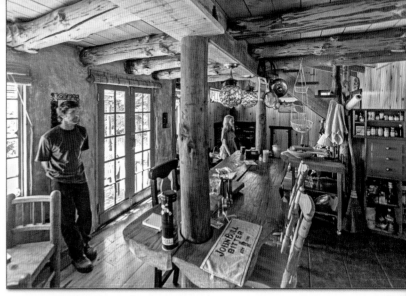

Interior posts and beams were cut and peeled on-site.

The below three photos by Sienna Anderson in 2016 (who is center in the photo at above right, taken by me in 2005, at age 12)

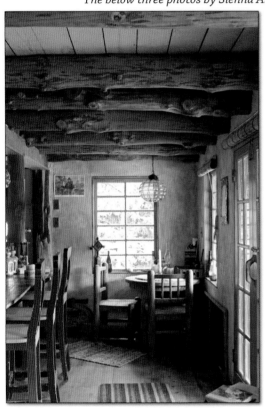
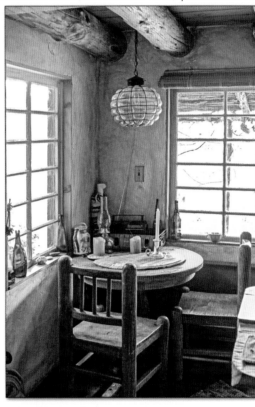

"No Internet, no cell reception, just a snug, half-timbered cottage overlooking the ocean and forest."

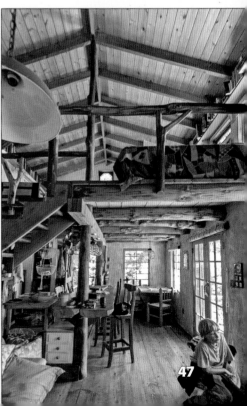

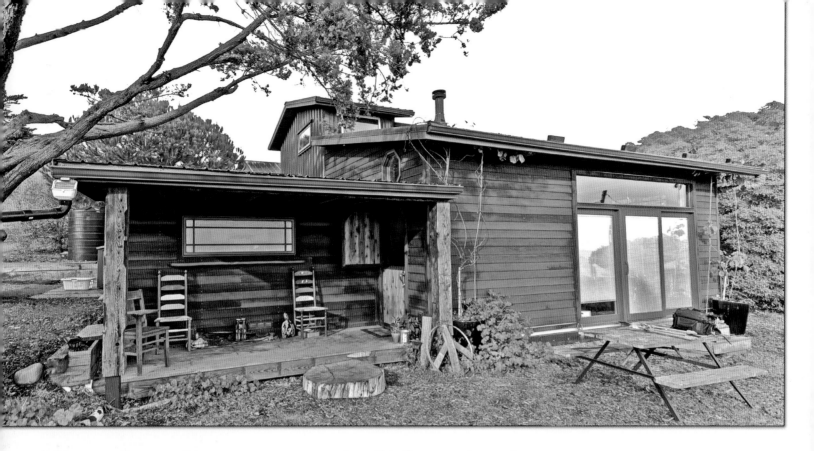

Wooden Home on California Coast Guner Tautrim

"…property that has been continually inhabited by my family for the last 150 years."

ON THE WEST COAST OF CALIFORNIA lies a property that has been continually inhabited by my family for the last 150 years. Six generations after its purchase in 1866, I am passionate about keeping it in the family for at least another 150 years.

Having some training in natural building, as well as conventional building, and armed with a bookcase full of prior Lloyd Kahn/Shelter Publications books, I began the process of designing and building a small yet comfortable home for me and my family.

I began salvaging and repurposing that which others left behind. Being a wood-worker by trade and owning my own sawmill, it soon became obvious that there were tremendous local resources to be had. Although not completely finished (Is it ever?), the house is currently being lived in and fully enjoyed by my wife, two boys, and me.

The 1100-square-foot house is more or less stick-frame construction with a few natural building perks. The framing for the structure was all milled out of a few local pine trees from a neighbor's place.

The house utilizes passive solar design and has an earthen floor living room, an interior cob wall, and an external "chip slip" wall (wood chips bound together with clay),

all of which provide ample thermal mass for the structure.

Interior woods were all milled on site and include a floor of black walnut, kitchen cabinets of silky oak and black acacia, wainscoting of red gum eucalyptus, red ironbark eucalyptus, and yellow acacia; as well as kitchen counters made from large slabs of swamp eucalyptus. Lots of redwood is used in the house, including all the custom natural-edge window frames, the bar top, and the exterior shiplap.

The house catches all of its rainwater and deposits it in 6500-gallon-capacity storage tanks.

All greywater is utilized in mulch basins and there is a Sun-Mar composting toilet. The outdoor shower is a ferro-cement structure and feeds a downhill bamboo grove.

Floor Area: 1100 sq. ft. / 102 m²

"I began salvaging and repurposing that which others left behind."

 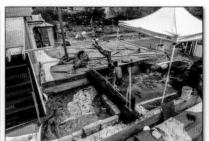 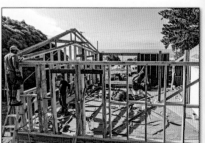

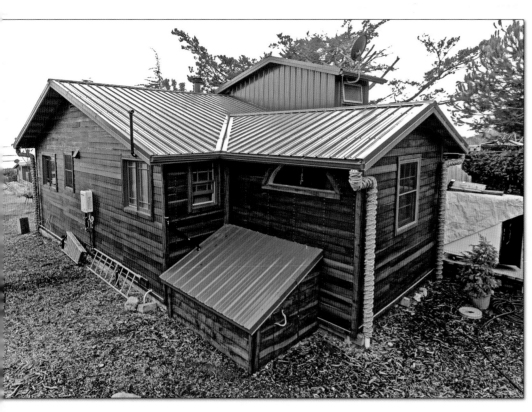

The framing for the structure was all milled
out of a few local pine trees from a neighbor's place.

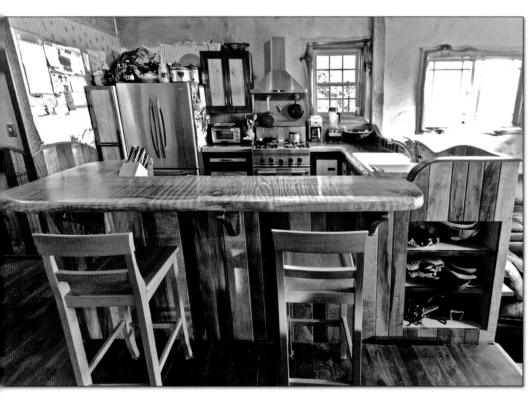

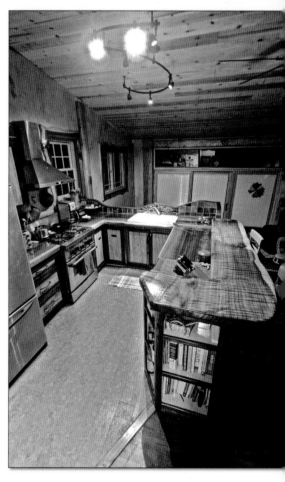

The house catches all of its rainwater.

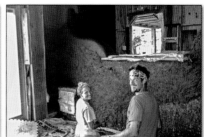

More...

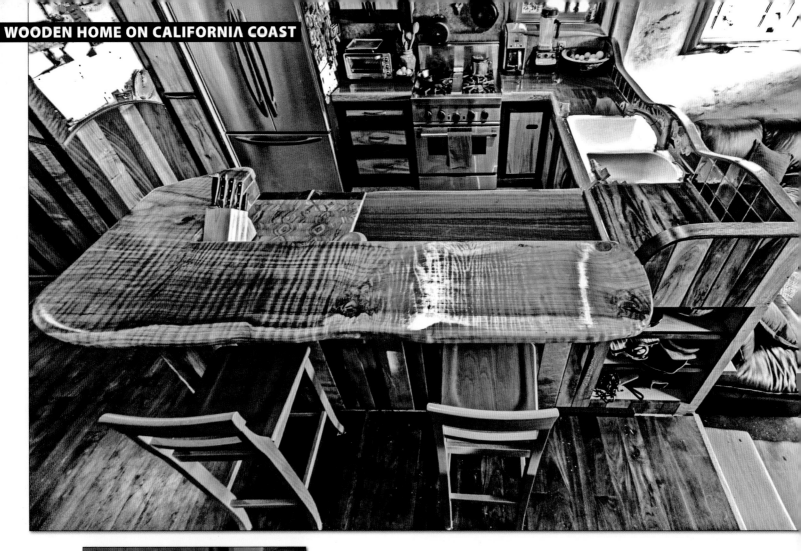

Interior woods were all milled on site …

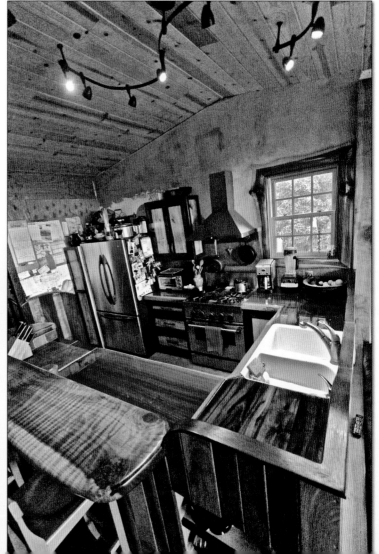

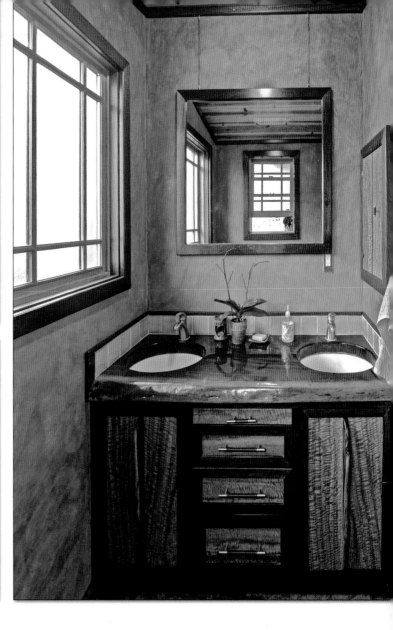

The house utilizes passive solar design.

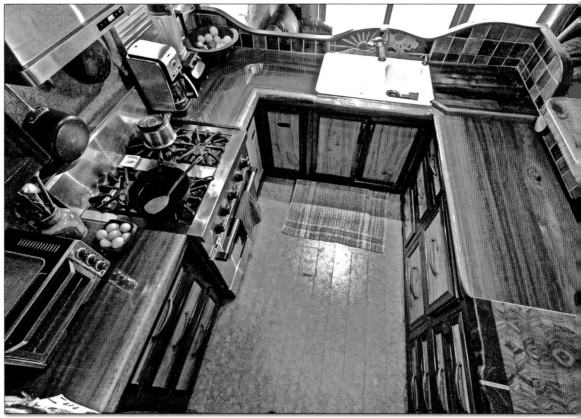

The Leafspring

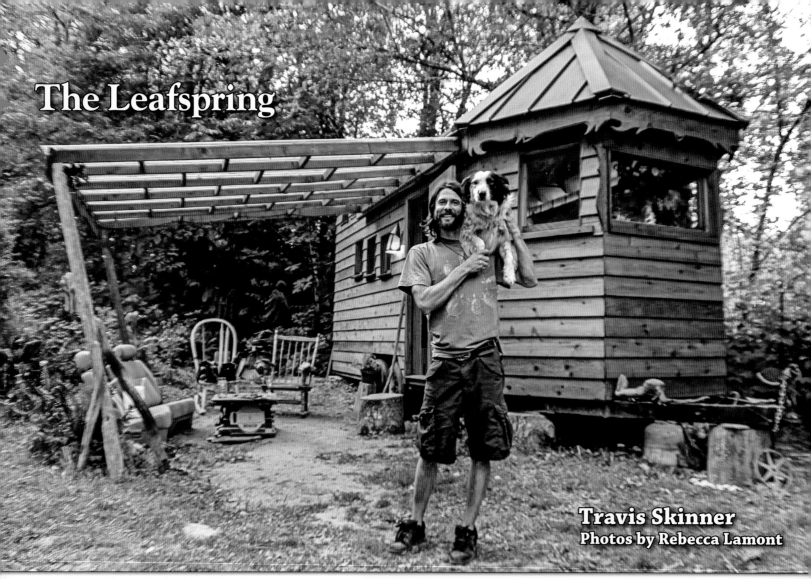

Travis Skinner
Photos by Rebecca Lamont

"I stripped the frame from a rotten 1984 Terry Taurus camper and welded the footprint of the house with steel tubing."

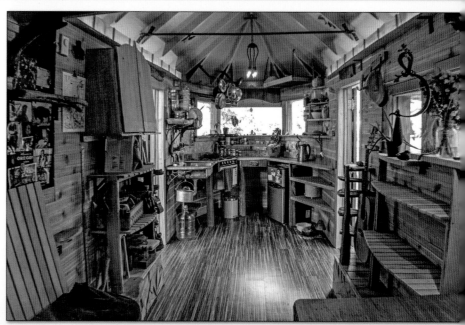

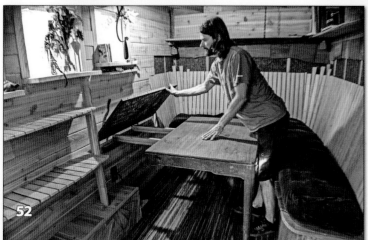

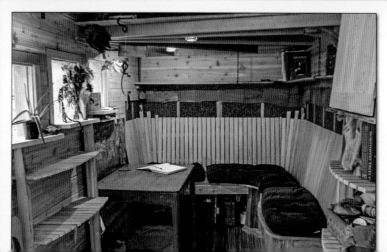

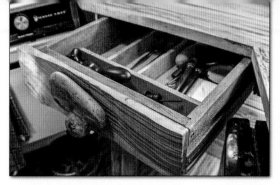

"I work in wood and metal."

I WAS RAISED WITH A SUPREME appreciation for trees. My father, William Skinner, is a carver and a fine woodworker and I grew up helping him maintain our home in Sykesville, Maryland and built everything from recurve longbows to an arch-top electric guitar.

I relocated to Olympia, Washington when studying land use planning at Evergreen State College in 2008. I focused my research on micro infill development—using the built environment creatively to offer more diverse housing and consequently higher density without expanding the footprint of development. I did carpentry, concrete, and electrical work to pay bills and learned the trades as a laborer.

The Leafspring allowed me to use architecture as a venue for developing multimedia art and academic endeavors. The house is an experiment in form and function. Everything from fixtures to switch plates is handmade and, more often than not, chiseled or hammered. Re-use and free-form creativity are the driving forces behind the design. I believe that materials should dictate design as the craftsperson is always both inspired and limited by understanding of the medium.

I work in wood and metal. The majority of wood used on the Leafspring is native northwest species and most of it came from a bandsaw mill a few miles down the road. I worked on a 20′ sailboat with a 13-year-old young man by the name of Zadi, in trade for Douglas fir, bigleaf maple, black locust, and western red cedar material from the owner of the local bandsaw mill.

The metal work is steel and copper. I stripped the frame from a rotten 1984 Terry Taurus camper and welded the footprint of the house with steel tubing. The brackets and components were forged in my smithy and the copper elements were engraved, chased, forged, raised, and *repoussé** in the evenings and on the weekends with the aid of Olympia-based metal artists Bill Dawson and Travis Conn.

The house features a monkey-bar staircase, an expanding dining room table, a jellyfish chandelier, custom doors and windows, a front porch, and a loveable pooch named Py.

Repoussé is a French term for a design raised in relief by hammering on the reverse side.

**Floor Area (including under awning):
400 sq. ft. / 37 m²**

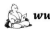 *www.pairoducks.org*

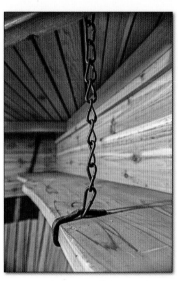

"Everything from fixtures to switch plates is handmade."

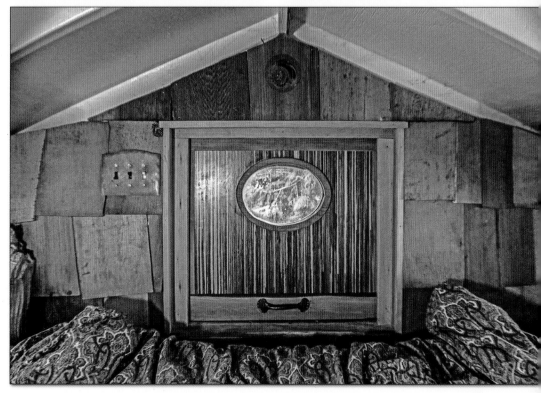

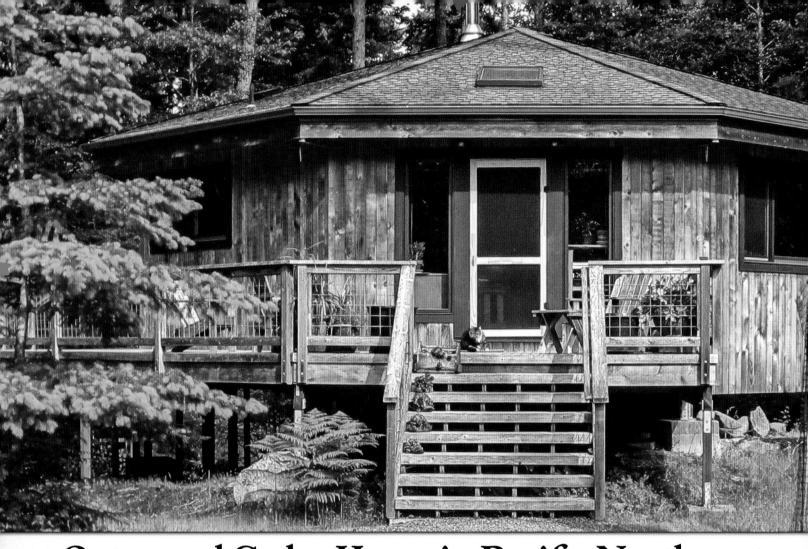

Octagonal Cedar Home in Pacific Northwest
Mark & Ruthie Thompson-Klein

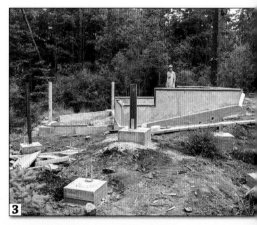

"Much as we admire the handbuilt structures in the Shelter books, we lacked the tools, skills, and experience to build the home we wanted in less than a year."

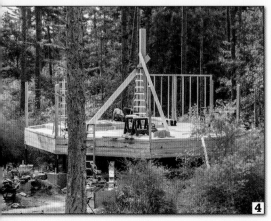

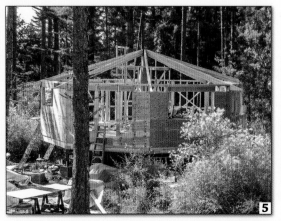

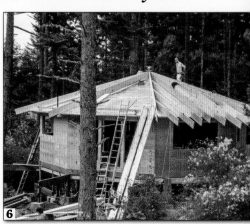

"We opted for a custom 'packaged home.'"

W E MOVED TO A QUIET, beautiful, forested community in the Pacific Northwest, intending to eventually build a small home with a large garden. Our land was solidly forested with a few rock outcrops, so we took on projects as time and resources became available.

We started slow: cutting trails by hand the first year; tent platform, privy and driveway the next; installing power in the third year.

We built a barn so we'd have a place for tools and our two horses. We worked nearby as live-in farm caretakers, so weren't in a rush to move to our own place.

Then the plan changed. Our employer died, and the situation accelerated and condensed our ten-year idea to a one-year plan. Much as we admire the handbuilt structures in the Shelter books, we lacked the tools, skills, and experience to build the home we wanted in less than a year.

Construction is extremely expensive here, with reliable contractors booked years in advance. We opted for a custom "packaged home" as a way to get into our place sooner.

Pan Abode Cedar Homes worked with our hand-drawn design, respecting (and engineering) our desire to perch our home atop a bedrock outcrop, and to use natural and least-toxic materials.

They shipped a large trailer filled with beams, brackets, three skylights, roofing materials, and more — everything we needed except interior finish materials.

We hired local contractors and became part of the work team. Construction took five months. We added interior built-in shelving and storage.

Our 946-square-foot, eight-sided, one-bedroom home includes cedar siding and wrap-around deck. We opted for 1″×6″ fir paneling inside, surplus eucalyptus flooring; alder kitchen cabinetry and fir trim throughout. No paint or other finishes on the wood. We used denim insulation in the walls, but had to use fiberglass batts to meet our county's standards for floors and ceilings: vapor barrier FSK (Foil Skrim Kraft).

Solar or wind power were initially considered, but our sun exposure is too narrow to provide whole-house power.

We collect, filter, and store rainwater from the barn roof for all our (incredibly delicious) domestic water. To save water, we installed a composting toilet (doesn't work as we expected — would not do again). We

heat exclusively with wood, a lifetime supply right from the backyard.

The garden has evolved slowly. We have very thin topsoil on solid rock, so we built framed beds over the exposed bedrock, and added a greenhouse last year. Soil is "made" from composted horse manure. Garden beds and the greenhouse are framed with locally milled fir, which we find lasts at least as long as treated wood.

We built a 96-square-foot sleeping cabin for guests, fashioned from trees we felled and milled ourselves, recycled windows and door, cedar shakes, and hand-built storage and furniture.

Floor Area: 946 sq. ft. / 88 m²

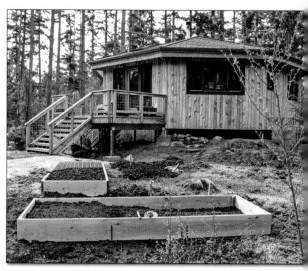

"We started slow: cutting trails by hand the first year."

"The garden has evolved slowly. We have very thin topsoil on solid rock, so we built framed beds over the exposed bedrock."

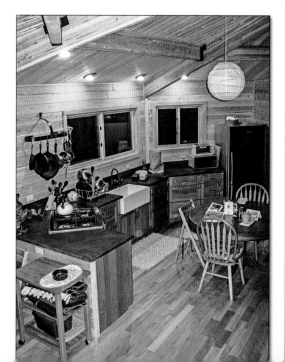

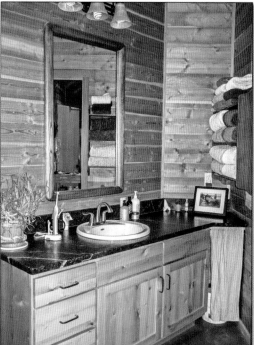

More…

SunRay Kelley's Two-Story Treehouse in the Woods

Uncle Mud (*aka Chris McClellan*)

In a gnarled old-growth fir is an actual tree house. Not a treehouse, but a house in a tree.

I LOVE TO DROP IN ON MY buddy SunRay Kelley (*Builders of the Pacific Coast, Tiny Homes, Tiny Homes on the Move*) because he's always building something. Whether it is a fleet of electric, art-car gypsy wagons or a cedar and clay temple for a hot springs church, it's always worth hunting him down.

If you manage to make it to his magic forest north of Seattle, you can book a stay in one of the wild treehouses popping up among the second-growth cedars. There's also an outdoor kitchen pavilion and a cedar sauna and a trout pond to jump into.

My favorite place to stay used to be the Stump House, built on the stump of a huge cedar cut down a hundred years ago, but the latest treehouses are pretty amazing.

First in the new crop of treehouses is Bob's stump house, a bachelor pad made of hand-hewn cedar with a garden growing on the roof — it's the only place with any sunshine. When I came to see the place, Bob was up top watering his vegetables. Down the path from Bob's, there's a rope-bridge crossing the ravine to a two-story treehouse pagoda with hammocks to sleep in.

On the other side of the property, in a gnarled, old-growth fir is an actual tree house. Not a treehouse, but a house in a tree. Two stories fully enclosed and insulated with kitchen and bathroom and woodstove. A spiral staircase leads up from the ground into the house.

Another spiral leads up to the loft with a commanding view of the valley and an amazing light-filled cupola.

When we arrived, SunRay was using his homemade boom truck to hoist loads of drywall and aspen poles inside through the upper-story balcony doors. With the help of my friends, he soon had the drywall up and a circular log formwork built for the shower stall.

Like most of what SunRay does, his formula for building flies in the face of any mechanical, technical approach. He prefers his buildings to feel as if they grew there.

The structure of the treehouse is a two-story wooden yurt with the roof supported by a web of small branches and spiraling cedar boards. The walls are cedar and hand plastered, tinted, gypsum over drywall.

The "tractor cob" shower is sculpted from the local sand-clay soil and straw mixed to a putty with his tractor-mounted tiller. Colored bottles laid up in the walls bring light into the cave-like interior. Local stone covers the floor and countertop.

SunRay works hard and plays hard. Even the experienced builders among us had to hustle to keep up with him when he was "on," and when he was "off," there were lovely meals together, time in the sauna, and dips in the ponds. Each night we took turns staying in the different gypsy wagons and treehouses.

Floor Area: 600 sq. ft. / 56 m²

 SunRay's website:
www.sunraykelley.com

Uncle Mud's website:
www.unclemud.com

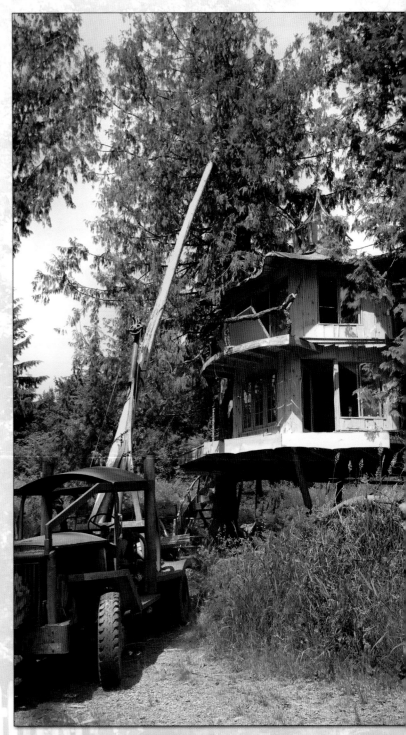

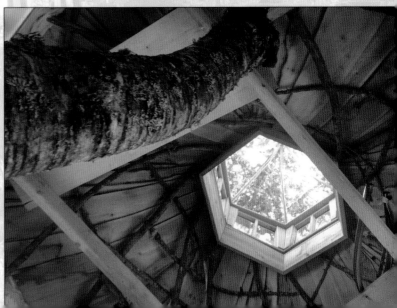

The structure of the treehouse is a two-story, wooden yurt with the roof supported by a web of small branches and spiraling cedar boards.

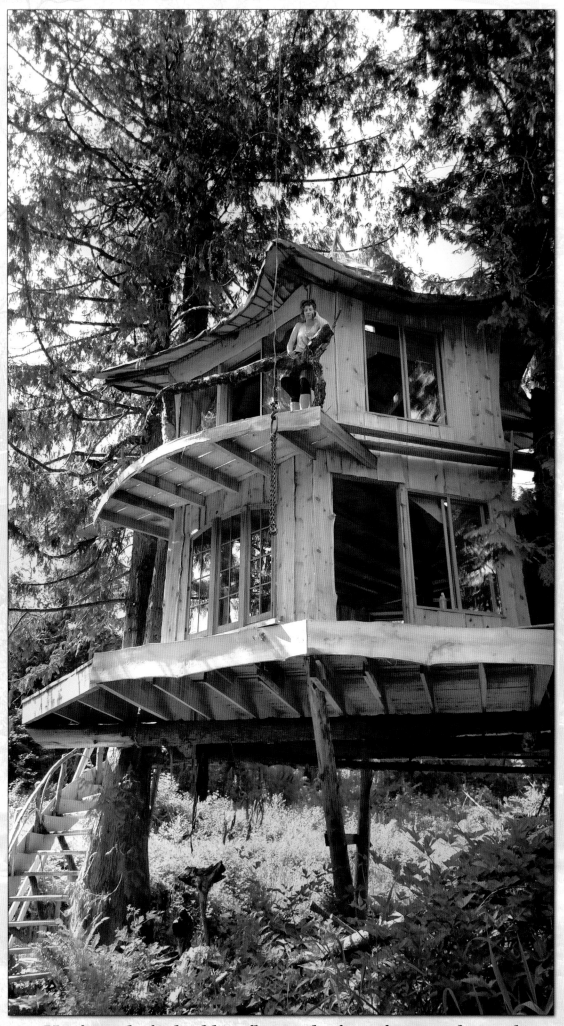

His formula for building flies in the face of any mechanical, technical approach. He prefers his buildings to feel as if they grew there.

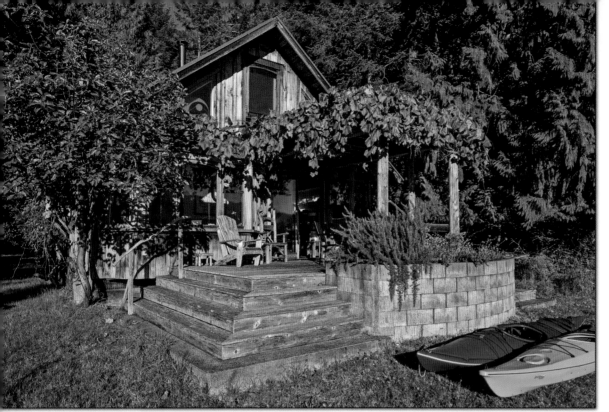

Sally's Beach Cabin

Michael McNamara

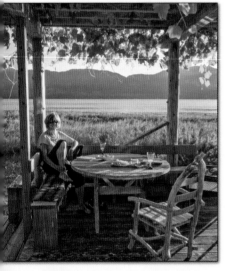

It was winter. Sally and I had been together for a little over a year. After living on neighboring islands for many years, we found each other and decided to live together on one.

At the same time, in an attempt to heal a land partnership gone sideways, Sally had traded houses with her land partner, given up the main house, and taken ownership of the 400-square-foot guest cabin.

The first visit in January with a few inches of wet snow on the ground and rain dripping from the eaves was a bit daunting. Sally wondered what she had taken on.

There was almost no plumbing in the cabin. No septic system. The shower was outside; the outhouse sported a urinal; decks were rotting away; gardens were overrun; a prolific second-growth forest was in the process of reclaiming the place.

I'd worked as a designer/builder long enough to be comfortable with the sow's ear phenomenon. In many ways I'd rather deal with a suffering site that has potential than with a pristine natural setting that is better off without human intervention.

And there were good things: The cabin had good bones, and best of all, it was well-sited, oriented with reverence to a tiny point of land that formed mini-bays on each side, looking out to the southwest over Baynes Sound and the mountains of Vancouver Island. A well-built, two-story workshop had been placed in the forest 40 or so feet behind the cabin.

We started by getting rid of rotting decks, loads of junk, and trimming back the forest so the space could breathe. We installed a decent foundation, rationalized incoming service lines, and scoped out a wastewater disposal system. We stripped the cabin and workshop down to the studs.

Hoping to tie the various parts together and bring things more in line with our needs, we positioned a small storage shed between the cabin and the shop, and connected the buildings with a covered walkway.

In a small home, spaces really need to work together, doing double duty wherever possible. Often it's a good idea to position key elements in corners so that diagonal sightlines extend the feeling of space.

In a counterintuitive move, we made the cabin space seem larger by building a dividing wall, creating an entranceway and an adjacent hallway with a powder room at one end. It's a gallery, a place to leave your shoes, hang up your gear, and adjust the sound system. Open shelves and a pass-through for firewood create a sense of flow.

The built-in bed, a European-style nook, is tucked in against the dividing wall which has softly lit display niches. A generous bay window at the head of the bed lets in the sea breezes and provides space for mementos, books, and morning coffee. The wall at the foot of the bed makes a corner for the woodstove.

In a few places, we bumped out walls at waist height to add space without increasing floor area.

The cabin had good bones, and best of all, it was well-sited.

Photos by Michael McNamara

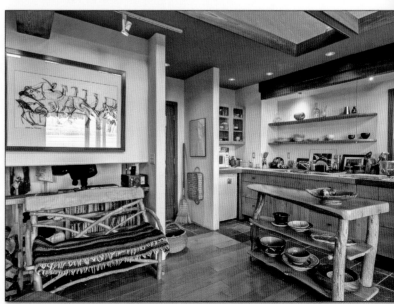

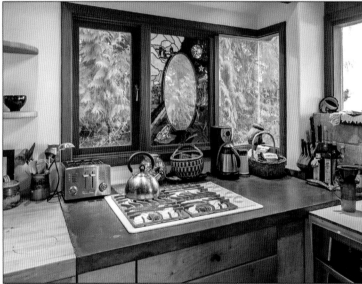

In a small home, spaces really need to work together, doing double duty wherever possible.

A substantial concrete planter supports one end of the deck, creating an outdoor living area, shaded in summer by grape leaves. It's also a buffer against high winter tides.

The converted workshop — connected by a covered walkway — is multifunctional. Used as a studio, it has a bathroom with soaker tub and showers, along with closets, laundry, and open space. Upstairs, accessible by an outside stairway, is more studio space and storage.

Fifteen years later the little place is as sweet as ever, and serves as a much-loved retreat.

Floor Area: 400 sq. ft. / 37 m²

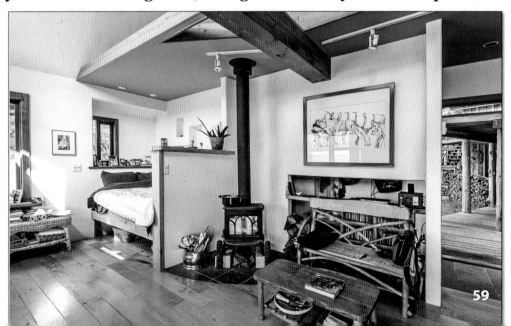

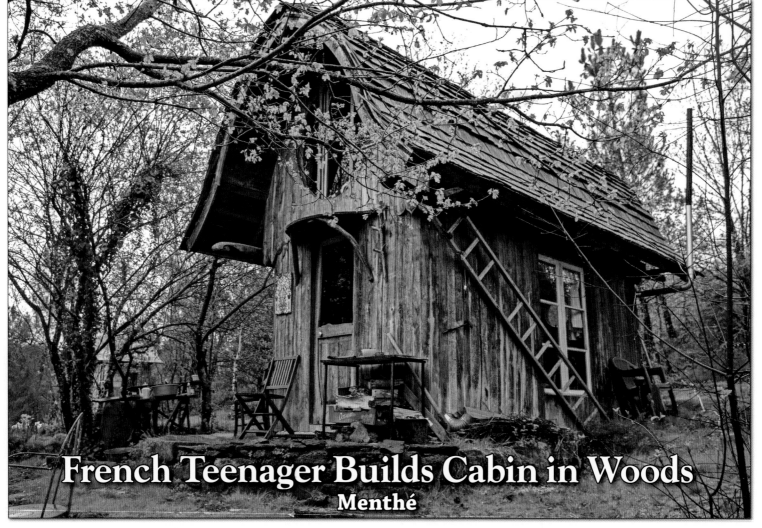

French Teenager Builds Cabin in Woods
Menthé

"So at 20 years of age, I had built my own house."

I GREW UP IN THE FOREST OF CORRÉZE IN SOUTHWESTERN France; it's really wild and green. I started building cabins when I was three years old, playing in the forest. I started this little one when I was 17 in 2000—I wanted my independence. It took me three years, and I lived there for two years.

The frame is made of chestnut from the forest, and all the windows are industrial window seconds. The roof is insulated with lime and woodchips—a really strong mixture once it's dry, and insects can't get in.

The interior walls are made of straw and lime; it's an inexpensive material—important when you're young and without money— and finished with natural-color clay. I built the entrance door with chestnut and walnut—my first work of *joinerie*, and it's still working well.

I was influenced by the architect Philibert de l'Orme (1514–1570), for me a revolutionary man—the first person to write a book on self-building. He devised solutions for getting more space with less materials, partly by using small dimensions of wood. Some of his research was developed for poor farmers; there are still some of his original barns in Lozére.

I was also inspired by *Handmade Houses—A Guide to the Woodbutcher's Art*, written by Art Boericke and Barry Shapiro (1973). My parents had this book and I grew up with it. With this house, I did my first *épure* (working drawings).

So at 20 years of age, I had built my own house; it was a real gift to know that I could be self-sufficient in house building.

Note: Carpenters will be interested in Philibert de l'Orme's *Nouvelles inventions pour bien bastir et a petits frais*, with elegant drawings for arches and vaults for wooden buildings, accessible online here:

www.shltr.net/de-lorme

Floor Area: 332 sq. ft. / 30 m²

"I started this little one when I was 17."

Menthé's original drawing

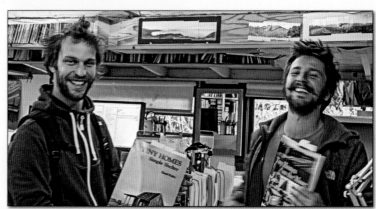

Menthé at right, with friend and fellow French carpenter Yogan at Shelter's studio in California, 2015

60

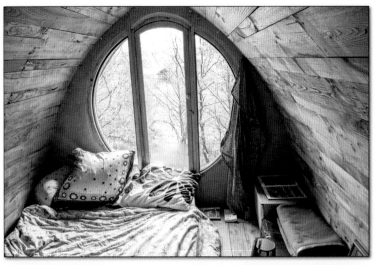

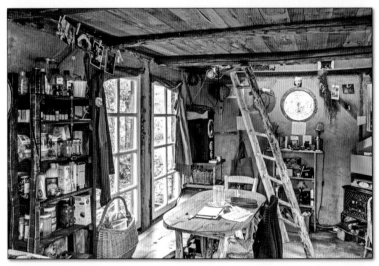
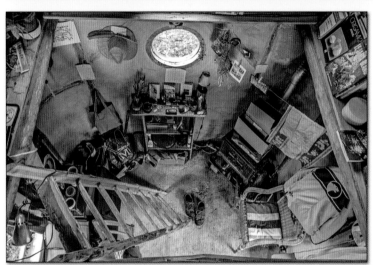
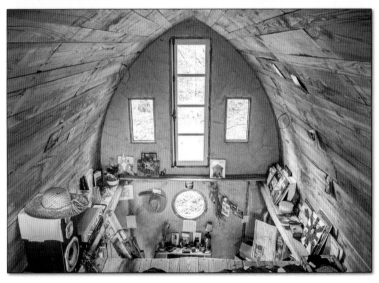
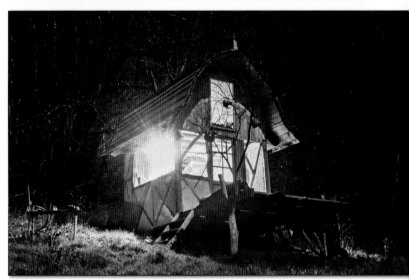
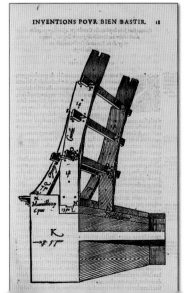

INVENTIONS POVR BIEN BASTIR. 18

"The interior walls are made of straw and lime…finished with natural-color clay."

Menthé used this 455-year-old drawing for his framing. It's from Philibert de l'Orme's Nouvelles inventions pour bien bastir et à petits fraiz, *with elegant drawings for arches and vaults for wooden buildings, available online at:* **www.shltr.net/de-lorme**
Drawing by Philibert de l'Orme

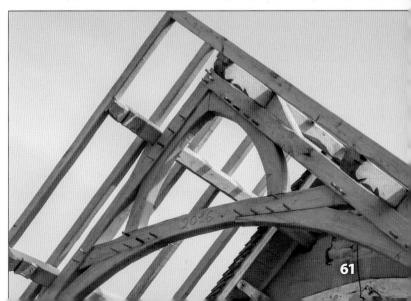

Wooden Yurt in the English Woods

Jesus Sierra

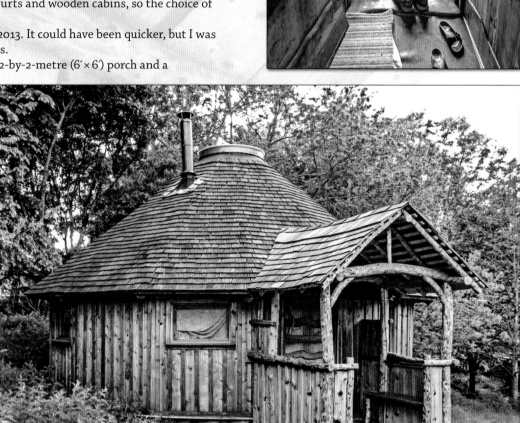

THIS WAS THE FIRST HOUSE THAT I BUILT FROM BEGINNING TO END. I MET MY customer while volunteering at a community garden. We started chatting about wooden buildings and ended up talking about books like *Shelter* and *Home Work*. We realized that we had an almost identical book collection.

Next thing I knew, he hired me to build his wooden house, with himself working alongside.

We designed the house together, no drawings, just the odd sketch on the back of an envelope. We were both fascinated by yurts and wooden cabins, so the choice of a wooden yurt made sense.

We built it in 1½ years, from 2011 until 2013. It could have been quicker, but I was at the time working on some other projects.

The diameter is 7 metres (22 ft.), with a 2-by-2-metre (6′ × 6′) porch and a small, but luxurious compost toilet just outside.

The frame is larch that we felled and debarked on the land, just 50 metres away. The trees were planted by the owner, his dad, and granddad 25 years ago.

The exterior cladding is western red cedar from Cornwall. The internal cladding is spruce and western red cedar. The insulation is 100% sheeps' wool.

The shingles are also western red cedar. The crown was made from reclaimed scaffold planks, 45 pieces joined together and finished by hand. The doors and windows are solid oak. As I don't have a workshop, everything was built on site with hand-held tools.

We made all the furniture and kitchen units, and also did the plumbing, (we both really hate plumbing!), the tiling, glazing, and the 12v electric system.

We made every curtain rail, door or cupboard handle, spindles, banister, and wall hooks using branches from maple, hazel, and birch growing just outside the building and whittled by hand on the spot. The worktop and the hand-carved draining board are solid 6-cm (2½")-thick English elm.

It was an incredible experience. We learned many things as the job progressed, becoming great friends in the process.

Floor Area: 345 sq. ft. / 32 m²

"We designed the house together, no drawings, just the odd sketch on the back of an envelope."

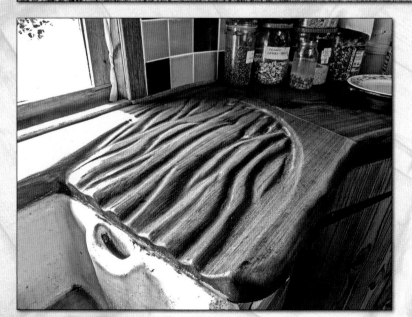

"Everything was built on-site with hand-held tools."

62

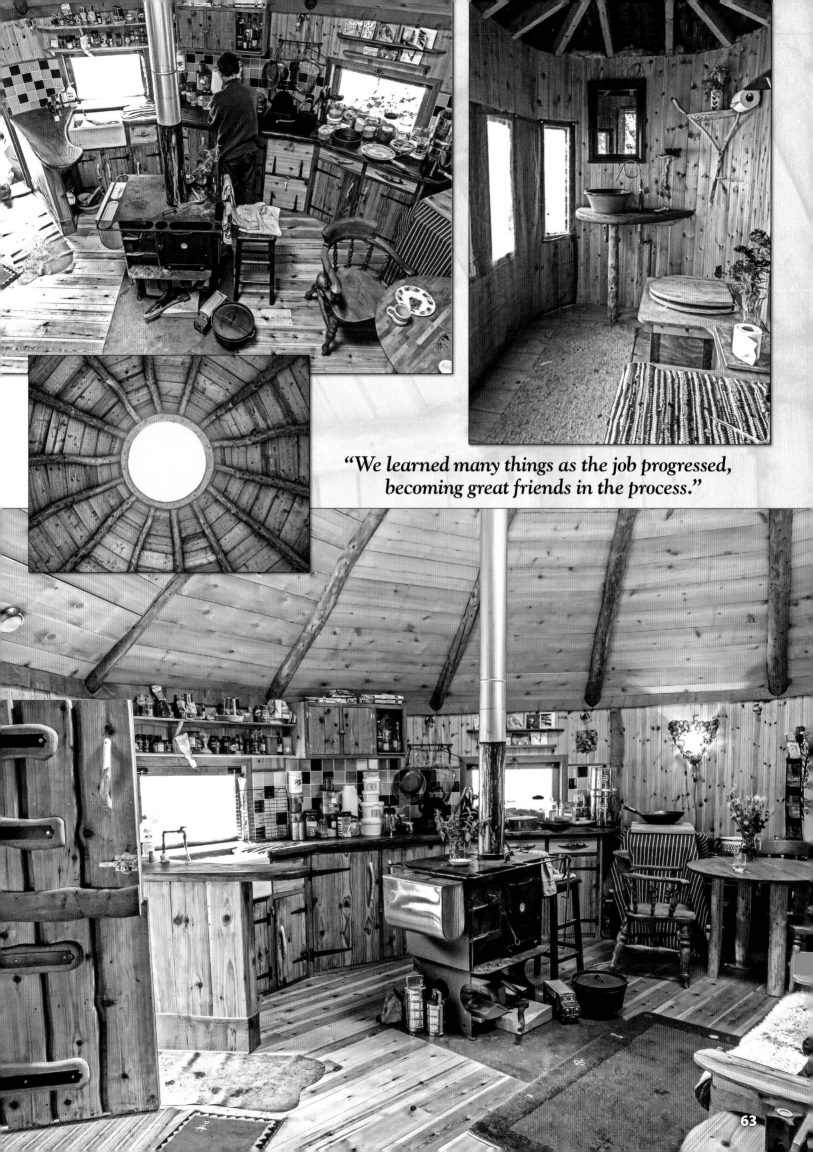

"We learned many things as the job progressed, becoming great friends in the process."

Small Woodland Home in Southwest England
Jesus Sierra

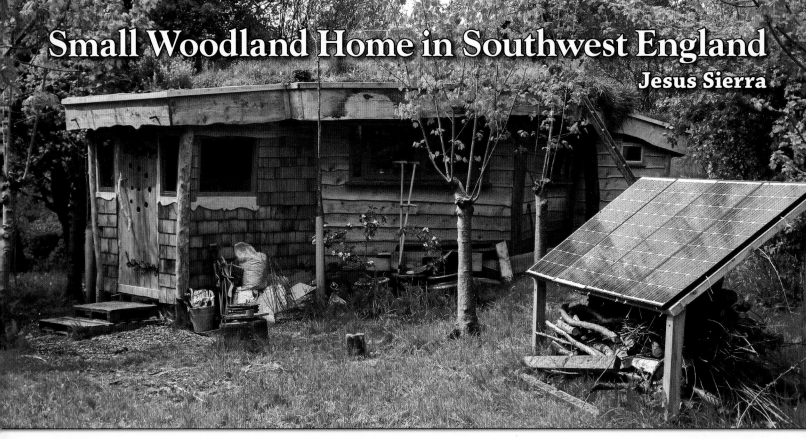

Dear Lloyd,

I became a carpenter and eco builder because of your books. *Shelter* and *Home Work* got me hooked. *Builders of the Pacific Coast* got me started. I used to work in an office before that.... Now I build homes (narrowboats, vans, caravans, yurts, cabins) for customers that want something different but can't afford hiring "big people." The poor also have the right to live in a nice home!

I built this 6.5-metre-diameter, heptagonal, tapered-walled, reciprocal green-roofed yurt, the "reciproyurt," last year and got more than 70 volunteers involved.

I love working with people without experience. They give any project a freshness that you never get with just professionals. They have no preconceptions. Really open-minded. They want to learn but they also teach you so much! They mainly helped with big jobs like raising the frame, planking the roof or carrying the soil to the roof....

The frame we built from larch felled 50 metres away and carried on our shoulders. The rafters are fixed to the wall plates by drilling rafter, plate, and post and driving a 60-cm-long, 10-mm-thick steel bar into the hole and bending the end, stapling the lot together. The internal and external cladding is western red cedar from Cornwall. The roof planking is spruce from Hampshire. All pretty local. The floor is made from scaffold planks.

The idea was to build a proper yurt crown and rafters, but when it came to that, I had 12 volunteers on site that I had to keep busy, so went for a reciprocal roof instead. I had never seen a reciprocal roof on a tapered Coperthwaite-style yurt, but I figured out that it could work well and it certainly does.

There is an 8-ton ratchet strap as a compression ring around the top of the posts keeping everything together.

The insulation is sheep's wool. The yurt is totally off-grid. It has four 100-watt solar panels and a 675A/h battery bank. Heating, cooking, and hot water come from a beautiful range wood-burner built by Parp Industrie from Devon. There's also a propane cooker for the summer.

There's a compost toilet and water is from a 1000-litre tank fed by a borehole. The fridge consists of two ceramic flowerpots with wet sand in between. Lights are SMDs warm white. Really economical to run.

I got the inspiration for the design from Bill's yurts and also from the Farrell's yurt in New York.

Although the main part is heptagonal, there is also a separate bedroom, a bathroom/toilet and an enclosed porch. The total surface is 48 m² (515 sq. ft.).

The total cost of the materials (including solar panels, batteries, wood-burner, everything) was around £10,000, with my labour on top of that. I also did the plumbing and the 12-volt wiring. That's a fully finished home for under £20,000. A contractor-built, affordable home.

It was a really fun project; I got to try many new things that I had never done before.

The people living in it love it more and more every day.

That's what I love so much about my job. You get to make people happy; you give them a home. It's such an honour to be able to do that for a living!

Floor Area: 515 sq. ft. / 48 m²

"That's a fully finished home for under £20,000."

"The people living in it love it more and more every day."

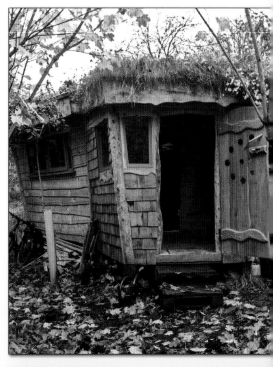

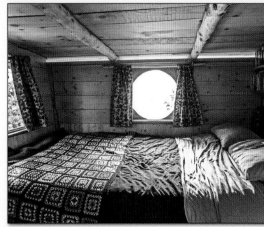

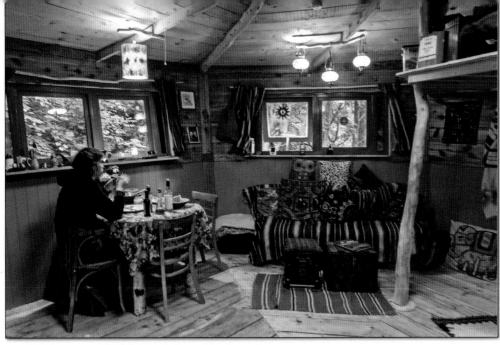

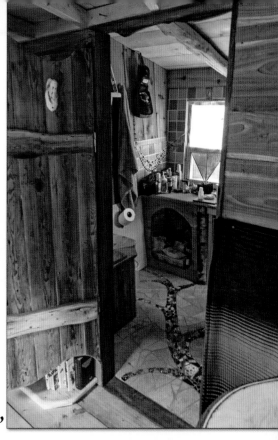

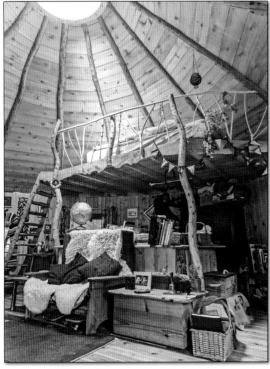

"There is an 8-ton ratchet strap as a compression ring around the top of the posts keeping everything together."

"That's what I love so much about my job. You get to make people happy; you give them a home."

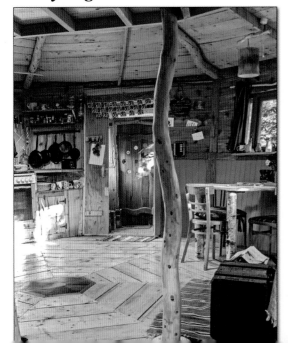

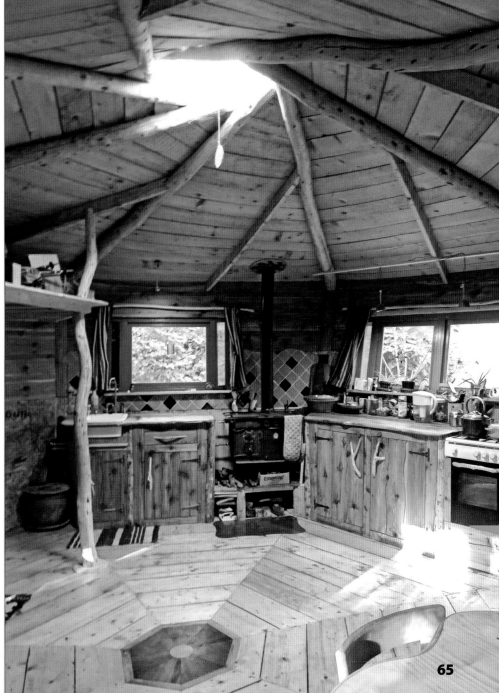

Stone Home in Southern Spain

Phil Rooksby

Drawings by Maureen Rooksby

EL POCITO IS 2.5 HECTARES/6 ACRES, dedicated to a real-life experiment living in a simpler, more sustainable, healthier, and creative way in the Sierra de Aracena in Andalucía, southern Spain.

The site faces south and is at an altitude of 600m (2,000 feet), with a panoramic view of 60km (200 feet).

The house was built from stone found on-site, chestnut roof timbers rescued from a 200-year-old house being demolished locally, and windows, floor tiles, and mortar from local sources.

Electricity is generated from two second-hand solar panels (total 100 watts), mounted on a pole that can be swiveled to follow the sun throughout the day, providing the equivalent of 800 watts of power per day year-round. Storage is one 250Ah car battery.

Water comes from a 60m (200 feet) deep well, using a solar-powered pump and stored in a 5000-liter (1300 gallons) tank placed higher up the hillside to create working pressure.

The house is just the one room, with no fixed fittings.

There is no bathroom or hot water. Washing is done either in a bowl or in one of the two sinks (indoors and out). Toilet arrangements are a bowl used outside, after which the contents are added to the compost heap.

Heating is via a wood-burner, using coppice from the oak and olive trees on-site. A passive fan on the stovetop increases efficiency.

Maureen and Phil Rooksby moved here in 2009, and have been working on converting the land into a forest garden ever since, with the aim of being self-sufficient in food as well as medicine. Full information can be found on their website.

Floor Area: 450 sq. ft. / 42 m²

 elpocito.wordpress.com

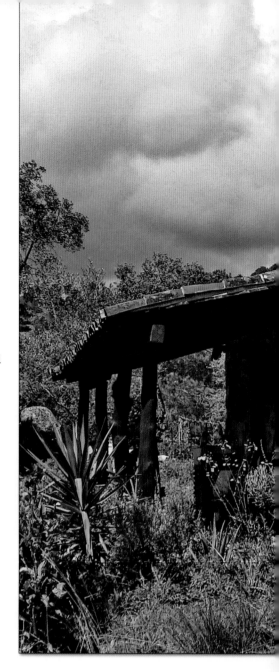

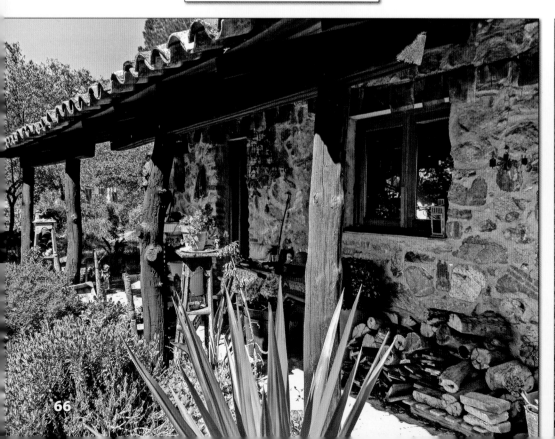

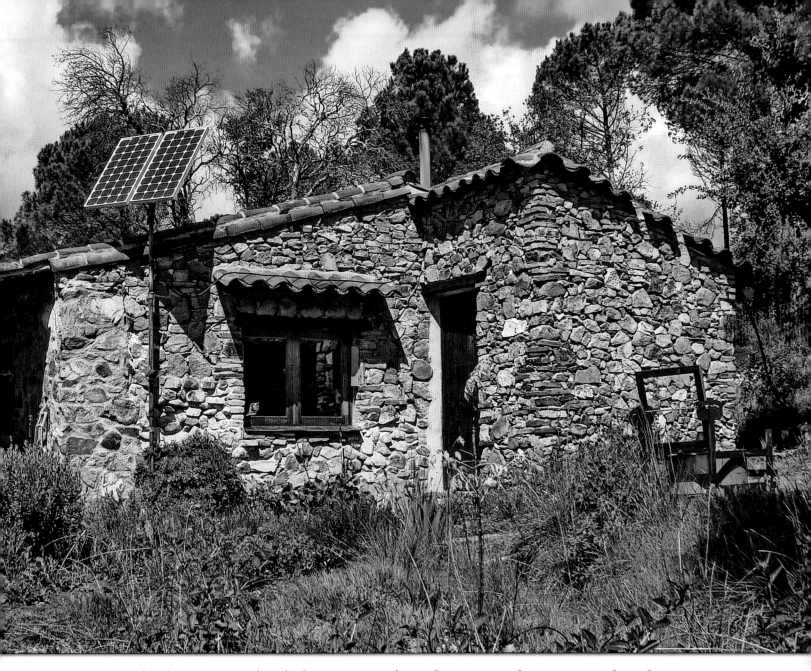

The house was built from stone found on-site, chestnut roof timbers rescued from a 200-year-old house being demolished.

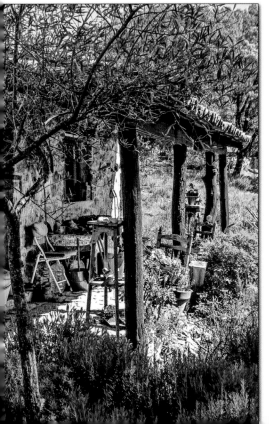

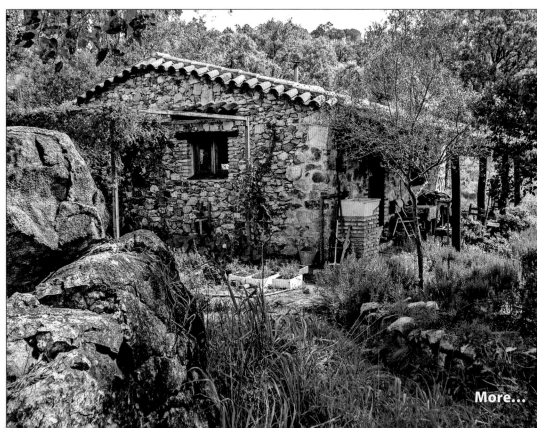

More...

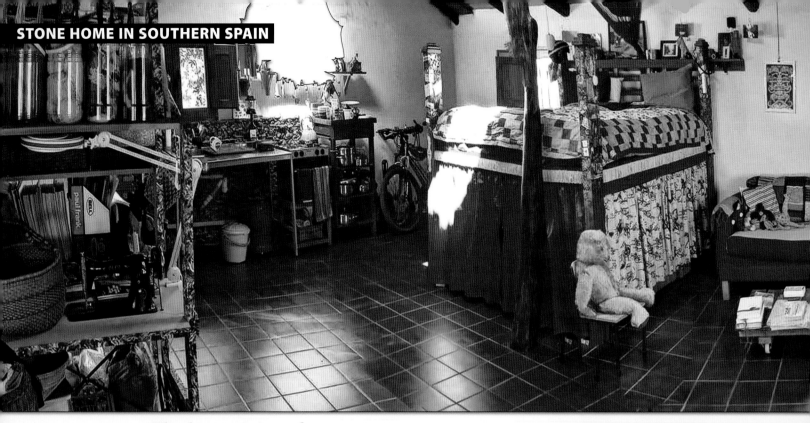

*The house is just the one room,
with no fixed fittings.*

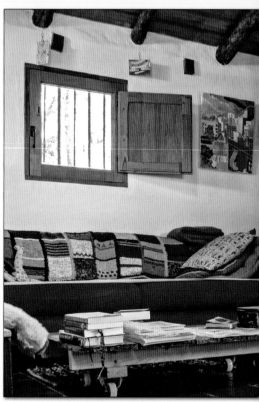

*Heating is via
a wood-burner, using…*

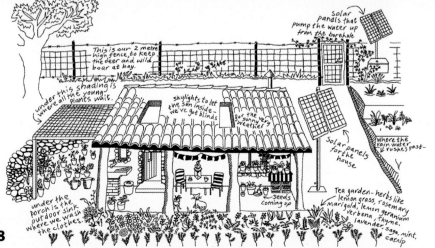

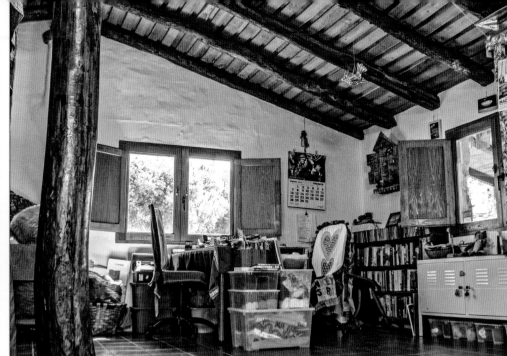

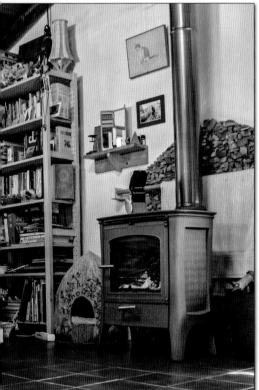

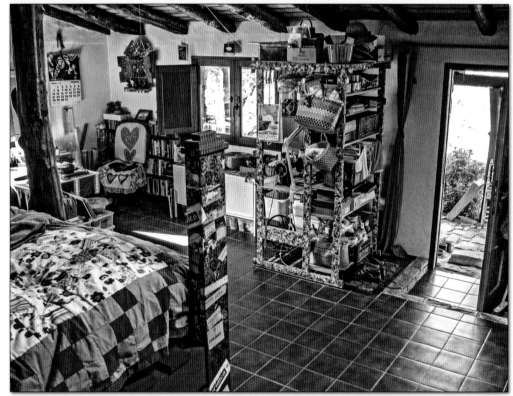

...coppice from the oak and olive trees on-site.

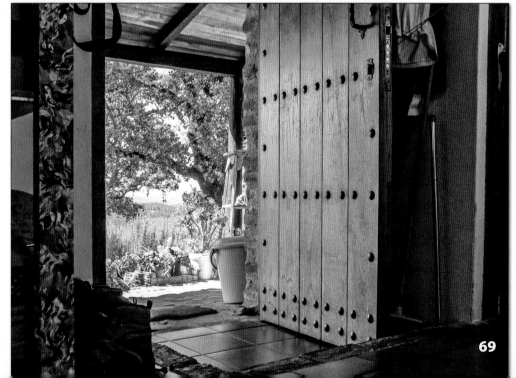

Small Straw Bale Home in Arizona

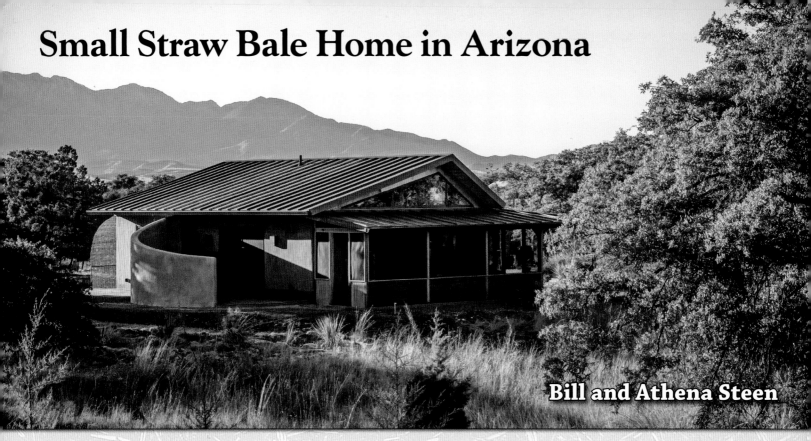

Bill and Athena Steen

Bill and Athena Steen were the foremost pioneers of strawbale building, not only in this country, but worldwide. Their book, The Strawbale House, published in 1994, was a bestseller and guided numerous people in the art of straw bale building.

*Their work was featured in our books Home Work, and Tiny Homes. Everything I've seen them do is wonderful. Not just the construction, but the colors and textures and their dedication to using natural materials. Everything they (and their boys) build **feels** right.*

—LK

Constructing buildings with clay-plastered straw bale walls has been our family passion. Whether we were working on building projects in Mexico or the U.S., or conducting workshops, our children were always present in one form or another. When they were young, they were busy hauling beer and Arizona Iced Tea with their little red wagon to workshop participants.

Little by little as they grew older they began to take a more active part in the building activities. Their early beer sales evolved into making tools to sell to participants.

This past year, 2015, we worked together on an 800-square-foot straw bale house, but this time they, Benito and Arjuna (*aka* Oso), were in charge. This was their project. Athena oversaw the design process. Athena and I played a support role, overseeing the building of the straw bale walls and the clay plasters.

They began the project together by building a somewhat conventional frame woodworking shop that was attractively finished with clay plaster on the interior and lime on the exterior.

Benito began work on the straw bale house, but had the opportunity to travel the length of Mexico into Central America. Of course he jumped at the chance and meanwhile, brother Oso took on the remaining phases of completing the straw bale building.

Since this was the first project we had done as a family, it was destined to be a crafted work of art. The client, Chip Fears, who had recently relocated from New York to southeastern Arizona, couldn't have been more perfect.

The groundwork was laid several years earlier when he attended one of our Canelo Project straw bale workshops. From that point on, the design began to evolve over a period of several years and did so to the very end of the project.

The house was built using a wall system we had developed over the years. It was neither what has been called load-bearing or in-fill, but rather a unique hybrid system that borrows from both. The bales, the plaster, window and door openings, and one-inch-diameter bamboo all play a part in taking the loads. Rather than go into a lot of detail here, the basic system that we now use is written up in Shelter Publications' *Tiny Homes*, entitled *Straw Bale Basics*.

"The clay plasters that we used both on the exterior and inside of the house were hand-mixed."

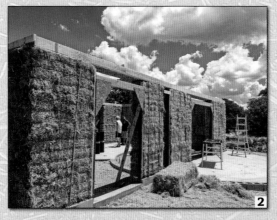

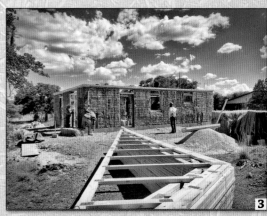

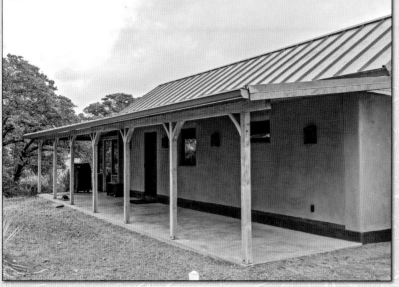

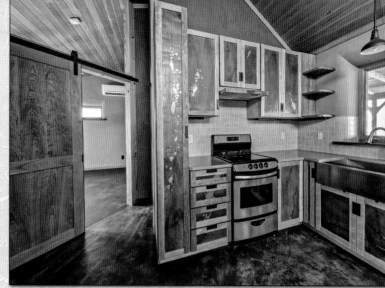

"Since this was the first project we had done as a family, it was destined to be a crafted work of art."

Oso is a fine woodworker, and put his mark on every piece of wood used in the house, from the kitchen cabinets to the wood ceiling, guard rails for the loft, barn doors for the closet, corbels for the porch posts, and much more.

Benito crafted doors from metal and wood as well as the hardware. The boys, along with a few friends, made all the adobes on-site that were used in the curved adobe wall that separates the living space from the bedroom. They had one main helper on the project, a young guy from Tucson, Guru Das Bock.

The clay plasters that we used both on the exterior and inside of the house were hand-mixed. I think one of the purest expressions of clay plasters is the base coat that has been one of our trademarks since the beginning of our straw bale work.

It uses large amounts of chopped straw with little or no sand and, with a little guidance, can be done by those who have no prior plastering experience. It's a fantastic and fun entry level for the novice. Athena, myself, and our friend Margit Beilhack from Germany, did the finish clay plastering and earthen floors.

Floor Area: 864 sq. ft. / 80 m²

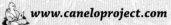
www.caneloproject.com

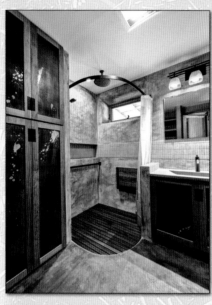

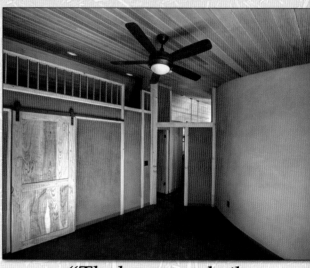

"The house was built using a wall system we had developed over the years."

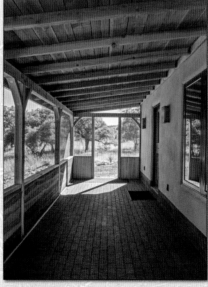

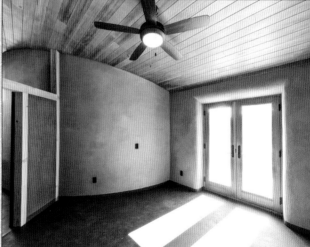

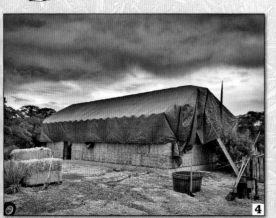

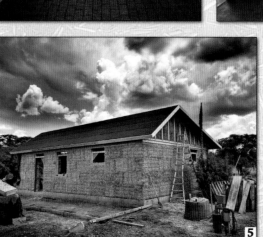

4

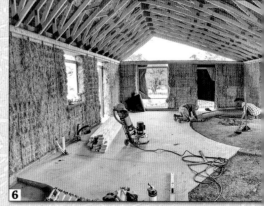

5 6

Lobelia: $35,000 Straw Bale Home in Missouri

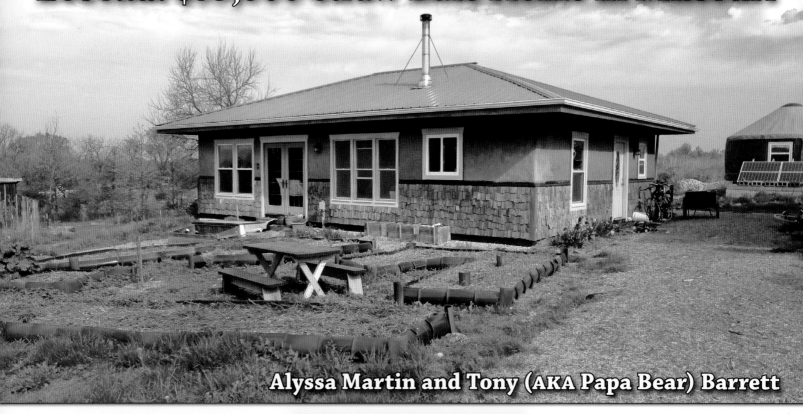

Alyssa Martin and Tony (AKA Papa Bear) Barrett

"Lobelia is the name of our 864-square-foot, two-bedroom, straw bale home."

IN SPRING 2006, WE MET AT Dancing Rabbit Eco-Village in rural Northeast Missouri.

By the time the winter winds blew, we moved into a small cabin — the first we designed and built.

Within a year, our son Zane came along and soon after, work began on the forever home.

Lobelia is the name of our 864-square-foot, two-bedroom, straw bale home. Named after a native wildflower, Lobelia was built with many reclaimed materials, including all framing lumber, most doors and windows, and even the kitchen cabinet.

The straw bale exterior walls are protected by earthen plaster inside and out. Outside, the hip roof and wood shingle skirt, made from pallet wood scraps, along with a coat or two of raw linseed oil, help protect the exterior plaster from the elements.

Radiant heating tubes were buried in the earthen floor, but thanks to the passive solar design, high levels of insulation, thermal mass, and the MBS wood cookstove, those tubes haven't been needed yet. We consistently use less than 200 pounds of propane, and 1½ cords of firewood for all our cooking and heating needs each year.

"The straw bale exterior walls are protected by earthen plaster inside and out."

The construction of Lobelia lasted roughly 18 months and involved the help of many, many friends. We estimate that we have invested just over $35,000 in materials and 4,000 hours of labor in the construction of our home. Now that Lobelia is (mostly) finished, Alyssa and Bear have been able to focus on other pursuits…gardening, orcharding, homeschooling, and building projects for others.

Floor Area: 864 sq. ft. / 80 m²

"We consistently use less than 200 pounds of propane, and 1½ cords of firewood for all our cooking and heating needs each year."

"We estimate that we have invested just over $35,000 in materials and 4,000 hours of labor in the construction."

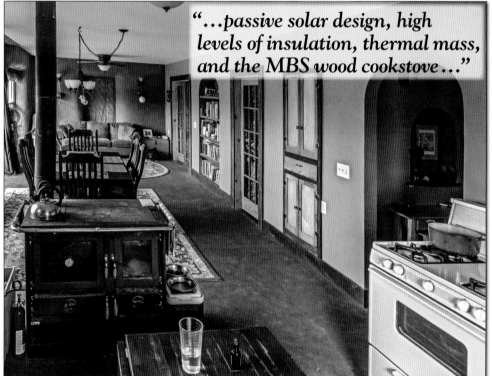

"…passive solar design, high levels of insulation, thermal mass, and the MBS wood cookstove…"

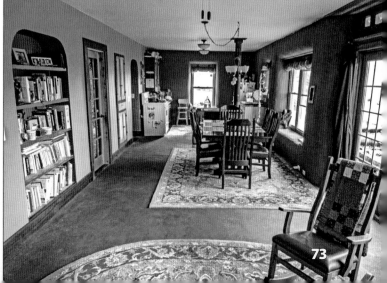

Tom and Satomi Lander's Natural Home

WE MOVED IN TO OUR earth-and-lime-plastered timber frame / straw bale home in July 2012. In June 2013, we were evacuated when a wildfire threatened our town. Satomi's comment was how sad, after taking over 10 years to build, that we only lived in our house for one year.

Our community survived. This wasn't the first fire for us. We almost lost our timbers when our storage building burned down. Straw bales gone, salvaged doors and windows gone, along with Tom's Frisbee collection valued at over 20 grand.

Not to be deterred, we broke ground on March 1st, 1999. Progress was slow. We had no mortgage and paid cash as we went. While we had some help, we built this pretty much on our own — true owner-builders.

Even with plenty of CAD drawings, the design continued to change and morph as we built. Changing plans as you build can be difficult, but we feel the changes were for the better.

We always tell people this is not how to build a house. Choosing flat ground will make it simple, but this was not our way. For us it's about art and craftsmanship.

Our house is really a small 450-square-foot mountain cabin, but everywhere you look, you see details. Satomi's natural clay and lime plasters are beautiful and accentuate all the woodwork. Floors are a combination of earth, bamboo, and tile. This is a no-shoe house with a Japanese-style entry where you sit and remove shoes — a bit inconvenient for guests, but no one complains.

There is a certain satisfaction in building homes for others, and we like to think our work improves their lives. But with this home, it was our turn.

Floor Area: 450 sq. ft. / 42 m²

www.LanderLand.com
www.JapaneseTrowels.com

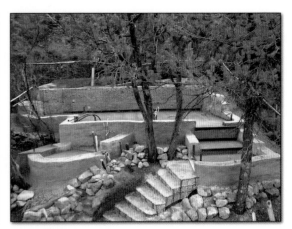

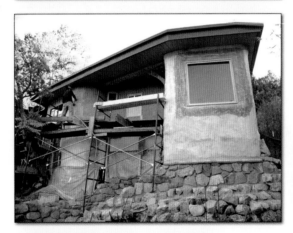

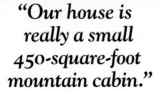

"Our house is really a small 450-square-foot mountain cabin."

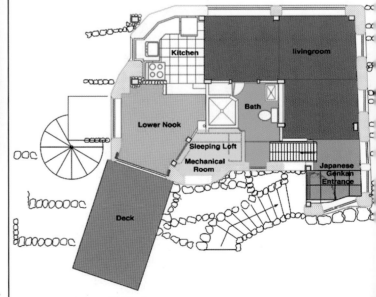

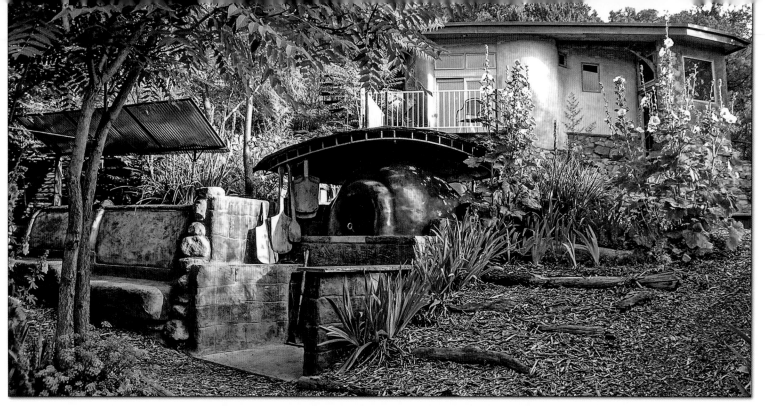

"For us it's about art and craftsmanship."

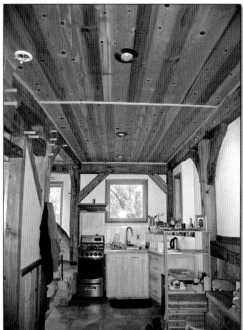

"Floors are a combination of earth, bamboo, and tile."

Timber Frame / Straw Bale Home on a Scottish Island

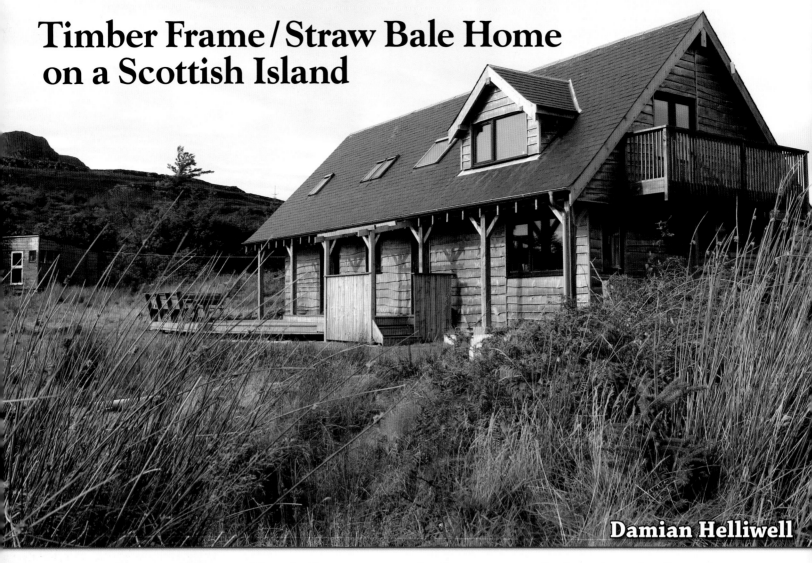

Damian Helliwell

For an additional level of protection, the house was clad with cedar boards.

In spring, 2016, Lesley and I spent a week in a tiny cottage on a small island off the west coast of Scotland. It was solar-powered and solar-heated, and it looked down on a white sand beach and the blue sea. It was a three-mile walk to "town."

I met two builders there, neighbors, who had built their own very different homes. (See also, carpenter Karl Harding's "Round House," pp. 120–121.)

–LK

I'D BEEN INTRODUCED TO the concept of straw bale through friends and, after a lot of reading and many enquiries, I couldn't find many tested examples in a harsh climate similar to that of the west coast of Scotland. But really liking the idea, I began to explore possible approaches.

In order to ensure the straw wasn't exposed to the elements during construction, I chose a design approach that allowed me to erect the frame and get the roof on first. Temporarily wrapping outside the house walls in heavy plastic gave me a dry environment to work-in before introducing the straw.

The design is freestanding, post-and-beam frame, independent of the compressed-straw walls — built in conventional, load-bearing technique, compressed, and then secured to the timber frame. I call it "retrospective load bearing."

As the wind and rain we get is fairly extreme and unforgiving, I paid particular attention to detailing with regard to window openings, drainage through the walls, and connection details between frame and walls. For an additional level of protection, the house was clad with cedar boards.

It's built on pad foundations, which take the load with only minimal strip walls boxing it in. I made sure these pads were really accurate to ensure I didn't have any worries later on, making the post-and-beam building a joy.

Working on my own throughout, with the exception of a few extra hands for plastering, I managed to stay well on schedule for the first couple of years. The whole process took over four years, which was at once both a battle of determination and an all-consuming meditative practice. I've always enjoyed working on my own and probably the most satisfying moment of the build was in erecting the heavy laminated ridge beam using only my car and a system of pulleys.

Damian and Sadie

The house incorporates a recording studio in one third. I was aiming to create an acoustically balanced, creatively inspiring environment. The living room is open to the apex with a mezzanine bedroom forming an embrace above it. The uneven finish of the lime plaster gives an even acoustic response whilst the thick, double-skinned, absorbent, core structure of the straw walls provides incredible sound isolation between rooms.

I would say almost half the build time could be accounted for by the flexibility I allowed myself to make changes and adjust plans slightly as I went, but this approach got me the house I wanted. Needless to say, a stick frame would have been easier and quicker to build by far, but for aesthetics alone, you can't beat straw walls.

Floor Area: 1600 sq. ft. / 149 m²

 Construction video:
youtu.be/_IrZAQbse_w

Damian's music:
youtu.be/ICxtSNBTiio

The whole process took over four years.

Left: Homemade rocket stove provides central heating and hot water. It's built out of ceramic fiber board, sheet steel, and copper pipe. It works as a gasifying boiler by separating combustion and emissions so that almost total extraction of emitted heat leads to total combustion of fuel, leading to less fuel used and clean emissions.

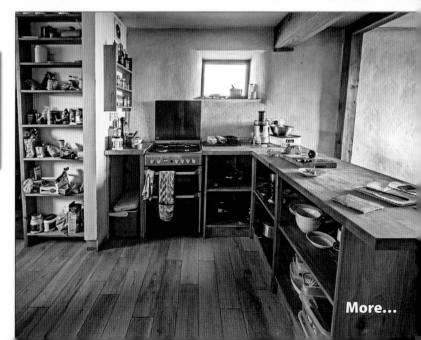

More...

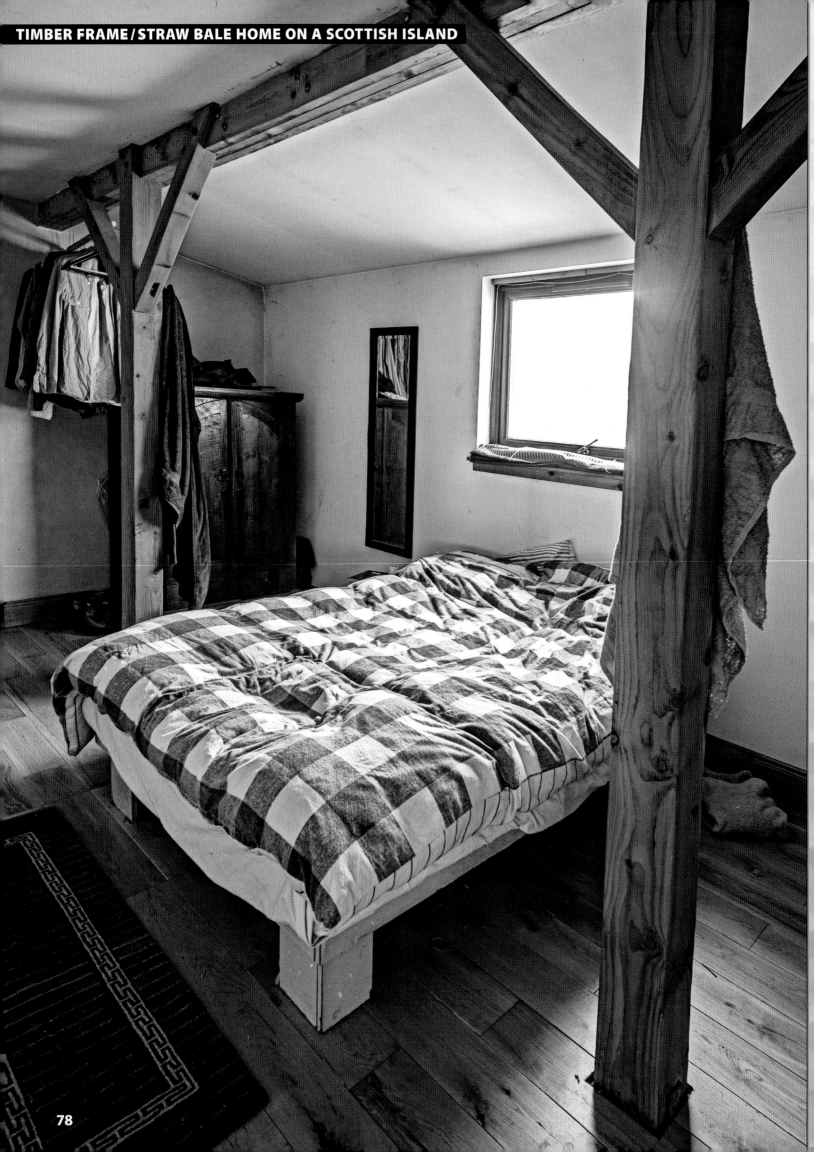

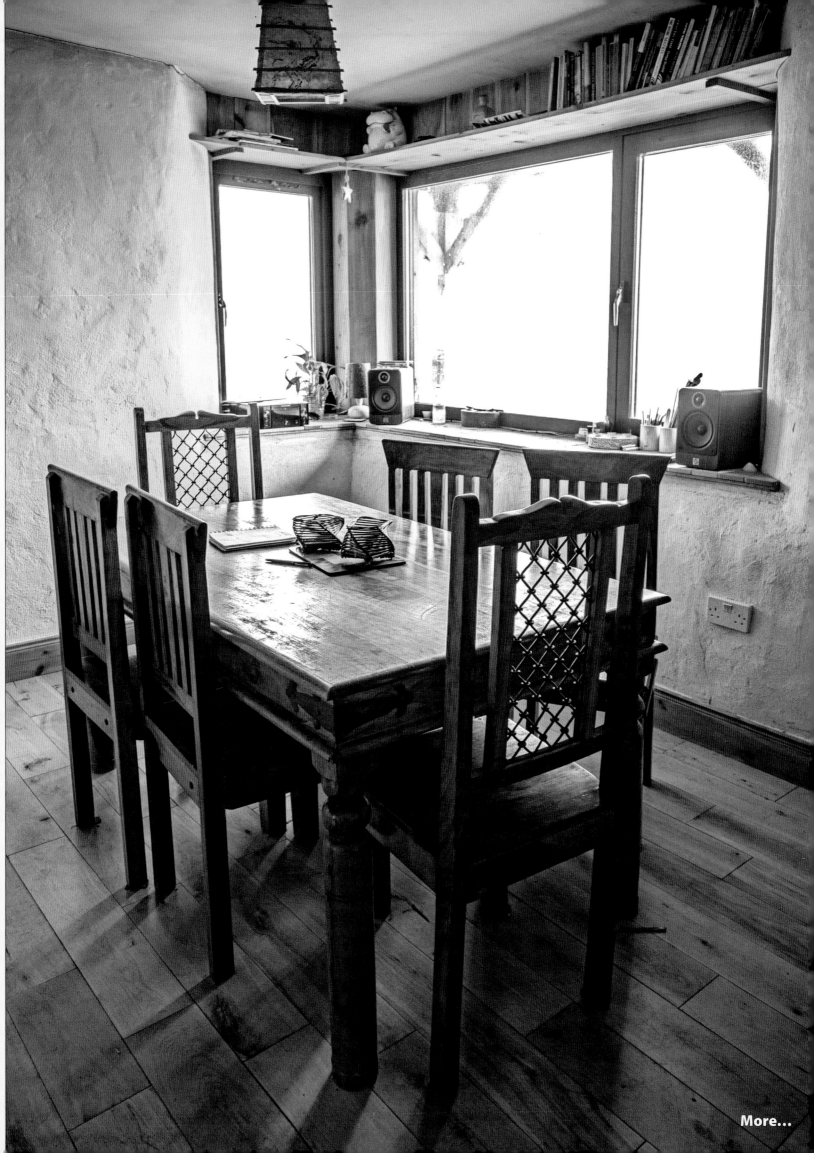

More...

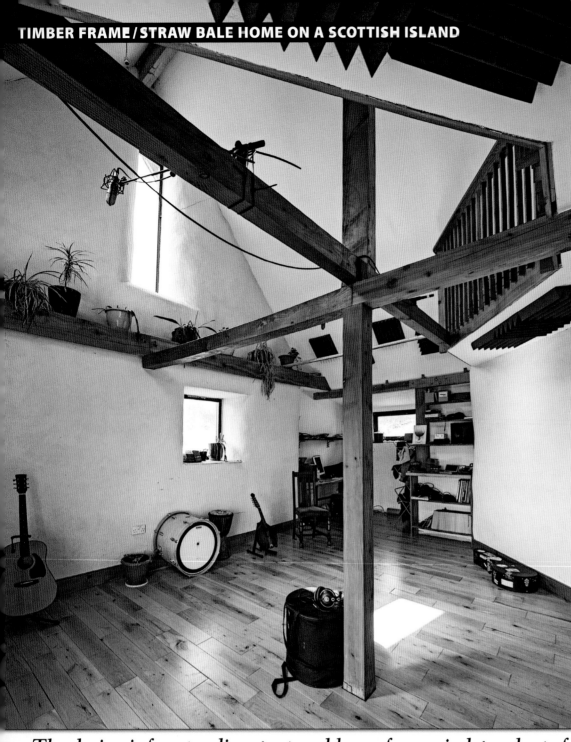

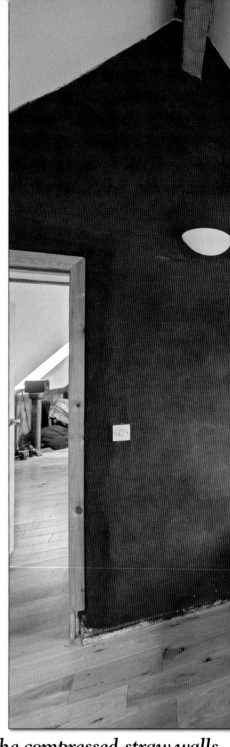

The design is freestanding, post-and-beam frame, independent of the compressed-straw walls.

All photos on these two pages, except the top left, are on the second story — accessed via the spiral stairway (below).

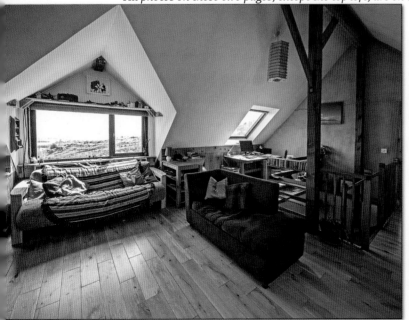

Needless to say, a stick frame would have been easier and quicker to build by far, but for aesthetics alone, you can't beat straw walls.

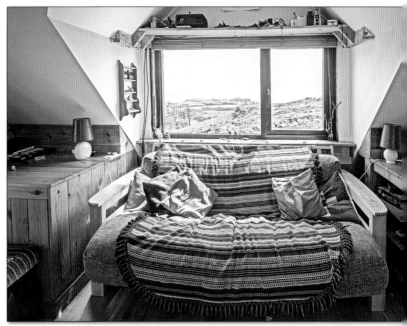

Ziggy and April's Timber Frame/ Straw Bale Home in Missouri

I N 2012, MY PARTNER APRIL and I embarked on an ambitious journey: we decided to build a straw bale and timber frame home. At the time, we were living in a small cob house ("Gobcobatron," featured in *Tiny Homes*), but that home proved to be incompatible with cold Missouri winters. By constructing a straw bale home, we could demonstrate the advantages of building with local natural materials, learn new skills, and push our limits. And, our design would be more compatible with the local climate.

Building the home would also be educational. We decided to host two natural building workshops to teach people how to build with natural materials. Looking back, I'm flabbergasted we were able to achieve our goals of constructing a challenging design, hosting two successful workshops, and creating a house that surpassed our expectations in a relatively short period of time.

> ## "We decided to host two natural building workshops to teach people how to build with natural materials."

The workshops not only educated others, but also enabled us to learn the skills we needed to pull off this ambitious building project.

In June of that year, we hosted a two-week Timber Frame Workshop and brought in Tom Cundiff, a top-notch timber framer, to lead a largely inexperienced group of learners through the fascinating process of joining wood together — without nails or screws.

We completed much of the frame, using only hand tools, and simultaneously survived two weeks of record-breaking heat. It was a sight to behold: sweaty, enthusiastic people cranking on antique boring

Brian "Ziggy" Liloia and April Morales

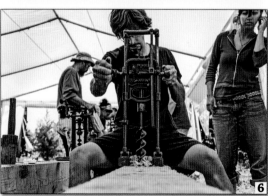

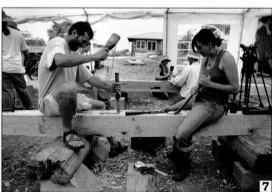

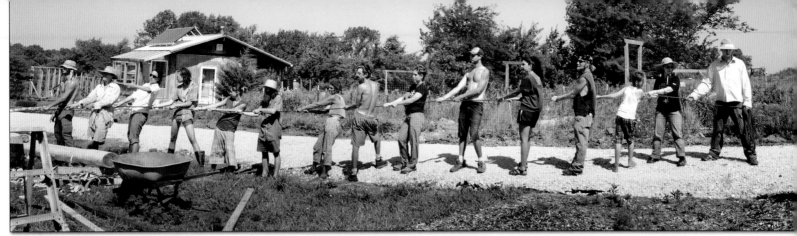

"The group energy was equivalent to a two-week adrenaline rush."

machines, wielding chisels and mallets, and sawing like pros in no time at all.

The group energy was equivalent to a two-week adrenaline rush — everyone got along incredibly well, and everyone was dedicated to our goal.

We had a month between the end of our first workshop and the upcoming Straw Bale Workshop to complete the roof and get everything ready for building the straw bale walls.

We were barely ready when our new batch of workshop participants began trickling in the door in July. (Many arrived as we were covering the roof with an EPDM pond liner — talk about timing!)

After the 10 days of the Straw Bale Workshop (and yet more punishing heat), we built the walls of our new home, installed all the windows and doors, and began the natural clay and lime plaster finishes on the walls.

Amazingly, we were able to live in the house by winter of that same year. Granted, the house was not complete, but we had a dry, warm space to rest in before the next year's work started. A year or so later, the house was completed.

Building our straw bale house challenged us in many unexpected ways. Just as we had taken a bare piece of ground and utterly transformed it, the straw bale house itself changed us in ways we could never imagine. In every sense of the word, it was a truly formative experience. I think that what stops many of us from trying to do something is that we don't trust or believe in ourselves — we let doubt overcome our intrinsic creative and problem-solving abilities. I would like to encourage people to instead try for what they aspire to, and learn along the way.

Floor Area: 500 sq. ft. / 46 m²

www.TheYearOfMud.com

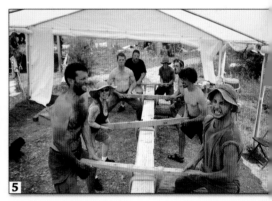

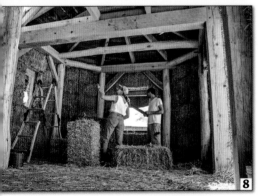

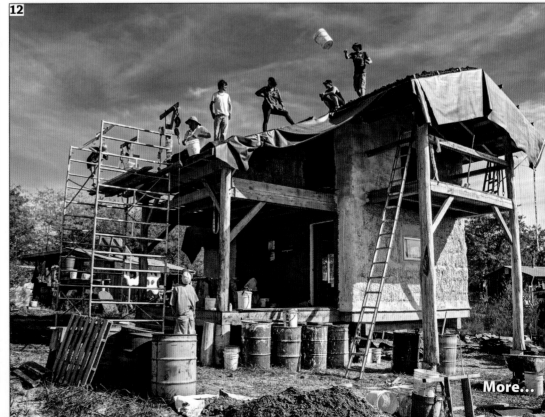

More...

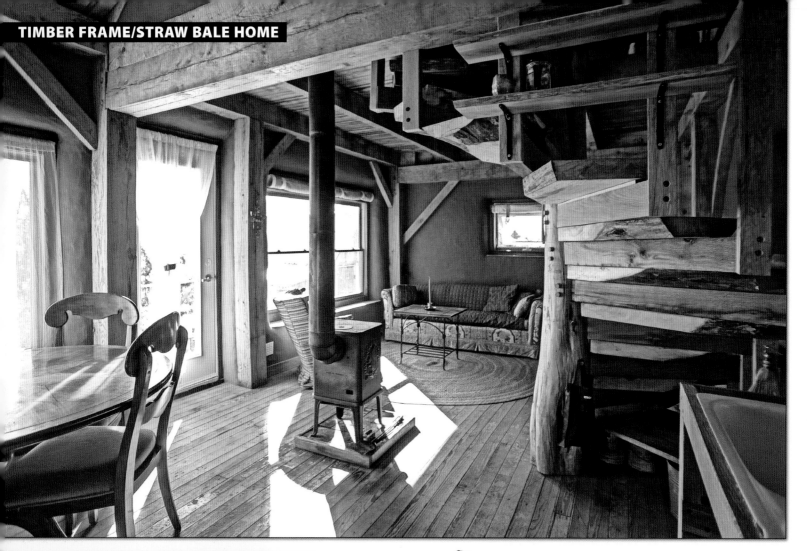

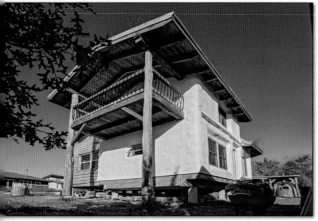

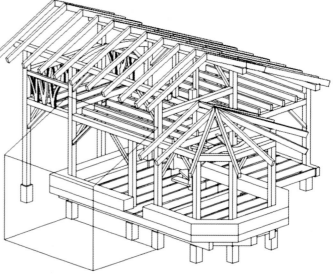

Strawtron House Specs:

- Approximately 500-square-foot interior-heated living space, and 165-square-foot enclosed porch
- Sawn oak and round wood, black locust timber frame with wood joinery, cut almost entirely with hand tools
- Straw bale walls (straw came from eight miles away!), with lime plaster finish on exterior, and local clay plaster on interior
- Living roof with 4″ of topsoil. *(By the way, I'm never doing that on a two-story building again.)*
- Pier and beam foundation with blown-in cellulose insulation
- Reclaimed wood floors
- Custom mortise and tenon spiral staircase with round wood center post, and sawn elm treads
- Porch with light clay straw walls, and live edge oak siding
- Heat provided by Morso 1410 woodstove

"Amazingly, we were able to live in the house by winter of that same year."

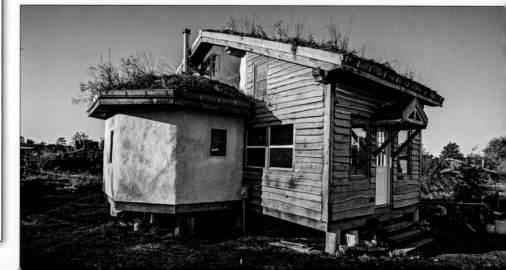

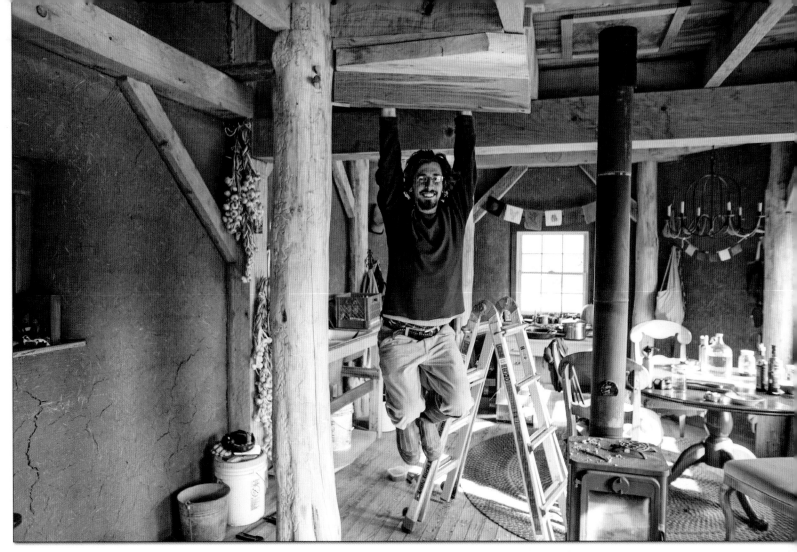

"I would like to encourage people to instead try
for what they aspire to, and learn along the way."

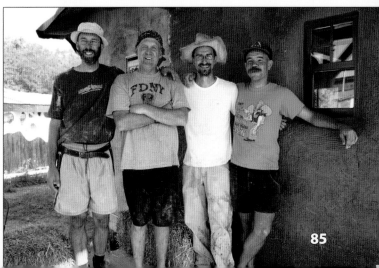

The FarmHouse at Hickory Highlands

John Freeberg and Susan Walch

Dear Shelter,

We bought Shelter, Home Work *and* Builders of the Pacific Coast *near the beginning of our design process. They were an inspiration and provided many ideas.*

Thank you for all that you do. Your books are beautiful presentations that help people open their minds to other possibilities.

–John and Susan

THE BLOOD OF ANCIENT BUILDERS courses through our druid hearts. It is the source of patience, wisdom, and vision, and has allowed shedding the chains of clocks and calendars. We practice architectural alchemy — turning stone, trees, and earth into wonder, joy, and beauty. This house, born on the crest of a hill, emerged from a desire for shelter from which to see and feel the unfettered sweep of the sky.

This seed for the FarmHouse was planted in a fertile field of images, ideas, and traditions — the Norsemen, the Celts, the Anasazi, the Rajasthani, the mound builders, Frank Lloyd Wright, Louis Sullivan — all contributed. But the main designers were the trees, the stones, and the sensuous clay earth. A tree would say, "I want to continue my tree-ness as your beam." A rock would say, "Turn me this way to be more beautiful." The clay soil would say, "Make me into plaster to radiate my peace from your walls."

A hardscrabble farm in the rolling hills of southeast Iowa has provided land for orchards and gardens, timber for shelter. We chose a site that provided views of the horizons in all directions, an adjacent pond, a magical woods, and an organic grain field with a creek bottom beyond.

The living room with its wooden ceiling, curved in a soft, barrel vault, emerged from a quiet place within me. This internal picture drew me into the snowy woods. A wood-artisan friend tells of the temple builders in Japan. They don't go to the forest to find timbers for the temple. Rather, they go to the forest to locate the temple and, when found, ceremonies are performed amidst the trees. Then, the builders relocate the temple from the forest to the people.

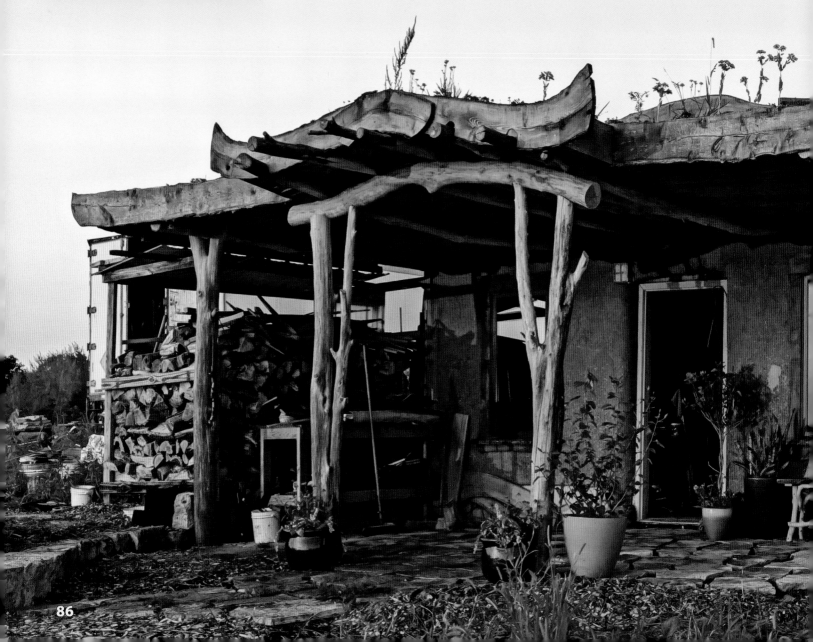

Photos by Werner Elmker

From the forest near our house, we relocated the living-room frame of shagbark hickory trees, which were debarked revealing a tawny, glowing, rippled sapwood.

The kitchen cabinets are thorny locust boards with the natural edges preserved. The breakfast bar is a slab of driftwood maple, rescued from the Skunk River by a friend. Dividing the kitchen and living room is a wood-burning stove sitting on a hearth of stones scavenged from my grandpa's farm in Wisconsin. The floor is compressed earth and cow manure. It offers a smooth, firm, nourishing support.

The walls are straw bales plastered with earth. The earthen roof is planted with a dozen different sedums. The pond provides water for domestic use, irrigation, and mid-summer respite. Electricity is provided by solar panels. Four tiny houses are tucked into corners of the farm. Perennial agriculture includes chestnuts, hazelnuts, and fruit trees.

One reason for loving life in the FarmHouse: There is little difference between indoors and out. The limestone floor on the west porch began life as coral in an ancient seabed nearby. That floor flows into the flagstone path leading through the house. The earth outside and the adobe floor inside are made of the same clay. The arched living room ceiling evokes the arc of the sky. The whole trees of the framework supporting that ceiling are still home to the divas of the forest, visible through the arched south window. The dogs and cats live inside and outside. Zebu cows live outside and the chickens are supposed to stay outside but make the occasional foray into the big house.

Floor Area: 1168 sq. ft. / 109 m²

www.shltr.net/hickory-highlands
www.wholetrees.com

"We bought an old farm in the rolling hills of southeast Iowa and soon discovered that we were its caretakers."

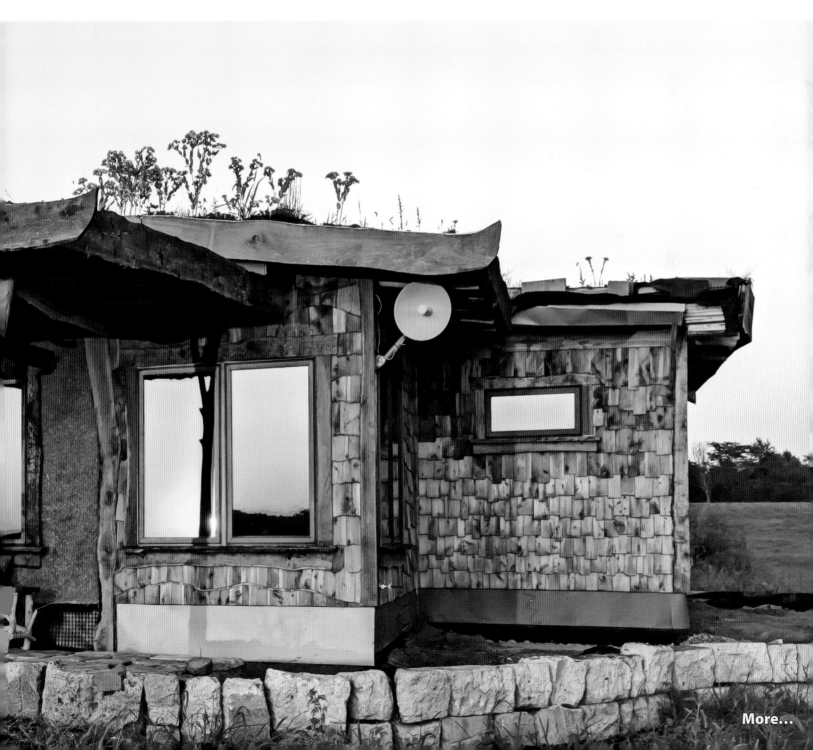

More…

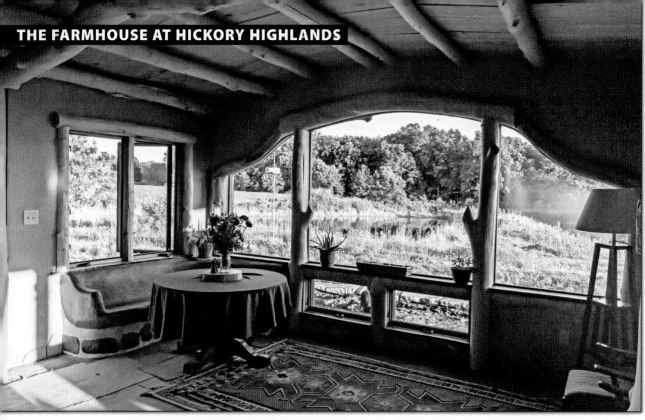

"Four tiny houses are tucked into corners of the farm."

"We practice architectural alchemy, turning stone, trees and earth into wonder, joy and beauty."

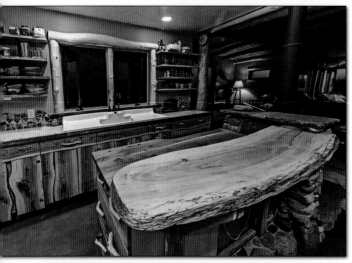

"The breakfast bar is a slab of driftwood maple."

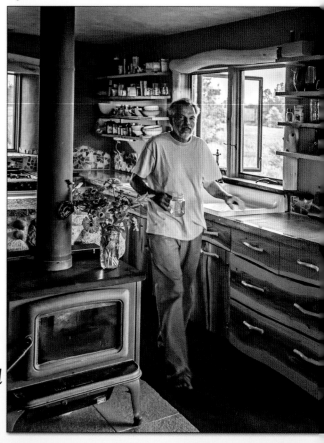

"This house, born on the crest of a hill, emerged from a desire for shelter from which to see and feel the unfettered sweep of the sky."

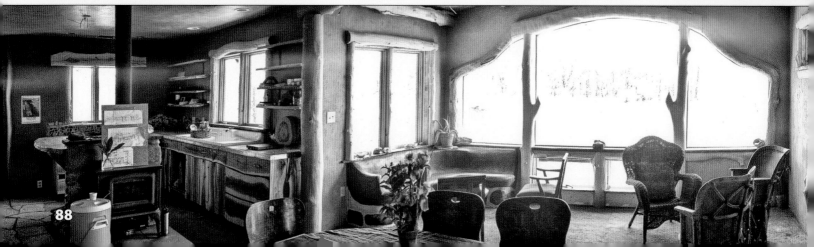

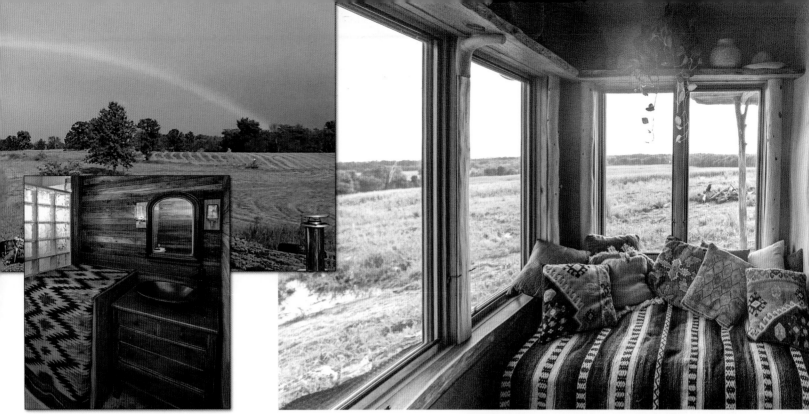

"We chose a site that offered views of the horizon in all directions, an adjacent pond, a magical woods."

"The gently curved roof of the living room is reminiscent of the arc of the sky."

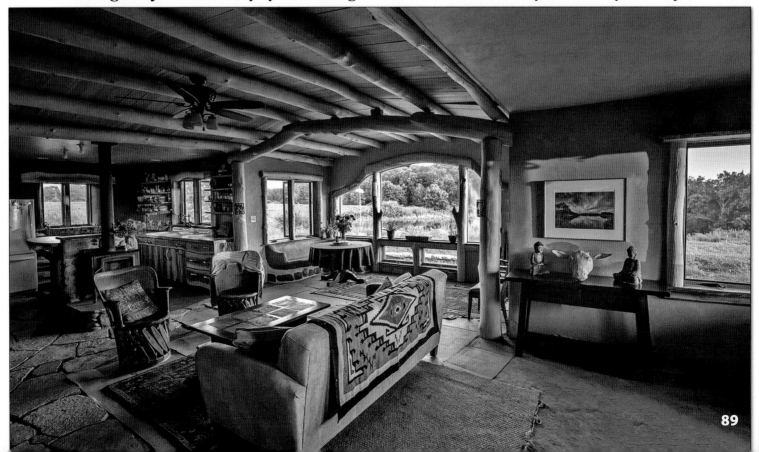

Hybrid Natural Home in Colorado High Desert
Brett LeCompte

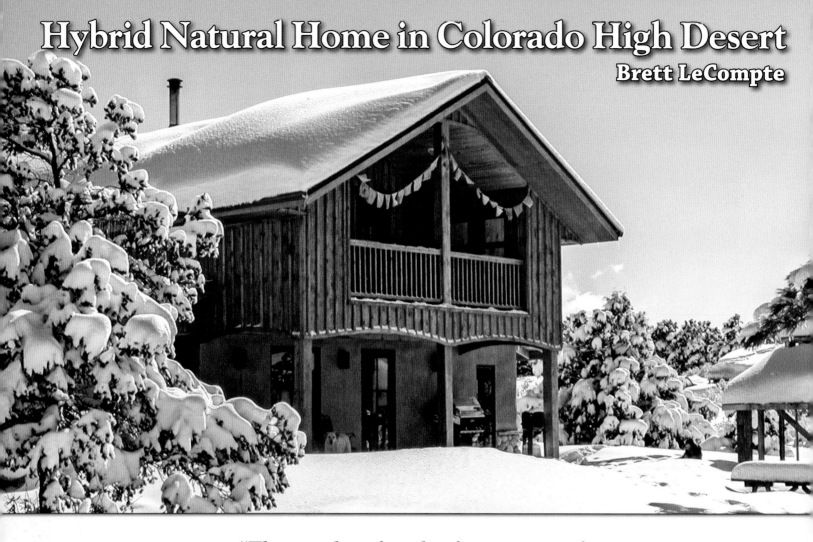

*"There are lots of porches for protection of
my earthen walls during a Colorado winter."*

MY HOME, WHICH I BUILT IN
2003–04, is a hybrid design.
The north, east, and west wall
are straw bale, while the south wall is adobe
and glass.

The upper story is framed with 2″ × 8″
rough-sawn local Ponderosa Pine, furred out
to about 9½″ to accommodate a heavy coat
of cellulose insulation, which also fills the
roof cavity.

Downstairs, there are earthen plasters
inside and outside, while upstairs is
sheathed in local, rough-sawn pine board
and batten.

Drywall walls upstairs are finished in
earthen plasters, which ties the two levels
together. A central woodstove heats the
home, which is off the grid.

I tried to use materials mostly from my
county in southwest Colorado. Ceilings are
tongue-and-groove aspen sawn in a mill six
miles away. The frame is local Ponderosa
pine, including a third of them milled from
my property.

I did my own bathroom and kitchen
cabinetry. Downstairs floors are earthen
(two thirds) and tile (one third).

There are lots of porches for protection of
my earthen walls during a Colorado winter.

One unique feature is a 10-inch lizard
(painted blue) that runs up the staircase on
an interior adobe wall. I named her Noelle
when I finished shaping her one Christmas
afternoon.

I share the house with my wife Shaine,
kids Rosie and Fielder, and dog Ella, who is
turning 14 today!

Most of my adult life, I have worked as a
guide and outdoor leader. Carpentry was a
sideline to get us through the winters. After
learning and laboring for two years to make
my natural home, I started my own business
called Swallows Nest Natural Building. I
most enjoy using natural and local materials
to create unique structures. I seem to be
creating a niche as the local round builder.

As I was working on the round underground
hobbit house *(next two pages)*, I was also
bidding on an 8-sided straw bale hogan.

There appear to be more round homes
in my near future. Tenures of living in a
yurt have made me very comfortable in the
round. I lived where there is the greatest
density of ancestral Pueblo ruins in the
country, and I draw inspiration from these
early natural builders.

I am most drawn to the simple cliff
dwellings that housed an extended family
over the urban developments of Chaco
Canyon and Mesa Verde. Nothing beats
sweet and simple!

Floor Area: 1360 sq. ft. / 126 m²

*"The north, east, and west wall are straw bale,
while the south wall is adobe and glass."*

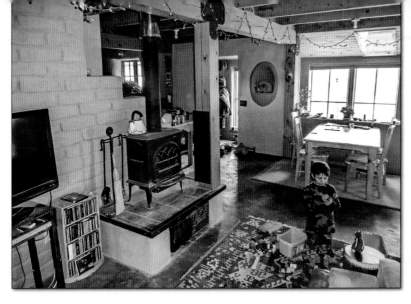

"I tried to use materials mostly from my county in southwest Colorado."

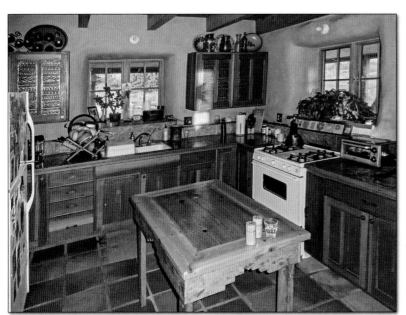

"Nothing beats sweet and simple!"

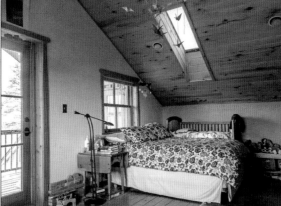
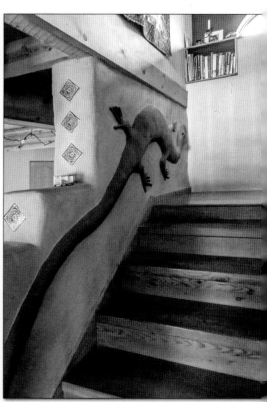

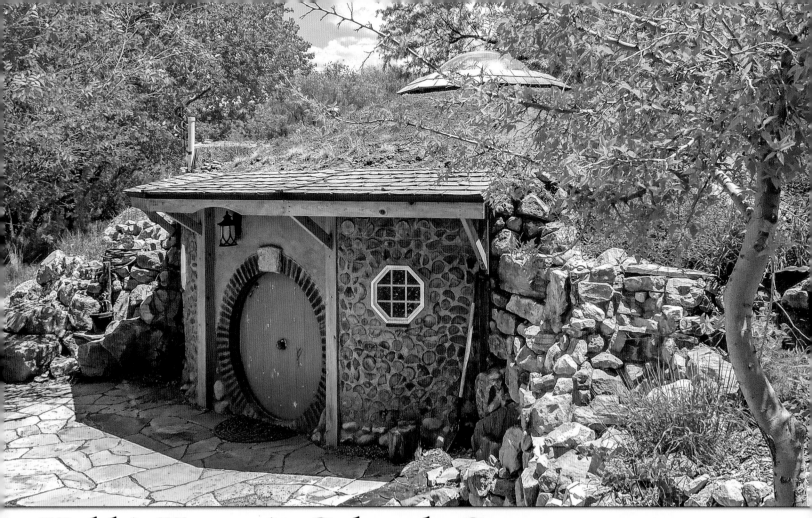

Hobbit House in Colorado Canyon Brett LeCompte

...inspired by J. R. R. Tolkien's The Hobbit...

TWO YEARS AGO, homeowners Marian and David Howarth asked Brad Wright and me to build a multipurpose craft studio/guesthouse in McElmo Canyon west of Cortez, Colorado.

They were inspired by J. R. R. Tolkien's *The Hobbit*, and asked if we could build something similar. What we created over the last two years is a 900-square-foot underground structure with a number of interesting features.

The basic design is a 24-foot diameter circle with an adjoining rectilinear space on one side. The walls are waterproofed concrete CMU blocks. The roof is local Ponderosa pine logs with rough-sawn boards protected by insulation and a roof membrane, then buried with native soil.

The circular ceiling has a lovely and rare reciprocal log rafter system with an openable, five-foot-diameter skylight. The floors are dyed concrete. The walls are earthen plaster.

There is a circular painting on the floor, designed by Marian Howarth, and created by Brad

Wright. From the circle, there are tangent lines radiating out to the wall, which mirror the beam pattern of the reciprocal roof above. On solar noon on the summer solstice, the beam of light coming through the circular skylight lines up exactly with the painting on the floor.

I recently completed a rocket mass heater woodstove that spans both interior rooms. The subterranean structure can be entered either through

a custom-crafted, circular front door or a conventional back door.

The exterior focal point of the Hobbit House, the circular door, is flanked by two cob/wood walls. In front of the door is a lovely flagstone courtyard with a waterfall feature and a fishpond.

The Howarth's Hobbit House has to be one of the most creative and unusual structures in southwestern Colorado. As a huge fan of all your books and blog, I would love to share the

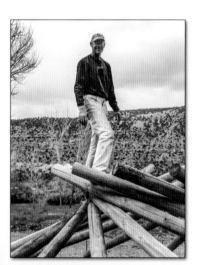

story of this structure. I live in a straw bale/adobe home (*see previous two pages*) and recently also completed a straw bale hogan perched on the edge of a 700-foot canyon.

Brett LeCompte:
Swallow's Nest Natural Building, Dolores, Colorado

Brad Wright:
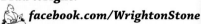 *facebook.com/WrightonStone*

Floor Area: 900 sq. ft. / 84 m²

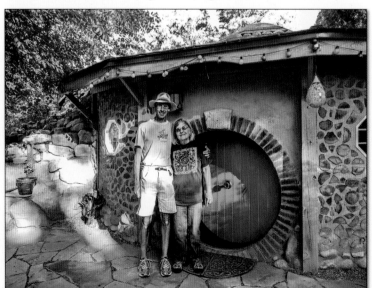

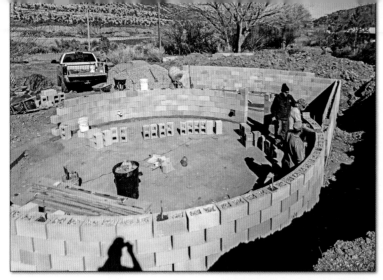 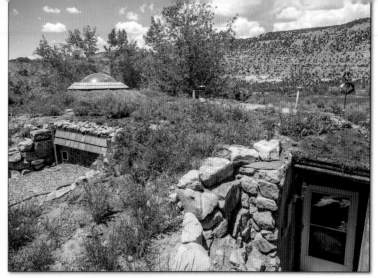

The circular ceiling has a lovely and rare reciprocal log rafter system.

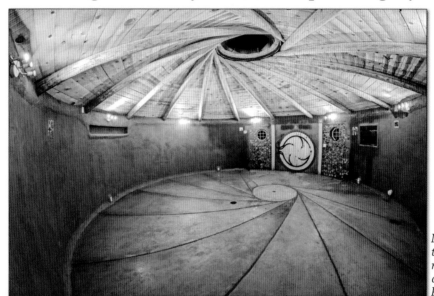

Night view: Radiating tangent lines on floor mirror beam pattern of reciprocal roof above. Photo by Dan Howarth

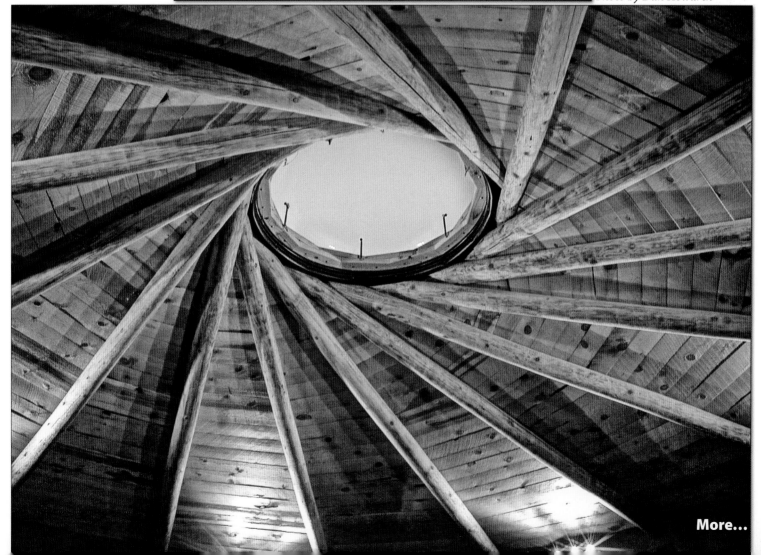

More...

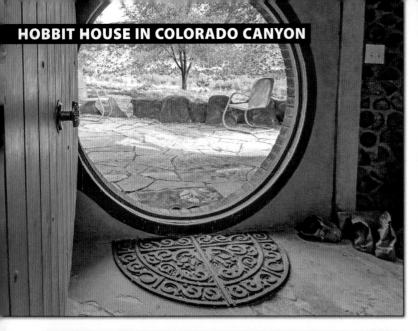

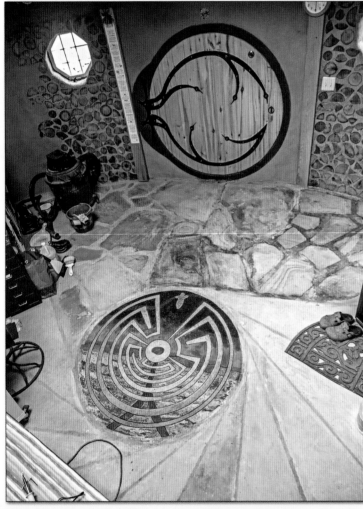

Painting on floor illuminated on summer solstice

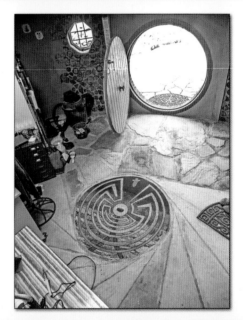

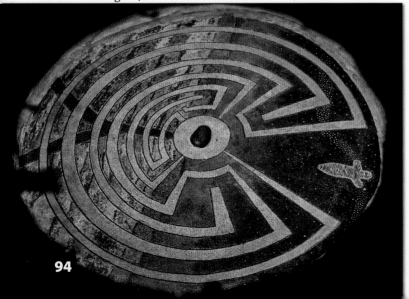

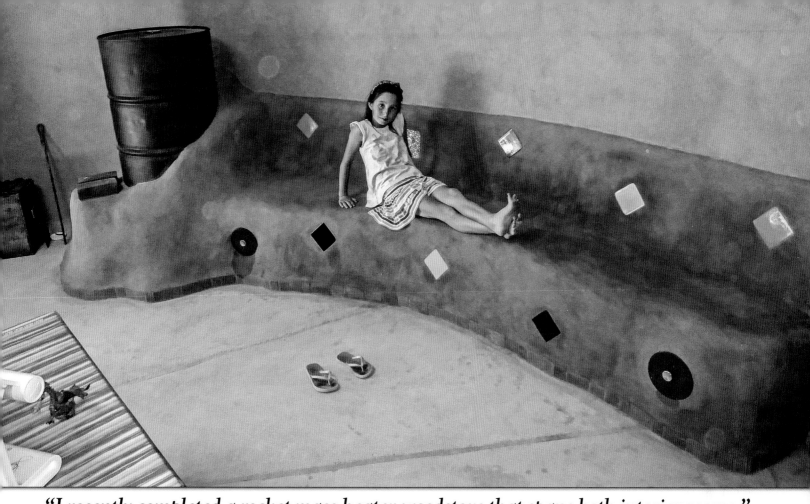

"*I recently completed a rocket mass heater woodstove that spans both interior rooms.*"

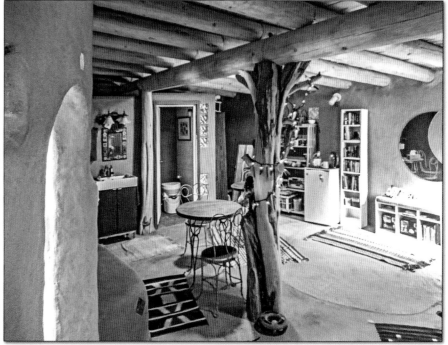

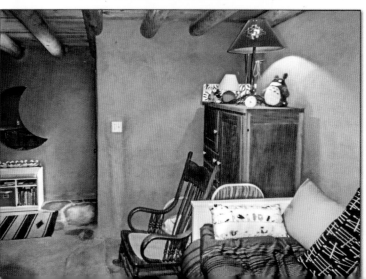

"*The walls are earthen plaster.*"

Rob & Jaki Roy's Two-Story, Cordwood, Lakeside Home

Mushwood Cottage

Rob Roy

CORDWOOD MASONRY IS our business — we've been teaching it since 1981 at our Earthwood Building School in northern New York — so Jaki and I knew that our summer camp on Chateaugay Lake, just 26 miles away, would need to feature our favorite creative building style. But why do we call it "Mushwood?"

About 25 years ago, we built the first manifestation of our summer home: a 22-foot-diameter, cordwood round house under a 29-foot-diameter, wooden-shingled, geodesic dome.

After 20 years, it was time to replace the shingles, but, upon removing the old ones, we discovered that many of the plywood triangles had gone soft with condensation. We had no idea of this from inside: There was never a leak and the interior finish was perfect.

What to do? Rebuild the dome? Or, we knew we could build a 22-foot-diameter, second story of cordwood under the dome's umbrella protection … and that was what we did. (Our son is now living in the dome, rebuilt this time, with condensation protections.)

With the dome on, the place looked like a mushroom. To keep the motif, we incorporated several mushroom designs into the cordwood masonry. Mushwood, situated on a lake with a wealth of wildlife, has become our little piece of paradise.

Curiously, our total area decreased from about 900 square feet to 600, due to the vagaries of πr^2, but it is easier to heat and — we say — cozier. We have a bathroom and two small bedrooms downstairs, with an open-plan, living-dining-kitchen area above.

Our 12-inch-thick cordwood walls have four inches of lime-treated, sawdust insulation between inner and outer mortar joints, each also four inches in width. We built the plank-and-beam system strong enough to support a heavy living roof in our snowy climate, but finished it off, instead, with flat stepping stones and pink granite crushed stone between them.

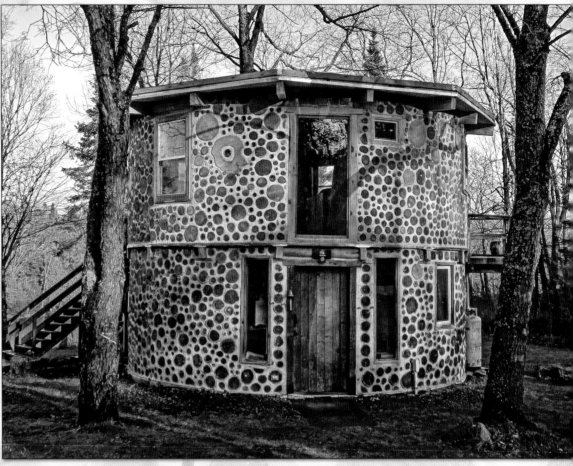

"Cordwood masonry is our business."

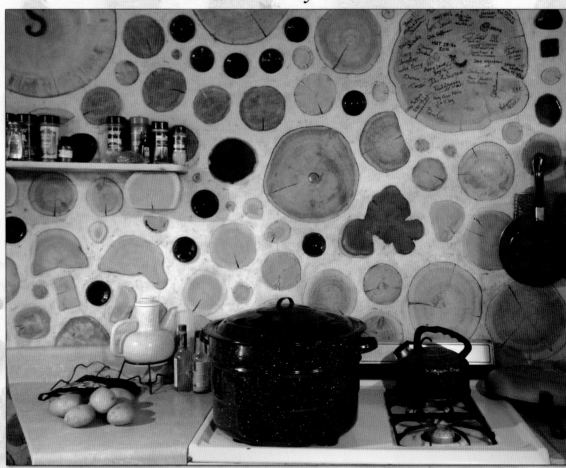

"Mushwood, situated on a lake with a wealth of wildlife, has become our little piece of paradise."

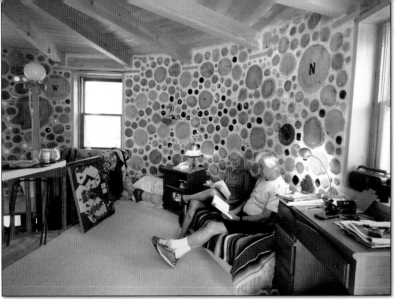

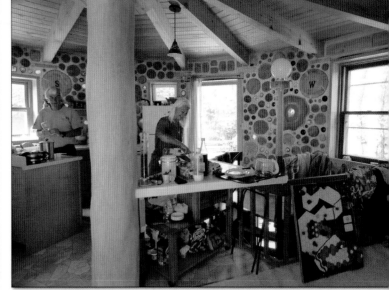

"Our 12-inch-thick cordwood walls have four inches of lime-treated, sawdust insulation."

"Even the local beaver cut us a perfect 12-inch log-end from quaking aspen."

We are often asked about mortar cracking in a cordwood wall. This can happen from mortar shrinkage (minimized by the use of cement retarder in the mix), stress cracking from load or building on a wood floor, or wood expansion. We recommend that people use wood with a low shrinkage coefficient, which means a low expansion ratio. If you do your homework, mortar cracking will not be a problem.

Jaki and I took great pleasure placing many special design features into the new upstairs cordwood walls, using bottle-ends, geodes, a crystal skull, special log-ends, and other items.

Four large pine log-ends mark the four compass points. The Big Dipper constellation points to Polaris, the North Star. Chateaugay Lakes Outlet is mapped in one panel with blue bottles, and a crystal skull — with which we have some history in Belize — is featured in another.

Our Australian panel features artifacts brought back from a season teaching cordwood "down under." Eighth-inch geodes, looking like glass log-ends, are featured in several designs.

Even the local beaver cut us a perfect 12-inch log-end from quaking aspen, with his distinctive chewed ends. Most of our log-ends, incidentally, are northern white cedar, with excellent insulation and a very low shrinkage factor of just two percent.

Floor Area: 600 sq. ft. / 56 m²

www.cordwoodmasonry.com

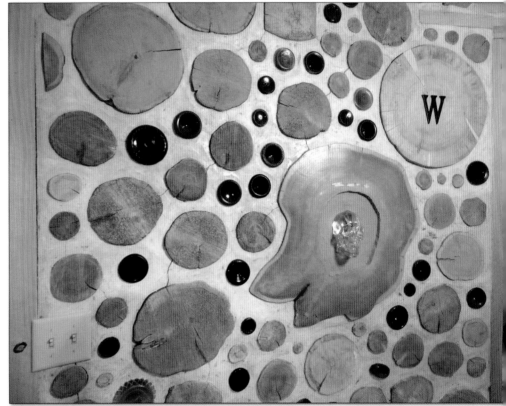

"Four, large, pine log-ends mark the four compass points."

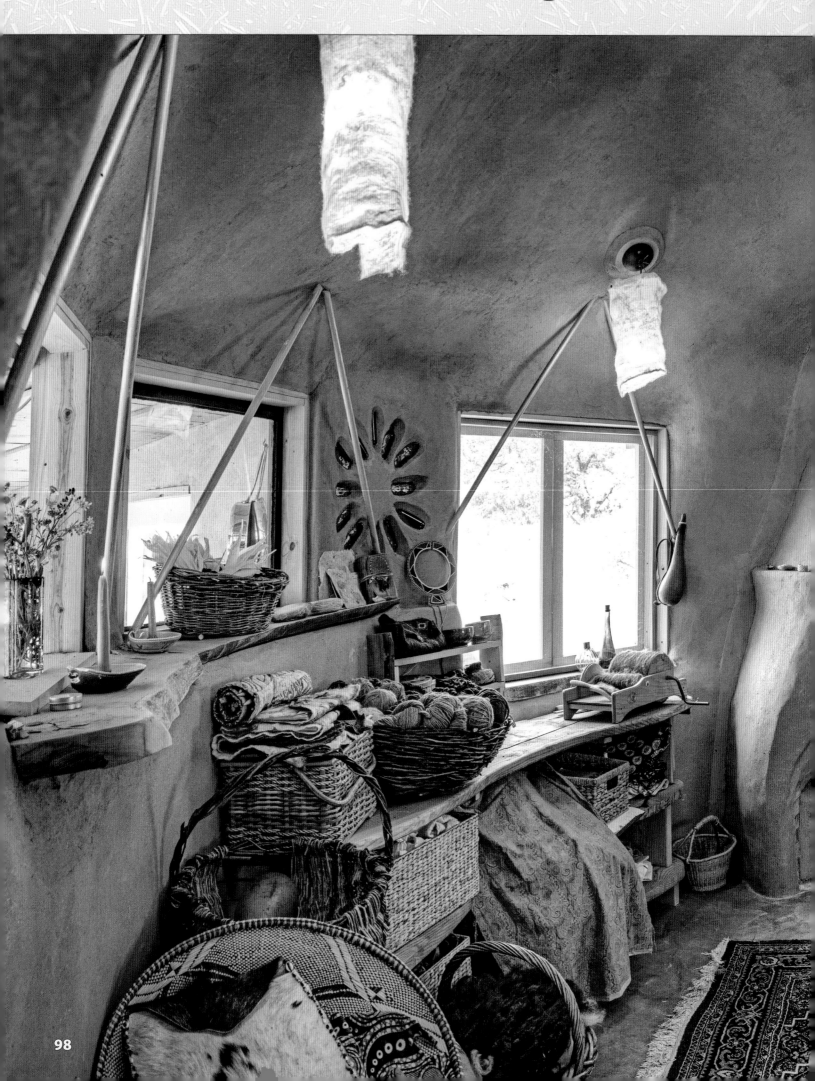

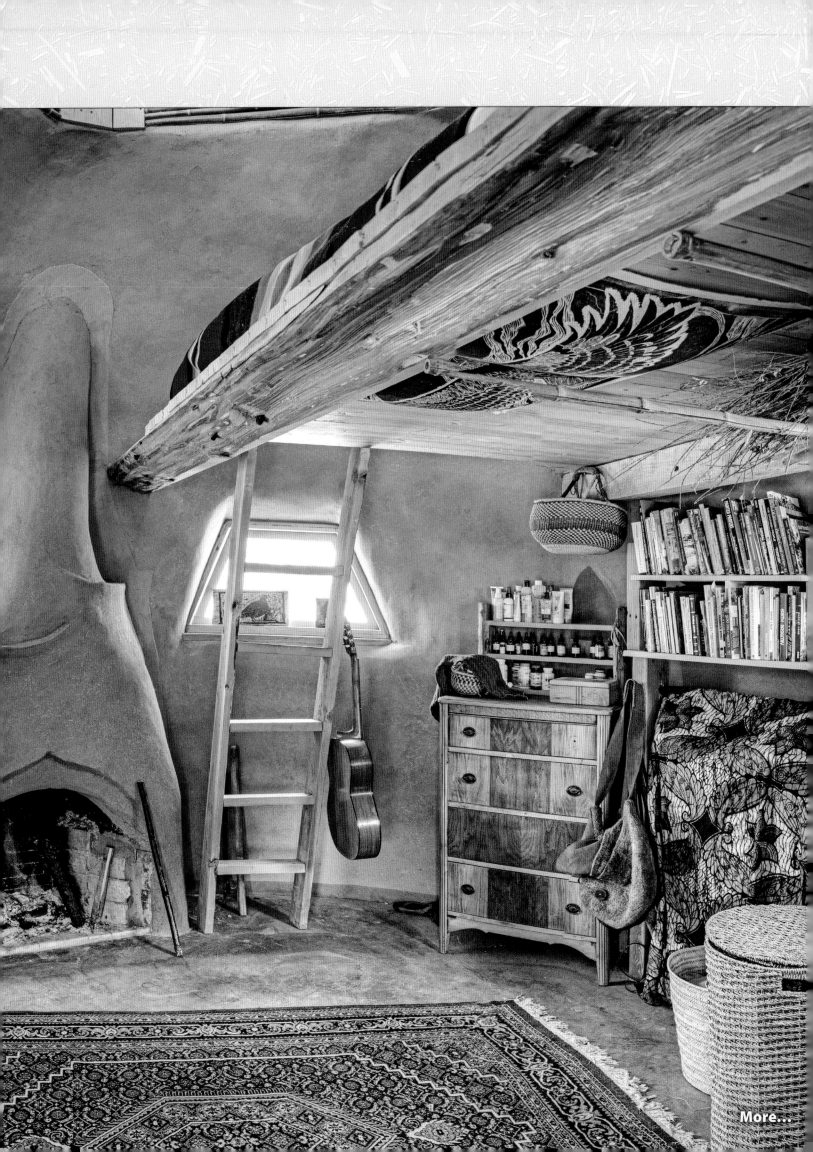

More…

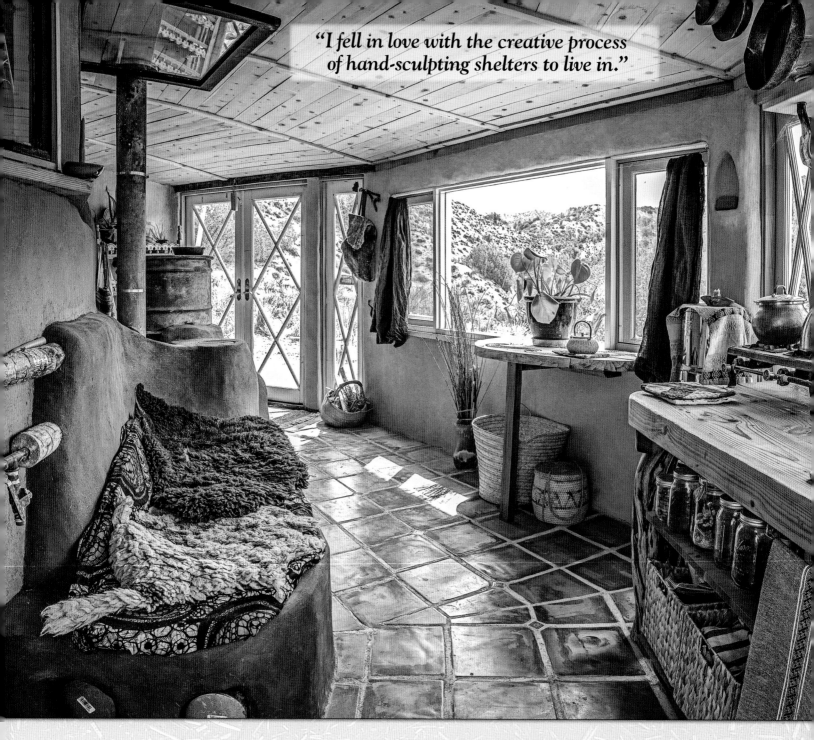

> *"I fell in love with the creative process of hand-sculpting shelters to live in."*

Sasha's Earthen Dome in the High Desert

A home made of cob, earth bag, light straw clay, and adobe

Sasha Rabin

**Photos: Ryan Spaulding (finished house)
Zeya Schindler (construction)**

I GREW UP IN BOLINAS, DOWN THE ROAD from Lloyd Kahn and Shelter Publications. My early years were surrounded by many of the wildly creative buildings that fill the pages of *Shelter*.

I started building with earth in 2002 with an internship at the Cob Cottage Company in Oregon, and have been creating structures with various modalities of earthen building and teaching workshops on these techniques ever since.

I fell in love with both the creative process of hand-sculpting shelters to live in, and as well as seeing people leave workshops with

deep inspiration after gaining skills to build their own homes.

When I started this building, I wanted to make the building process fun. I invited five friends to come work with me for a month, and we got the basic framework up, and we did indeed have a lot of fun! Although I have been the main builder (working on and off between other projects finishing it), I have received a huge amount of help from all the community members I live with.

There are about twenty of us living in this beautiful canyon in the high desert of Southern California, and I am deeply

grateful for all their help. Although the material cost of this style building is relatively low, it took a lot of labor. It almost necessitates community support, which results in beautiful community building.

We host a lot of workshops, classes, and school groups, which has led to groups of college kids from Minnesota helping with the floor, people from an outdoor school in Washington helping with the plaster, and my Dad coming down and building the cupola on top of the dome, to mention a few. I would guess that close to 100 people have put their hands on this building.

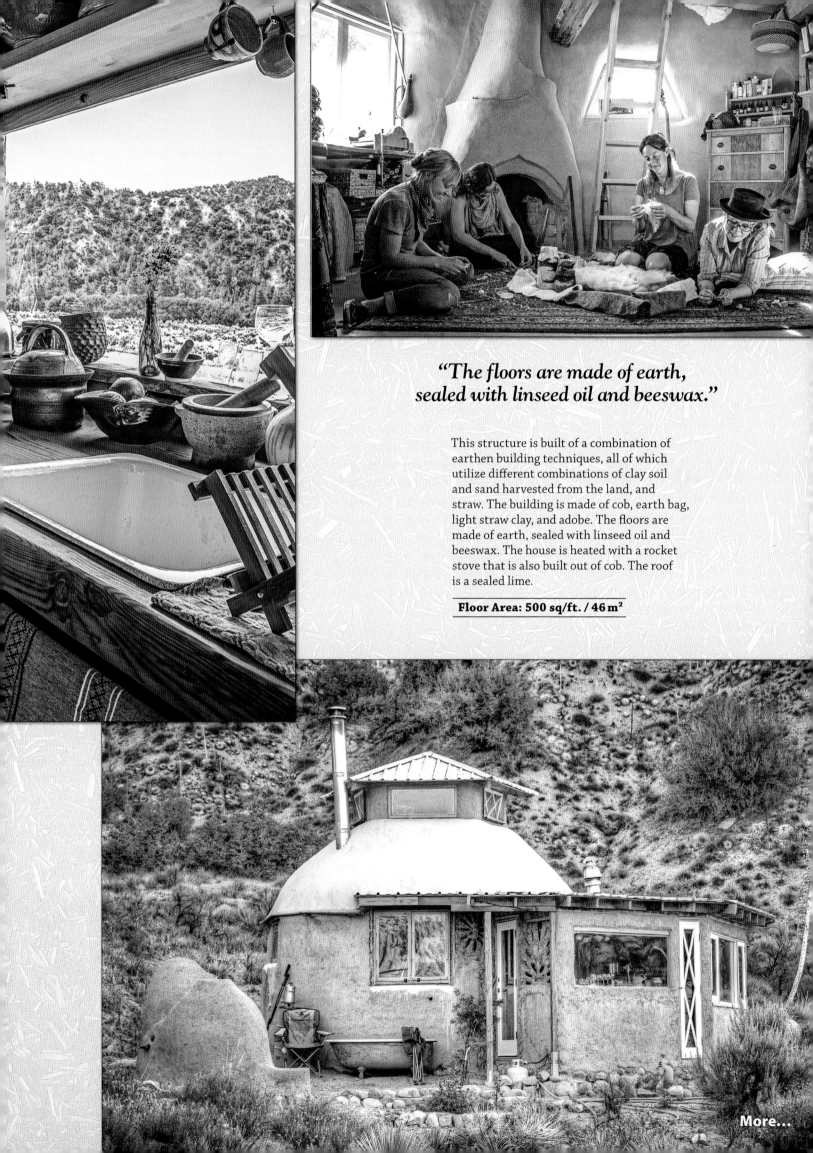

> ## "The floors are made of earth, sealed with linseed oil and beeswax."

This structure is built of a combination of earthen building techniques, all of which utilize different combinations of clay soil and sand harvested from the land, and straw. The building is made of cob, earth bag, light straw clay, and adobe. The floors are made of earth, sealed with linseed oil and beeswax. The house is heated with a rocket stove that is also built out of cob. The roof is a sealed lime.

Floor Area: 500 sq/ft. / 46 m²

More...

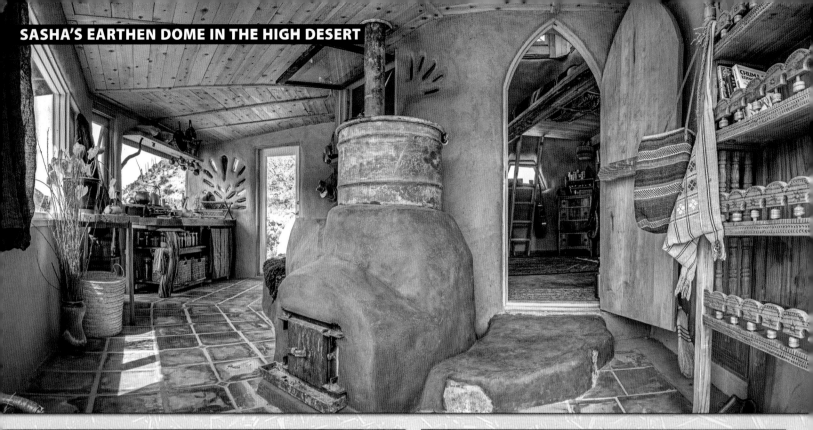

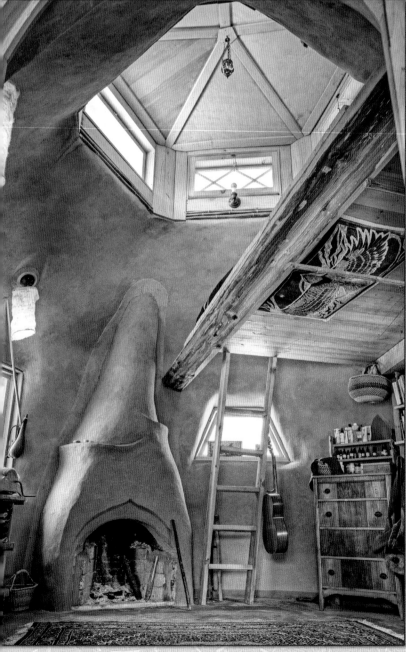

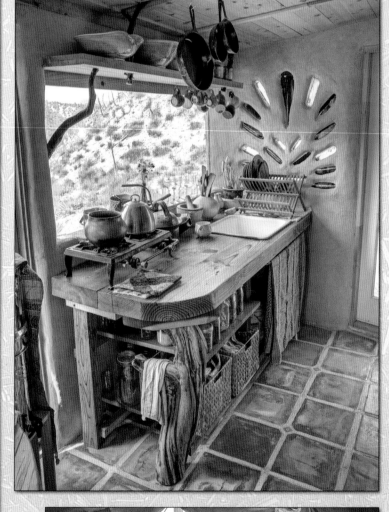

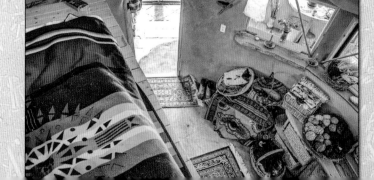

"Although the material cost of this style of building is relatively low, it took a lot of labor."

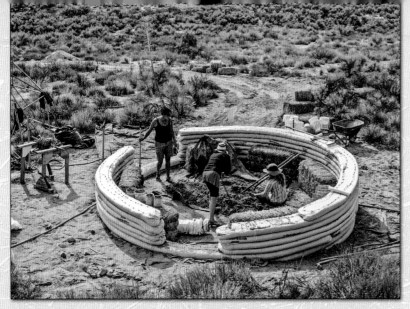
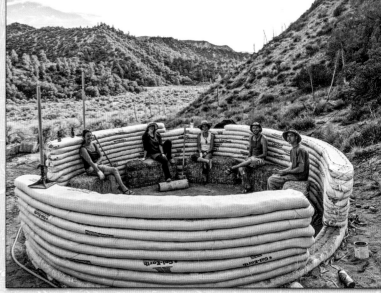

"I have received a huge amount of help from all the community members I live with."

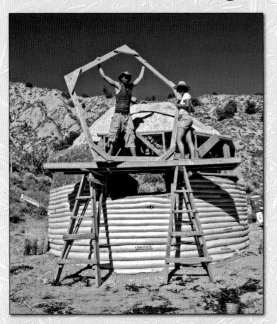
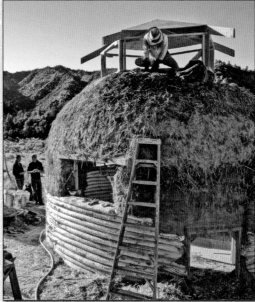
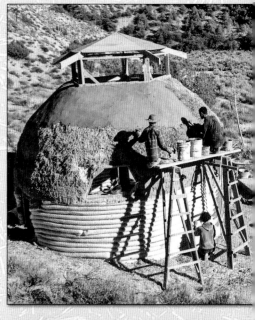

Three Books on Natural Building

The Natural Building Companion
Jacob Racusin and Ace McArleton
A good technical book

Built by Hand
Yoshio and Eiko Komatsu,
and Athena & Bill Steen
*Amazingly beautiful natural buildings
from all over the world*

Using Natural Finishes
Adam Weismann and Katy Bryce
Comprehensive book on natural plasters

Since beginning her natural building career in 2002, Sasha Rabin has taught extensively through organizations that she co-founded — Seven Generations Natural Builders and Vertical Clay — and through collaborations with The Yestermorrow Design Build School, The Canelo Project, The Solar Living Institute, and Quail Springs Permaculture. She has taught natural building in Jordan and Kenya and currently runs her own natural building organization, Earthen Shelter. Although she enjoys the act of building, her true passions lie in teaching natural building to others.

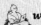 *www.earthenshelter.com*

Sun-Filled, Old Adobe Home in New Mexico

Joel and Erin Glanzberg

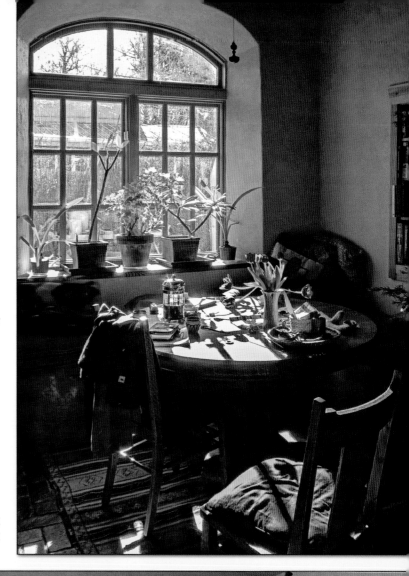

LIVING IN A SMALL HOUSE IS ALL ABOUT THE SENSE OF SPACE and light, two things that are often lacking in old adobe homes. The high ceilings of this 100-year-old adobe schoolhouse help, as does the abundant New Mexico sunlight which streams in through the windows and French doors in these thick mud walls; the greenhouse also brings in light. Light-colored earth plasters with mica help as well. (Check out the book *Clay Culture: Plasters, Paints and Preservation,* by Carole Crews.)

A midwinter freezing of our pipes that watered the house for days provided the opportunity for a remodel.

We always have spent summers living out on the covered portal or porch. When we added the greenhouse and a small pallet/clay/straw shed (see *Tiny Homes*), the space they define became an obvious outdoor kitchen and dining/work area.

We were inspired by gardens we had seen in Italy to brick the area and install an old O'Keeffe-Merritt stove, water-catchment, and an outdoor sink for food processing, with drain-off going to water the garden. The area also shades the house in the summer and helps to let heat and light in during our cold — but sunny — winters.

The uninsulated adobe north wall of the house had always been a source of lost heat every winter. To insulate it and to provide more storage space for our growing family we built a two-foot-deep closet with sliding barn doors along the driveway.

It holds 6 inches of foam against the once-cold wall, while providing easy-access storage to the gear for farming, craft shows, and building as well as for camping, skiing, etc.

A tiny addition of space in a small home can make a significant difference. The cushion-covered bench in the solar windows next to the woodstove makes for a cozy couch, as well as dining nook. The loft in the kids' room, the high library accessed with a rolling ladder, and the shelves in the bathroom all help, as does the shower in the greenhouse. Nothing is wasted or neglected, either in the house or the tiny yard.

All of the materials, windows, doors, even the boiler for the new, in-floor, radiant heat system, were second-hand or saved from years of construction. Select pieces of wood and much of the plaster was found or dug. Erin jokes that I can tell where every board in the house came from. With a small home, it's easy to pay attention to details, which can create a well-loved home.

Floor Area: 1000 sq.ft. / 93 m²

www.patternmind.org

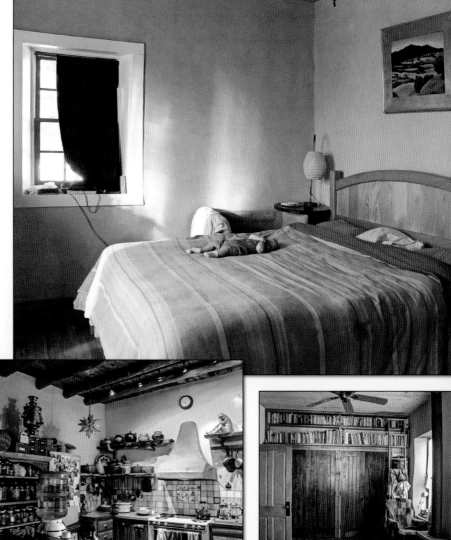

A tiny addition of space in a small home can make a significant difference.

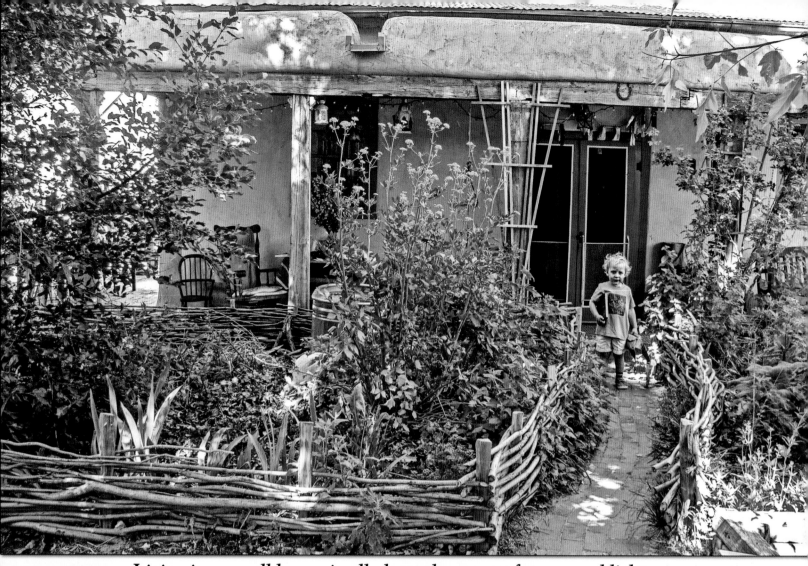

Living in a small house is all about the sense of space and light.

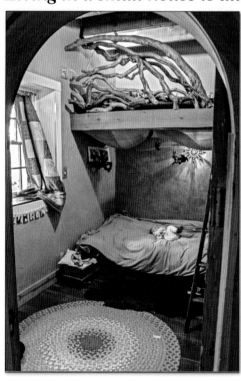

The abundant
New Mexico
sunlight streams
in through
the windows.

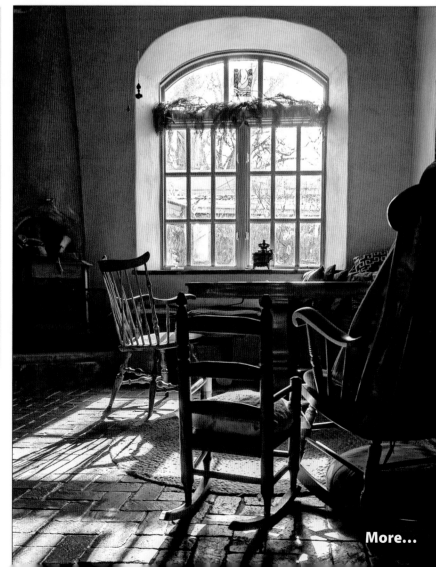

More...

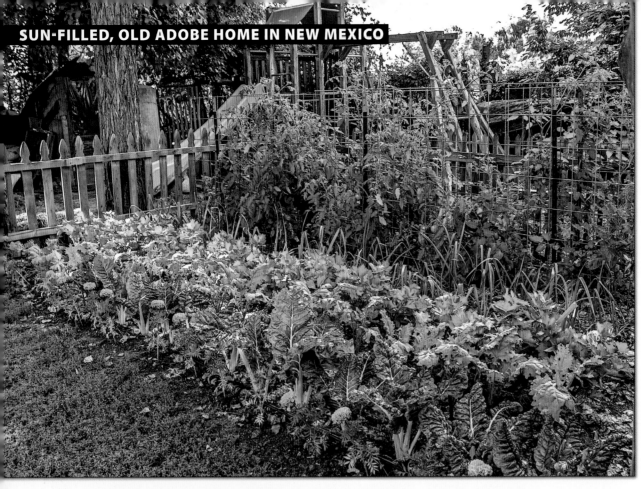

"We were inspired by gardens we had seen in Italy."

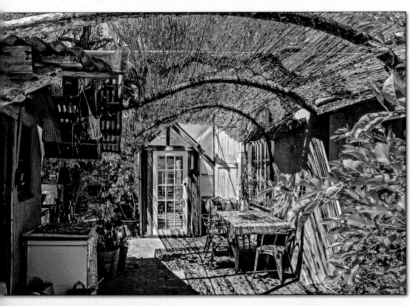

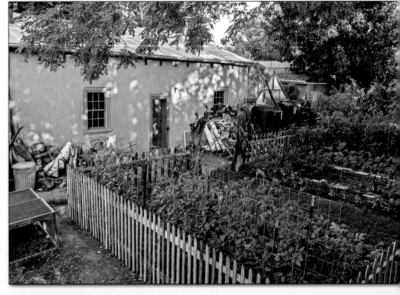

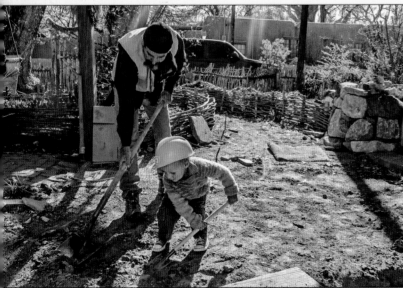

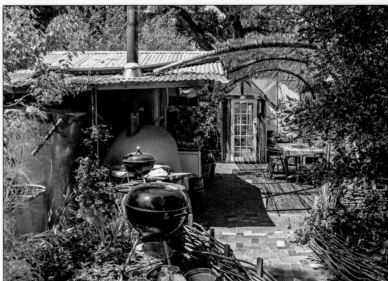

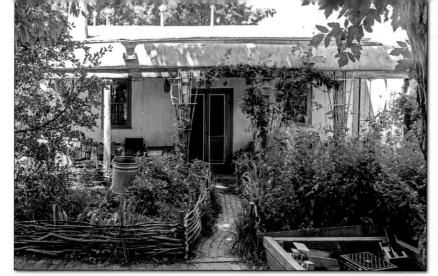

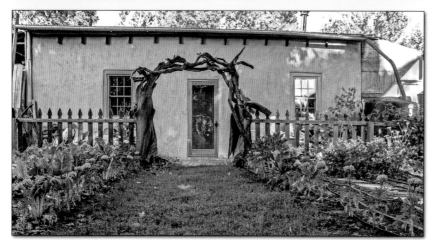

"Erin jokes that I can tell where every board in the house came from."

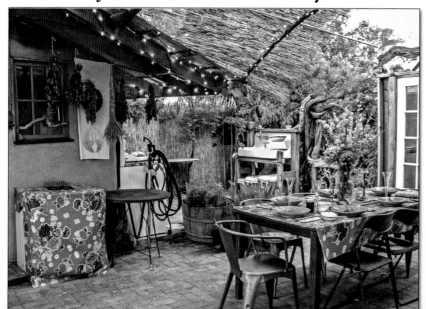

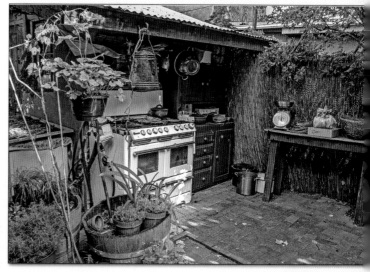

Round, Straw-Clay Home in Vermont

Greg Ryan

THIS HOME IN CENTRAL VERMONT CONSISTS OF TWO buildings—the main house is 706 sq. ft. with an additional sleeping loft. The smaller building is a writing/yoga studio and is 201 sq. ft. It was built with help from my good friend Walt Barker and many community members who came to help at the various work parties.

I designed the two straw-clay, yurt-inspired structures to use as much local material as possible, much of it from the site itself.

The walls are a 12″-thick, straw-clay mixture of locally grown straw and locally harvested clay mixed together and packed into forms.

The spruce rafters (or roof poles) were harvested from the land and peeled by hand on-site. Wood for the loft was harvested on-site and cut into beams with a portable sawmill.

The stones that make up the stem-wall (bottom 18″) of exterior walls were collected on-site. The roof system in the ceiling is beautiful, with the spruce rafters all meeting at a central oak skylight—a particularly elegant geometry.

It is a passive solar home, taking full advantage of the path of the sun. Window placement and sizing were essential in maximizing the passive solar potential.

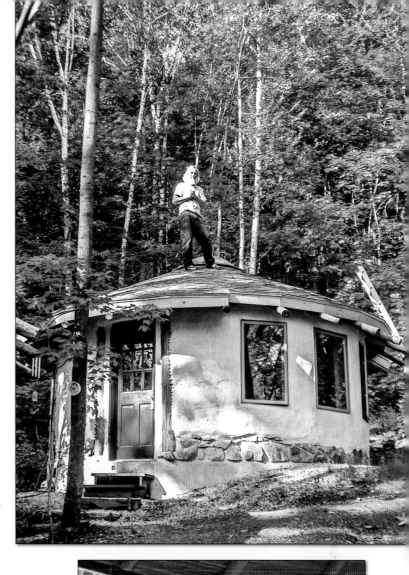

> *The walls are a 12″-thick, straw-clay mixture of locally grown straw and locally harvested clay mixed together and packed into forms.*

Electricity is provided by solar panels. There is in-floor, radiant heating and a soapstone woodstove for heat.

The best thing about building this house for me was the process. We had three or four organized work parties with 20+ adults and their children helping—something you don't often see. People found out about the project and came from all over the state to help out. I've never had a building experience like this before.

Someone would show up with a banjo or a guitar and entertain us for hours. Folks would bring food to share. We had a lot of fun.

A couple that heard about the project came up to work and ended up staying for weeks. A guy from Ghana came, who was quite familiar with earthen construction and turned out to be a tremendous asset. He was also surprised and impressed that anybody in the states valued this type of construction. It was a great community effort.

From a design standpoint, I have been influenced by the work of Christopher Alexander. *A Pattern Language* is an amazing book, as are his others. Ianto Evans was another big influence.

Floor Area: 907 sq. ft. / 84 m²

> *It is a passive solar home, taking full advantage of the path of the sun.*

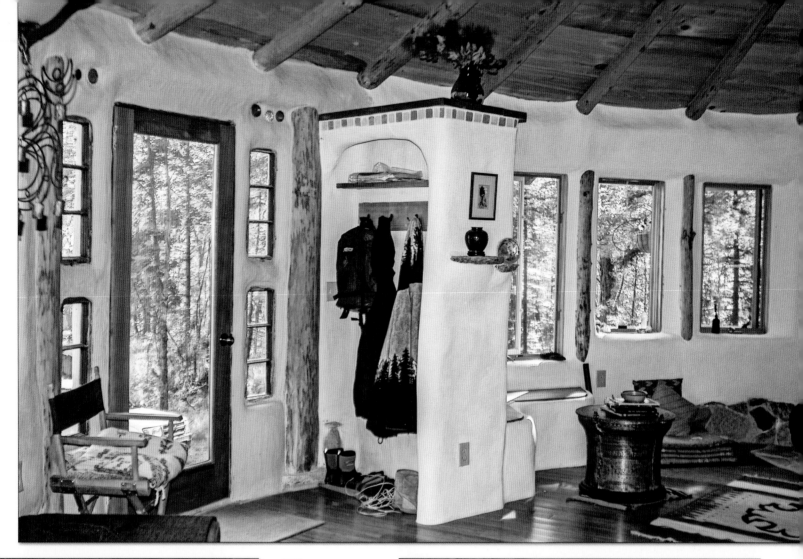

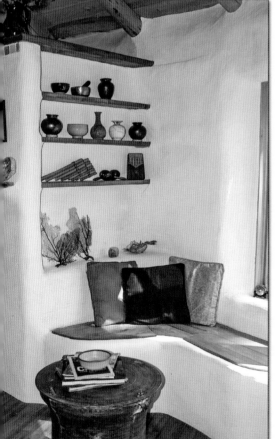

The spruce rafters (or roof poles) were harvested from the land and peeled by hand on-site.

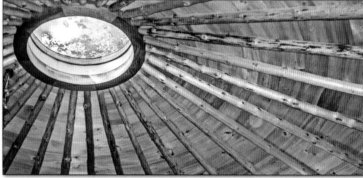

Someone would show up with a banjo or a guitar and entertain us for hours. Folks would bring food to share. We had a lot of fun.

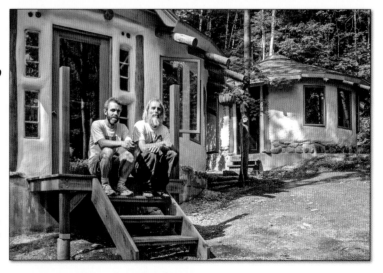

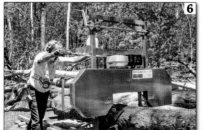

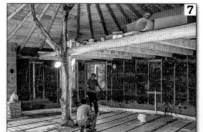

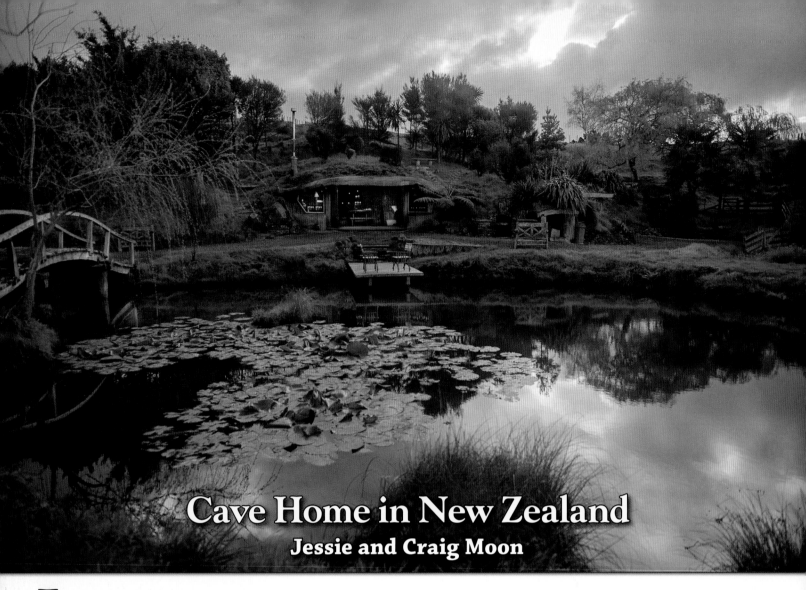

Cave Home in New Zealand
Jessie and Craig Moon

LEAVING HIS ENGLISH HOME AT THE AGE of 16 to travel the world, Graham Hannah had his heart set on settling down in rural New Zealand. As an intrepid traveler, he had passed through many countries, including Afghanistan, Iran, Istanbul, and Iraq, and had stayed with many locals in their homes, some built into the sides of hills in the desert.

In 1972, he purchased a beautiful, 15-acre homestead in the Waikato agricultural region of New Zealand. Soon after purchasing the property, he decided to create a secluded stream and pond area at the lower end of the property, with an underground retreat in the bank overlooking the pond and countryside.

He dug out an area of about 120 sq. ft. in the bank, leaving the space open to the sky. His aim was to create a cave-type dwelling that was stable, dry, and free of moisture seepage through the clay walls—and to use all natural materials in the process.

Using huge beams of local New Zealand timbers, he framed a structure within the "cave" and filled the entire area with tons of compacted sand, covering both the vertical and horizontal beams. He then laid large river stones from the local mountain stream on top of the sand. To create the roof of the cave, he mixed reinforced concrete, which was poured over the sand and river stones, with the concrete roof being embedded in the existing bank of solid clay walls.

Leaving his English home at the age of 16 to travel the world, Graham Hannah had his heart set on settling down in rural New Zealand.

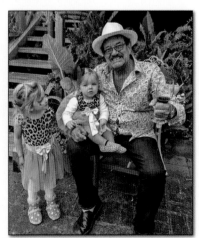

Creator of the cave house, Graham Hannah with his granddaughters Piper and Frankie

Once the concrete set up, the sand was dug out, leaving the vertical and horizontal beams and the exposed river stones locked into the concrete roof structure.

Drainage paths were formed around the perimeter so no moisture would enter the living space. The clay walls were sealed and plastered to create the effect of a traditional cave.

Windows and doors look out over the pond and rural vista and were crafted by local artists, using hundred-year-old timbers; the windows and doors follow the contours of the cave's structure.

The interior of the cave feels like stepping back in time 150 years. Cooking and hot water are provided by a coal range built in 1890, with hot and cold water running through brass and copper piping. Oil lighting and candles provide a wonderful ambient glow whilst a luxurious double bed with woolen duvet, and possum-fur–covered cushions is molded into the bank of the cave.

In a smaller cave is the bathroom, with a composting toilet and underground shower area. Outside, there is a turn-of-the-century, cast iron, claw-foot bathtub overlooking the countryside.

In 2012, Graham's daughter Jessie and her husband Craig purchased the property and decided to offer guests the opportunity of spending time in this unique environment, which is now referred to as Underhill. The secret location in the heart of the Waikato countryside attracts guests from all over the world.

Floor Area: 260 sq. ft. / 24 m²

 www.canopycamping.co.nz/underhill

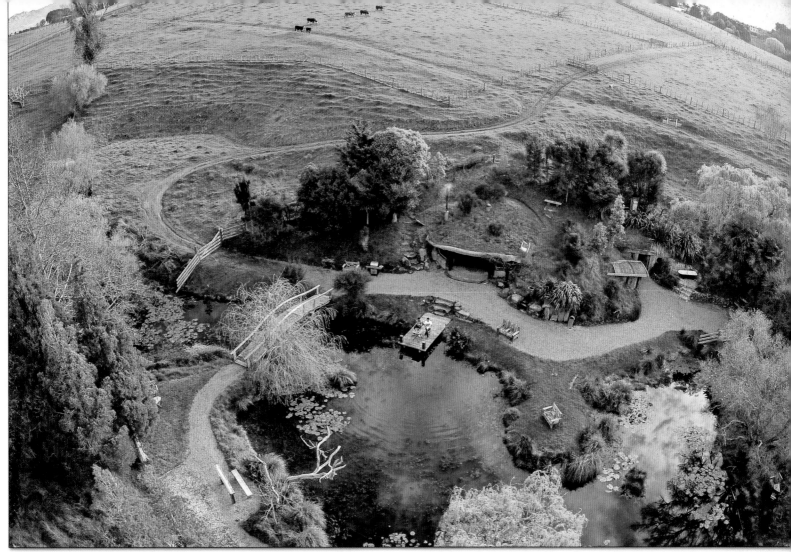

Aerial shot of Underhill Valley. Photo: Colin Ennor and Sergio Lopez

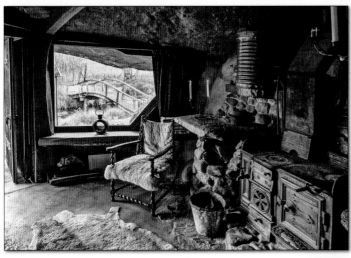

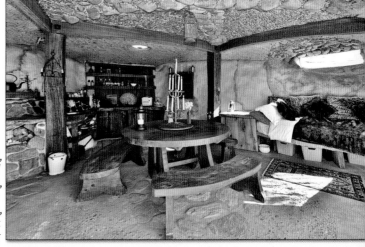

Note bed, handcrafted table, wooden beams, rock work on ceiling

The interior of the cave feels like stepping back in time 150 years.

View of pond from shower

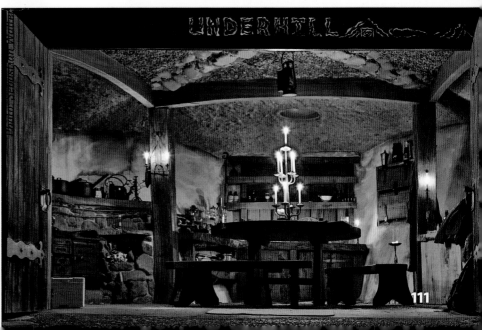

Earthbag Home in Turkey

Digging Myself Out of the Daily Grind

Atulya K. Bingham

I ALWAYS WANTED TO WRITE, AND LIKE MANY WRITERS, I had to fit this passion in between sessions of paid work. One day I had enough of compromising. Fortunately, I owned a small square of land in Turkey.

I moved there with a tent and not much else. It was the beginning of an adventure that changed every preconceived idea I had about what actually would make me happy.

I found that I loved the outdoors so much that I'd live in a tent forever. The weather, however, changed my mind. Six months later, a storm almost pulled me from my slope. I realized I needed a house.

With only $6,000 left and winter a month away, I gathered a team and embarked on the construction of a small earthbag home. I had zero building experience at the time.

Building my house was probably the most transformative thing I've ever taken on (and I'm no stranger to adventure).

I ran out of money, made a heap of mistakes, and was continually hounded by naysayers.

But today I'm sitting inside this beautiful, handcrafted home. Not one bit of cement was used and it is 100% solar-powered.

My earthbag house has enabled me to leave behind the drudge of a job my heart wasn't in and spend my days creating and writing instead.

It has survived three earthquakes and severe flooding, and I love it.

Floor Area: 330 sq. ft. / 31 m²

Full story of my earthbag adventures (a book) and a free earthbag building PDF:

 www.themudhome.com

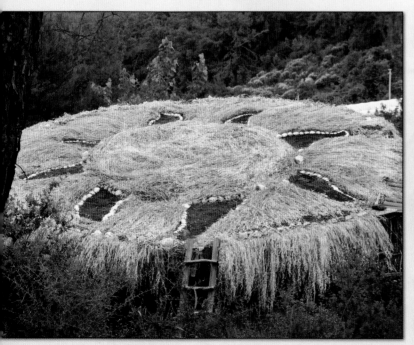

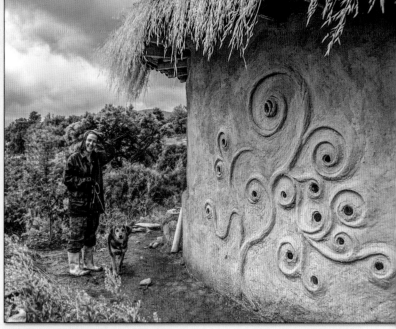

"One day I had enough of compromising."

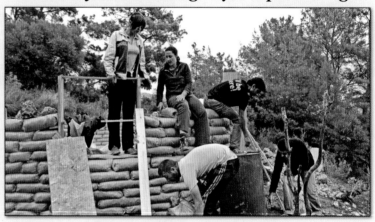

"Fortunately, I owned a small square of land in Turkey."

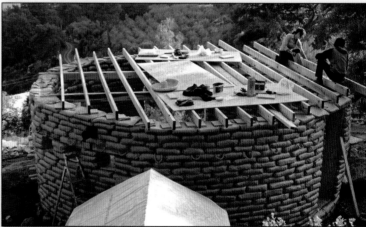

"I moved there with a tent and not much else."

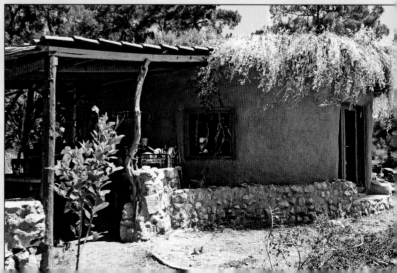

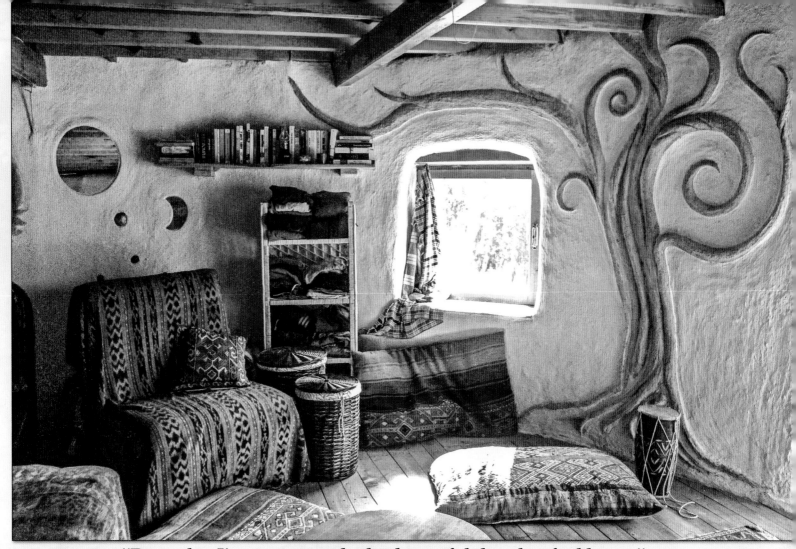

"But today I'm sitting inside this beautiful, handcrafted home."

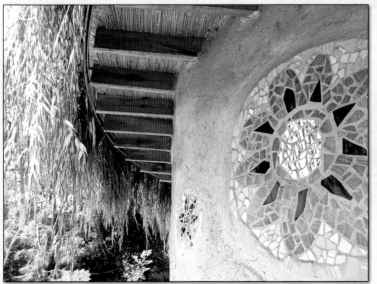 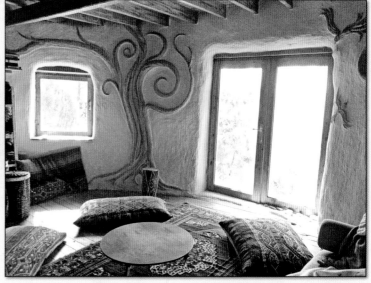

"It has survived three earthquakes and severe flooding, and I love it."

Solar-Powered Quonset Hut Home in Northern California

Elaine Doss

"The previous owners of my parcel had acquired the disassembled Quonset hut as free surplus from the navy."

One day, Elaine, who is in my yoga class, told me about her Quonset hut, and that Val Agnoli had designed the remodel of it into a home. Val was one of the three featured builders in Shelter; *he's a rare combination of visionary architect and master builder: Unlike most architects, he can build whatever he designs. (Below is a detail from his home on a California hillside.) So I was intrigued to see what he had done with a Quonset hut. Beautifully, it turns out.*

–LK

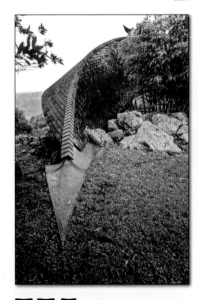

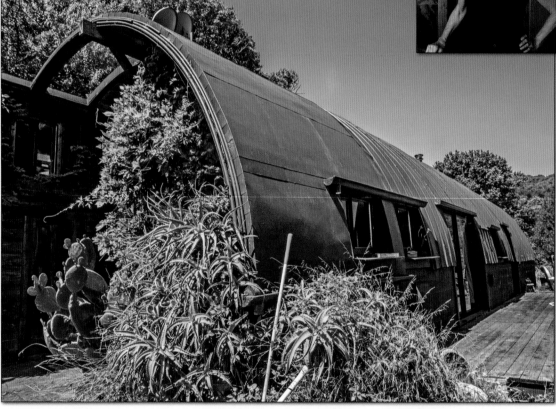

WHILE LIVING IN Stinson Beach, California, in 1977 with two horses in my backyard, I went looking for more acreage in West Marin. I located and purchased a 150-acre, fenced parcel in Nicasio and moved my horses there. On one of my daily trips between Stinson and Nicasio to tend to them, I ran into my Stinson neighbor and friend, architect Val Agnoli.

"What are you doing here?" asked Val.

"I just bought a parcel."

"Does it have any improvements?"

"Just an old Quonset hut."

"A Quonset hut? I've always wanted to remodel a Quonset hut."

And that's how I ended up living these last 37 years in a WWII U.S. Navy Quonset hut remodeled by Val Agnoli.

The previous owners of my parcel, a Catholic group, had acquired the disassembled Quonset hut as free surplus from the navy along with a cement mixer and Onan generator. They poured a concrete slab, built a four-foot-high concrete wall as base, and erected the Quonset hut atop the wall. For power they used the Onan housed in a concrete stall in a small, flat-roofed addition to the rear of the hut.

We converted the generator stall in that rear addition into a shower in what is now the master bathroom, which includes a Victorian acrylic slipper tub, sink, and flush toilet. For aesthetic value, at the front of the hut, the roof of both the 8-foot addition and the additional 8′ long by 5′ wide storage room that creates a pleasant, sheltered entrance, and mimics the Quonset curve, using bent plywood.

When each of my sons was young, his bedroom was what is now Closet 2. Next, I moved each in turn into the storage room, which we converted into a bedroom, with a loft bed extending above the front bathroom.

My husband, Sandy Doss, and I continue to live off the grid using a photovoltaic system with backup gas generator. Water comes from a well with a solar pump, and is then gravity-fed to the house; livestock water is from springs. We have a bedroom wood-burning stove, living room propane fireplace, and propane wall heater in the study. TV and Internet services are via satellite.

My father, who was a master craftsman cabinetmaker, trained in Torino, Italy, by his father, crafted (for his NYC apartment home) the hand-carved Italian provincial furniture that now graces my Quonset home.

Floor Area: 1200 sq. ft. / 111 m²

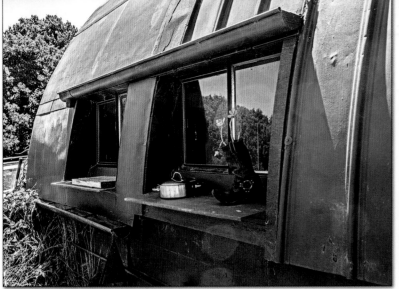

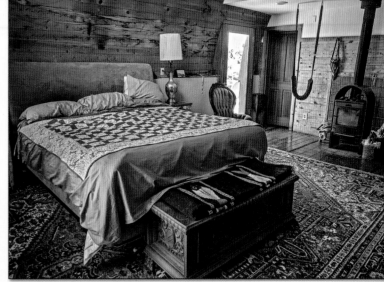

"We continue to live off the grid using a photovoltaic system with backup gas generator."

"I've always wanted to remodel a Quonset hut."

"TV and Internet services are via satellite."

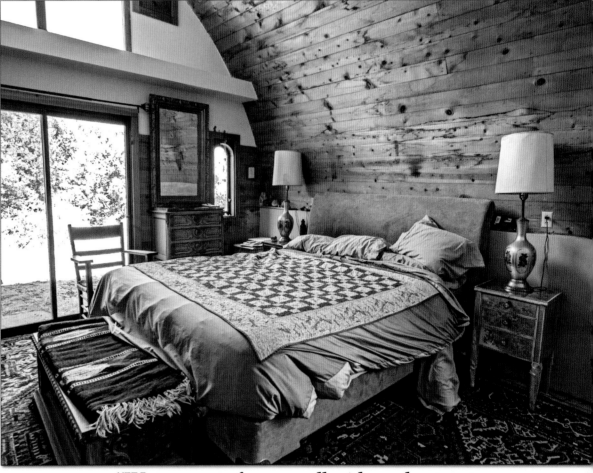

"Water comes from a well with a solar pump, and is then gravity-fed to the house."

Homestead of Recycled Materials in Quebec
Sophie Belisle and Marc Boutin

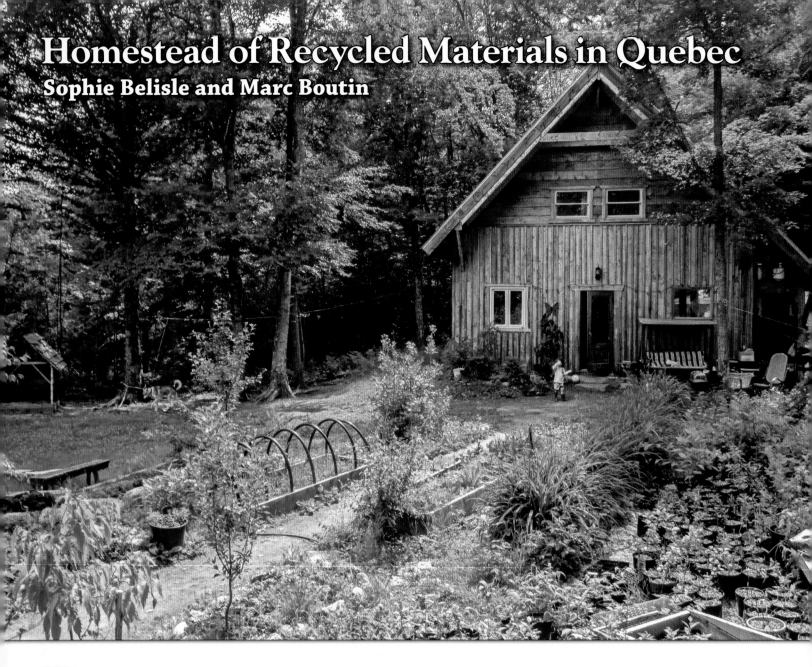

DEAR LLOYD & SMALL HOME LOVERS, Marc and I met in 2006. Our immediate goal as a couple was to build our own home. We believe in scavenging and recycling, so we decided to build with as much free stuff as possible.

We began our search for the perfect piece of land as well as drawing up the plans of the new home.

In the fall of 2008, we came across an opportunity to pick up pine trees that were locally cut. We adapted our plans to the amount of wood available. We hired a local sawmill owner to cut the timbers for us.

That winter we rented a shop and prebuilt a 24′ × 30′ timber frame of 9″ × 9″ pine. The joinery is mortise-and-tenon, sculpted with mallet and chisels.

During winter 2009, a client offered to tear down a house for salvaging materials. *Merci la vie!* We continued our search for land, which paid off in the spring of 2009 when we acquired 5½ acres in Val-Morin, Quebec.

The house is raised on a concrete slab. Hemp oil is used as a preservative for the wood inside and outside the house. There is a minimum of electrical light and heating

required because the main fenestration is south-facing.

We believe the 1200-square-foot home is suitable for six people. Seventy-five percent of the building materials are recycled.

We use a surface well and a traditional system for greywater. Our piece of land has three cascading streams, an island of an acre with a wooden platform and a tipi, a wetland, and mature forest.

Our home building and landscaping are guided by Permaculture principles. We have implemented an edible forest garden of 150 fruit and nut trees, vines, shrubs, and small berries, as well as our vegetable garden. Our philosophy is to aim towards food security for the family and slowly educate our neighbors to plant shared orchards on public land.

I am a birth doula, a death midwife, and firefighter.

Marc works in landscaping, gardening, dangerous tree removal, and traditional construction of log and timber frame.

We currently live in our home with four children: Sonam, 15; River, 7; Dylan, 6; and India Rose, 4; as well as Boots, the cat and Balto, the husky.

Floor Area: 1200 sq. ft. / 111 m²

 lavieenvertdesign.blogspot.ca

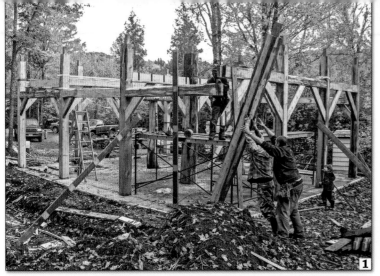

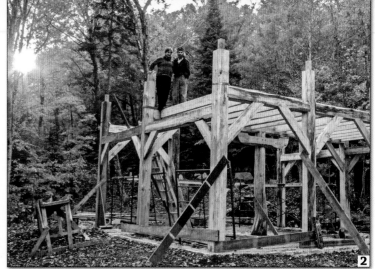

The joinery is mortise-and-tenon, sculpted with mallet and chisels.

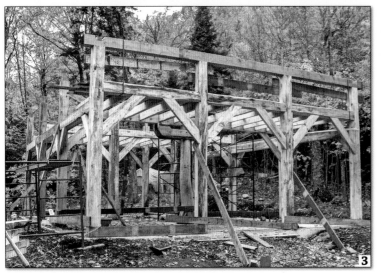

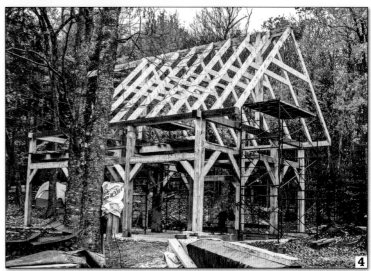

SPECS

Bedrooms: 3

Bathroom: 1

Foundation: Concrete slab

Construction: Mortise-and-tenon timber frame with 2″×6″ studs and afters

Siding: Exterior walls, tamarack board and batten, 50% recycled; gable ends, recycled western red cedar; trim: black recycled cherry, milled locally

Roof: Cathedral collar tie roof system is 3″×8″ spruce.

Insulation: R30 Airmetic soy spray foam

Sheathing: V-joint pine inside and galvanized tin outside

Heat: Electrical. Convectair convection heaters are 60% recycled; woodstove is slow-burning and meets environmental codes.

Electrical Service: Electrical panel recycled. Electrical and Internet wires buried to eliminate visual pollution

Windows: 60% recycled

Stairs: Local wood

Floors: Recycled pine, oak, spruce, maple, red pine

Kitchen: recycled sink; cupboards: recycled pine milled locally, mahogany palettes, tamarack, and recycled cherry, milled locally

Bathroom: Toilet, sink, hot water tank, water reservoir, bath, and plumbing fixtures all recycled

Bedrooms: Walls in the lofts are 100% recycled pine.

Finishing: Living room: barn siding; dining room and kitchen: recycled v-joint pine; entrance: 14″ white pine salvaged from tree work, cut and milled locally; short walls inside loft area: recycled red cedar shingles; moldings: butternut and cedar bought and milled locally

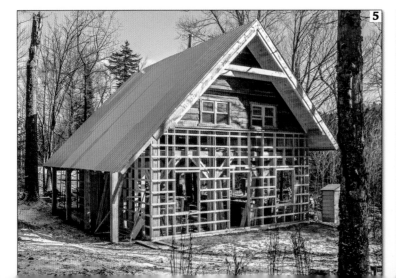

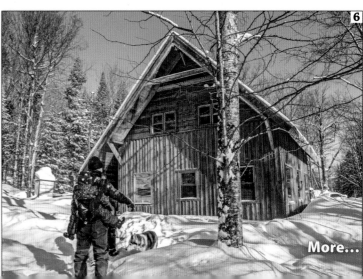

More...

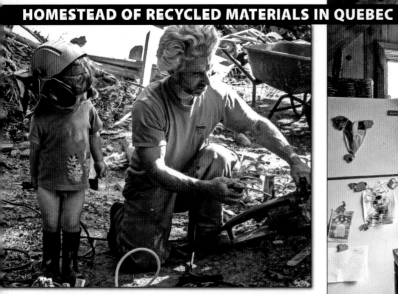

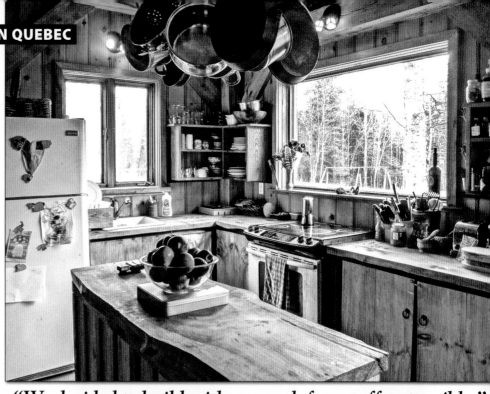

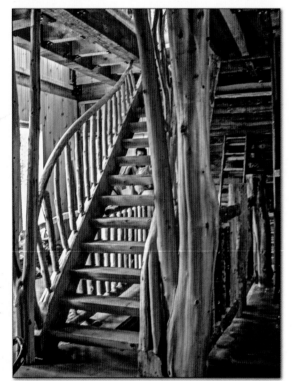

"We decided to build with as much free stuff as possible."

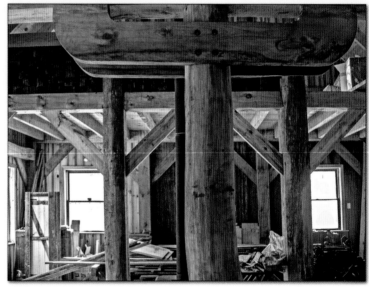

"A minimum of electrical light and heating is required because the main fenestration is south-facing."

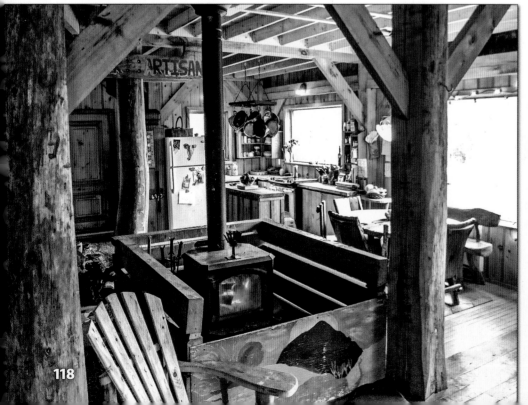

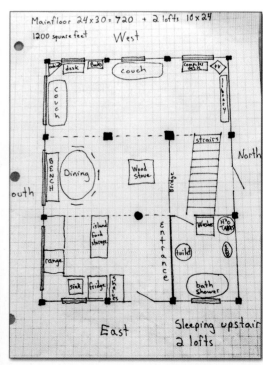

Mainfloor 24x30 = 720 + 2 lofts 10x24
1200 square feet West

South

North

Sleeping upstair 2 lofts

East

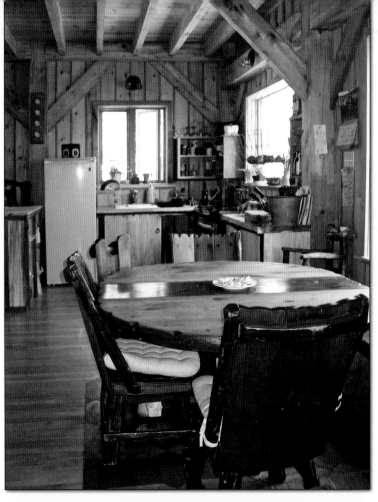

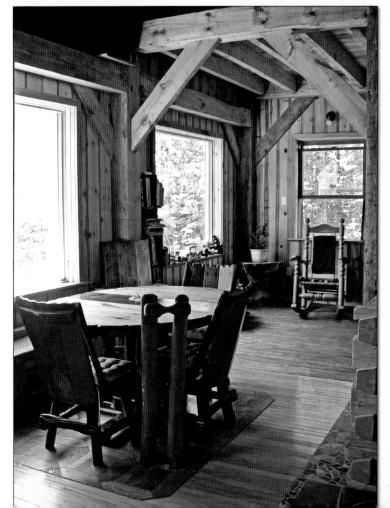

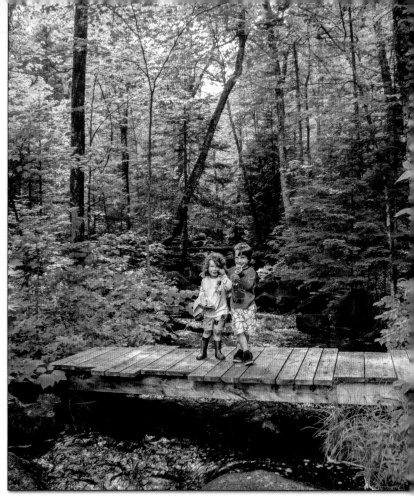

"We have 150 fruit and nut trees, vines, shrubs, and small berries, as well as our vegetable garden."

"We currently live in our home with four children."

Karl's Round House on a Scottish Island

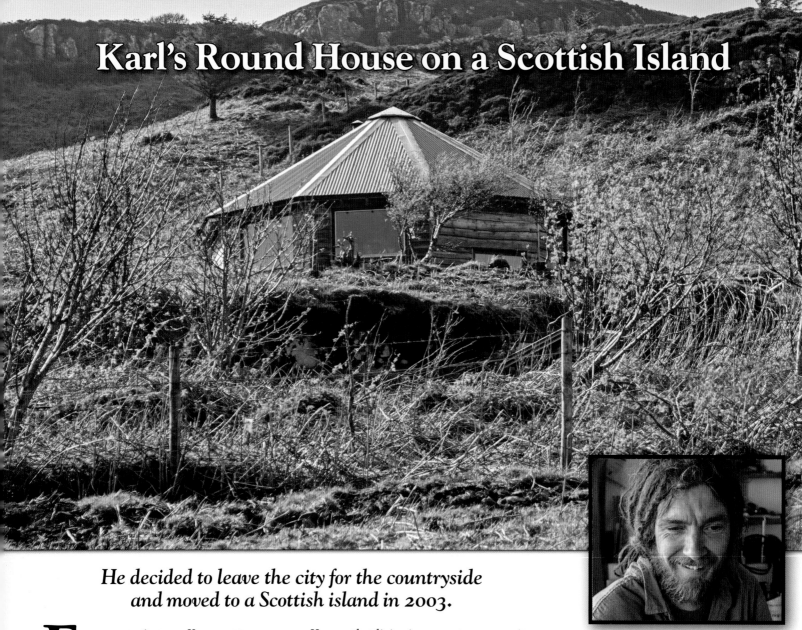

He decided to leave the city for the countryside and moved to a Scottish island in 2003.

Karl Harding

Insulation is sheep's wool fleece.

FROM AGES 16 TO 24, KARL WAS A welder working in a body shop in Manchester, England. He decided to leave the city for the countryside and moved to a Scottish island in 2003, when he was 27.

He started working as a builder; he says his welding experience was a good base — it taught him how to put things together.

"I learned how to be practical."

He worked on four houses before starting to build his own. He chose the round shape because of its structural strength in the fierce winds that blow on his side of the small island. He says he also liked the challenge of building in the round.

All the wood — spruce and larch — came from the island and was milled in the island's community shop with a Swedish Logosol mill, run by a Stihl 066 chainsaw. The exterior shiplap siding is larch.

Windowsills and shelving were made using offcuts from the main structural posts. The flooring is reclaimed from the community hall and a house renovation. Reclaimed slate is used in the kitchen. Insulation is sheep's wool fleece.

"Having little money makes you use what you can."

Heat, as well as hot water, is provided by a Goodwood stove from England, with a self-made flue. The base of the stove is from an old stone house.

He says that living in a remote community makes you be practical — and local. Equipment like, say, a crane, is not accessible, and it's expensive to import materials.

"It's still unfinished," says Karl.

Floor Area: 581 sq.ft. / 54 m²

It's a ten-sided roundhouse with a central post supporting the rafters. On top of the post is a salvaged 4-foot circular saw blade; he cut a hole in the center of the blade to fit around the post. The ten rafters, spruce poles (9″ diameter at one end and 6″ at the other), are mortised 50mm (2″) into the post and bolted through on top to the saw blade. (It's a form of yurt construction.)

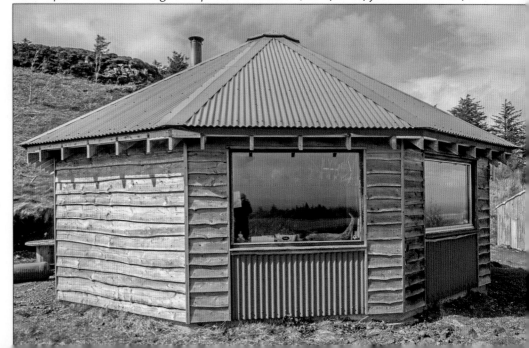

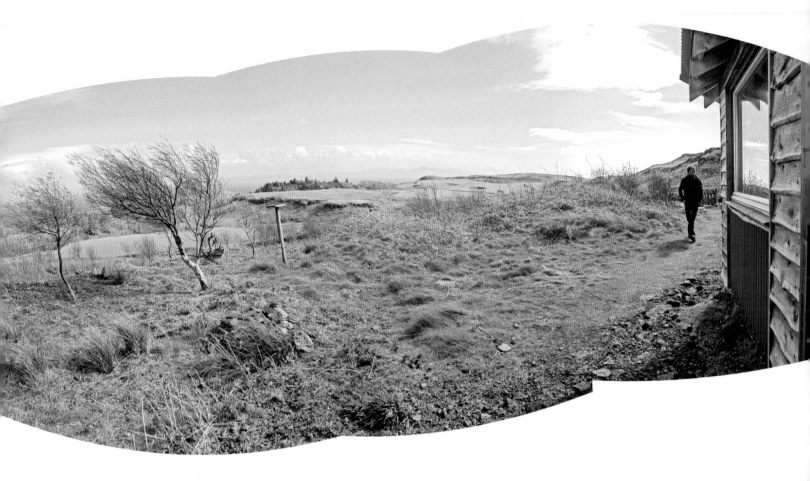

His welding experience taught him how to put things together.

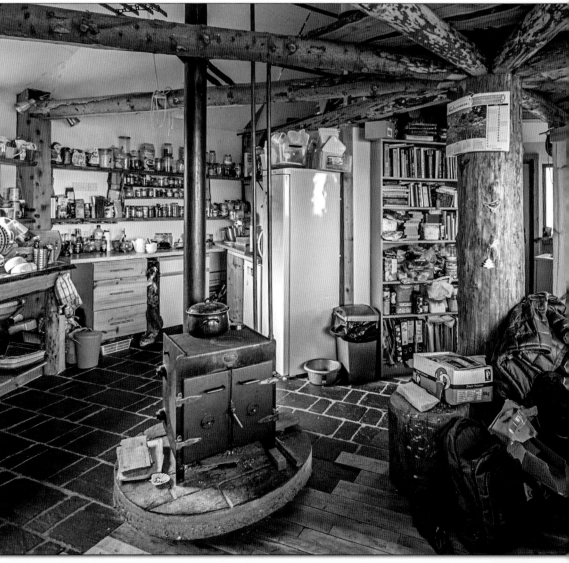

More...

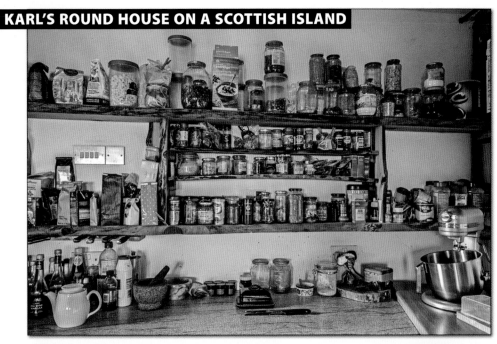

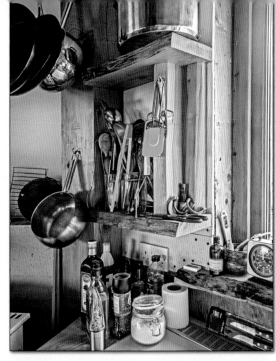

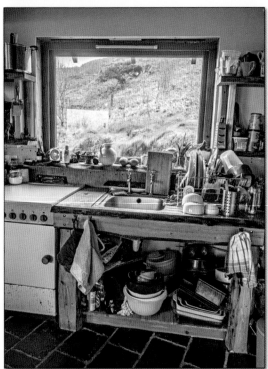

*All the wood—spruce and larch
—came from the island.*

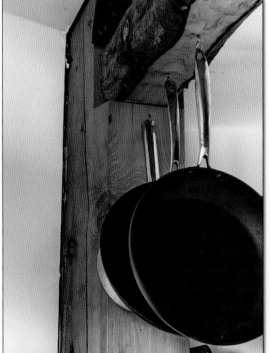

Workshop built with driftwood lumber.

> **"Having little money makes you use what you can."**

Karl's latest building, under construction, with a curved roof. "Simpler than a circle," he says.

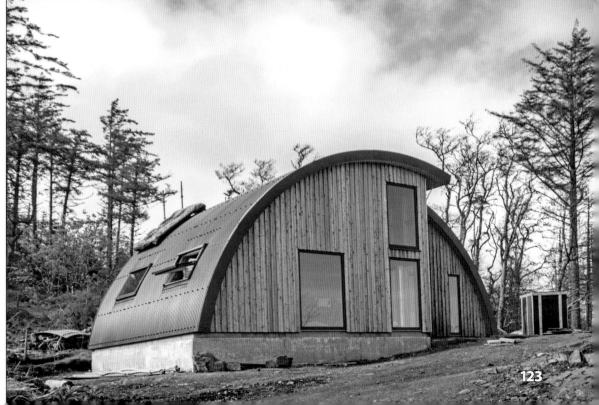

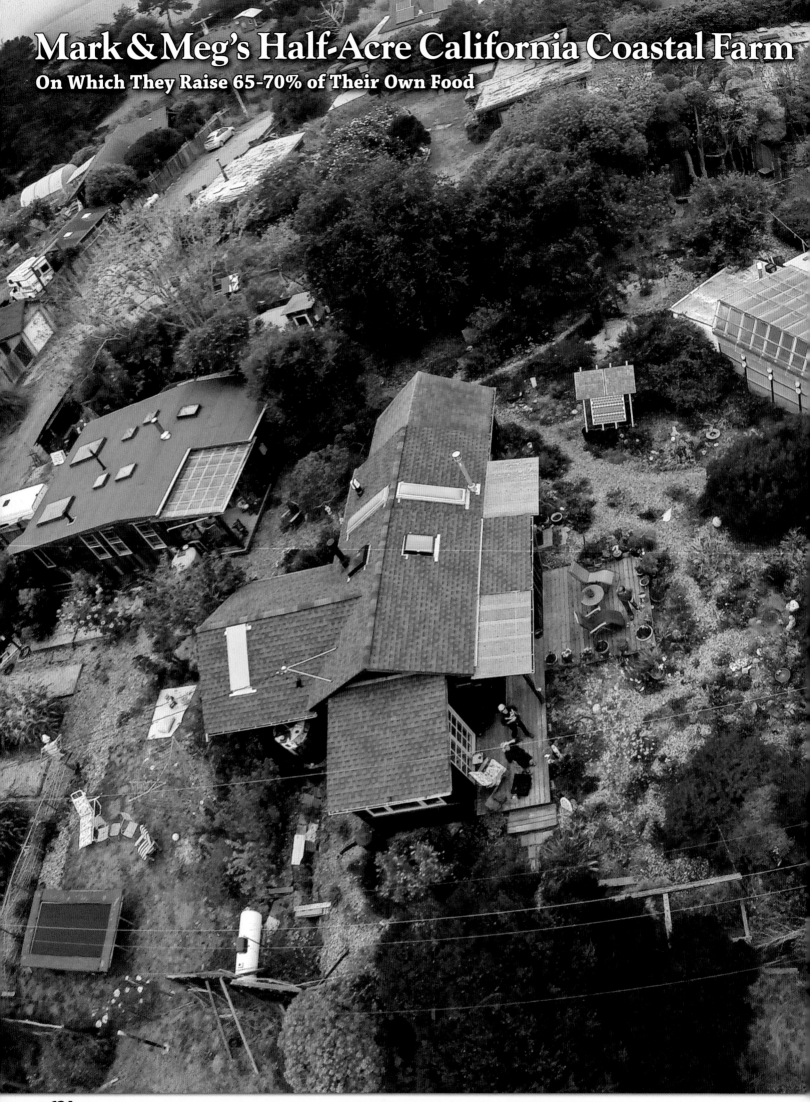

Mark & Meg's Half-Acre California Coastal Farm
On Which They Raise 65-70% of Their Own Food

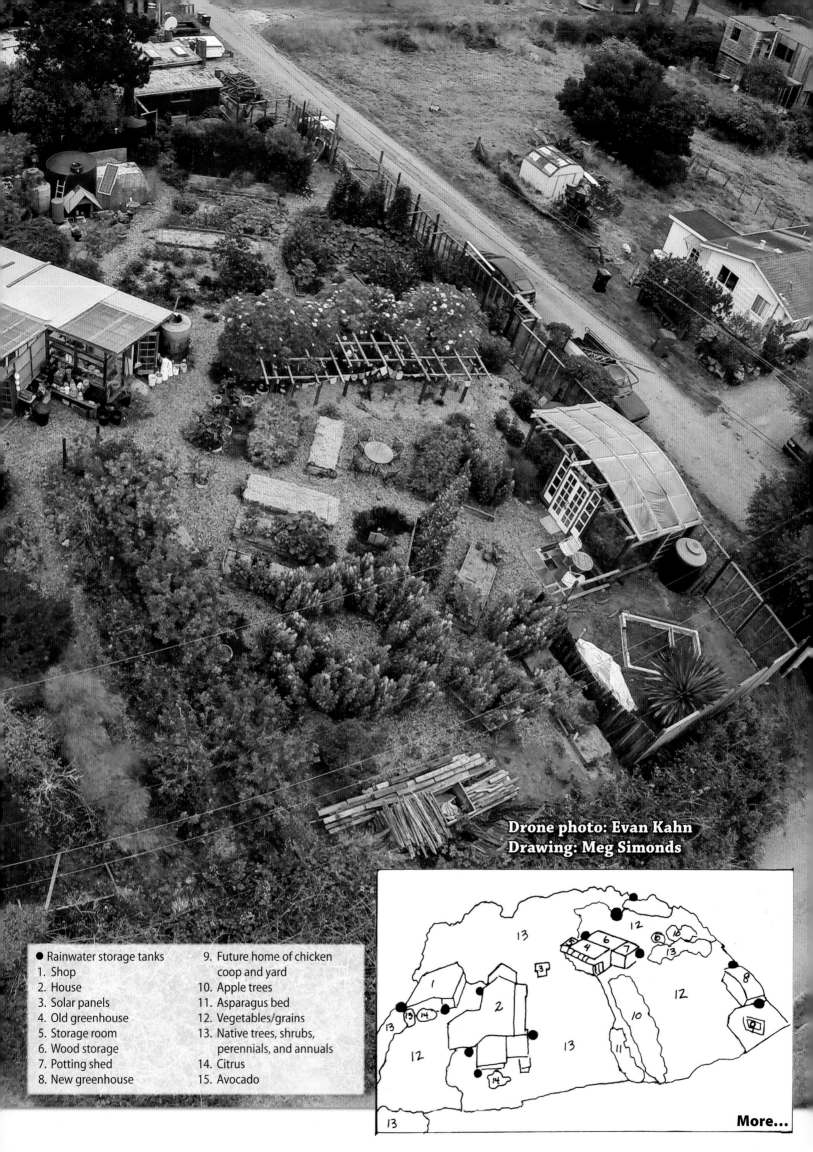

Drone photo: Evan Kahn
Drawing: Meg Simonds

● Rainwater storage tanks
1. Shop
2. House
3. Solar panels
4. Old greenhouse
5. Storage room
6. Wood storage
7. Potting shed
8. New greenhouse
9. Future home of chicken coop and yard
10. Apple trees
11. Asparagus bed
12. Vegetables/grains
13. Native trees, shrubs, perennials, and annuals
14. Citrus
15. Avocado

More...

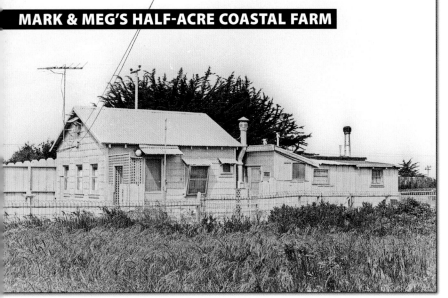

Mark and Meg walk the walk. In their small town they are well known for their planet-conscious ideology, as well as commensurate actions. Meg rides a bike (with big baskets) to go shopping. Mark scrounges wood and corrugated metal panels for their home and garden. They are both active in helping out kids in town. And over the years, they've rebuilt an old cottage and created a mini-farm that supplies over 60% of all their food. (It's pretty much a full-time job.)

Watching them made me think that retired people, even in cities, could be doing something similar — if not in magnitude, in spirit.

In the early '70s, before Mark and Meg got the property, I shot this photo. It was called the silver house back then, and was, shall we say, eccentric. It was completely covered with shiny aluminum paint: sides, roof, window trim, fence, and the rock landscaping in the front yard.

You can see it three decades later in the photo below, rebuilt, remodeled, and added on to. What a transformation!

–LK

Mark Butler and Meg Simonds

"The home you see here was built over a 25-year period."

W E LIVE IN A SMALL coastal village in northern California. In 1985 we bought a half-acre lot with a small, 400-square-foot cabin on it. Originally, and somewhat infamously, known as the "silver house." The whole place, inside and out, was silver.

The previous owners had remodeled when we bought it. It was shingled and cute. It was perfect! There were some outbuildings and six espaliered apple trees. This is what we started with.

At the time we were social and environmental activists. We had very strong feelings about what kind of world we wanted to live in. We realized that with this half-acre we could manifest our beliefs: Build a home from recycled materials, grow our own food organically, landscape with native plants, and use water as efficiently and respectfully as possible. These were our goals.

The home you see here was built over a 25-year period. Everything eventually came down and over the years we rebuilt, using redwood, fir, and pine — our native woods. Building with recycled wood is a slow and arduous affair, from finding it to pulling the last nail. It is a lot of work and rarely is it delivered. The payoff is twofold. The quality of older wood generally surpasses that of new and its deep, rich beauty only comes with age. For us, more importantly, is getting to have a truly deep relationship with the wood.

Floor Area: 875 sq.ft. / 81 m²

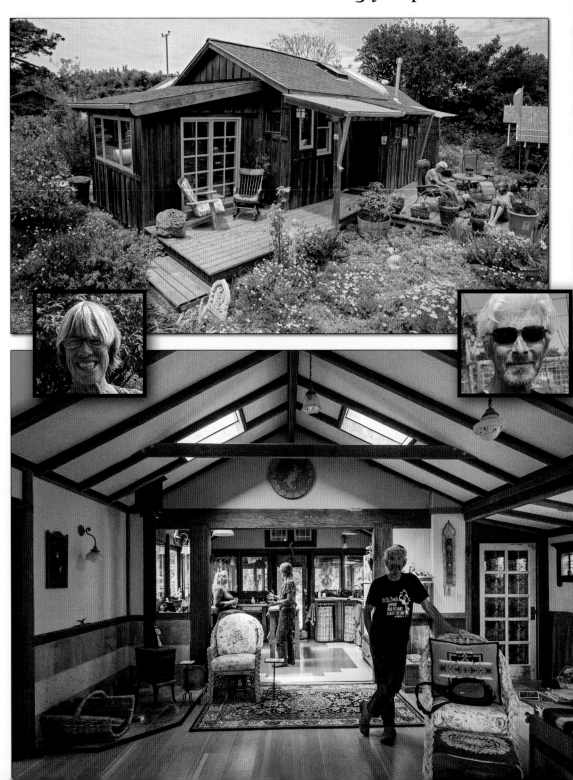

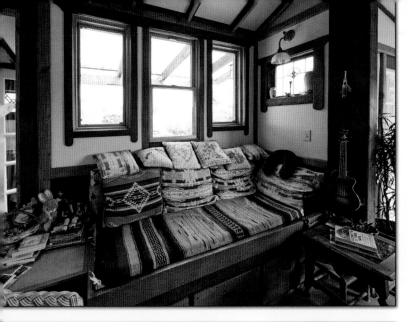

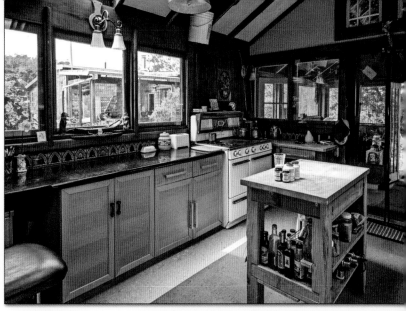

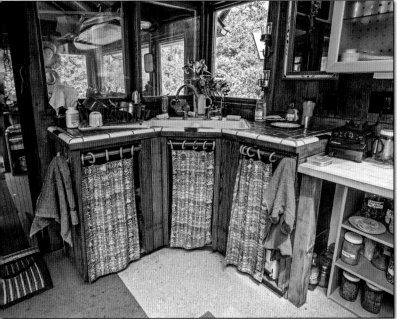

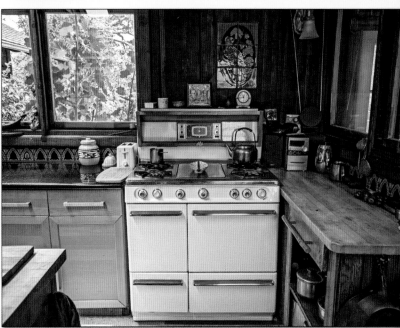

"We can tell you where almost all of our wood came from."

All this wood once had a home, an ancient forest, the lungs of the earth; little of this remains. The best we can do now is to have a deep respect for what was and what is. We approached building our home with this in mind.

We can tell you where almost all of our wood came from. The redwood post and beams that frame the rooms are from a 150-year-old barn in Fort Bragg, California. Our flooring was milled from the University of Southern Illinois gymnasium bleachers.

The beautiful redwood wainscoting was removed from the house of our friend and dharma mate after she died.

We could go on and on, but the important thing is to try to live one's life consciously and respectfully. Literally everything comes from Mother Earth.

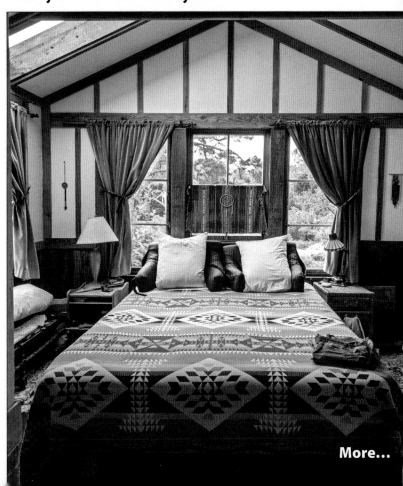

More...

"With this half-acre we could manifest our beliefs: Build a home from recycled materials, grow our own food organically, landscape with native plants."

We started growing our garden after the first year and never looked back. It has steadily grown a little each year for 29 years. Now it comprises about ¼ acre. There are also 20 fruit trees, and we have chickens for eggs.

Approximately 65–70% of what we eat, we grow. If necessary, it could be 100%. Our temperate climate allows us to grow year-round. We always have dry stores of grains, beans, and seeds, plus onions, shallots, garlic, and winter squash. We also freeze, dry, pickle, and can some foods. This feeds four adults, one child, and occasionally friends and neighbors.

There is limited water where we live

and owing to the size of our garden we decided to use rain catchment. Our holding capacity is 16,000 gallons, held in tanks from 350 to 3,000 gallons in size. With a solar pumping system we are able to use drip irrigation throughout the garden.

The landscaping is primarily native, mostly requiring no additional water beyond the winter storms. Greywater goes to some of the landscaping and the fruit trees.

The majority of the house runs on our small (350-watt) 20-year-old solar system.

Our goal remains to keep our footprint as small as possible.

"The majority of the house runs on our small (350-watt) 20-year-old solar system."

"Approximately 65–70% of what we eat, we grow."

Slow Boat Farm on Washington Island

Ginni Callahan

"THE BANK DOESN'T KNOW WHAT you can do with a piece of land, and we do," Dad declared when he and Mom loaned me the money to buy an abandoned 21-acre farm that once was a 10-cow dairy.

I was working as a sea kayak guide and living in a '71 Winnebago on a friend's farm, trading work for rent when they encouraged me to look at property. The bank laughed at my loan request.

It's a love story, really. Of family and belief. Of travel and roots. Land and water.

That was Puget Island, Washington, in the Columbia River, 2005. I named it Slow Boat Farm and entertained dreams of market gardens, education, camping, and kayak trips launching from the forested waterfront. "Deepening the human connection to the environment through recreation and sustenance," became the motto.

The Lower Columbia Kayak Roundup (LoCo) ran from 2006 to 2011. It brought world-class kayak coaches from as far as the UK, and students from North America, Chile, Australia, and Denmark. They ate from the garden, watered the plants by showering, and enjoyed local musicians in the evenings. They contributed nutrients for future trees through the composting toilets. Compost advocate Larry Warnberg held a toilet workshop on SBF to teach and to construct 10 bucket-based composting toilets for use at LoCo.

In 2009 I met Henrick Lindström and his sailboat Misty in Mexico, where I guided kayak trips in the winter, and life took another dimension. If I brought homegrown food and community to the relationship, Henrick brought South Seas adventure and travel. We crossed the Pacific in 2012, a story included in

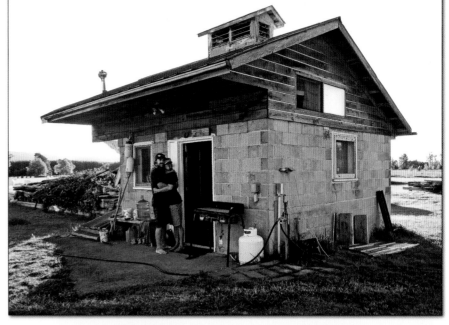

Above and at right: The Milkroom — our house

"The kitchen is where food and conversation bring us all together."

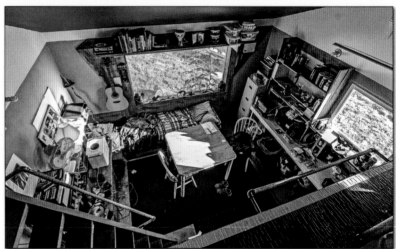

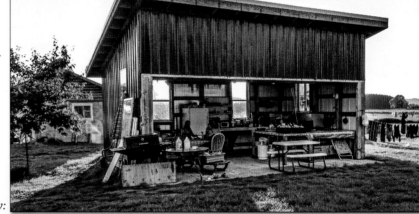

At right and below: Outdoor kitchen

Bonfire for campers

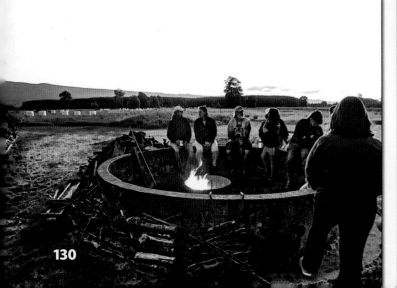

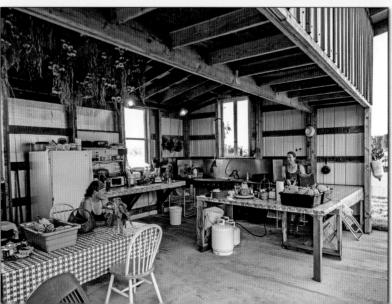

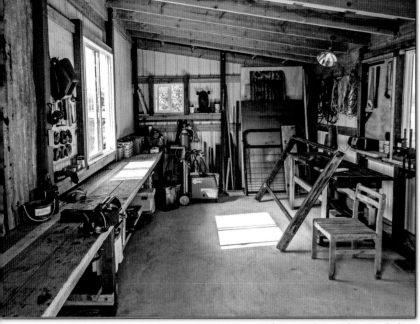

Above and at right: Workshop

Tiny Homes on the Move. Long distance though it sometimes has been, the relationship brings balance and great satisfaction to two independent people.

Beyond just the two of us, Kyleen Austin joined the Slow Boat Farm family in 2013. She tends the farm in the winter, starts the garden in spring, manages the rental of the 3-bedroom farmhouse on the property that is too big for any of us to want to live in (or afford), and connects us more deeply to the social fabric of the community. She has started two local creameries, performed her music at the local brewery, performs and manages the music stage at the Puget Island Farm Market, guides kayak trips with Columbia River Kayaking, and helps out just about every market farmer on the island in some way.

Below and at right: Interior of Milkroom

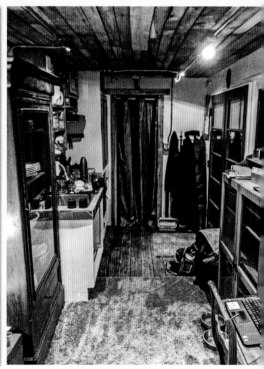

With Henrick's welding help, she is remaking a 40-foot shipping container into a home on Slow Boat Farm. Other buildings on the property include the Milkroom, a 280-square-foot concrete room formerly used for processing milk where Henrick and I live; the Coop, a former chicken coop converted into an office; Henrick's new workshop; and the open lean-to kitchen, built with reclaimed materials by LoCo volunteers who traded labor for kayak coaching. The kitchen is where food and conversation bring us all together.

Camping is available on Slow Boat Farm by appointment.

> *"It's a love story, really. Of family and belief.
> Of travel and roots. Land and water."*

Floor Area:
Converted milk barn room: 308 sq. ft. / 29 m²
Kyleen's tiny home: 320 sq. ft. / 30 m²

www.ColumbiaRiverKayaking.com/sbfarm.html

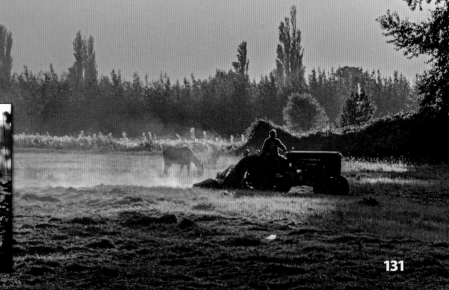

131

Small Home in California Foothills

Michael Easterling

I TOLD MY SISTER SHARON that when she retired from teaching I would build her a house here on our small farm in the foothills of the Sierras. The design went through many rough drafts before we arrived at one that met all our criteria.

The house had to be beautiful, a home that would be a joy to live in. It needed to be small, to fit her budget and to comply with our county building ordinance concerning secondary residences: no more than 1200 square feet. The design of the house had to compliment the main house, a two-story, farm-style dwelling. And the new house had to minimize any deleterious effects upon the environment, both in the building and in its continued use.

Taking in all these factors I drew up a blueprint for a house I would describe as simple cottage-style. The main section of the house is a square, 24′ × 24′, which contains the living room and dining room on the first floor, and the master bedroom and bath on the second. The upper floor is an extended attic, a 45-degree pitched roof with added space provided by two shed dormers.

On opposite sides of the main body of the house are two smaller wings, each 12′ × 12′. One serves as a guest bedroom, the other the kitchen. The ceilings, pitched to match the upper story, provide a feeling of spaciousness. A covered porch wraps around from one wing to other.

Our building department does not count porches in the space requirements, which is fortunate, since the porch makes the house seem larger than it is, helps to unite interior and exterior spaces, and keeps the house cooler on summer days.

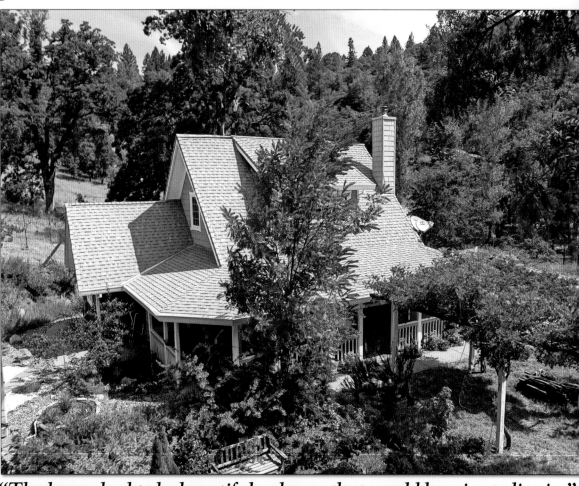

"The house had to be beautiful, a home that would be a joy to live in."

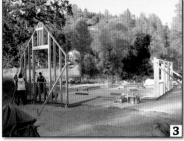

"To minimize energy requirements, the house was built upon an insulated concrete slab."

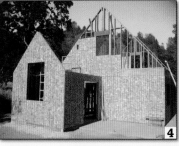
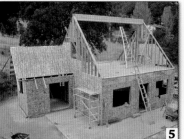
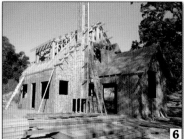

"As the building progressed, new ideas emerged."

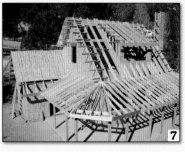

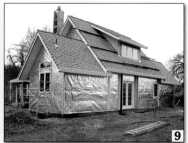

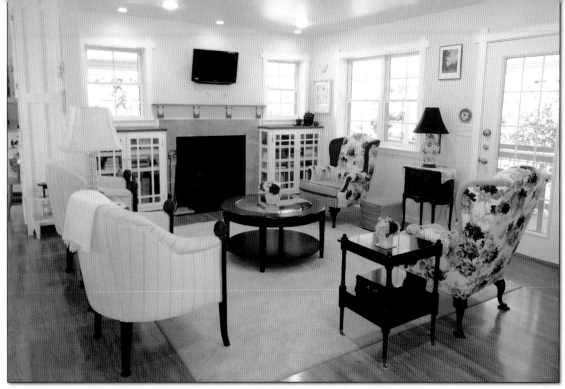

Details of the house changed, of course, as it was being built. I joked with Sharon that building her house was a joint project; she told me what she wanted and I did it.

But as the building progressed, new ideas emerged. Sharon purchased a Shoji pocket door for her bathroom. This led to me building Shoji doors for her clothes closet and folding Shoji screens to hide her washing machine. I also made stairwell lights that look like Japanese lanterns.

In contrast to the oriental style of the second floor, the first floor is decidedly "old English cottage," featuring lots of white wainscoting, cabinets with lattice doors, and the use of oak in the stairs, fireplace mantle and cabinet tops.

To minimize energy requirements, the house was built upon an insulated concrete slab. Before attaching the concrete-fiberboard siding, the walls and roof were wrapped in radiant barrier. The windows have gas-filled, double panes. The walls are insulated with R-19, formaldehyde-free batting; the rafters with R-30. As a result, the interior stays quite comfortable with just the aid of a window evaporative cooler in summer, or a small energy-efficient kerosene furnace in winter. There is a fireplace for those days, thankfully few, when the power goes out.

All lighting is either compact fluorescent or LED. A greywater system drains showers, laundry, and sinks, and provides water for a row of shade-providing cottonwood trees.

As it turned out, Sharon's house evolved into something better than we imagined. We started with certain criteria, but, as in many things, the sum turned out to be greater than the parts. I believe one of Sharon's visitors best summed it up when she said, "Your house is such a happy place!"

Floor Area: 1200 sq. ft. / 111 sq. m.

"Sharon's house evolved into something better than we imagined."

"Your house is such a happy place!"

133

River House

Alice Durrie

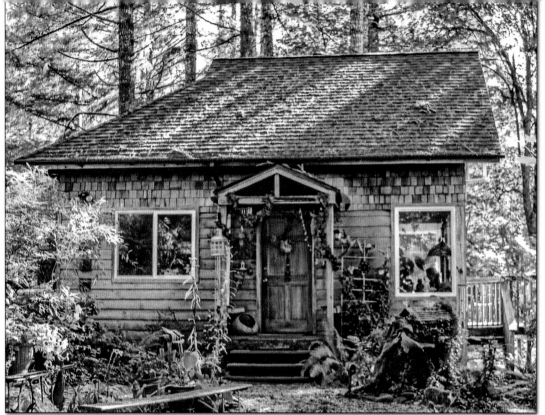

Photos by Teresa Smith

"I could picture a home on the upper slope, playtime in the meadow, and endless fascination with the beach and river."

TWENTY-TWO YEARS AGO, WHILE LOOKING FOR DEEP-WATER moorage, a realtor showed me waterfront property that turned out to be alongside the Tahuya River (in the state of Washington on the Kitsap Peninsula). It was too shallow for a boat, but was enormously appealing topographically.

I could picture a home on the upper slope, playtime in the meadow, and endless fascination with the beach and river. I bought it, contrary to all my other plans.

My brother and nephew, Michael and Nicholas Durrie, shared my enthusiasm, and while Nick designed the house, Michael and I worked on finances and permits. Less than a year later it became a reality. Home!!!

Nick incorporated our love of wood, light, and openness into a design that pleases everyone that enters. He incorporated some Feng Shui concepts that work well and put everyone at ease.

In the loft, spanning open spaces to below, are fine maple railings we made from young trees we had to remove when we cleared for the house. These open areas allow music, sight, and woodstove heat to circulate throughout the house.

With the bedroom on one side and an office on the other, there's a sense of privacy—yet only a few steps away, you can look over the railing to see what's cooking in the kitchen below, or wave at a friend at the front door.

There is just one interior door, the bathroom laundry. It opens to the woods—nice view from the tub.

The furnishings are small, compact, and carefully designed: They all open for storage. The tables open, the bench opens, and the butcher-block table is hung on brackets so that stools can slide under it to recapture floor space.

The floor is oak and the ceiling/upper floor is car decking. Mahogany rail caps are salvaged wood from the shipyard. The rafters are boxed in cedar and the entire exterior is covered with cedar shingles.

I am forever grateful to the friends and family that gave work, sweat, and vision to my sweet home.

Floor Area: 700 sq. ft. / 65 m²

"Nick incorporated our love of wood, light, and openness into a design."

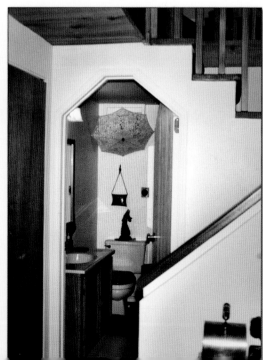

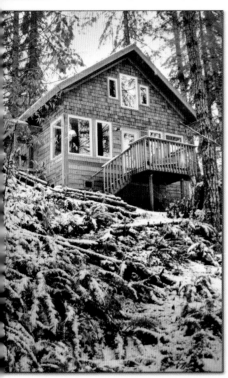
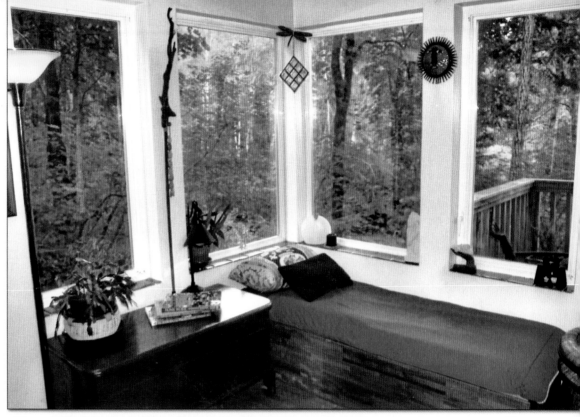

"He incorporated some Feng Shui concepts that work well and put everyone at ease."

3 photos above, left to right: Nicholas Durrie, as boy, man, and Nicholas and Alice this summer

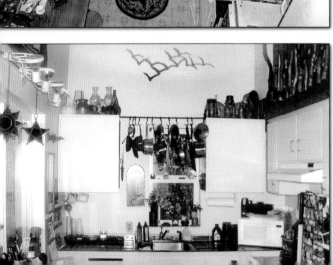

"These open areas allow music, sight, and woodstove heat to circulate throughout the house."

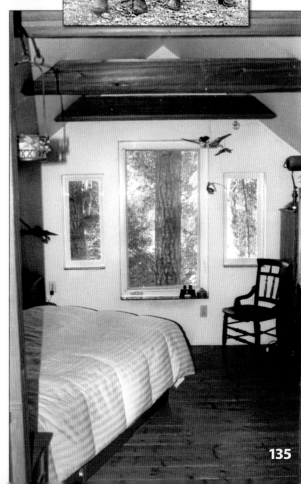

Debt-Free in Washington

Kirsten and Bryan Cook

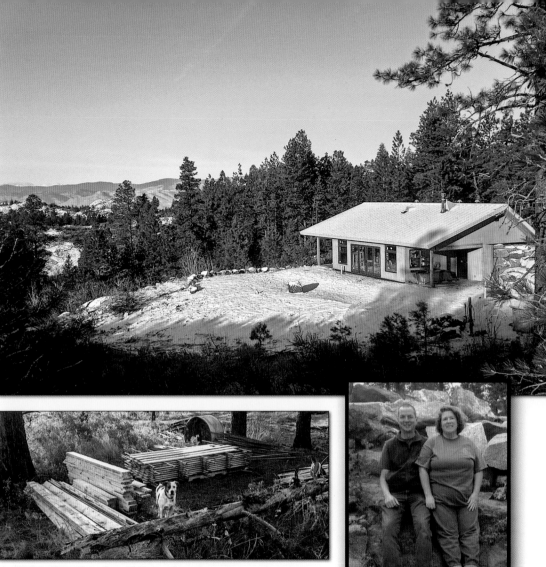

W E'RE A FORTY-SOMETHING couple, originally from Massachusetts, but drawn to the Pacific Northwest after a stint at Crater Lake National Park in Oregon.

We lived in Seattle for almost 20 years, always nurturing this idea of buying enough land so we could go hiking or snowshoeing from our front door and not run into anyone else. We looked all over Washington State, and fell in love with 42 acres in Okanogan County.

When the parcel next door came up for sale three years later, we managed to buy that, too; mostly to preserve it from development. My joke was that we needed a bumper sticker that said "going broke for conservation." We hope to put a conservation easement on most of the 85-acre property eventually.

After a year of living in a terrible rental house in town, we decided to move to the property full time so that we could make sure we designed a home that fit the landscape . . . and that we could handle the winter!

We lived in two tiny cabins for two years: one for sleeping, the other for cooking; about 300 square feet between the two of them. We used battery-powered lights and hauled water from the well into the kitchen cabin. Our outhouse was a really simple composting toilet kit from the Sunfrost folks in Arcata, California.

We had two main design goals for the house: that it be solar (both passive and active, since the property is off-grid), and "just big enough."

We worked with a local designer known for his passive solar portfolio; we did most of the room layout design while he made sure our mass-to-glass ratio and overhangs were correct and drew up the plans for the builder.

The house has one bedroom, one bathroom, with a pantry, an office nook, a mudroom, a power room for the PV system, and one big room for the kitchen-living-dining space. Our inside square footage is 924, plus another 175 square feet from two covered patios.

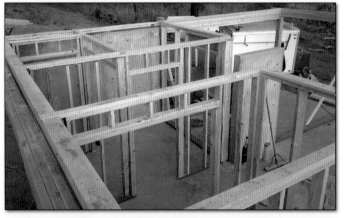

"We had a builder do the foundation and shell, and we finished the rest of the building ourselves."

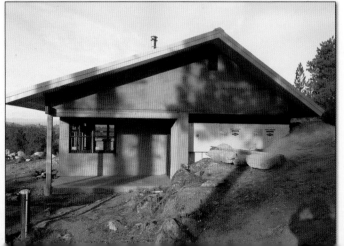

"We tried to use as much 'green' product as possible."

We had a builder do the foundation and shell, and we finished the rest of the building ourselves, hiring subcontractors for jobs we didn't feel qualified to do.

We tried to use as much "green" product as possible, which is not very easy in a rural area. We had to order online or pick up supplies in Seattle when we went back to see friends. We tried to do without a standard septic system, but that didn't fly with the building department. We did put in pipes for greywater diversion at a later date.

The other big factor was Firewise™ building.* We have done everything we can to harden the building against ember intrusion and other risk factors from wildfire. The house has a stucco exterior, metal roof, metal-enclosed eaves, and all the vents screened to resist embers.

*Firewise offers a list of materials and techniques to minimize risk of wildfires to homes:

 www.firewise.org

"We feel fortunate that both of us have jobs in our tiny town of 2,500 people, so we only have an 8-mile commute."

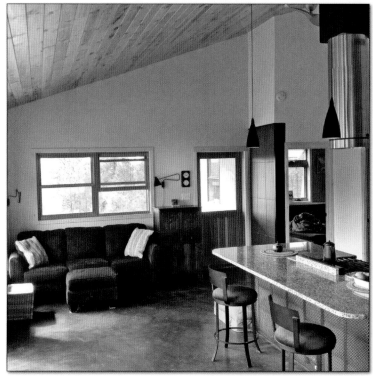
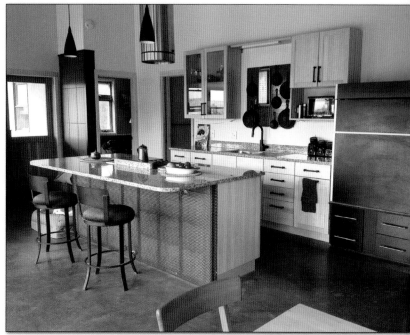

"We own our land and new house debt-free!"

The passive solar design, including partial earth-berming, is performing wonderfully. This winter, when it was 10° F and sunny out, the house was 75° F without any need for the propane heater. This summer, when it hit 102° F, the house never got hotter than 78. The house melds into the landscape so well that we feel very connected to the land — even when we are inside.

We feel fortunate that both of us have jobs in our tiny town of 2,500 people, so we only have an 8-mile commute.

When we bought a house in Seattle in 1999, we did so with the intention of using it one day to buy and build on rural land. We have to pinch ourselves sometimes to realize it worked out like we planned, and we own our land and new house debt-free!

Floor Area: 924 sq. ft. / 86 m²

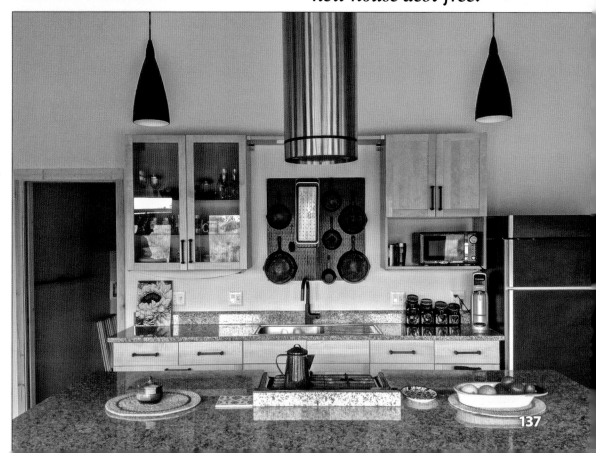

The Little Red-Haired Girl
in the Little Yellow House

Jes Leneé

"I dreamed of building a debt-free little cottage surrounded by gardens and fruit trees."

MY FRIENDS CALL ME THE "LITTLE red-haired girl in the little yellow house." It all started once I returned home to Tulsa, Oklahoma, from a long period of traveling adventures.

I had harvested lavender near the sea upon islands in British Columbia, drunk tea with prophets in Istanbul, taken clarinet lessons along the Seine in Paris, and hitch-hiked through the Amazon in Ecuador.

I adored travel, yet as a bird needs a nest, I needed a home base. To be specific, I dreamed of building a debt-free little cottage surrounded by gardens and fruit trees on a beautiful plot of land.

Being a 24-year-old traveling musician didn't make me rich, but after a year of saving, learning how to use tools (well, kind of), and searching, a beautiful half-acre lot seemed to find its way to me.

It was just outside the city and had potential. It had a magical, ancient oak tree, a cellar perfect for storing canned goods, sunny areas for gardening, and a shed that could easily be converted into a pottery studio and all for an extremely reasonable price. My dream was going to come true!

I began drawing up house plans for a 480-square-foot cottage with a 120-square-foot loft. I wanted the house to feel very open and spacious, so I designed 16-foot cathedral ceilings and 10 big windows. Over the next several months, I scoured garage sales, thrift stores, and friends' closets, collecting as many recycled building materials as I could find.

With the help of my 80-year-old grand-father, and a small crew of family and friends, my happy yellow cottage was built in six months.

As I write this article beneath the shade of the oak tree, I think about the past three years I have lived in this small house and how many additions I have acquired — vegetable, fruit, flower and herb gardens, three funny hens (Clover, Scarlet, and Rutabaga), a pond with a waterfall, a soccer-playing bird named Asparagus, and a partner that is as passionate about home-steading and traveling as I am.

No matter how small the space is, a lot of life can blossom and bloom. It certainly has for this little red-haired girl in a little yellow house.

Floor Area: 480 sq. ft. / 45 m²

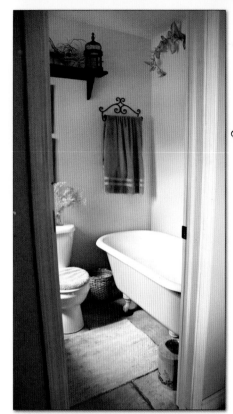

"With the help of my 80-year-old grandfather, and a small crew of family and friends, my happy yellow cottage was built in six months."

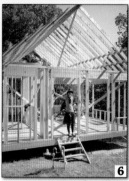

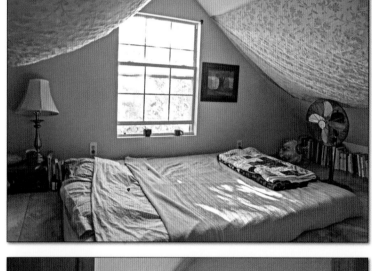

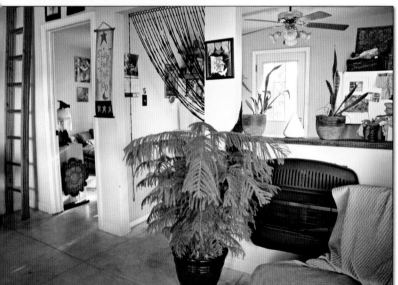

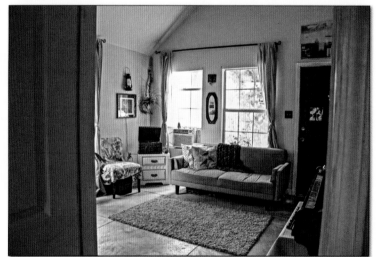

"No matter how small the space is, a lot of life can blossom and bloom."

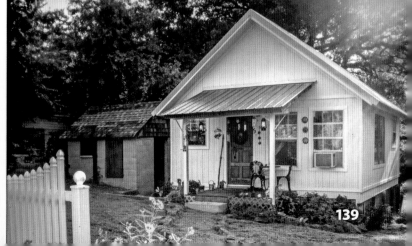

Small Home in Texas

Based on Shape of Local Barns

Tohner Jackson

MY FATHER AND I BUILT THIS SMALL home in the middle of a meadow surrounded by a small scattering of woods, not far from a creek.

The clients had it designed by a talented and thoughtful home designer. The clients wanted it to look like a typical barn found in our part of Texas (near Austin); they also wanted it to be an energy-efficient, custom home to serve their modern needs, while maximizing the small footprint.

The exterior design is as simple as can be: a straight gable with tall walls and a steeply pitched roof that makes for the best use of the small space. There is an attached porch on the back.

Downstairs consists of a bedroom, bathroom, kitchen, small dining area, and a living room, which feels spacious due to the tall ceilings. From the living room you step onto the back porch with views of the open meadow.

Upstairs is an open loft that serves as a den with an attached bathroom and a bedroom in which we built custom bunk beds that can comfortably sleep six kids. To access the loft, we built a ship's ladder, which turned out to be not only fun, but also a space-efficient way for the kids to get upstairs to their beds.

Instead of the space under the stairs being wasted, the kitchen cabinets were built to fill the entire space below them.

We built the doors out of fir on-site, which turned out to be a great way to customize and continue the bunkhouse vibe we were going for.

We used 1″× 6″ yellow pine tongue and groove for the floors, walls, and ceilings—no sheetrock.

My father and I, along with Artisan Builders, our company, primarily build high-end custom homes, and in our area of Texas, this means the bigger, the better.

As a second-generation homebuilder, this saddens me, as I think that these oversized homes are getting away from what homes really mean.

Yet there seems to be a mini-revolution going on these days in downsizing, and my hope is that attitudes continue to change and that people realize that bigger isn't better—it's just bigger.

This new direction in building smaller homes gives me hope for the future, and I hope that more and more people join the revolution.

Build it smaller and build it better.

Floor Area: 1200 sq. ft. / 111 m²

www.artisanbuilders.com
www.onetreewoodwork.com

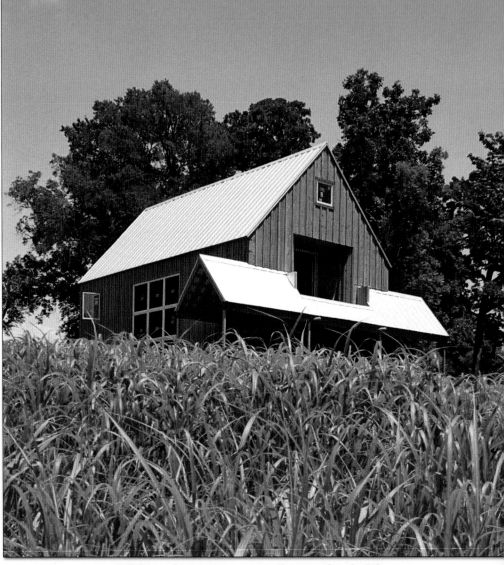

"The clients wanted it to look like a typical barn found in our part of Texas."

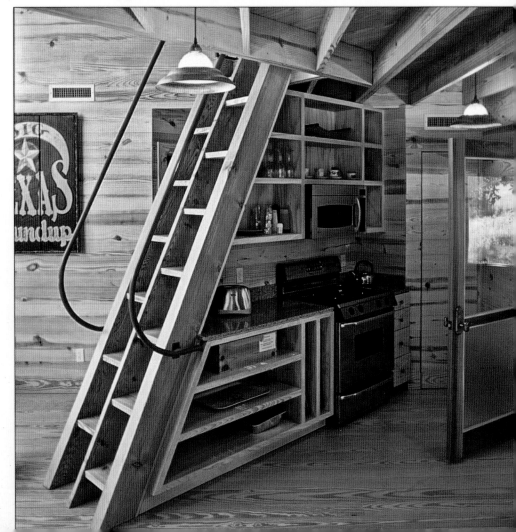

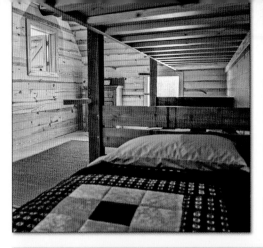

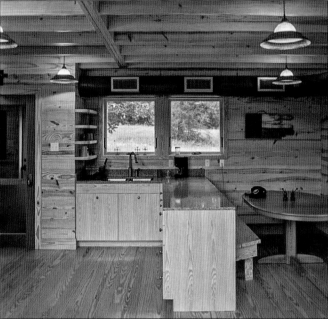

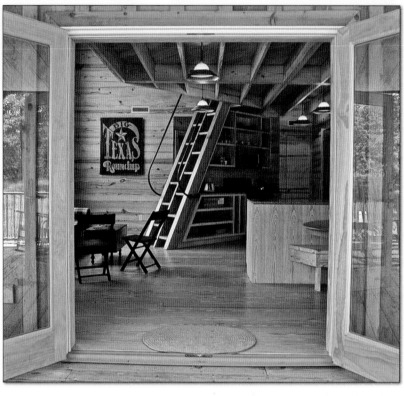

"We built custom bunk beds that can comfortably sleep six kids."

"Build it smaller and build it better."

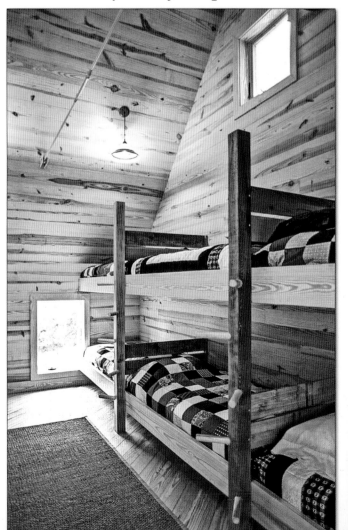

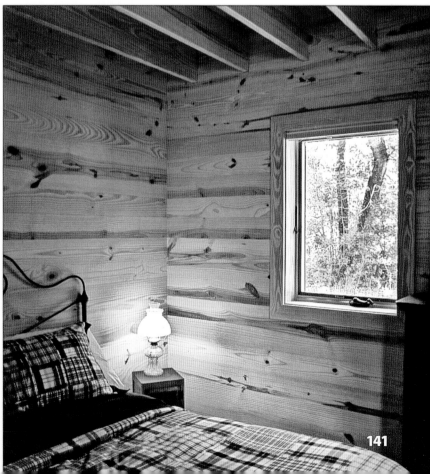

141

Small Home in Missouri

Emily Priddy and Ron Warnick

As you may know, our building books are generally heavy on graphics and light on details. However, this meticulous rendering by Emily and Ron of their ideas for living in a small space, and the cost-conscious ways they've carried out their goals is rare and useful, practical information.

–LK

A JOB OFFER IN APRIL 2013 TOOK US from Tulsa, Oklahoma — where we'd turned a 950-square-foot, faux-Tudor-style cottage in a working-class neighborhood into the solar-powered, wood-heated home of our dreams — to Cape Girardeau, Missouri, a vibrant college town on the Mississippi River, where we purchased a 700-square-foot Craftsman-style cottage in a working-class neighborhood less than two miles from our office.

The house, built in 1928 and blessed with hardwood floors and a quirky but clever floor plan, was mistakenly listed as 1400 square feet. That normally would have disqualified it from consideration, but we were facing a tight deadline to move into a town full of rental properties with intractable no-pet policies, so Emily — who organized the move — reluctantly agreed to look at it. After measuring it and discovering it was only half its advertised size, she made an offer on the spot.

Small living suits us. Small houses are cheaper to buy, heat, and cool than McMansions, and their limited storage capacity reduces the temptation to spend money on unnecessary gadgets. The items we do buy tend to be of higher quality, smaller footprint, and greater versatility.

Because our retirement goal is to build a tiny, off-grid house in New Mexico, we've also found our small house useful as a sort of testing lab for space-saving products and strategies. Here we've experimented with various storage strategies (Ron didn't like the bed risers, but that roll-out shelf Emily built next to the refrigerator is a godsend); analyzed our appliance usage; and reorganized cabinets and closets many times in an effort to maximize space.

In addition to advancing our long-term goals, these experiments have stretched our creativity and enabled us to design a living area that feels so spacious — even with three dogs and a cat in the house — that Emily jokingly compares it to the Tardis from Doctor Who, the sci-fi spaceship known for being "bigger on the inside."

Floor Area: 700 sq. ft. / 65 m²

Ron Warnick's blog:
www.route66news.com

Emily Priddy's blog:
redforkhippie.wordpress.com

"We purchased a 700-square-foot Craftsman-style cottage in a working-class neighborhood."

The ball chair — an Eero Aarnio knockoff I got for half-price because it was a color nobody liked — takes up more than its fair share of floor space, but it's so comfortable, and my nieces and nephews love it so much when they come to visit, I'll probably design our future tiny home around it. The living room will look much more spacious after Christmas, when that shelf can go to the basement and its contents can go to their rightful owners.

Photo: Laura Simon

Because the front of the house is basically a square divided into fourths, the long-ago architect who designed it in 1928 worked around the need for a hall — which would have taken up precious floor space — by simply slicing the corners off the bedrooms to provide a visual transition from the living room to the dining room. In the front bedroom, which we use as an office, the slice came out of the closet; in the back, it came off the room itself. I think the poorly rendered stripes and "family tree" mural are meant to make the dining room look bigger. We haven't gotten around to repainting since we moved in, but that's on the to-do list for the coming year.

We're big fans of record crates. They're not fancy, but they're cheap, practical, and pretty cool. That's basically the trifecta, right? I'm toying with the idea of building a double-sided desk out of record crates and scrap lumber to make more efficient use of the space in our office. For about $50, I think I can come up with something just about perfect for our needs.

"Small houses are cheaper to buy, heat, and cool than McMansions."

There wasn't really room in the bedroom (or money in the budget) for a full-size dresser, but a couple of sets of inexpensive storage-cube units made a sleek, simple alternative with a much smaller footprint.

Our dining room. We could put the table in the middle of it like normal people, but then our blind rat terrier would crash into it, and we wouldn't have room to do yoga. We'd like to make sure the only downward-facing dogs are really human, so we just tucked the drop-leaf dining table against the wall.

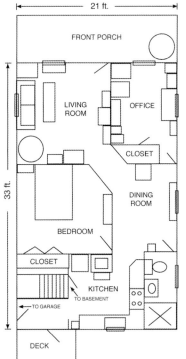

If you can't afford an elaborate, custom-designed closet to maximize limited space, aftermarket items such as wire shelves (bottom left), hanging sweater-storage units (middle) and hangers designed to hold multiple pairs of pants (to the right of the hanging storage unit) can maximize closet space and minimize the need for large pieces of furniture such as dressers. Bed risers — available at most home-supply stores for as little as $8 to $10 a set — can provide clearance for underbed storage. Try packing seldom-used items into flat plastic storage tubs or vacuum-sealed "space bags" and slipping them under the bed. (The damaged drywall was the result of an ill-advised attempt to find out what was in that box by cutting a hole in it. The answer: our basement. The "box" was just the back side of a knockout that provides clearance for the basement stairs. Oops.)

More...

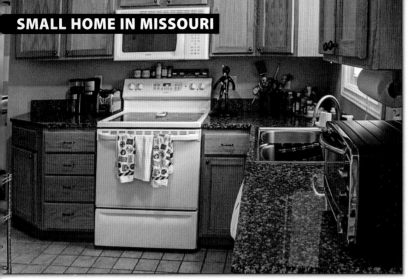

Our kitchen is small, but it's laid out well, with cabinets all the way to the ceiling. We sacrificed a little counter space for the toaster oven, which we're using for as much of our baking as possible to determine whether we'll need a whole stove when we downsize to a tiny house in a few years.

A folding dish rack and mat allow for hand-washing without taking up precious counter space when they're off-duty.

"Small living suits us."

It's hardly unique, but this stemware rack helps conserve precious cabinet space by allowing room for mugs or Mason jars underneath.

The compost caddy was a recent acquisition. At roughly $40, it was a bit pricey, but it doesn't clutter up the counter, and the activated charcoal filter in it handles odors nicely — even when we throw onion and banana peels in there — so we can wait until it's full to empty it in the outdoor bin.

This shelf unit on heavy casters was my version of an idea I found on Pinterest. I kept my costs down by using yardsticks — which I got for free from the feed store — as rails to keep things from falling off the shelves when we pull out the unit. This easy little project freed up an entire shelf in one of the cabinets last winter. Behind the shelf unit is the basement door, which leads to more storage, including built-in shelves next to the stairs that are perfect for storing cookbooks, Mason jars, and the like.

That little space at the end of the cabinets drove me crazy for a long time, because it seemed unusable — I couldn't put the trash can there or store anything on the floor, because it would block the heat vent. I started reclaiming the space with a plant stand tall enough to let the air circulate around it. Because that space is right next to the back door, I put a peach basket on the plant stand and filled it with items we use outdoors, such as insect repellent, pond dechlorinator, and garden gloves. A sturdy coat hook holds a beekeeping jacket and veil so I can grab it on my way out to inspect hives, and a planter designed for mounting on a fence or deck is just the right size to hold a few essential tools for handling bee-related emergencies.

In a small house, you want to avoid wasted space wherever possible. A set of wire shelves helps keep things neat and visible on top of the refrigerator, while Command hooks mounted near the ceiling on either side of the refrigerator hold reusable grocery bags, and a roll-out shelf stores spices and canned goods next to the fridge. The space on the other side is just wide enough to stash a dust mop and the folding stepstool I use to access the cabinets near the ceiling. With its slick surface, the refrigerator itself pulls double-duty as a dry-erase board for planning menus and making grocery lists. To save paper, I snap a photo of the refrigerator with my phone and set it as my lock screen so I have my list handy when I go to the store.

Entrance to the kitchen. It's small but laid out well. Note the paper-towel rack mounted under the cabinet and the plant-hanging bracket attached to the wall near the ceiling to hold a set of old-fashioned hanging baskets.

"Limited storage capacity reduces the temptation to spend money on unnecessary gadgets."

Photos by Laura Simon (above, below left, below right)

Emily uses part of the backyard behind her small Craftsman bungalow to keep a small flock of quail — one of the few species allowed within city limits. The birds supply eggs for the household.

145

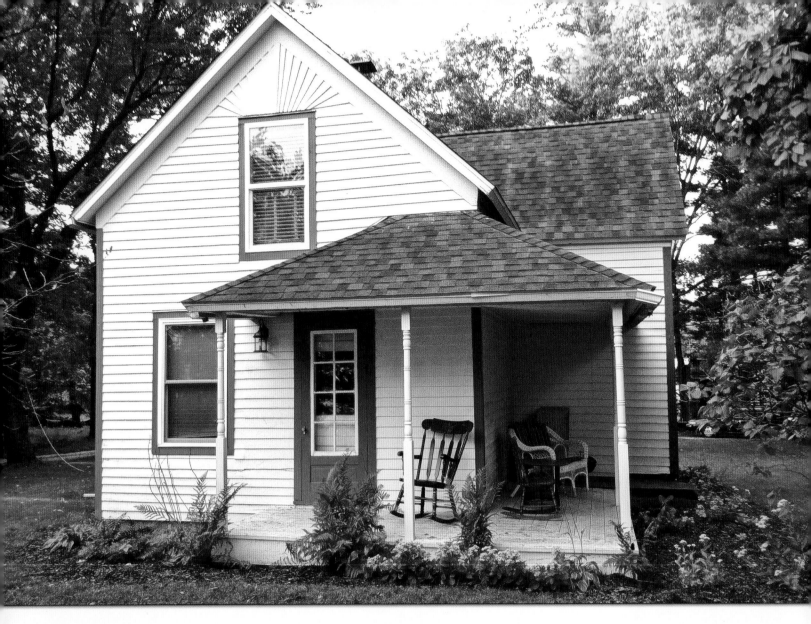

Fixing Up a 100-Year-Old Farmhouse in Indiana

Dan & Julie Perkins

IN OUR COMMUNITY AMONG OUR friends and family, it's not the norm to live in a small house, especially with three children, but we love it for lots of reasons — and so do our kids, at least for now!

In 2009, my husband Dan and I began searching for land to begin our dream: owning and operating our own farm. We expected to find an empty parcel of land and live in a trailer or yurt while getting the farm going. But my parents found a 20-acre property near them that included a small (1216-square-foot) Montgomery Ward farmhouse that'd been built around 1918, after being delivered to the town by train and hauled by horse and wagon to the building site.

Our realtor recommended bulldozing the house, as it had no monetary value in the sale of the property. But we saw charm, historical appeal, and potential, so we kept the house, expecting to make a few repairs and call it good.

The first step was to repair a water-damaged wall, which is when we discovered there was no insulation on the first floor. The only

"In 2009, my husband Dan and I began searching for land to begin our dream: owning and operating our own farm."

"Our realtor recommended bulldozing the house, as it had no monetary value."

heat source for the entire house was a corn pellet stove. So, as much as we wanted to keep the plaster and lath, we decided a constant and consistent source of heat was a must for our young family. With the help of family and friends, we gutted the first floor and prepared for some serious reconstruction.

Dan, who'd done minimal wiring in a greenhouse, bought the *Black and Decker Complete Guide to Wiring* and updated all the electric work himself. We then had an electrician friend inspect the wiring so we could meet the local construction codes.

We contracted out spray-foam insulation and ductwork for central heat, then spent a bit of money on an outdoor wood boiler, as 11 acres of our property is wooded.

One of our goals was to retain the original farmhouse feel. We kept as much as possible of the thick original window and baseboard trim. The window trim is all up (but not all painted), and the baseboard trim is still in the barn — we'll get to it some day!

The original pine floors upstairs were covered in carpet, the ones downstairs in a dark, heavy varnish. The initial sanding with a belt sander, to the final coat of stain, took about 40 hours.

Also, back in the day, families used a Hoosier cabinet for storage and a workspace. The previous homeowners left behind their old cabinet, and a friend recently fixed it up so we could return it to the house.

Other features of the early twentieth-century farmhouse include small rooms and no closets. Downstairs we took out a dividing wall and a pantry wall to open up the main floor.

Upstairs, we added a partial wall to create a very cozy third bedroom for us. The other two bedrooms are for our children. And we even fit a small guest room/reading nook upstairs. We use wooden dowel or curtain rods to hang our clothes.

The exterior needed work, and we took each project one year at a time, beginning with the roof. In year two, my sister painted the exterior. The next year Dan built the back porch, and the year after that he reconstructed the front porch, which was falling off the house.

Neither Dan nor I ever expected to fix up a little old farmhouse — we had (have!) a lot of dreams and goals, but that wasn't one of them. Yet we're both so grateful to live here, to fix things up little by little, and really appreciate what goes into making both a house and a home. Recently, after visiting friends living in an especially large house, our 6-year-old son mentioned offhandedly that he liked living in our "small house."

Floor Area: 1216 sq. ft. / 112 m²

www.perkinsgoodearthfarm.com

"One of our goals was to retain the original farmhouse feel."

"We're both so grateful to live here, to fix things up little by little, and really appreciate what goes into making both a house and a home."

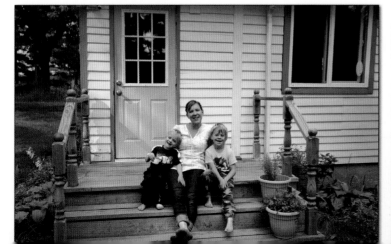

Small Home in Minnesota

Frank Rodrigue

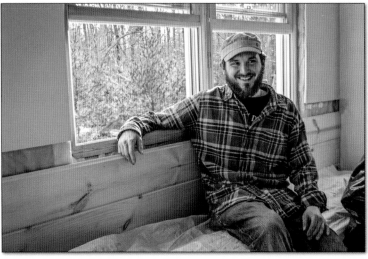

MY 16′ × 20′ HOME SITS on a concrete slab which was poured on my birthday, August 1st, with the help of several friends who had experience with concrete; it was my first time working with it.

The slab was smoothed with hand trowels so that we could create a uniquely textured finish.

This spring I acid-stained the concrete to create a more natural-looking surface.

The small footprint of 320 square feet, not including the sleeping loft, is actually quite spacious due to the number of windows, tall ceilings, and open floor plan made possible by a main carrying beam.

Passively designed, the house is easy to heat and cool. The concrete slab acts as thermal mass as light passes through the southern exposed windows, which also lets in lots of natural light, as well as warmth. The tall ceilings, with the clerestory windows, act as a "chimney" in the summer, allowing for any warm air to escape, while the elongated eaves help shade the windows from direct sunlight.

Heating for the home is currently provided by a centrally located Vermont Castings green enamel woodstove with a glass front — adding the perfect ambiance on a cold winter evening.

Interior wall coverings will be a mix of shiplap pine and sheetrock for a varied wall surface and to allow for different paint colors.

The bathroom floor is constructed 18″ above the slab so that all of the plumbing can be accessible above the concrete (besides the main drain and sleeve for the future waterline).

The electric source consists of a generator, and a vehicle battery jump-start kit, which can be plugged directly into the wall to power the outlets; solar will be next.

Roofing consists of gray metal sheets and the exterior siding will consist of locally harvested and milled cedar shakes.

I have done all construction on the building myself after work and on weekends with the help of a childhood friend — both of us rather inexperienced.

From the start, my goals for the project have been: mortgage-free, easy to maintain, and doing as much of the work myself as possible. Future landscape plans include low-maintenance, edible plants, with a permaculture focus, an outdoor rock wood-fired oven using rocks from the property as well as a smoker, natural swimming pool, wood-fired hot tub, and coppiced woodlot.

Floor Area: 320 sq. ft. / 30 m²

> *"From the start, my goals for the project have been: mortgage-free, easy to maintain, and doing as much of the work myself as possible."*

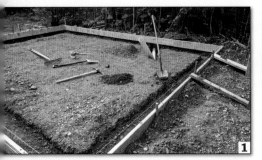

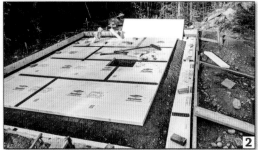

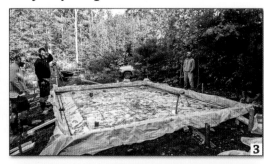

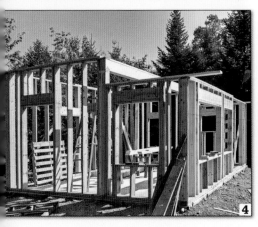

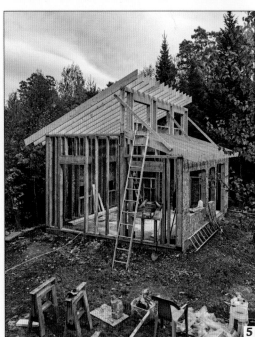

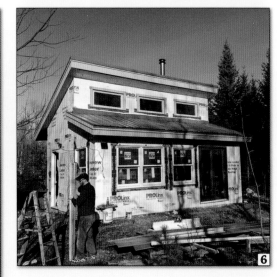

> *"Passively designed, the house is easy to heat and cool."*

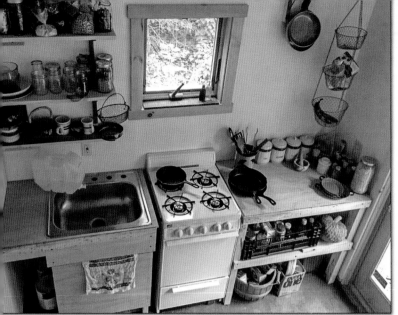

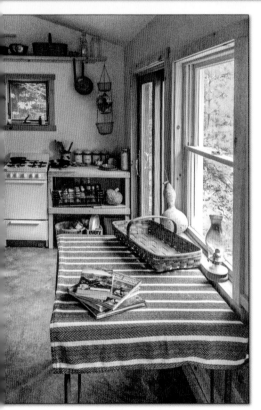

Inspiration board

"The bathroom floor is constructed…so that all of the plumbing can be accessible."

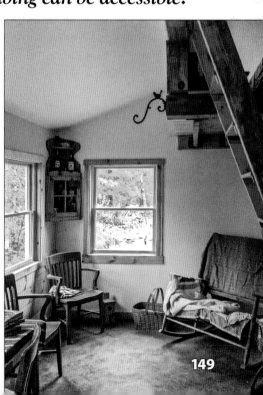

Aunt Lillie's House

Old Farmhouse in Georgia

Suzy Etheridge

MY NAME IS SUZY, AND I'D LIKE to tell you about our small home. It's a little 1943 ranch-style farmhouse, 1082 sq. ft., and sits on 10 lovely acres just outside historic Madison, GA.

When we began to search for our first home, we had to choose between either a "desirable" neighborhood or acreage in a more rural setting.

We'd been in Atlanta for a year and it was way too busy for us, so we began looking around outside the city. All the houses we looked at were either on small lots with large odd-shaped homes ('80s weirdness), or trailers on large plots of land.

It had always been my dream to own an old home. I fell in love with a bungalow while living in West Allis, Wisconsin, and midwestern architecture remains my favorite.

Then this little farm caught my eye. When I first saw this house, something about it spoke to me.

It had an old barn, a few outbuildings, large old pecan, oak, and black walnut trees, and 10 acres of mixed woods and meadows. Picturesque, to say the least.

But the house was half the size and the acreage twice the size we were looking for. There were only two bedrooms and one little bath. It was smaller than the apartment we were renting. And we are a family of three: my husband Nathan, daughter Rini, and me.

Still I just had to see it. All that acreage and those buildings would give us a lot of options. It was small, but neatly arranged. What it lacked in interior space, it made up for in external space.

Plus, both neighbors were large land-owners with lots of trees. We weren't in the wilderness, but it felt like it. My husband was skeptical, but I just had to have it.

The first year was a little rough; there were things not done right in a previous renovation, and stuff not disclosed.

Work on the house was so demanding I couldn't get started on outside projects as planned. I had to strip and repair the walls in the master bedroom, which took two months.

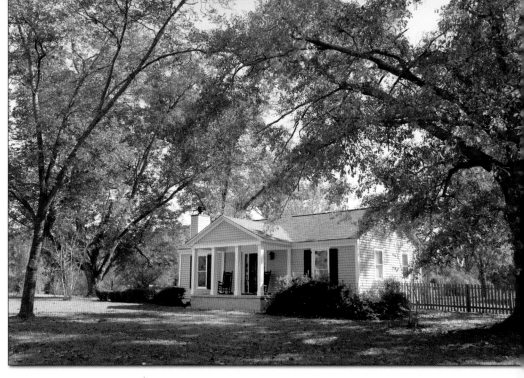

"When I first saw this house, something about it spoke to me."

The landscaping was mostly wild and overgrown. But once I started digging up old bottles, broken ball jars, wrought-iron nails and spikes, I began to wonder who else had been here?

It's an old house, I believe handbuilt by the original owner. The rafters are hand hewn, most likely from the pines growing on the land.

In the barn I found 20 large, rough-hewn planks for some future project, and two log piles waiting to be milled. The owner was apparently a woodworker by trade, but had passed away.

There's even an old cemetery just off the barn with five nicely inscribed graves of some other family who once lived here. One was interred in 1865, and the rest around 1904. I'm still researching who they were.

The neighbors refer to the house as "Aunt Lillie's House." Maybe it was built for her? I think after her family passed away, the house sat empty and deteriorated.

I've found this area of Georgia to be one of the prettiest rural/agrarian settings I've seen in a long time. There's so much variety: horse farms, grazing cattle, goats, donkeys, cotton, corn, sunflowers, sorghum, as well as fascinating old houses and sharecropper cabins. So much history.

There's something magical here. Lots of deer and turkey. We even came across a fawn that let us pet it. Stuff of dreams.

Currently I'm planting fruit trees, and berry bushes, composting, and getting a larger plot ready.

I'm enjoying learning homesteading skills, and backwoods skills, right on my own land. I can play Survivorman right in my own backyard!

We moved here for the house without jobs or knowing anything else about the area — and it's worked out really well.

We decided to go with a small house because we didn't want a mortgage, it gave us more land, and there isn't too much house to overwhelm us.

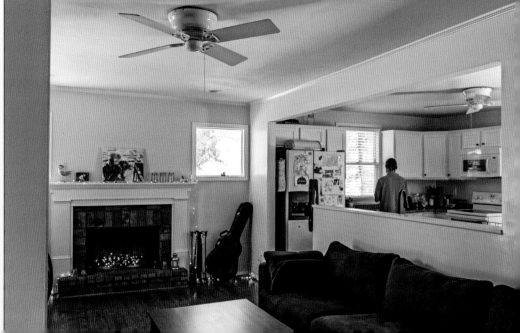

"It's an old house, I believe handbuilt by the original owner."

It's just a simple shelter and I think it's happy to be filled with love again. First its owners had died, then it sat empty, except for the squirrels in the attic, and the next owners fought a lot and got divorced.

Then we come along — the whimsical, weird, funny people. I think she's happy to have us. We're lucky and blessed.

Thanks for giving me the chance to share my home with you. I'm very proud of our little house.

Floor Area: 1082 sq. ft. / 100 m²

"It's just a simple shelter and I think it's happy to be filled with love again."

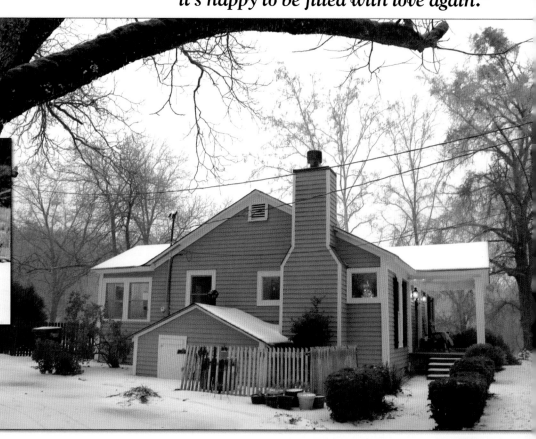

"Thanks for giving me the chance to share my home with you. I'm very proud of our little house."

151

Rose's Small Farmhouse in North Carolina

Rose Davis

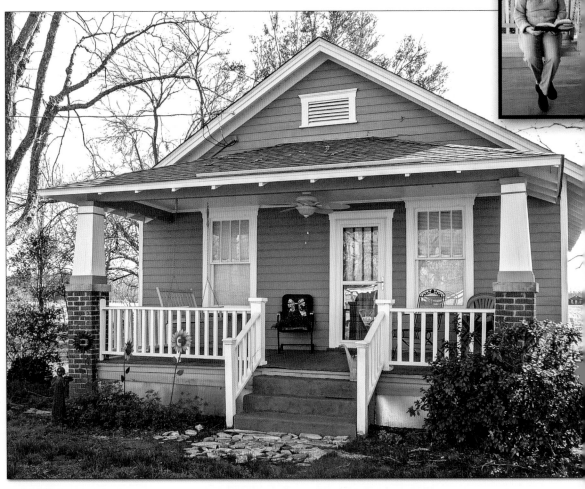

MY SMALL HOUSE IS a labor of love. It belonged to my mother's parents who bought it in 1969, when I was 4 years old. My Dad was renovating it when he passed away in 2006. I inherited it in 2012 and my journey began.

I spent the first few years cleaning up the yard, mowing grass and dreaming about living in this little old house. It is 864 square feet, was built in the 1930s, and sits on five acres of farmland in Castle Hayne, North Carolina.

In February 2015 the renovations began and I moved in on August 24, 2015.

While the house repairs were being done, I started downsizing. I was living in a 1400-square-foot townhouse with lots of storage while my small house had only one very small closet and an attic.

Needless to say, I donated, shredded, and tossed lots of "stuff." I had a yard sale! And then I gave more stuff away and I still needed a storage unit for about six months. Finally, by December 2015 the storage unit was empty—but the back porch and attic of the house were not. I am always looking for creative ways to store things and I'm hoping to gather ideas from others featured in this small house book.

My boyfriend and I started our first garden in the spring of 2015, while construction was still in progress. I have plans for a barn/garage and greenhouse, as well as a chicken coop; there are lots of garden and landscaping possibilities to keep me busy. We spend lots of time with family, friends, and neighbors in the yard under the shade of a beautiful pecan tree or by the fire pit.

After having lived here now for almost six months, I can honestly say I have no regrets. Restoring this house was my way of honoring my parents and all they worked hard for during their lives—a small payback to them for all they did for me.

Floor Area: 864 sq. ft. / 80 m²

"My small house is a labor of love."

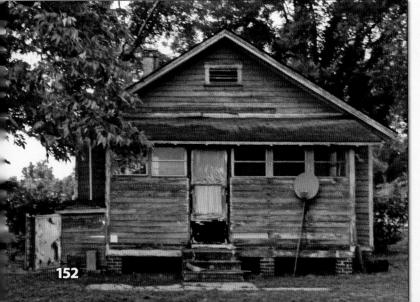

Rear of house, before

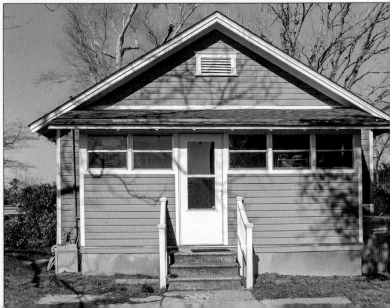

Rear of house, after

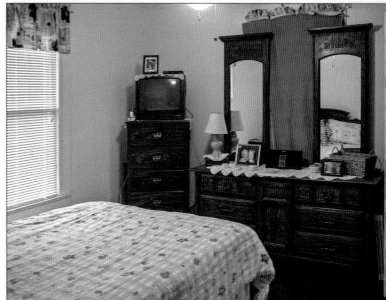

"We spend lots of time with family, friends and neighbors in the yard under the shade of a beautiful pecan tree."

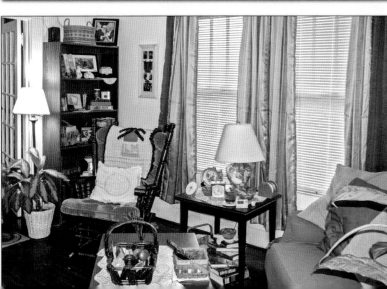

"Restoring this house was my way of honoring my parents."

153

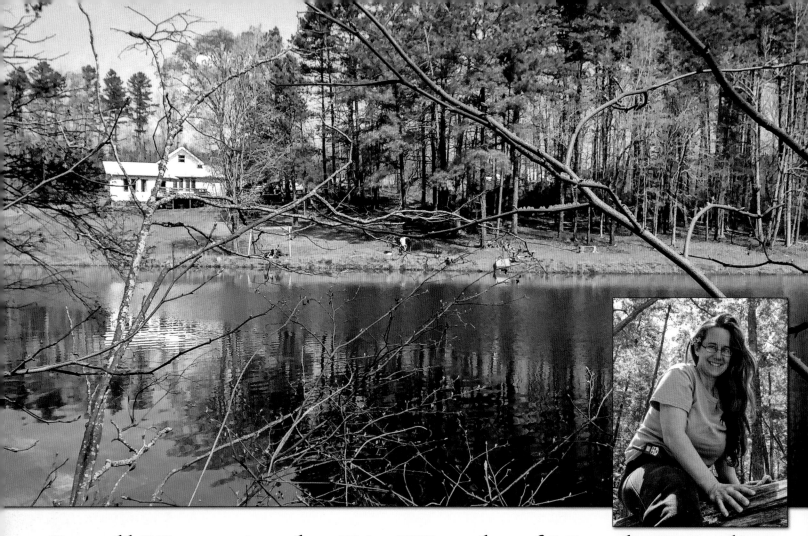

Small Home in the Big Woods of North Carolina
David and Candice Brasington

IN 2013, WE BOUGHT OUR very own little house in the big woods, gleefully leaving behind the chaotic, cramped, and congested life of the Myrtle Beach area in South Carolina.

Even before we brought our final load in a U-Haul, we had already discussed the many plans we worked, reworked and now continue to change for our new homestead that includes a mix of hills, woods, pasture, and a "mini-me" version of Walden's Pond, albeit in the small, two-stoplight town of Norwood, North Carolina.

With our wooded driveway being a half-mile long, we relish the absolute, 100% privacy and euphorically enjoy the enigmatic sights and sounds of all kinds of wildlife that abound around us.

We downsized from our modest 1300-square-foot home to one much smaller at 940 sq.ft. We also have a separate building quite a walk from the house —about 400 feet— that is currently used as my library and storage.

We bought the property for the landscape, not the house; but the house, while small, is practical. We agreed that with our girls being teenagers and soon to be out of the house in a couple of years, we could creatively manage to live in close quarters.

The sunroom became my oldest daughter's bedroom, which overlooks the pond. My other daughter's room, the loft, has views of the pasture on one side and the pond on the other. The living room windows welcome us with breathtaking views

of God's beauty overlooking the pond.

While we did not build the house ourselves, we are continually trying to improve its energy efficiency. We are slowly fixing and remodeling as our budget allows.

We recently replaced our roof with white metal roofing, which has the highest reflectivity of the sun to reduce the heating of the home. However, when the sun shines through the living room in the winter on days that are cold, but not quite below freezing, it heats up the room to a comfortable level (to me), but sometimes to a level that causes my husband to want to put the air conditioning on!

Floor Area: 940 sq. ft. / 87 m²

"…our new homestead that includes a mix of hills, woods, pasture, and a 'mini-me' version of Walden's Pond."

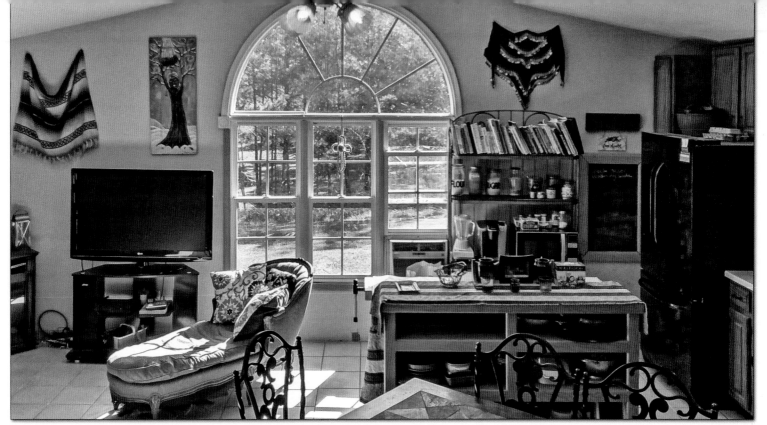

"We downsized from our modest 1300 sq. ft. home to one much smaller at 940 sq. ft."

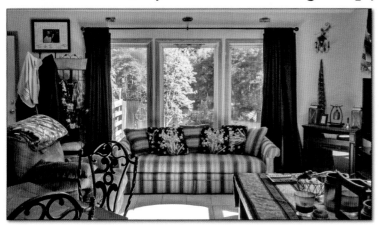

"We are slowly fixing and remodeling as our budget allows."

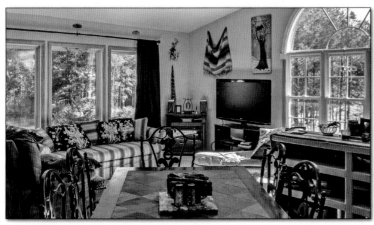

"We bought the property for the landscape, not the house."

"We relish the absolute, 100% privacy."

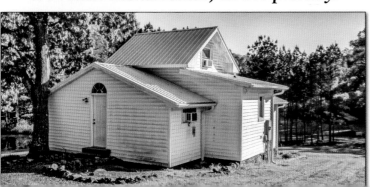

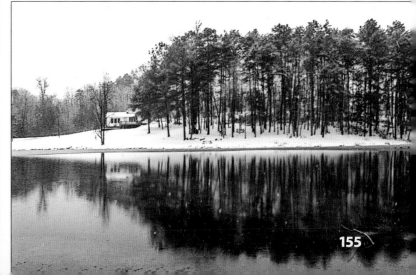

Owner-Builder Small Cabin in North Carolina

Tom and Cindy Wechter

Afour watching TV shows and reading articles about "tiny" houses, my wife Cindy and I found them to be way too small and knew we would not be able to live with a space that tiny.

So, with the help of Google SketchUp and my degree in Architectural Technology, I came up with a simple, yet functional 16′ × 32′ design with an additional 8′ × 16′ covered front porch and an 8′ × 24′ side deck on the south side. We are finding this size small enough to be efficient but big enough to be practical.

The floor plan consists of a living room with a vaulted ceiling (which really makes that space feel large) a kitchen area, bathroom and a good-sized bedroom with enough space for a king-sized bed. The porch and deck provide an additional 320 square feet of outdoor space to enjoy.

After earning my living doing home improvements and minor remodeling for several years, I was eager to build an entire structure from scratch. I didn't want to be too ambitious and jump into building a full-sized home for my first project, and we didn't we have the funds for that, so the small size made things much more practical for us.

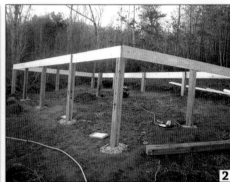

I believe in the old saying: "If you want something done right — do it yourself." So, other than installing the heat pump and insulation, I have done all the work myself with help from Cindy and a good friend who assisted with some of the difficult tasks like the roof structure and such. It has been a wonderful experience and gave me a place to use the sum of all my life's experiences.

While planning, I kept my eyes open for opportunities to re-purpose building materials. I saved quite a bit of cash by snagging all the 6′ × 6′ foundation posts from our church playground equipment that was being replaced. Then, a few weeks later I scrounged about fifty, nice, 10-foot 2 × 6's from some large crates that were headed for the dumpster. I also was lucky enough to receive a bunch of perfectly good deck boards and about a hundred fancy spindles to use on the front porch from a friend who was redoing his deck. Free is good!

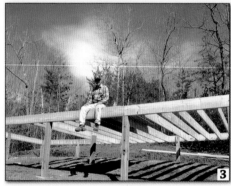

Starting from scratch with nothing but raw land was a new experience for us. Doing a driveway up a fairly steep hill, putting in a septic system, and digging a well were all milestones.

The well was nerve-wracking because they cannot tell you how deep they might have to go and they really can't guarantee they will hit water at all. You just have to let them start and pray they are successful. Our well went 350 feet deep and cost $6,000! The driveway was another $6,000 and the septic system was $4,000. Lots of big expenses to deal with before the first nail is driven!

Another exciting milestone was when the electricity was turned on. Being able to flip on lights and run the AC and heat was fantastic. Oh, did I mention flushing the toilet and being able to take a shower? WOW! Doing without all these "luxuries" really makes you think about the things we take for granted!

> *"After watching TV shows and reading articles about 'tiny' houses, my wife Cindy and I found them to be way too small."*

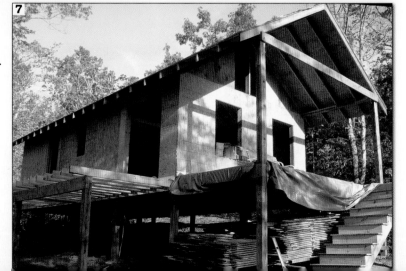

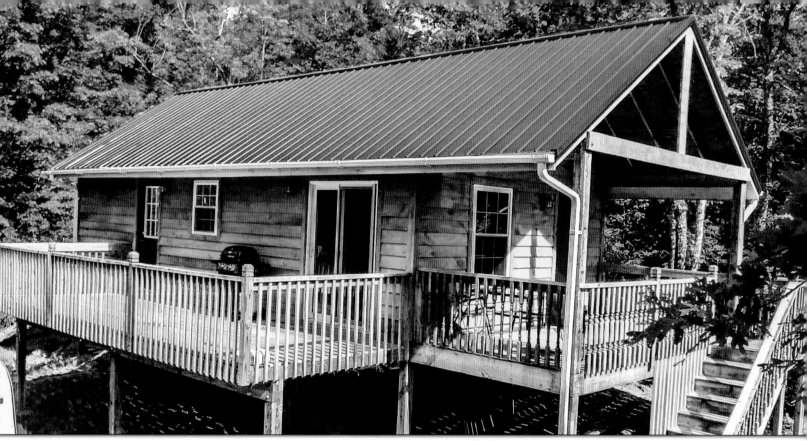

"Being able to flip on lights and run the AC and heat was fantastic."

One problem we ran into was finding a building site. We wanted southern exposure for some passive solar features, as much of a mountain view as we could afford, and — the really tough part — a lot *without a minimum square footage requirement.*

Every building lot on the market required over a thousand square feet of heated space, many required over 1400. It seemed that the only way to get around this problem was to buy a larger tract that was not a part of a subdivision, but this was way out of our price range.

While looking at lots in a subdivision in Old Fort, North Carolina, which is about a half hour east of Asheville, we found an owner willing to cut out a two-acre tract for us and exclude it from his restrictions. This was the only way we could pull off building our 512-square-foot cabin. So for the "Small House" mentality to take root, we are going to have to rethink minimum square-footage requirements.

We have been working on the project for about three years now and are just about done. I just have to finish the kitchen cabinets and deal with a few more finishing touches.

We are currently living in a huge 3700-square-foot house that is WAY too big for just the two of us. We have two furnaces and two air conditioner units to deal with. We try to economize as much as possible by closing off unused rooms and only running the units that we need, since one furnace/AC is for the living areas and the other is for the bedrooms, but it still requires a lot of energy. It's a big job just to open all the windows in this huge house when it's nice out! We'll be glad to get into our small house eventually and be comfortable without all the hassles and expenses of the big house.

**Floor Area: 512 sq. ft. / 48 m² interior,
320 sq. ft. / 30 m² porch and deck**

"We have been working on the project for about three years now and are just about done."

"Doing without all these 'luxuries' really makes you think about the things we take for granted!"

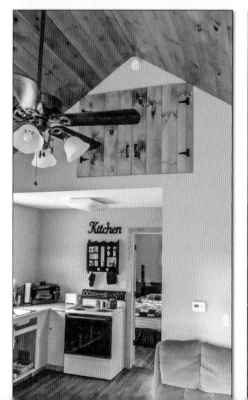

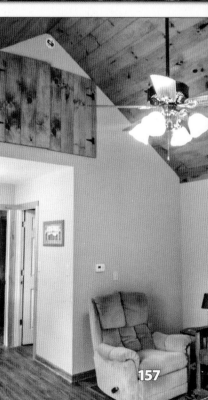

Small Home in Shenandoah Valley, Virginia

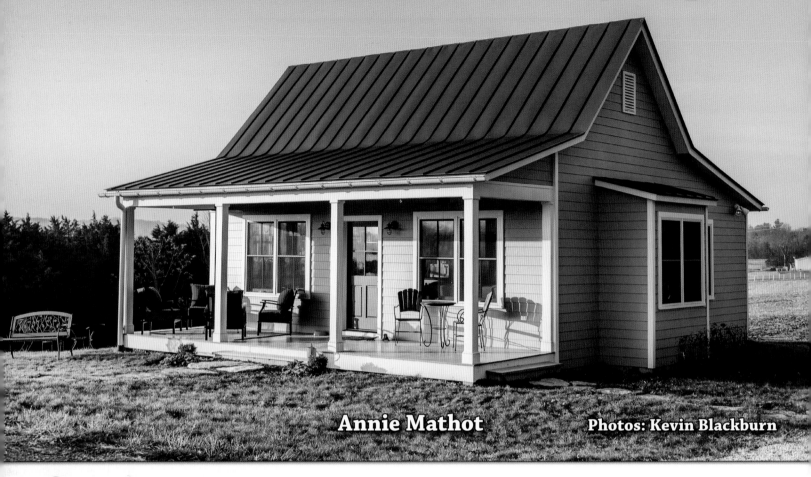

Annie Mathot Photos: Kevin Blackburn

SEVERAL YEARS AGO, I BOUGHT SOME land with beautiful views in the Shenandoah Valley of Virginia. I built a horse barn and some fence. Once the horses were happy in their new home, I started the process of preparing to build a house.

I wanted to build a "small" house for three reasons. First, it was just for me and my 12-pound Jack Russell (more on that in a minute). Second, I only wanted to build, condition, and maintain the amount of space I would use on a daily basis. And finally, high-quality materials and craftsmanship were more important to me than a bigger house.

As it happened, a good friend and talented architect Chris Jenkins, was working with William Drumeller, a contractor whose company, Responsible House, was embarking on a venture to build prefabricated, energy-efficient houses based on traditional regional styles. I volunteered to buy a prototype.

As the plans developed, we decided to build the house on-site instead of off-site, but we kept the 14-foot-wide modular dimensions of the prefabs so it would be adaptable to modular additions later on.

The vernacular architecture of the Shenandoah Valley farmhouses has always been one of my favorite styles — simple, suited to the environment, and beautifully proportioned. These were qualities we wanted in the design of our home.

"I wanted to build a 'small' house."

"The truth is, we don't think of our home as small. To us, it's perfect."

We used updated versions of our favorite traditional materials: a standing seam metal roof with today's best technology for prefinished color; lap siding in fiber cement, traditional trim profiles in composite materials, and double-pane, highly efficient fiberglass windows, with simulated divided lights and proportions to match the windows of the home's predecessors.

We added the latest technology in energy efficiency, including spray-foam insulation, zip-system sheathing, and an energy-recovery ventilation (ERV) system to filter the air. The floors throughout are reclaimed oak harvested and milled by a local company.

Around the start of this process, my farrier, Marcus Wise asked me out on a date. I turned him down. As it turned out, in addition to being the kindest and funniest person I'd ever met, he was also the most persistent. And persist he did! I finally gave in to a dinner date, and we've been together ever since.

Throughout construction, he was helpful and supported my decisions, until one day when the builders installed the poplar paneling on the vaulted living room ceiling.

I wanted to paint it; my supportive sweetie told me that if I did that, he would sit down in the middle of the living room floor and cry. I gave in, of course, and now the unpainted paneling is one of my favorite features in the house.

On completion, the house happily accommodated the two of us, the Jack Russell, and a 90-pound chocolate Labrador retriever.

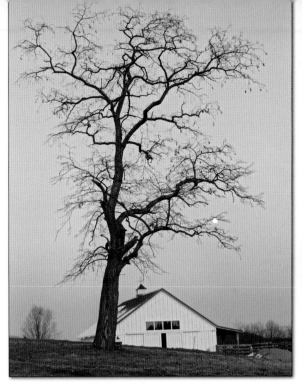

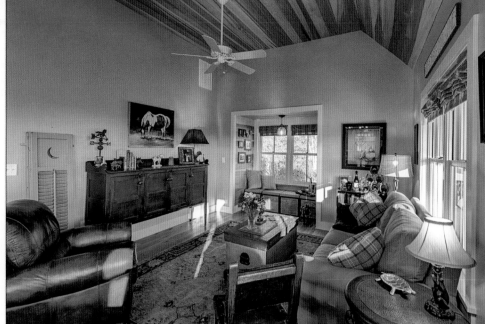

We were married in January, 2013 and had a daughter, Audrey, in July, 2014. The house has adapted well to our growing family. After the arrival of the baby, the office became the nursery/guest bedroom, and the bay window became an office nook.

While modest in square footage, the house feels open and spacious, even when hosting dinner for eight at the kitchen table, largely due to the open design of the living spaces.

We've filled the house with all the things we love and that have special meaning, from family heirlooms to crafts and art by friends.

The truth is, we don't think of our home as small. To us, it's perfect.

Floor Area: 810 sq. ft. / 75 m²

"We added the latest technology in energy efficiency."

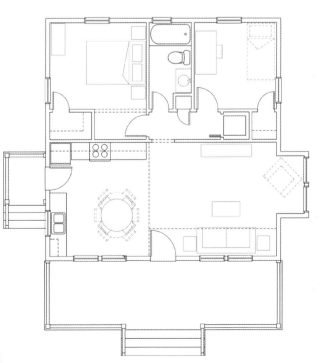

"While modest in square footage, the house feels open and spacious."

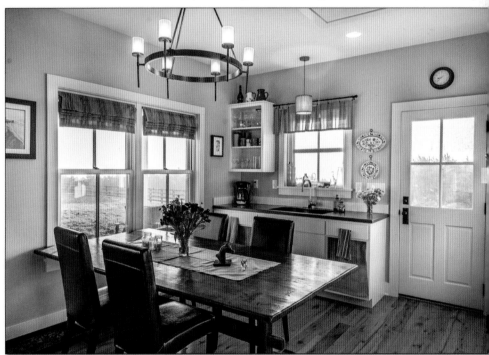

"High-quality materials and craftsmanship were more important to me than a bigger house."

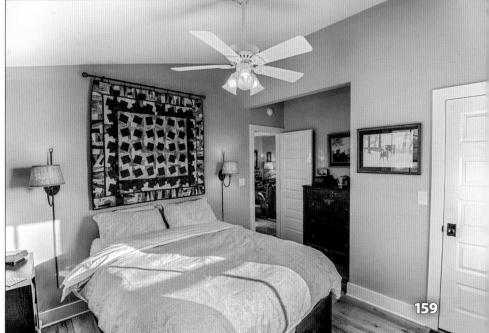

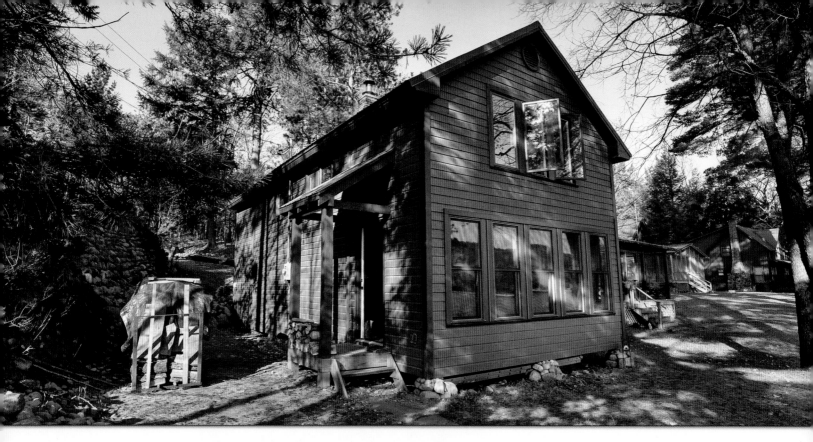

Family Rebuilds Adirondack Lodge

Jim Leach

THE *WHOLE EARTH CATALOG* WAS A REVELATION TO US IN the '70s. Then we (my wife, her brother and sister, and I) were twenty-somethings sharing a family camp on a remote lake in the Adirondack Mountains of New York. Over the years, everyone got married, had kids (six in all), the kids got married, had kids of their own, and the camp got decidedly smaller.

Four years ago, when a lake neighbor turned 90 and decided to sell his 100-year-old camp, 200 yards away, Linda and I cashed in some savings and bought it.

With our kids and their families, we've torn the place apart and rebuilt it. We talked Keith Huff, a retired carpenter friend, into doing the framing and roofing, and we've paid for some other services that were beyond us. But a lot of what's happened has been our sweat equity.

New York strictly governs construction inside the six-million-acre Adirondack Park, and limited our project to the rectangular footprints of the century-old camp (18′ × 34′) and boathouse (20′ × 28′).

The core of the camp was an 18′ × 18′, two-story box — the original hunting cabin — with a massive fieldstone fireplace at its center. We gutted the core, saving only the fireplace and the turquoise stairway.

Earlier owners built shed-like porches, front and back. We tore them off and built new two-story construction to add space.

Our carpenter friend was the guru who encouraged us to try things we'd never done before. And he built our kitchen cabinets using hickory he'd harvested himself. Drawer bottoms are salvaged from the paneling on the old camp walls.

I have one of the first copies of your *Tiny Homes* book. It's inspiration for a one-room cabin that we're planning to build behind the camp.

There were six of us when we started this; five years later we're nine and growing. And we all fit comfortably in the four small bedrooms and two small baths that we built ourselves.

Because, right outside, there are those six million acres....

Floor Area: 1206 sq. ft. / 112 m²

"…a family camp on a remote lake in the Adirondack Mountains…"

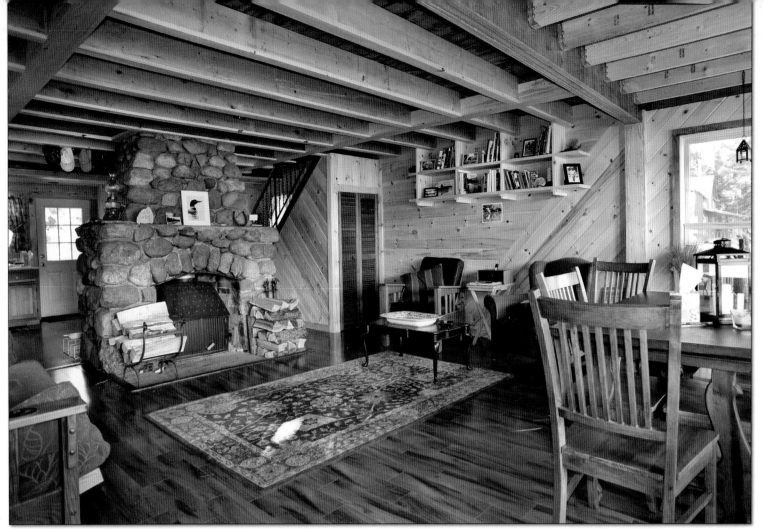

"He built our kitchen cabinets using hickory he'd harvested himself."

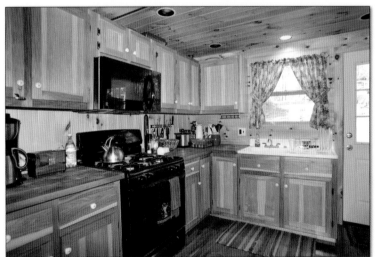

*"We all fit comfortably in the four small bedrooms
and two small baths that we built ourselves."*

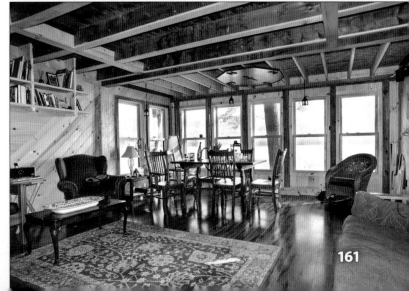

Solo Builder of Small Homes in New England
Jim Bahoosh

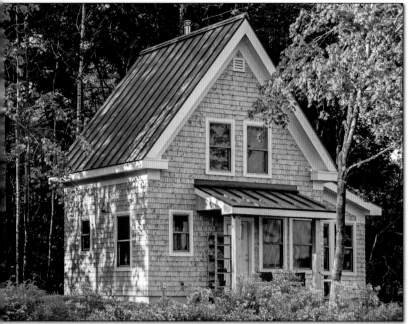

Erica's house — Floor Area: 720 sq. ft. / 67 m²

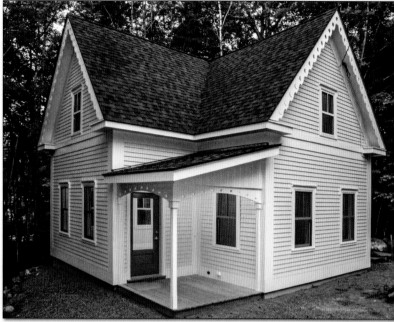

Bayside house — Floor Area: 980 sq. ft. / 91 m²

"I'm a solo house builder and designer."

We ran across Jim just as we were putting the last touches on this book. Since his work was so good, and appropriate for the times, we made room for him in the book.

What he's doing — building high-quality, aesthetically pleasing, practical, small homes — solo — could be a template for young builders anywhere.

THERE ARE MANY GREAT reasons to have a smaller house. Smaller homes consume fewer resources to build and maintain. They're easy to heat and keep clean. For me, though, it comes down to personal preference. I just plain like smaller homes. They resonate with my ideal of what home should be: safe, solid, cozy, and sweet.

square feet, still designed in a traditional manner.

When I started building, my construction experience was pretty much non-existent. What I had was faith — faith in my ability to learn and solve problems. I wouldn't have known how to phrase it then, but I was learning how to look at all the individual components of a building as a system. I was also willing to make mistakes. And a good deal of tenacity certainly helped.

My design sensibilities, material choices, and construction technique are solidly New England. I design with available and high-quality materials in mind. For example, in my area, #4 pine is readily available. It's ⅞" thick, dressed to standard widths, and has one face planed.

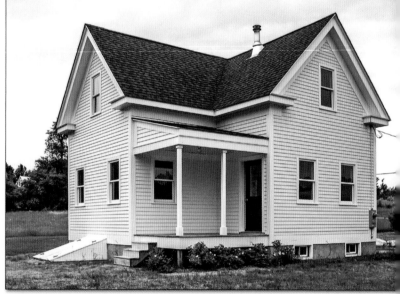

Judy's house — Floor Area: 980 sq. ft. / 91 m²

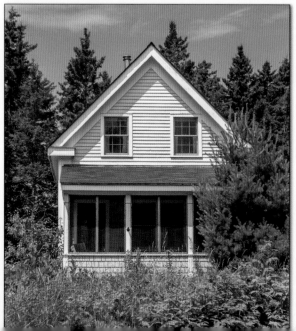

Brooklin cottage — Floor Area: 720 sq. ft. / 67 m²

"I turned to building new homes designed to look and feel like the traditional New England homes I love."

I'm a solo house builder and designer. In 1983 I started buying, moving into, and rebuilding old houses. Next I turned to building new homes designed to look and feel like the traditional New England homes I love. Since 2002, I've focused on smaller homes: homes from 500 to 900

As a solo builder it's easier to work with than sheet goods when I sheath a roof. I order extra and cull the best boards for use as exterior trim. Scrap feeds the woodstove, not the landfill. It's lovely to work with.

And if it's not lovely, whether as a material choice or design, why bother?

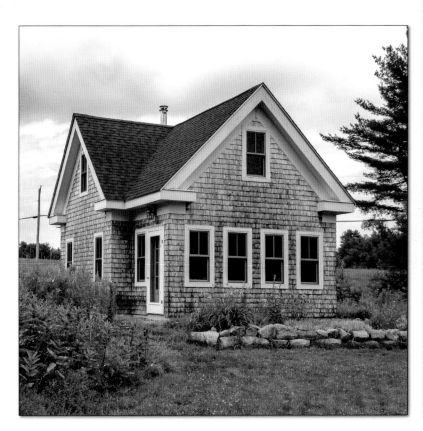
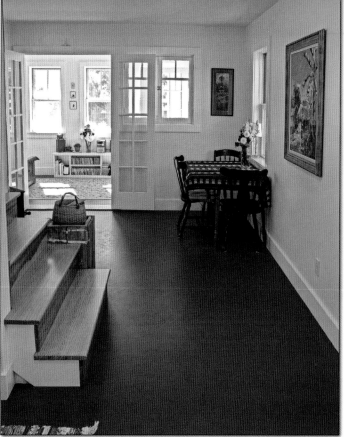

"Smaller homes consume fewer resources to build and maintain."

All photos on this page: Martha's house — Floor Area: 740 sq. ft. / 68 m²

"I just plain like smaller homes."

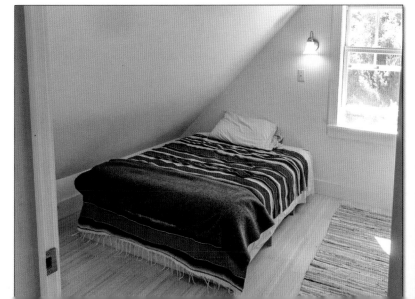

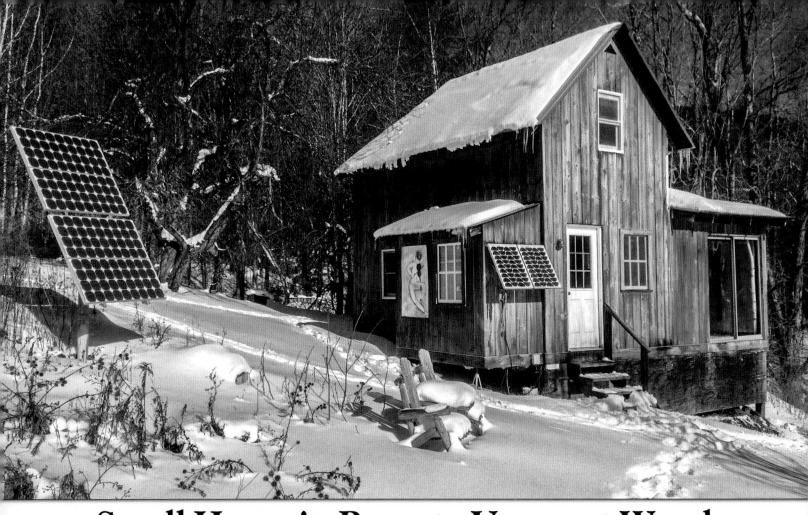

Small Home in Remote Vermont Woods

Greg Ryan

"I designed this house when I was 16."

I DESIGNED THIS HOUSE WHEN I WAS 16, around the time my dad gave me a copy of Lester Walker's book *The Tiny Book of Tiny Houses*. That book still inspires me!

Well, I was sure there'd be a market for plans, so my brother loaned me the money to put an ad in the back of *Popular Science* magazine for "Tiny House Plans." I thought I'd soon be rich. It wouldn't be the last time I thought I'd hit on something big only to realize that things were not that simple.

Anyway, I held onto those plans and years later, after buying a beautiful piece of land in central Vermont, decided to build my house.

There were just one or two problems. I had only $3,500 to my name and no credit and my wife at the time was seven months pregnant. Did I mention that the land, although extremely beautiful, is in the middle of nowhere? No phone, no electricity, not even a town-maintained road! These

were just minor obstacles for a young, adventurous soul with more determination than common sense.

The winter we closed on the land turned out to be a mild one, which was good news indeed. I was able to drive a Nissan Sentra up the road with no plowing in early March — although I did tear the muffler off once or twice. It turns out a more substantial vehicle was needed to carry lumber up the class 4 mountain road, even in the best of conditions.

So, $3,500 and a month or two later, we had a home — well, sort of. We moved in two weeks before Aidan (son #2) was born!

No running water, no electricity, no backup heat. No idea how hard it would be to carry groceries up a half-mile long driveway on snowshoes! Some of the window frames were covered with plastic, and there wasn't much in the way of insulation. It took a

while to figure out some very basic things, such as not cutting your firewood the same day you need to burn it.

A couple of years later I added a few solar panels and some insulation. The water is gravity-fed from a spring so no pumps are needed. This, along with a super-efficient Sun Frost fridge, helped keep the power needs very low. Even after 20 years there's just 400 watts of photovoltaics.

There's a funky little outhouse with a composting sawdust toilet. The house is very cozy and gets a lot of sunlight, which helps greatly during the long Vermont winters.

For over two decades this little house served my family (and sometimes three to four additional family members) very well. At only 732 sq. ft., it provided shelter for a family of four — mortgage free!

Floor Area: 732 sq. ft. / 68 m²

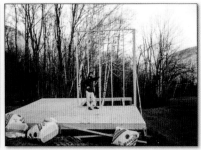
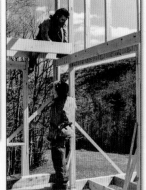
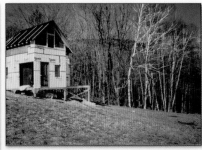

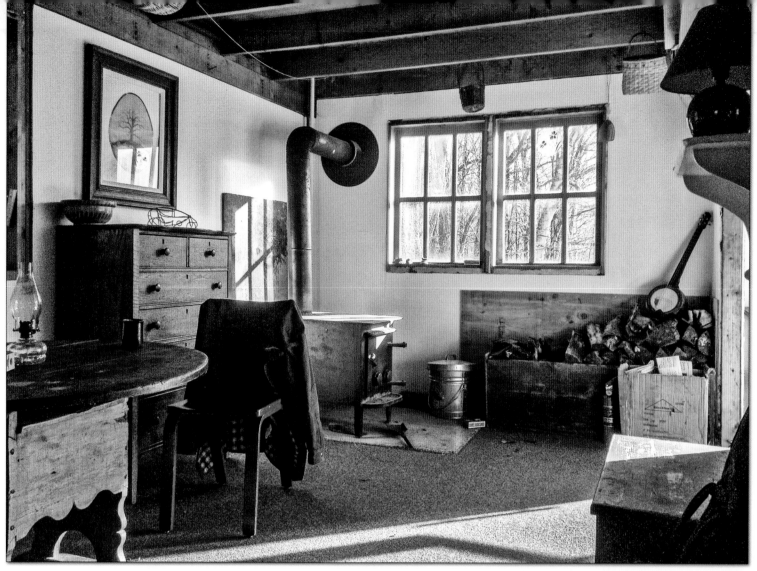

"I had only $3,500 to my name and no credit and my wife at the time was seven months pregnant."

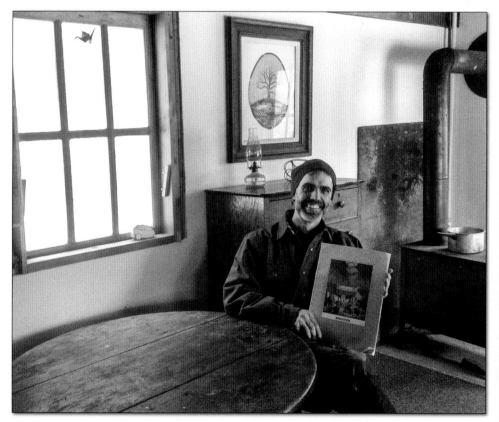

Casey Ryan, age 6, playing mandolin on deck

"It has provided shelter for a family of four—mortgage free!"

More...

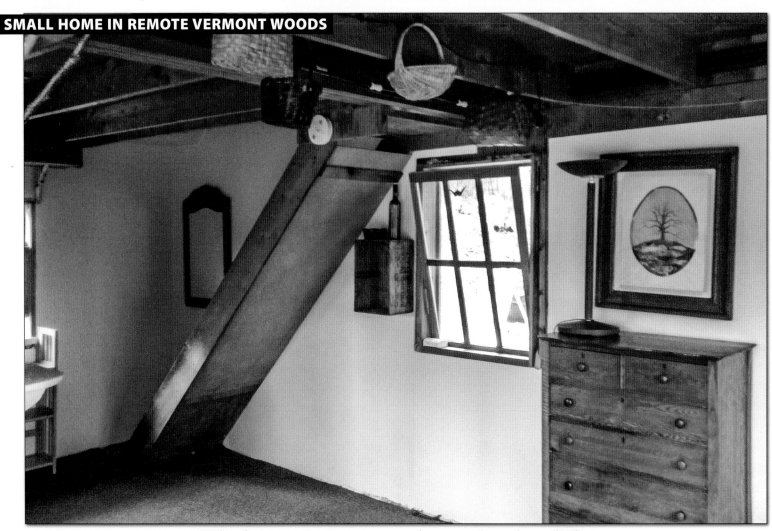

*"The house is very cozy and gets a lot of sunlight,
which helps greatly during the long Vermont winters."*

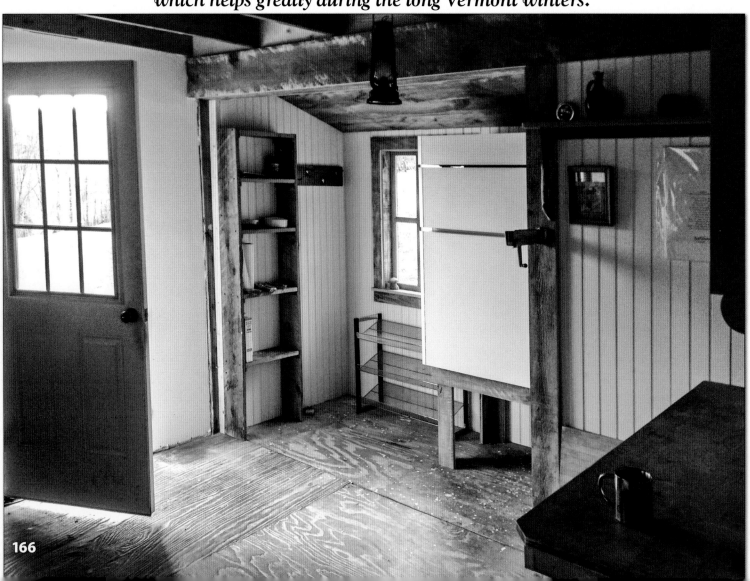

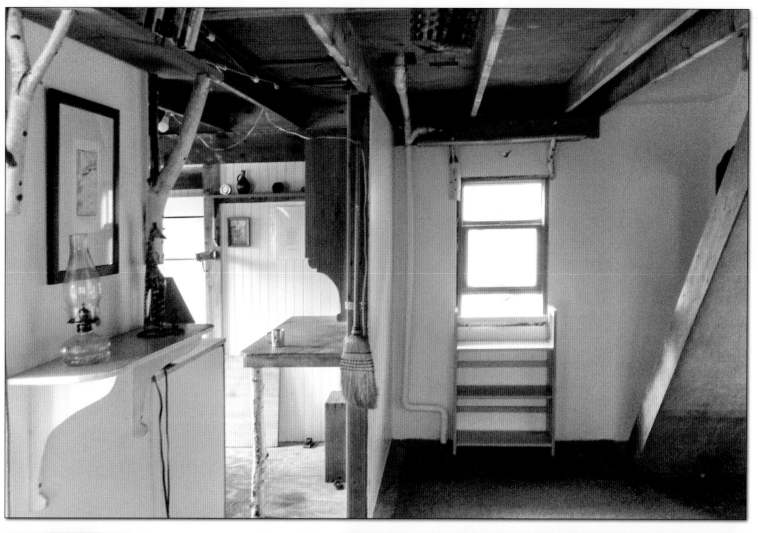

"For over two decades this little house served my family (and sometimes three to four additional family members) very well."

Casey Ryan, age 7, in red summer attire

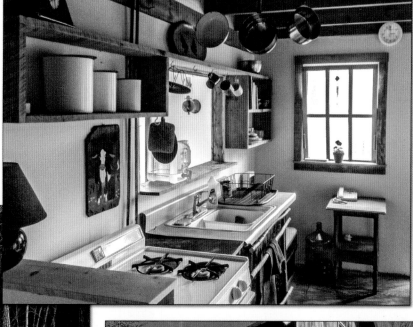

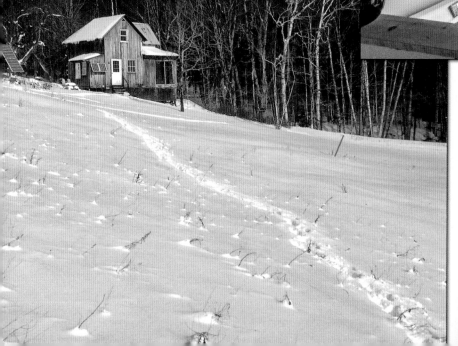

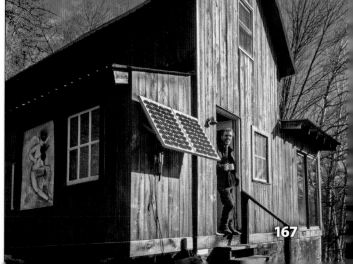

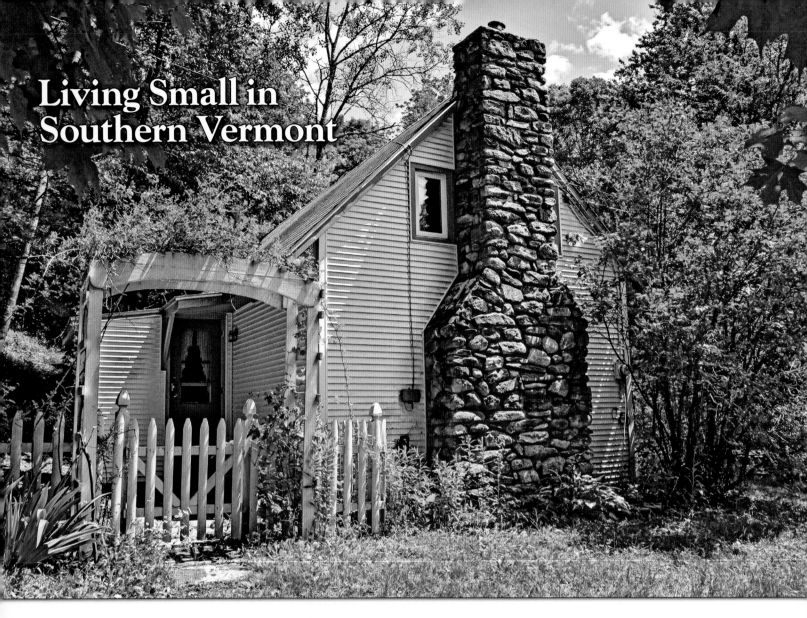

Living Small in Southern Vermont

Linda and Rob Sperry

Greetings! Welcome to Deer Valley Cottage, our 480-square-foot small home in southern Vermont. Our house consists of a living room/kitchen, bedroom, and a bathroom. My husband Rob and I have lived here since July 2013.

The main part of the house was built around 1960 but the bathroom extension (with sliding "barn door") was added about seven years ago. My heritage is strongly Norwegian and I have decorated our home with many objects handed down to me from my Nordic grandparents.

Our cottage sits on just over six acres of land, partly forested, and rocky throughout. A 75′ × 55′ man-made pond is an "offshoot" of the stream that borders the property. And for an extra special touch there's a sturdy 14′ × 14′ treehouse up in the woods, which serves as a warm-weather guesthouse.

Aside from a 6′ electric baseboard, our only heat source had been the inefficient propane insert in the fireplace. (The room is too small for a woodstove to fit comfortably.) In October of 2014 we had a

Mitsubishi cold-climate heat pump installed in the bedroom. You can see it high on the wall above the desk in the bedroom photos. It has worked better than we anticipated, putting out heat at temperatures as low as minus 10°F. (The propane insert and/or electric baseboard are needed to supplement the heat at temps below 15°F.) A simple shelter keeps snow off the small outside unit.

We calculate that the heat pump saved us at least $2000 last winter, keeping in mind we also had added insulation and caulking before installing it. The unit in the bedroom has various fan speeds; the lower ones are extremely quiet and are used at night. During the day we run a small fan in the bedroom doorway to help warm air reach the rest of the house.

Fortunately, I enjoy organizing things to be as efficient as possible, which is important when living in a small home. Much of the furniture does double-duty. Keeping clutter, whether it's everyday "stuff" or decorative items, to a minimum is a challenge.

"Our cottage sits on just over six acres of land, partly forested, and rocky throughout."

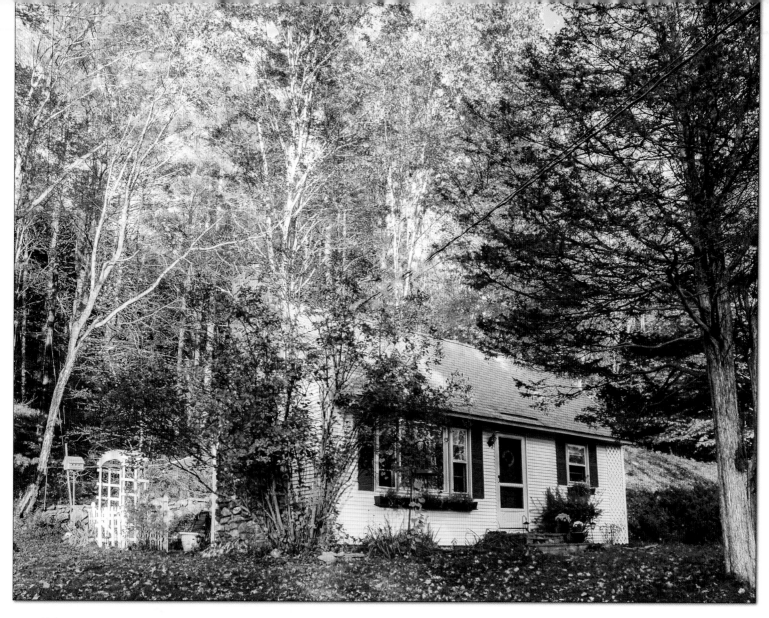

"A 75′×55′ man-made pond is an 'offshoot' of the stream that borders the property."

More...

As with many people's homes, Deer Valley Cottage is a work in progress. One project for this year is replacing the wall-to-wall carpeting in both rooms with cork or wood flooring. There are many other plans as well, including board-and-batten siding to replace the vinyl.

Storage is a challenge in a small house, especially if, like us, you own hundreds of books, even after a few "purges"!

Shortly after we moved in, Rob installed pull-down attic stairs and we insulated the roof rather than the floor up there. Enough heat sneaks up to the attic to keep it in the low 50s in the winter and not overly hot in the summer. It's fairly well organized and we can find books or other things we want quickly. I have claimed one end for my photo and art studio even though there's not a lot of headroom. Bulky kitchen appliances that we may use about once a week are kept on shelves near the attic stairs so you only have to go halfway up to reach them.

The kitchen has no counter, cabinets, or drawers. My grandparents' cottage-style buffet, the perfect height for a counter, provides food storage as does a tall, free-standing cabinet just a few steps away in the bedroom. Rob's old chest of drawers, next to the buffet, holds silverware, utensils, and linens.

Most of our clothes are stored in cheap plastic laundry baskets that slide out from under the bed. Hanging clothes go in the primitive wardrobe we've had for years. The attic has a metal bar at one end for hanging off-season clothes.

Rob and I prefer to entertain just a few people at a time, which is an advantage in a compact home, though we have fed eight people inside with the help of a folding table that fits nicely over the coffee table in front of the couch (stored in a shed). Most often the leaves that extend our table are used for seating ourselves and two guests. In the spring, I clip a large, white, waterproof tarp to the house and two trees, protecting our patio from sun and rain in the warm weather and creating a comfortable space for ourselves and visitors.

Certainly we've made lifestyle adjustments, but we love "living small" and have found that almost everyone that visits says they would love to "live small" too!

Floor Area: 480 sq. ft. / 45 m²

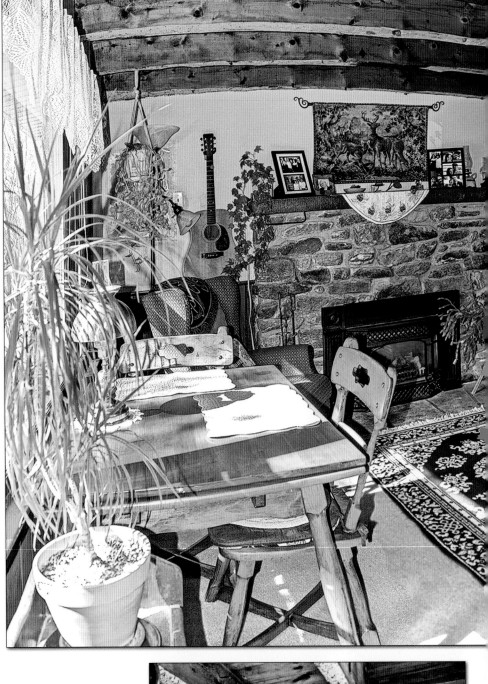

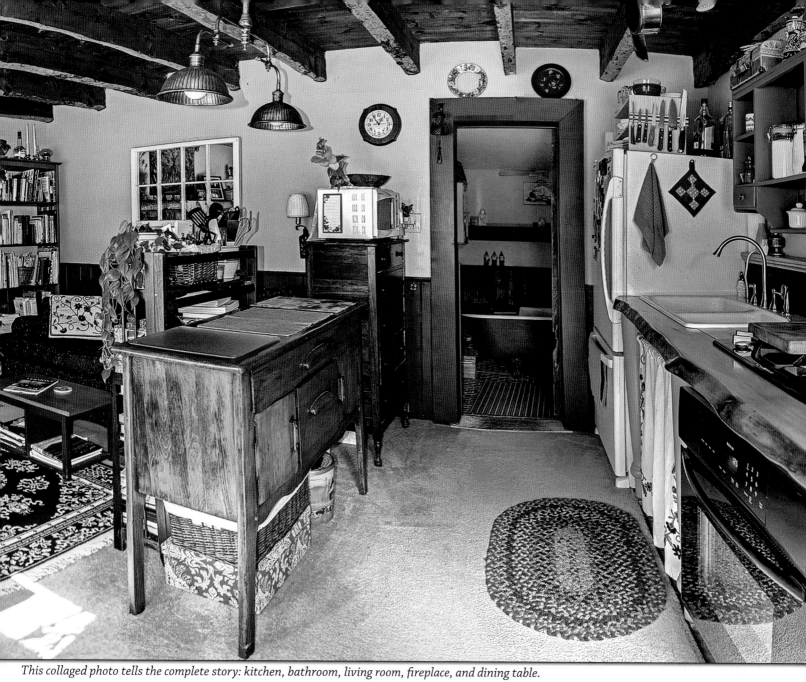

This collaged photo tells the complete story: kitchen, bathroom, living room, fireplace, and dining table.

"In October of 2014 we had a Mitsubishi
cold-climate heat pump installed in the bedroom."

"Most of our clothes are stored in cheap plastic
laundry baskets that slide out from under the bed."

More...

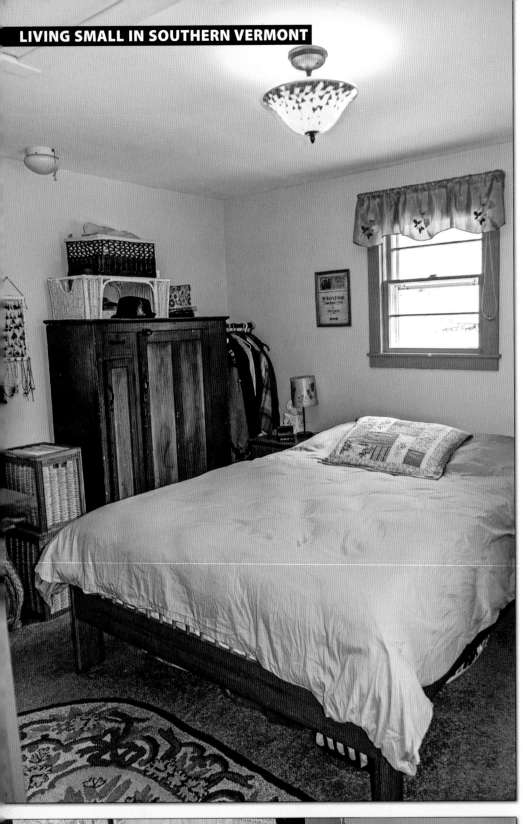

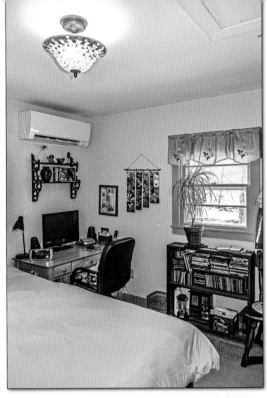

"The kitchen has no
counter, cabinets, or drawers."

"There's a sturdy, 14′ × 14′ treehouse
up in the woods, which serves
as a warm-weather guesthouse."

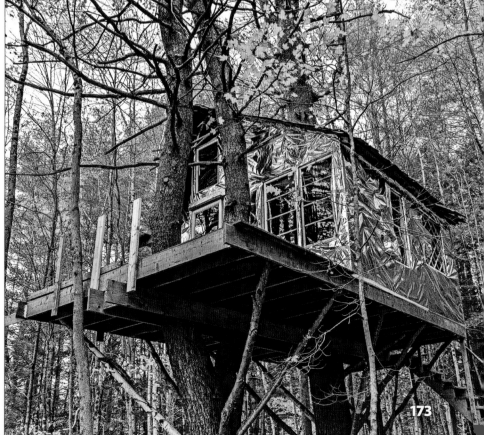

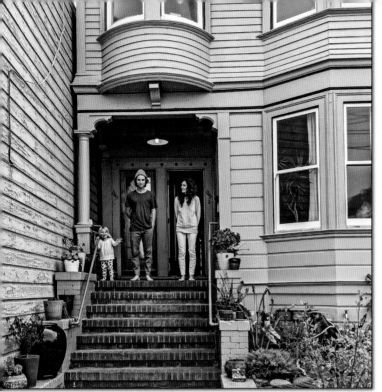
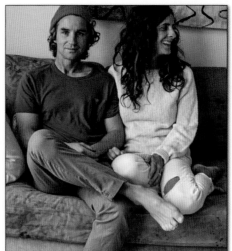

The big benefit is that it cuts the price of a home in half.

A Two-Family Home in San Francisco

Jay Nelson, Rachel Kaye, and Dalia Burde

"WE WOULDN'T HAVE BEEN ABLE to buy the house ourselves," says Jay Nelson. Four years ago, a contractor friend of Jay's wanted to sell his San Francisco home, in a neighborhood near Ocean Beach, but Jay and his wife Rachel couldn't afford it. So they made a *tenants-in-common* agreement with their friend Dalia Burde to buy the house jointly.

This type of agreement, popular in high-priced San Francisco, allows multiple parties to pool their incomes and qualify for a bank loan. A lawyer will draw up a contract, trying to foresee any changes that might arise in the future.

This home had already been converted into two units. "San Francisco is always cold," says Jay, so he did a lot of insulation, replaced old windows with double-paned ones, and ran pipes under the floors for radiant heating with hot water.

Jay, Rachel, and their daughter Romy live downstairs, and Dalia lives upstairs.

In the backyard there's a studio, a pizza oven, some vegetable beds, an outdoor shower, and a spiral staircase going up to a deck on Dalia's level. Clear communication is a necessity, they say, and once a month the three of them have pizza in the backyard and talk about their joint venture.

This seems like a viable alternative for people in cities. The key factor of course, is that all parties get along well. The big benefit is that it cuts the price of a home in half.

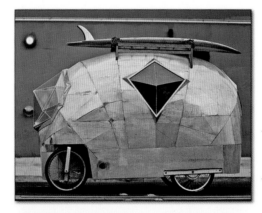

I ran across Jay's work several years ago. Witty and elegant moveable vehicles.

Then I started seeing his carpentry creations: a wonderful treehouse, outdoor shower, and small cabin in tropical Hawaii, a studio built of recycled lumber with huge sliding doors; creative carpentry with good design, used lumber, and good craftsmanship.

One day I went to his house and he was just coming in from surfing. He hurried into the backyard, and took an outdoor shower. We were looking around at the benches, tables, pizza oven, garden beds—all in the backyard of a house in a big city—and he said, "I want to build *everything*."

Jay is not only a builder, but also a prolific artist and painter, whose work has appeared in *Tiny Homes* and *Tiny Homes on the Move*. Rachel is a painter, and Dalia is a filmmaker.

Floor Area:
Downstairs: 800 sq. ft. / 74 m²
Upstairs: 900 sq. ft. / 84 m²

www.jaynelsonart.com
www.rachelakaye.com
www.avocadosandcoconuts.com

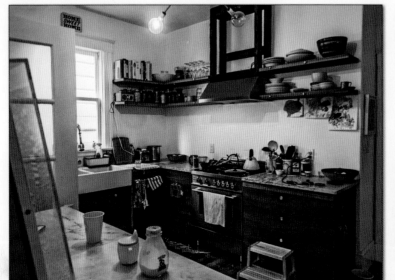

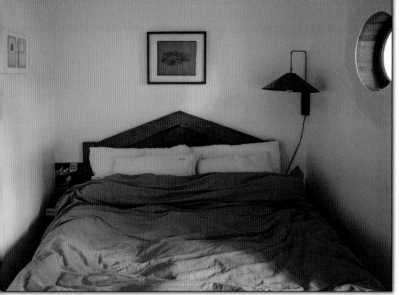

Jay, Rachel, and their daughter Romy live downstairs.

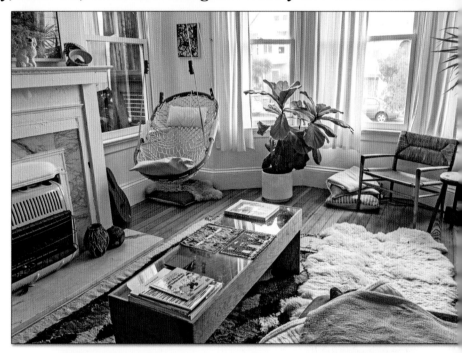

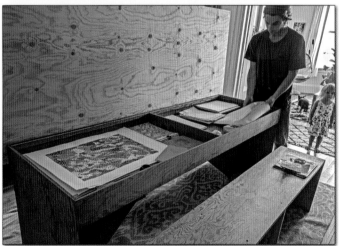

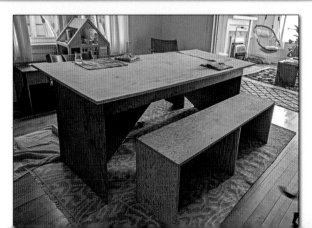

More...

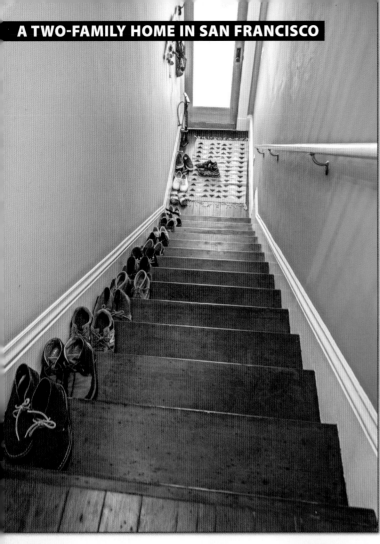

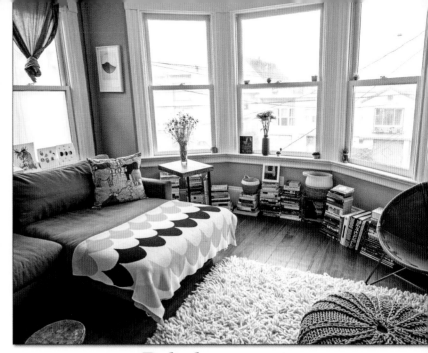

Dalia lives upstairs.

In the backyard there's a studio,
a pizza oven, some vegetable beds,
an outdoor shower, and a spiral staircase
going up to a deck on Dalia's level.

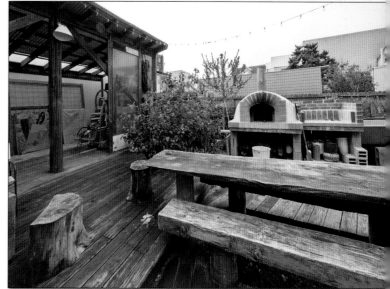

Fixing Up an Old, Small Home in LA

"We are a family of four living in Los Angeles."

Josh and Donna Robinson

Lloyd,

We are a family of four living in Los Angeles. The real estate market is pretty tough here, but after much looking and effort, we were able to get into a bank-owned home three years ago; it had been vacant for a couple years.

It is approximately 1100 sq. ft. and was built in the late '50s. It was moved from the valley to its current location in NE Los Angeles (just 4 miles from Union Station) in 1967.

Our challenges have been many. The house, as it was built in the '50s, lacks any kind of real character. But the real problem turned out to be that much of the work done on it over the years has been more of a band-aid than anything else and was done at a minimum.

Floors were rotten, structural framing had been shredded into cardboard by termites, etc. But it's a beautiful little spot in LA and we feel fortunate to have found anything here.

There's a large, undeveloped park area down the street, the neighbors are neighborly, and we're really close to downtown. We are also really close to the Lummis home (a famous rustic American Craftsman stone house built in the 1800s.

I had hoped to get more done on this place before sending you photos. But there are always more things to do (and more ideas about what could be done) than there is time.

In any case, I was happy to hear that you were doing this project. I first came across your book *Home Work* in Kansas City at a used bookstore. I'm on board with everyone who says they are inspired by what they see in the books.

But I've always been a builder and a maker. The idea of doing those things never seemed daunting to me; what's always inspired me more are your perspectives and the way that you personally seem to live your life. Obviously, the eye-opening and inclusive lineage of Rudofsky, the culture of the renegade builders, and the escapist ideas of the '60s are compelling and alluring.

But for me, leaping that far has always seemed problematic, and perhaps a bit short-sighted. In any case, as less and less of the world remains wild, these ideas become more difficult and more critical. Although that has been said for generations already.

The critical space lies in the midst of these things and I think that may be why the concept of the small home in the city is rather poignant and insightful. For my wife and me, who are both art-school kids and makers, neither the idea of living totally outside of civilization or in a beehive apartment are conducive to the life we want to live.

She works in ceramics and glass and I'm in architecture (don't judge me) and spent a decade in the trades as a builder, but also went to school for fine art painting. These things take space, and they are also communal (besides being a painter anyway).

Our house actually doesn't quite cover it for the makers in us, but it does pretty well as a home. Being from the '50s it was built incredibly spatially efficient.

It's a 3-bedroom, 2-bathroom house and its 1100 sq. ft. is smaller than most homes being built today. But it's perfectly adequate for us and serves our needs of living within the city in a way that's responsible.

Floor Area: 1100 sq. ft. / 102 m²

www.robinsonindustry.com

Josh, Donna, Domenico (Nico), River

"I've always been a builder and a maker."

"The real estate market is pretty tough here, but after much looking and effort, we were able to get into a bank-owned home three years ago; it had been vacant for a couple years."

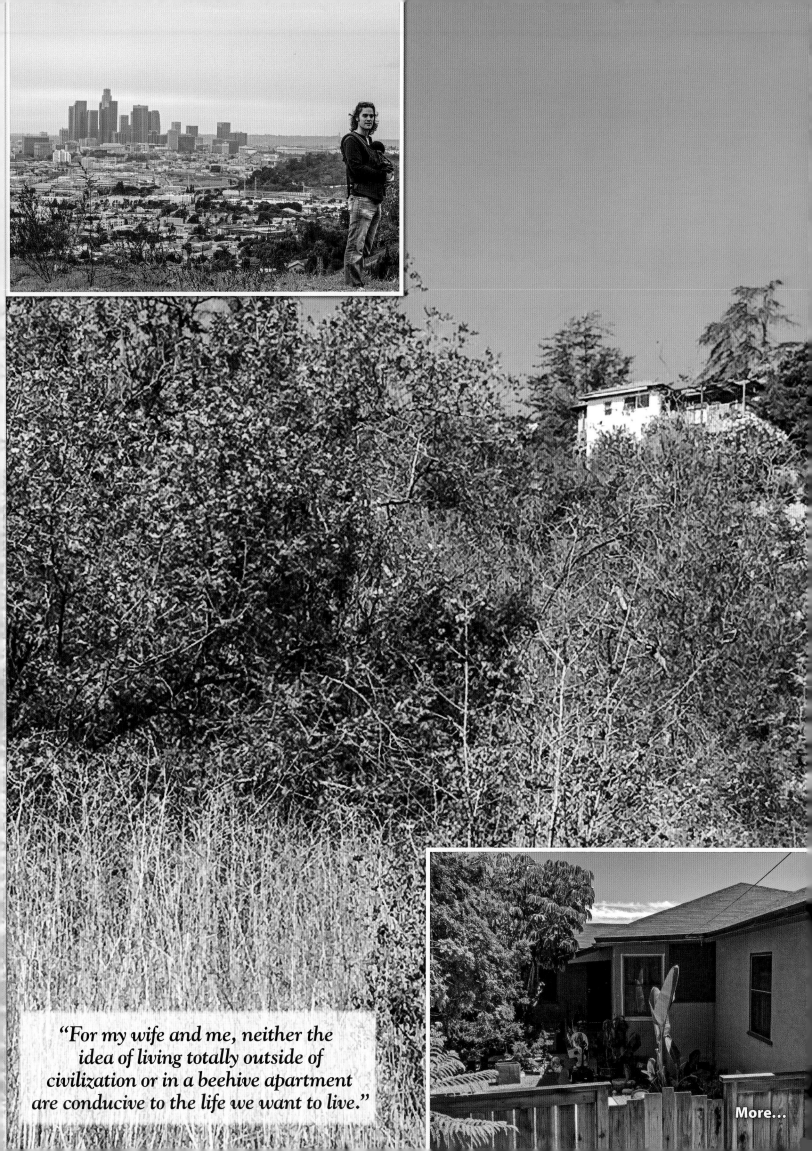

"For my wife and me, neither the idea of living totally outside of civilization or in a beehive apartment are conducive to the life we want to live."

More...

> "*Floors were rotten, structural framing had been shredded into cardboard by termites, etc.*"

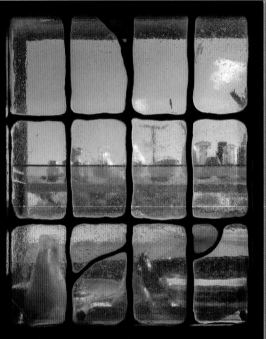

This is our kitchen window, which we found at a salvage place. Apparently there was a Wallace Neff home being remodeled nearby and this beautiful window wasn't desirable anymore.

Our deck is still built rather thinly, but when we moved in there wasn't even a railing. So with a baby on the way, we had to act fast. We also live in an area where hillside fire clearance is an issue and because our home was bank-owned for years, the back area was overgrown. I used some of the invasive trees I cut away as balusters for the guardrail.

We gutted the bathroom to replace galvanized plumbing, rotten sub floor, and windows. We reused the toilet, and put in a salvaged medicine cabinet, tub, and sink basin. I built a cabinet around the basin and the marble is a remnant we were able to get from friends who recently remodeled their kitchen. We brought in a tile setter, since I'm working full time and didn't have time to do it myself, but otherwise I did all the work.

We found this cabinet at a salvage place. Not sure of its age, but it appears to originally have been built completely on-site out of full-dimension lumber. So clearly it's pretty old. I had to rebuild the back of it a bit, but it's made a useful and aesthetic addition to our dining area.

"It's a beautiful little spot in LA and we feel fortunate to have found anything here."

"It's perfectly adequate for us and serves our needs of living within the city in a way that's responsible."

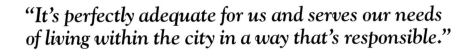

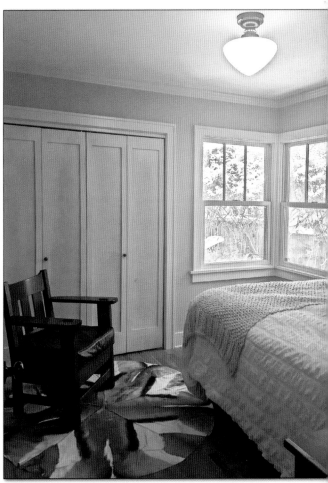

The bedroom was actually the first project because I thought it was going to be simple. Take down some wall paneling, sand the windows, build up a closet wall, and spread some paint around. Instead the windowsills had been shaved down because after the move they were slanted and the headers were practically paper from termite damage (amongst some other surprises). It took a bit longer than expected.

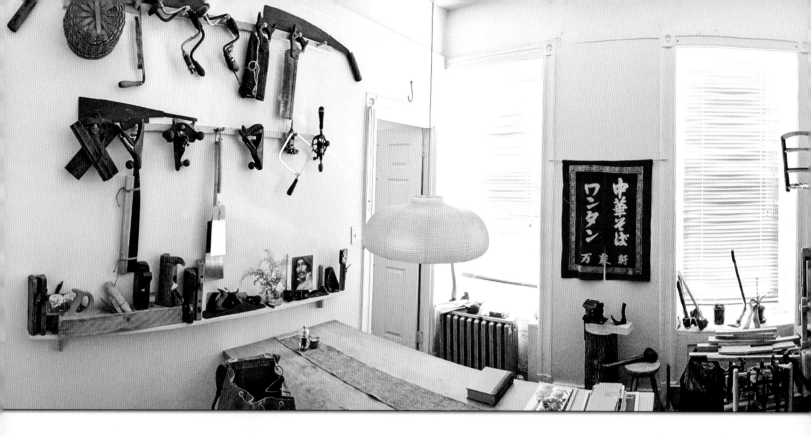

Cabin in the Woods in Brooklyn

Derek Lasher

The most prominent pattern in the apartment is the thorough use of wall space for storage.

Tom Bonamici's apartment has been described as a cabin in the woods in Brooklyn, and it's definitely my favorite museum in all of New York. He's an industrial designer and carpenter who is particularly interested in kitchens inspired by workshops. In the three years he's lived in this generic, low-end NYC (Bed-Stuy, Brooklyn) rental, he turned it into a space that both fit and reflects him perfectly.

The most prominent pattern in the apartment is the thorough use of wall space for storage. Inspired by the Shakers, peg rails wrap both the main room and the entry hall while the pegboard over the stove and the hutch above the counter keep everything in the kitchen close at hand.

With tools, flea market finds, and a diverse book collection in plain view, visitors can't help but explore the small space, picking up objects, and flipping through volumes about building, foreign cultures, and old-time rural life.

It has also been the setting for friends, new and old, to come together over meals, cooking, and projects. I've built furniture there, carved spoons, mended clothes, cooked food, and learned a ton. A productive mess is always welcome and the brooms are kept close at hand.

Tom's choice to use the main room for dining instead of lounging is uncommon, but it's what I'd recommend to anyone forced to pick one or the other. A couch and coffee table are great for relaxing, but leave you wanting around mealtime. Gathering around a table—whether you're socializing or sharing a meal—is always a delight.

In all, it's one of the most inspiring places I've ever experienced.

Floor Area: 350 sq. ft. / 33 m²

Inspired by the Shakers, peg rails wrap both the main room and the entry hall.

"I've built furniture there, carved spoons, mended clothes, cooked food, and learned a ton."

More...

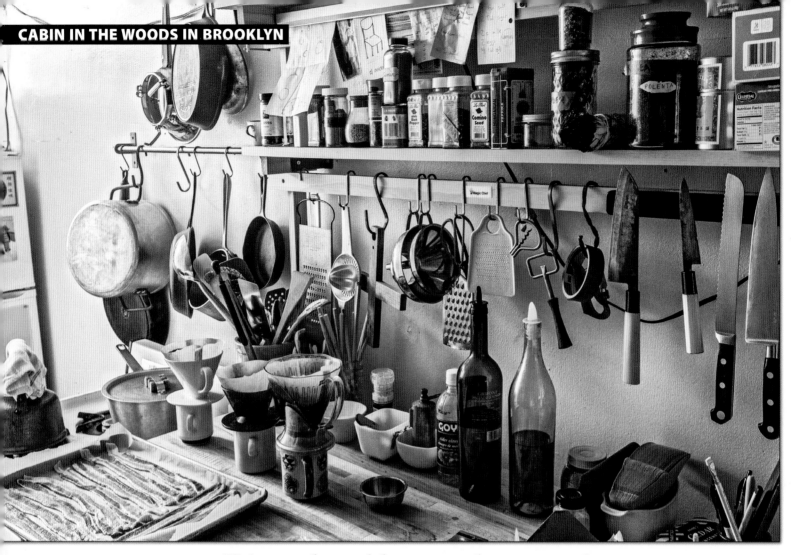

He's an industrial designer and carpenter who
is particularly interested in kitchens inspired by workshops.

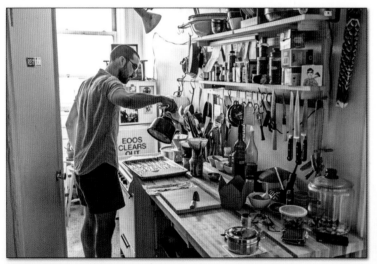

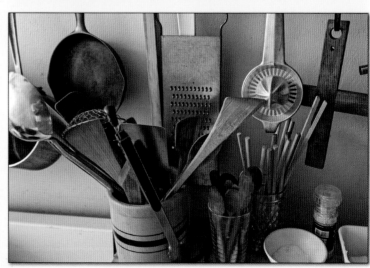

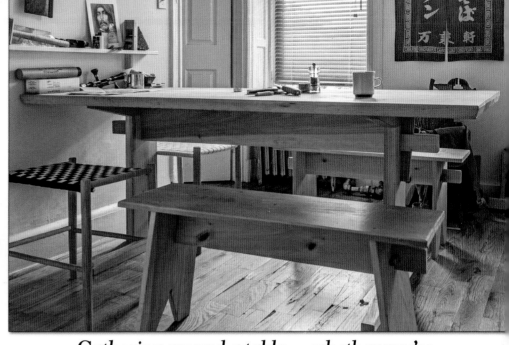

It has been the setting for friends, new and old, to come together over meals, cooking, and projects.

Gathering around a table—whether you're socializing or sharing a meal—is always a delight.

Urban Cabin that Harvests Sun, Rain, and Shade

Brad Lancaster

**Photos from *Rainwater Harvesting for Drylands and Beyond*
by Brad Lancaster**

IN 1994, INSPIRED BY THE ARTICLE "Residence Renaissance" in *Shelter* and a permaculture course, my brother and I purchased an about-to-be-condemned 1919 adobe bungalow on a ⅛-acre lot just north of downtown Tucson, Arizona. We renovated the home and yard into a sustainable showcase.

For many years we (my brother, his family, and I) all lived in that same 740-square-foot house (where I also worked); but, as the family grew, I decided to move into the site's stand-alone, 200-square-foot, one-car garage *(at right)* after transforming it into a cottage, or "garottage."

I wanted that small space to feel expansive and connected, while having a positive impact that was both accessible and big.

To do so, I collaborated with bigger, free energies and potential such as sun, rain, and community. The building's orientation to the sun was ideal for *free*, passive winter heating and summer cooling. At our latitude, the *winter* sun rises in the southeast, sets in the southwest, and is always low in the southern part of the sky; while in *summer* the sun rises in the northeast, is due east around 9am, is overhead at noon, due west at 3 P.M., and sets in the northwest. Thus the building's long, south-facing wall faces the winter sun, maximizing free winter heat and light all day long. The shorter, east- and west-facing walls face the summer's morning and afternoon sun to minimize unwanted direct summer sun exposure.

When I raised the roof to create loft space and more south-facing windows, I was

One-car garage before transformation. Most of the junk within had just been removed to begin reconstruction.

sure to maintain winter sun access for my neighbor's house to the north — by limiting the height of the roof and setting its angle close to that of the winter sun. This ensured *both* buildings could be freely heated, lit, and powered with the sun, rather than with costly fossil fuels.

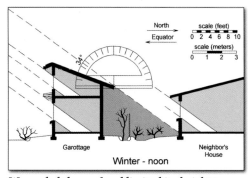

We angled the roof and limited its height to maintain solar access for neighbors. A shadow is cast on the neighbor's south-facing wall at noon on the winter solstice. Protractor shows angle of winter solstice sun at 32°N latitude.

The south/equator-facing roof overhangs and windows were designed to *let in* the maximum amount of direct *winter* heat and light, while *shading out* the maximum amount of direct *summer* sun *(see below)*.

Passive summer shading/cooling was further augmented (without hindering winter heating) by building a covered porch over the 100-square-foot outdoor kitchen on the east side of the structure and by planting food-bearing trees to the east and north. West-side shading was enhanced by building an outdoor closet/shed against the west wall, and planting more food-producing trees. As a result I'm bathed in the warm glow of direct sun throughout the winter days, and in summer I'm embraced by cooling shade — passive bliss.

To make the interior feel bigger, it is all one multi-use room *(see pp. 188–189)*. But I can temporarily divide the larger room with curtains into smaller curtained rooms as needed.

Minimizing the footprint of the buildings maximizes yard and outdoor living space. This saved money, as did putting some indoor rooms outdoors.

All irrigation needs of the landscape and garden are met with free, on-site rainwater and greywater distributed by gravity-fed systems. All water for the garottage comes from its roof plus a 100-square-foot section of the main house roof — all of which is directed to two 1,000-gallon rainwater tanks which double as a fence and privacy screen on the northern property line. Overflow from the tanks cascades through

"I purchased an about-to-be-condemned 1919 adobe bungalow on a ⅛-acre lot just north of downtown Tucson, Arizona."

Noon on the winter solstice. Full winter-sun access provides free heat and light when we need it most. Arrow denotes the angle of the sun's rays and the resulting shadow cast by the roof's overhang.

Noon on the spring equinox. Direct sun exposure is designed to decrease as temperatures rise and less direct solar gain is needed.

Noon on the summer solstice. Full summer shade provides free cooling when we need it most. Awning has been extended for the hot season to maximize the cooling shade. See www.SunAndShadeHarvesting.com for video.

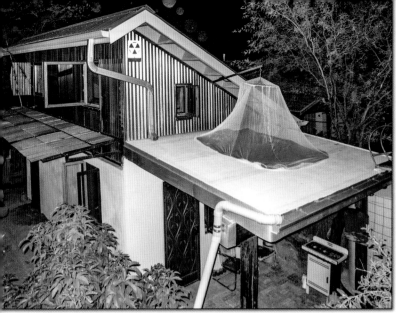

Porch-roof bed. Summer night. Due to dramatic nighttime radiant-heat loss in our dry climate, summer-night temperatures on the roof are 10°F (5.5°C) cooler than below the roof, and 5°F (2.7°C) cooler than on open ground.

Outdoor closet/shed on west-facing wall shades and cools the garottage from hot afternoon sun, and keeps clutter and stuff out of the limited interior space. Photo taken on winter afternoon.

"We renovated the home and yard into a sustainable showcase."

stepped rain gardens from the top of the yard to the bottom.

A legal, site-built compost toilet takes care of that need, while turning human waste into a safe and fertile soil amendment.

Electricity comes from a grid-tied photovoltaic power system on the roof of the main house, which produces three times the power needed by both households. Surplus power goes to our neighbors.

A 5-gallon propane tank fuels a two-burner camp stove in the outdoor kitchen. For oven cooking, I use a solar oven I made 20 years ago from scrap wood, metal, insulation, and glass. Water is heated on the stove or by a batch-style solar water heater my brother and I built — again using many salvaged materials *(below left)*.

Seventy-five percent of the building materials were salvaged. For example, the metal siding was the old metal roof from the garage. The wood beams for the loft and porch, along with the outdoor kitchen's brick floor, came from a local school being renovated three blocks away. Curtains came from scrap fabric from a theater four blocks away. Coat racks, hooks, and other hardware were fabricated from salvaged bicycle parts from a bicycle coop three blocks away *(top right photo, p. 189)*.

Family, friends, friends of friends, neighbors, and I did all the work. This made for a jovial work site that also cycled barter and work pay numerous times throughout the local community.

"All water for the garottage comes from its roof plus a 100-square-foot section of the main house roof."

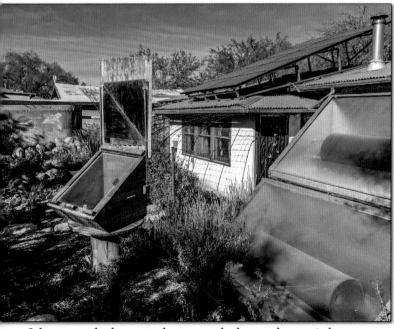

Solar oven, solar hot-water heaters, and solar panels at main house

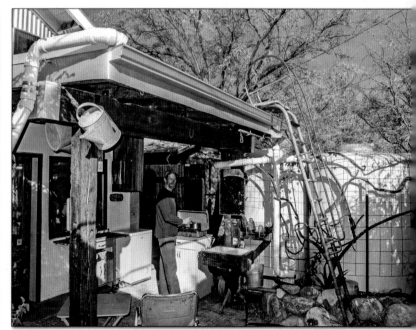

Outdoor kitchen under east porch roof, and two 1,000-gallon rainwater tanks. Rainwater collected from 450-square-foot roof area provides all the water needed for the garottage in Tucson, Arizona, where 11 inches of rain falls in an average year. Water is distributed with a gravity-fed system — no pumps.

More...

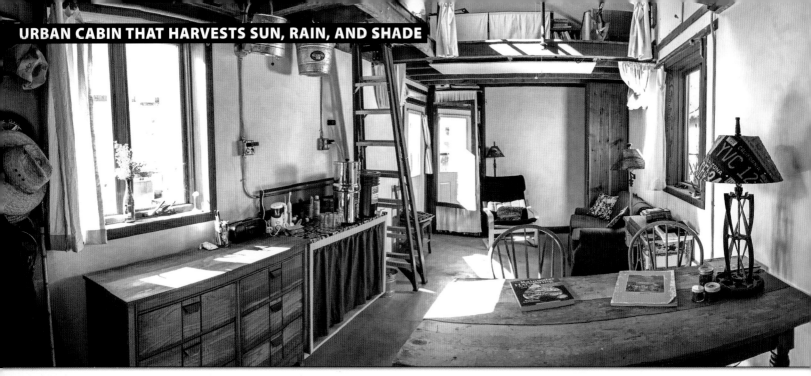

"I'm bathed in the warm glow of direct sun throughout the winter days."

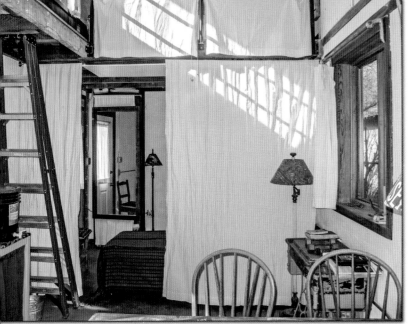

"Minimizing the footprint of the buildings maximizes yard and outdoor living space."

Indoor and outdoor thermometers on either side of window by the main door let us know when to open windows to let in desired exterior warmth or cooling, or close windows to keep out unwanted exterior temperatures.

Interior looking west with guest-room sofa bed extended, guest-room curtains partially drawn, and bedroom loft curtains drawn

"Electricity comes from a grid-tied photovoltaic power system."

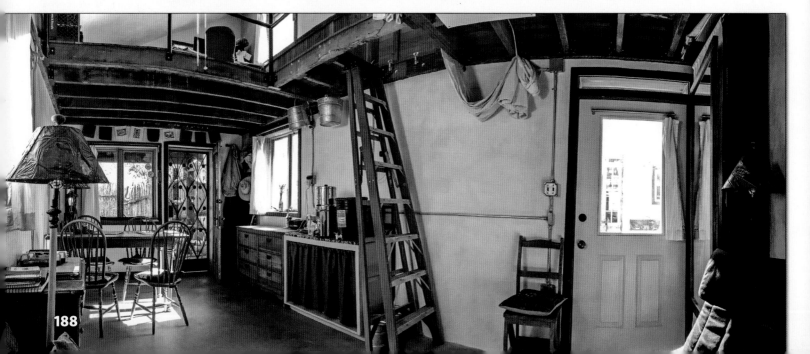

Simultaneously we continued working with neighbors and others at community plantings and workshops to transform a sterile public rights-of-ways along our neighborhood streets into beautiful botanical gardens of primarily native food–, medicine–, craft material–, and wildlife habitat–producing vegetation —all of it irrigated solely by passively harvested rainwater and street runoff to create regenerative, flood-controlling, *living rooms* for all within the public commons (*bottom photo*).

Floor Area: 200 sq. ft. / 18.5 m²

For a huge amount of information on planetary-friendly design (and more on this house), see:

 www.HarvestingRainwater.com

Additional notes:

- Cotton batt insulation used between 2″× 8″ salvaged wood studs
- 2-inch thick, rigid CFC-free and HCFC-free foam insulation used on outside of CMU block of original garage
- Backup cooling provided by a Solar Chill solar-powered evaporative cooler using harvested rainwater
- Backup heating provided by a Sola Ray radiant heater powered by our solar panels.

Coat and hat hangers made from salvaged bicycle parts at BICAS, the neighborhood bicycle cooperative

Before the 1996 planting of grain and trees in the public right-of-way adjoining property. Pile of black rubble is the just-removed asphalt driveway to the garage.

The public right-of-way adjoining property in 2015. All vegetation is irrigated solely by passively harvested rainfall and street runoff. All perennial plantings selected for their food-, medicine-, and wildlife habitat–producing characteristics. Vaughan, Chi, and Rodd Lancaster in photo

The Tin Shed

Mike Buckley

I BUILT THE TIN SHED IN Salida, Colorado, in 18 months with little prior building experience. I once heard someone say, "If you don't know how to do it, just start."

Drawing the plans myself proved to be invaluable. It was then that the bulk of my research occurred. I drew every stud in the house, so when it came time to build, I had a very clear idea of how the structure would go together.

The lot size is 24 × 150 feet, leaving only space for a 14-foot-wide house.* Building on such a narrow lot was a challenge. Large windows opened up the space.

The backyard faces south where a glass garage door in the living room lets in tons of light. In the summer, we open the garage door and extend our living room into the backyard.

The house was designed to be very maintenance-free, using durable materials. It has a metal roof, 22-gauge corrugated Corten steel siding, concrete floors, and 8″ wide, oak-plank floors upstairs.

4″ × 12″ Douglas fir beams were salvaged from the Seattle Federal Building for the stair treads. I used simple, inexpensive materials for much of the build to save money, but the house has zero particle board. I wanted the materials in the house to be identifiable, real materials.

I believe that beauty is the highest order of sustainability. Whatever you put into this world, make it beautiful. It will be loved and maintained for a longer, useful life. At the same time, I try to keep Buckminster Fuller's quote in mind, "When I am working on a problem, I never think about beauty, but when I have finished, if the solution is not beautiful, I know it is wrong."

*The house is 13′10″ wide by 42′ long.

Floor Area: 1162 sq. ft. / 108 m²

"The house was designed to be very maintenance-free, using durable materials."

190

"If you don't know how to do it, just start."

First level Second level

A Living Room
B Dining Room
C Kitchen
D Pantry
E Entryway
F Bathroom
G Bedroom
H Office

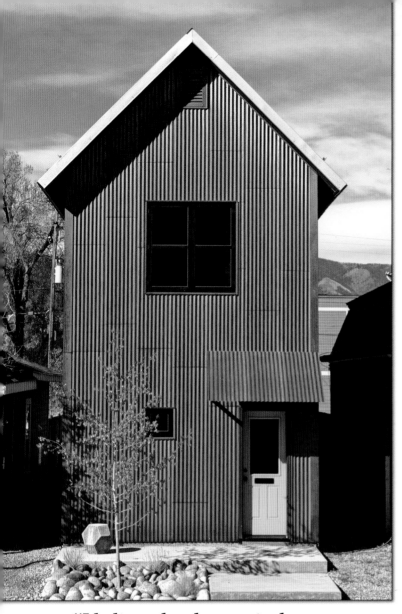

> *"I believe that beauty is the highest order of sustainability."*

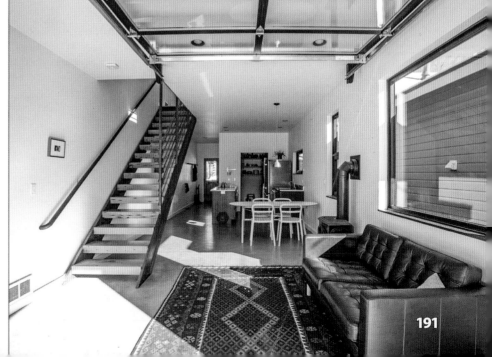

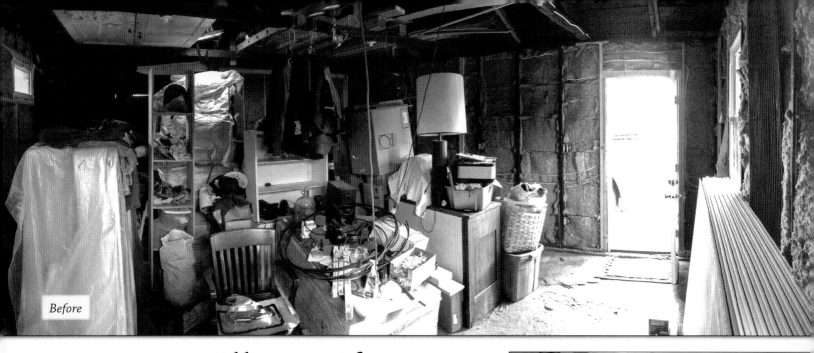

Before

Between Hills — Life in a Converted Kentucky Garage

Glen Dentinger

These photos didn't excite me when they first came in, but as I kept looking at them and corresponded with Glen, I got more and more interested, And now realize how great this is.

He has spent $6,000—not $60,000, or (hello, California)—$600,000 to create his home. That's equivalent to two to three months rent for a big-city studio apartment, and he's got a permanent home with no rent and no mortgage.

How great is that?

–LK

IN LATE 2013, I NEEDED A PLACE TO live. There seemed to be just two options: Buy a house or rent an apartment. Both had downsides, not the least of which would be to add significantly to a growing financial strain.

Meanwhile, a nearly 100-year-old garage languished, filled with junk, behind an apartment building I own. That it was a modest 400 square feet was much less a concern than its location across the alley from an industrial machine shop and some 75 yards from a heavily traveled railroad track. I knew from experience that a remodel could be expensive, but much less so with some resourcefulness and patience.

Finding materials was an adventure. Tin roofing, salvaged from a collapsed barn, became the wainscoting and vaulted ceiling.

Discarded outdoor-grade signage from a defunct business made an impervious lining for a shower stall. Off-cuts too small for the local cabinetmaker became a stereo shelf. Leftover reclaimed wood

flooring from an installation at a local business became cabinet face-frames.

I diligently combed Craigslist and found a free casement window, an antique propane stove, and a metal storage cabinet that I modified into a rolling wardrobe.

And the big haul: multiple bundles of recycled blue-jean insulation, known for its sound deadening qualities, was given to me by a retail shop after it had briefly gotten wet and was no longer fit for sale. Two days in the sun and it was ready to go.

While there have been trips to the hardware store and lumberyard, many of the materials were scavenged.

I'm a carpenter, and my work is mostly remodeling and repairing homes. With intimate knowledge of what goes into maintaining a structure, the goal for my own was that it be efficient and easy to maintain, leaving more time for creative projects. My hope is that modest size and sturdy materials will make this possible.

The current project cost is approximately $6,500. There's a lot yet to be done, but the need for affordable shelter means I've been living here through all stages of the renovation.

Official city paperwork still lists my home as a "garage," and by all outward appearances, that's what it is. I don't mind the classification, or even admitting that I live in a garage, when it has everything I need for it to feel like home.

Floor Area: 400 sq. ft. / 37 m²

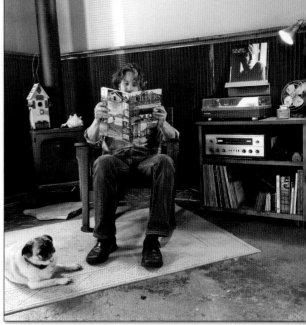

Reading Builders of the Pacific Coast

"Finding materials was an adventure."

"I diligently combed Craigslist."

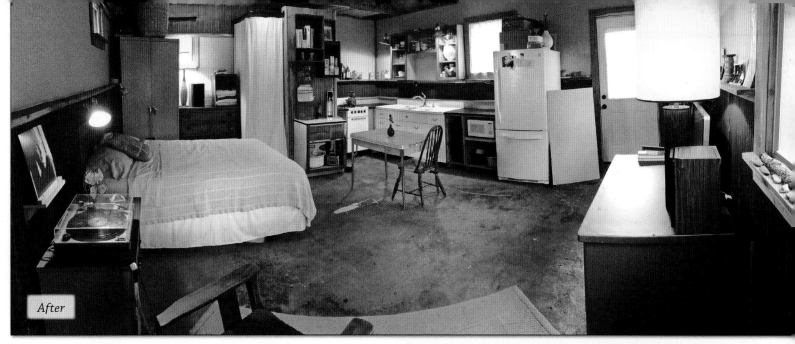

After

"The current project cost
is approximately $6,500."

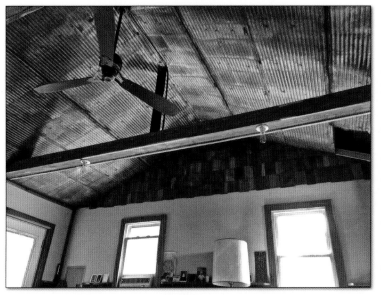

"Tin roofing, salvaged from a collapsed barn,
became the wainscoting and vaulted ceiling."

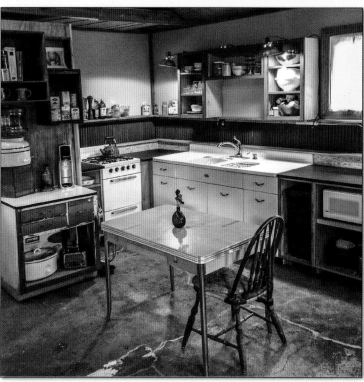

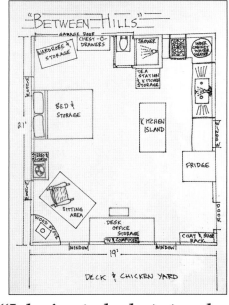

"I don't mind admitting that
I live in a garage, when it has
everything I need for it to feel like home."

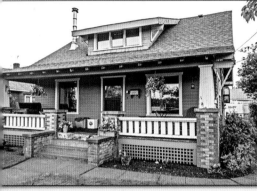
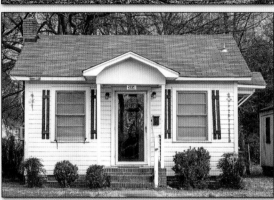
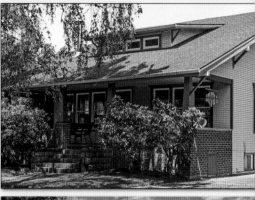
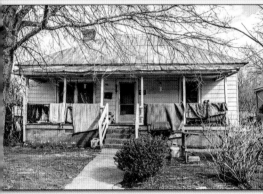
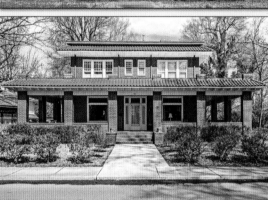
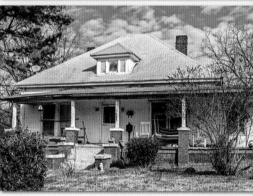
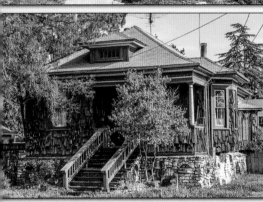
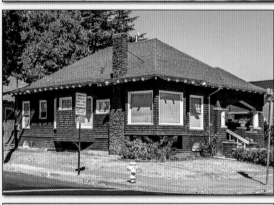

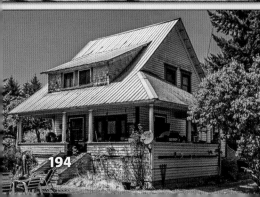

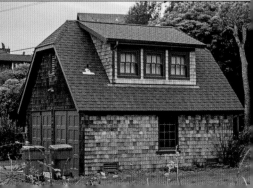

Small Homes in Cities and Towns

I SHOOT PHOTOGRAPHS WHEREVER I GO. When I go into cities or towns, no matter in what state or country, I take pictures of simple, small homes.

On these 20 pages are small homes from various locales. Many of them are in the East Bay of the San Francisco Bay Area: Richmond, El Cerrito, Hayward, Berkeley, Oakland, etc. Others are from San Francisco, Petaluma, Watsonville in California, and from Oregon, Washington, Ohio, Indiana, North Carolina, Connecticut, British Columbia, Hawaii— wherever my travels have taken me.

There are two reasons for showing them here:

1. If you are going to build a small home from scratch, here are ideas for design and size. Practical, simple, economical, based on tradition and experience. Ideas for roof shapes, dormers, porches, placement of doors and windows.

2. More to the point: There are small homes like this just about everywhere in the cities and towns of North America. Many are run-down or unloved. Whereas a prevailing idea in the '60s and '70s was finding a piece of land and building on it, times have changed. Costs are higher, codes restrictive or prohibitive, and life is more complicated.

Fixing up an old home in a neighborhood has these advantages nowadays:

a) The price is right.

b) It's easier than starting from scratch. You have the basics to begin with: foundation, wiring, plumbing, and waste disposal.

c) You have the many advantages of living in a city or town.

To tell you the truth, I'm amazed by the purity and simplicity of these little buildings. I hadn't really looked at them until I dug them out of my voluminous files a few days ago. They look so *right* in an era when so many homes look so *wrong*, especially those recently built.

Looking at them, I can't help but think of the lives lived and the shelter provided for decades by these simple, small dwellings — and still doing so.

Why don't we see any homes like this being built nowadays?

In the early 1900s, plans for homes such as these were readily available in North America. Moreover, homeowners could buy all the components as well as plans for specific houses from Sears Roebuck and other companies.

Here are a few books on the subject:

Sears, Roebuck Catalog of Houses, 1926
Dover Publications, 1991

500 Small Houses of the '20s
Henry Atterbury Smith
Dover Publications, 1990

Bungalows, Camps, and Mountain Houses: 80 Designs by American Architects
Originally Published in 1915
AIA Press

Houses by Mail: A Guide to Houses from Sears, Roebuck & Co., 1927
The Preservation Press, 1996

Authentic Small Homes of the '20s
Dover Press, 1987

Sunset's Cabin Plan Book
Sunset Magazine, 1936

Here is a wonderful source:

Images of Sears Homes — 447 house designs, including floor plans:
www.searsarchives.com/homes/byimage.htm

Note: If you're out and about with a camera and so inclined, shoot pictures of little buildings like this and send them to us. Who knows, maybe we'll do a book on them one day!

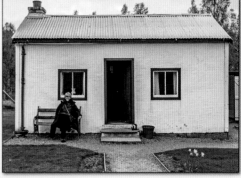

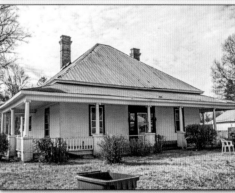

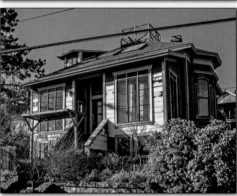

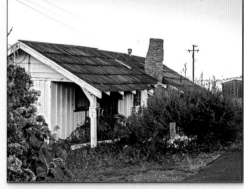

More...

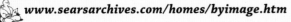

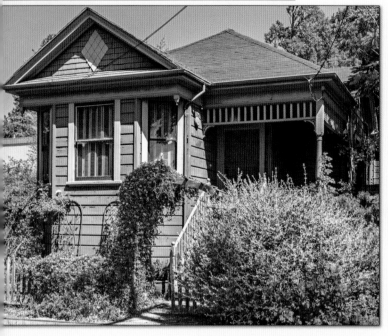
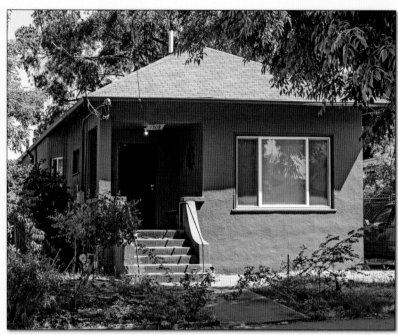
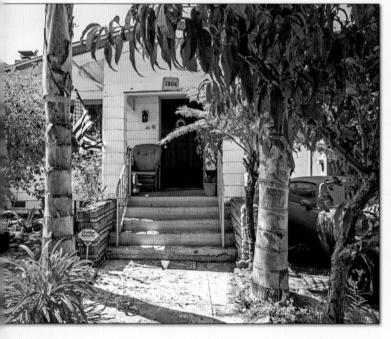
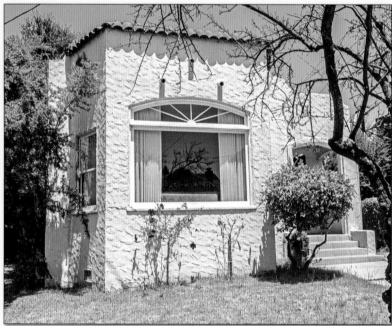
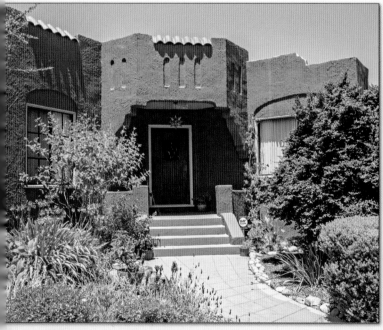

More...

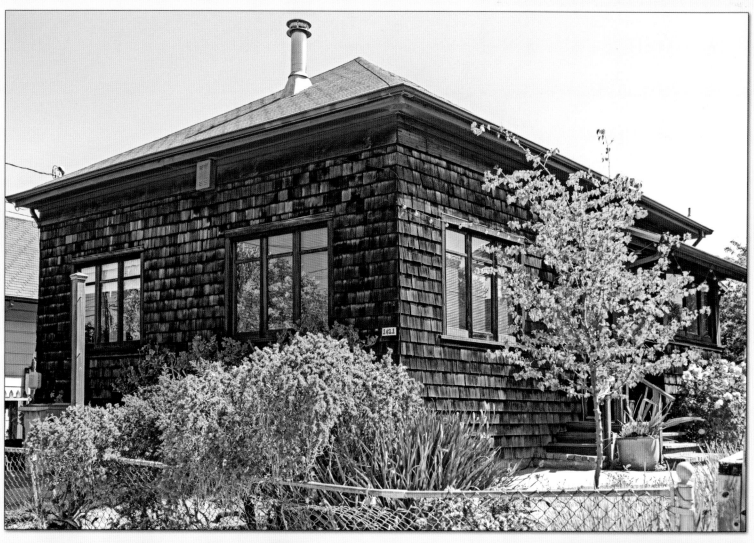

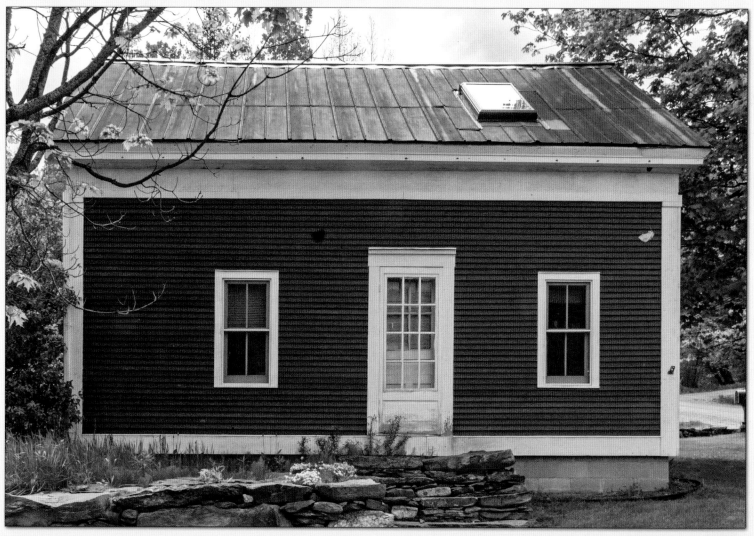

More...

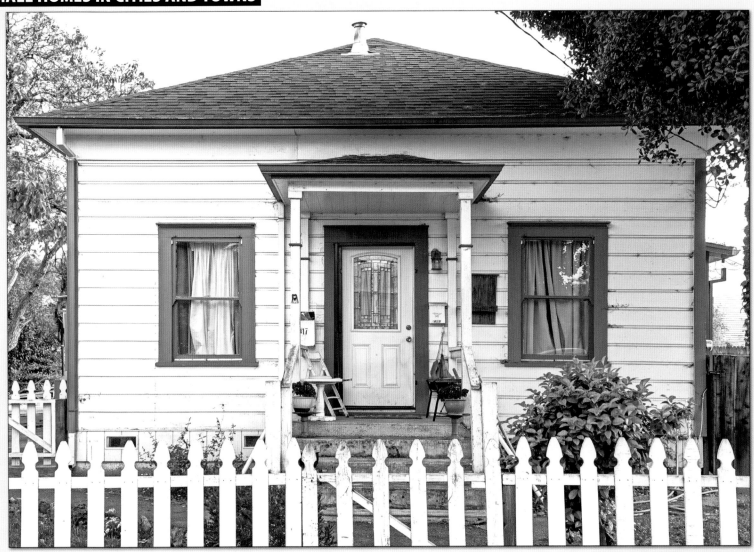

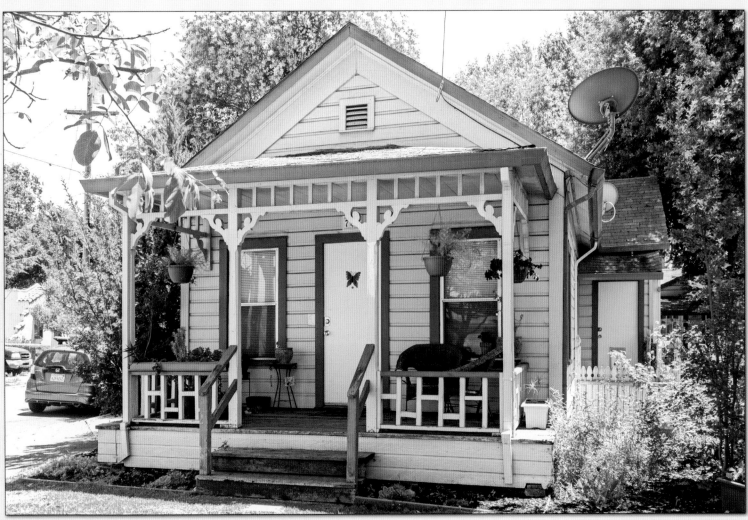

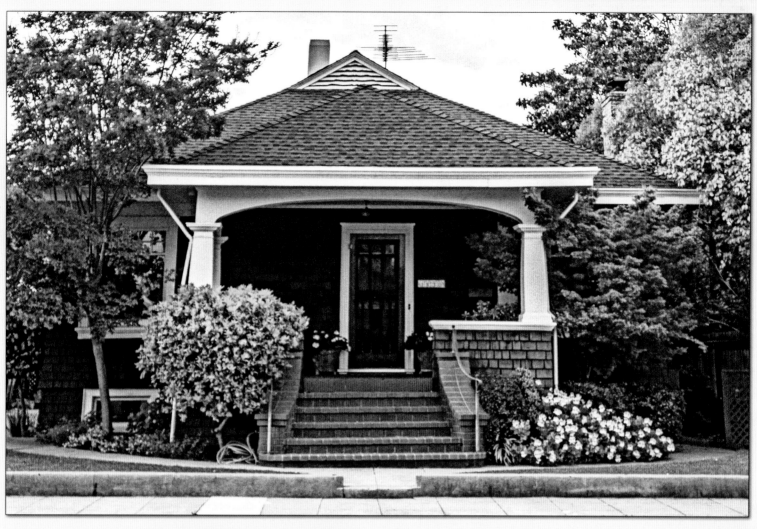

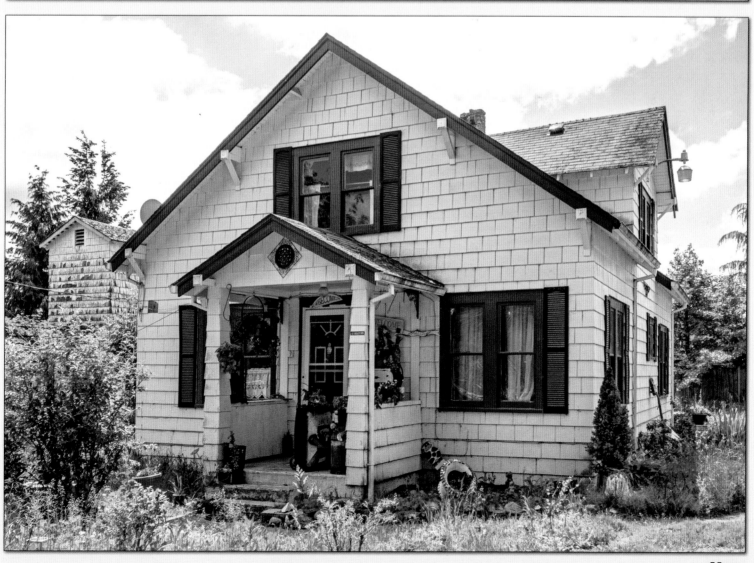

More...

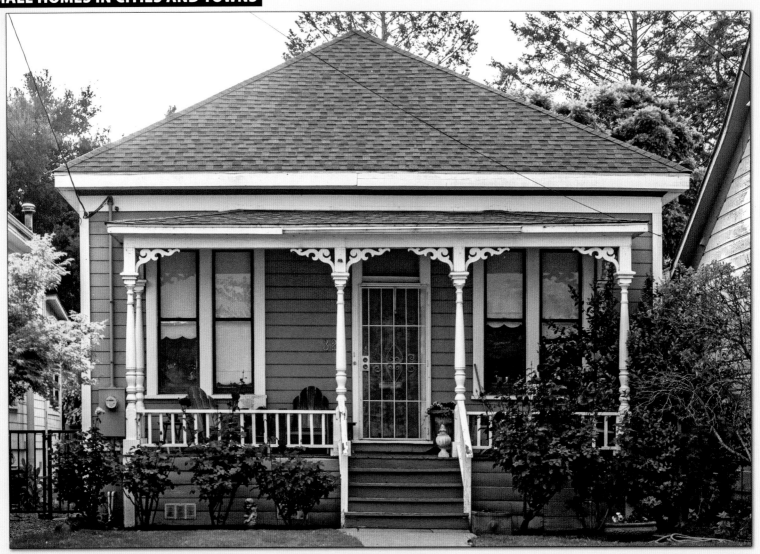

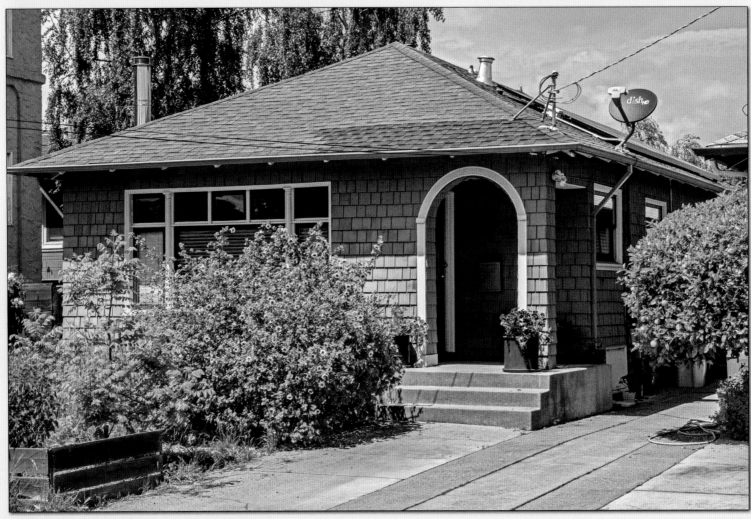

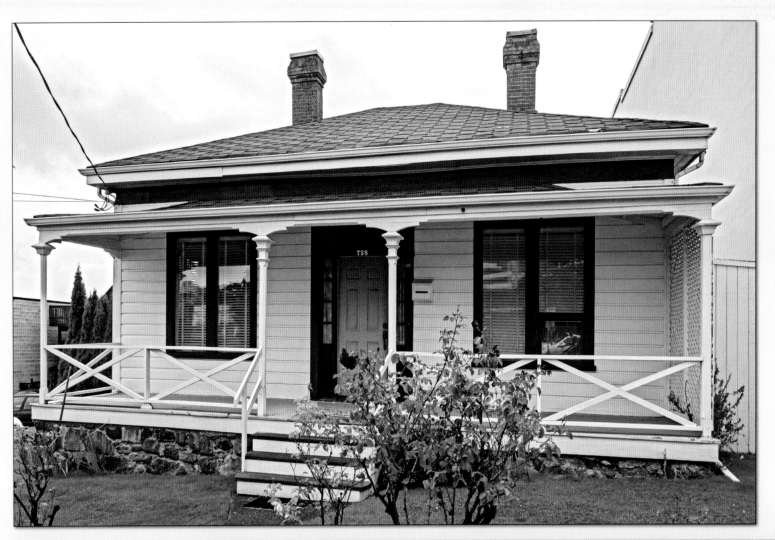

More…

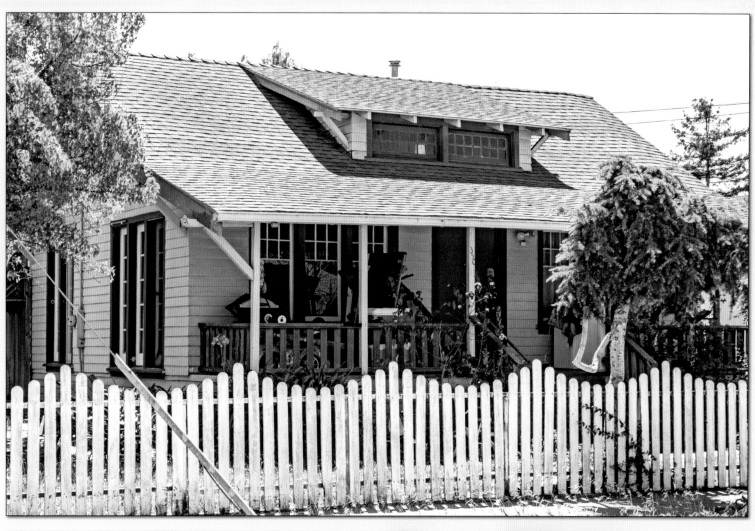

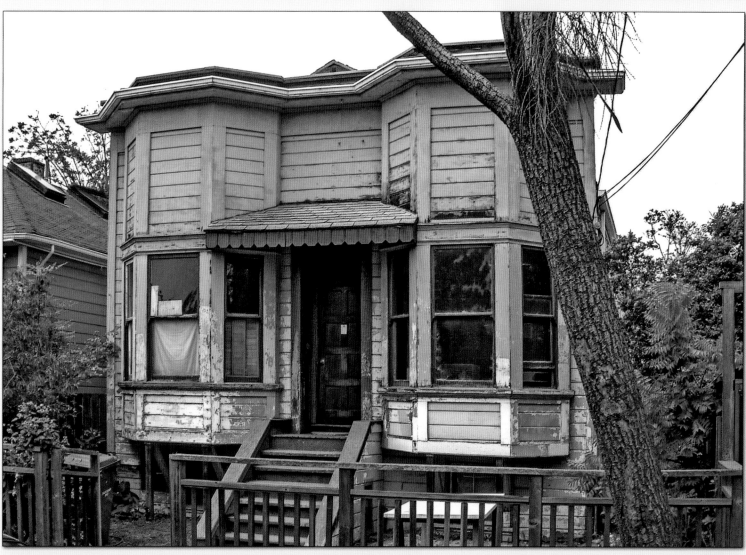

More...

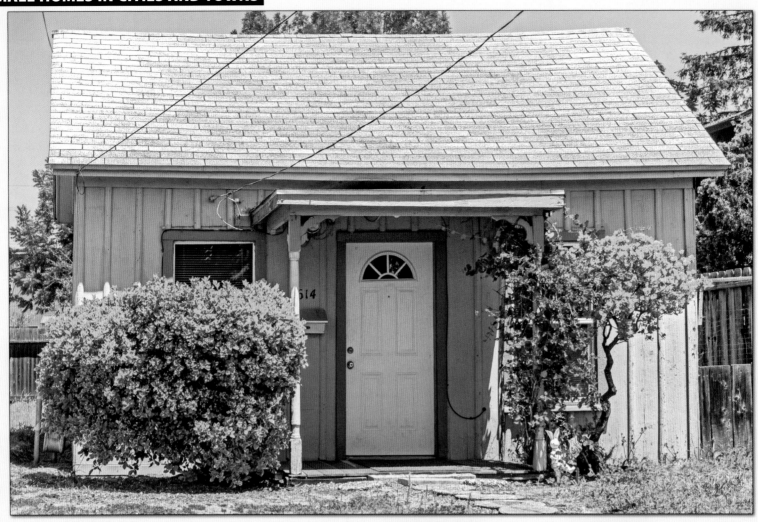

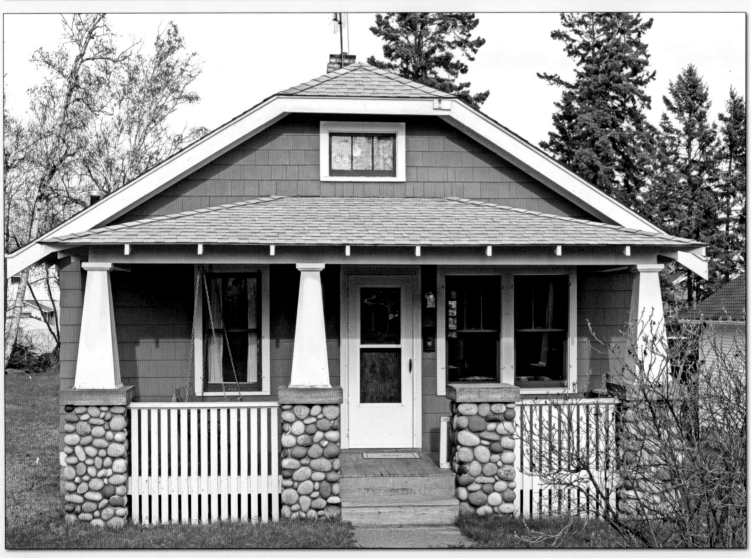

More...

More...

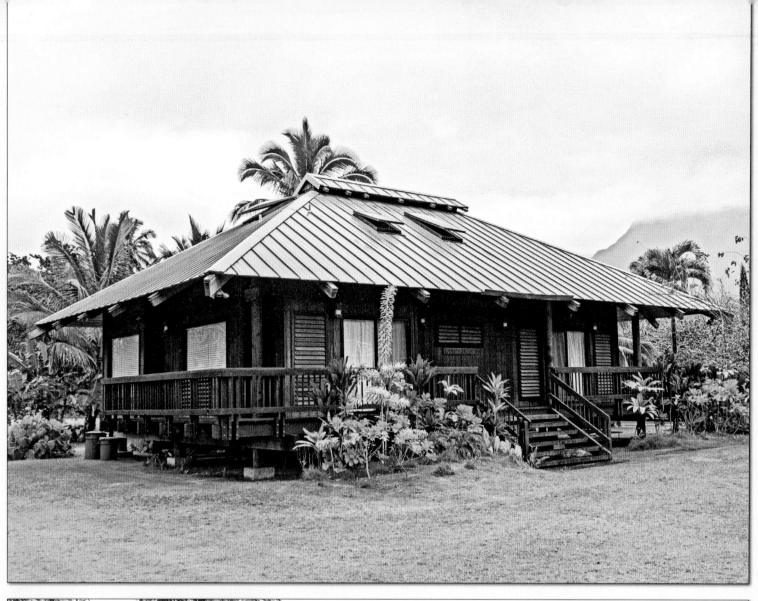

These four homes are on Kaua'i, Hawaiian Islands.

The building with the "Office" sign is our house (also photo at bottom center). The "Bank," "Saloon," and "Barbershop" are our motel rooms.

Small Home, Small Motel in British Columbia
Diane and Bob Sterne

MY HUSBAND BOB, AND I live in a house that was built in 1913 and was originally 360 sq. ft.; it's in the tiny town of Coalmont, which is on the Tulameen River in British Columbia.

At one time a family of seven lived in it. When we purchased it, it was 500 sq. ft. We used it as a cabin for a few years and then decided to move in full time.

The building was originally a carpentry shop with only two rooms. When we bought it, it had a room roughed in on the back. When we decided to move in full time, we knew we would need a source of income. This led to our decision to run a small, three-unit motel.

Since our cabin/home didn't have any storage, closets, or laundry room, we added a laundry room at the back — we didn't want to interfere with the integrity of the original building. We now have 800 sq. feet of floor area.

Local building rules wouldn't allow us more than one building on-site, so we got creative and joined the motel to our house with a greenhouse. From the outside, our place looks like our house alongside another building with three doors. It's a unique space and took two years for my husband to design before we could begin renovating.

Our home is also the office to the motel. Our front room doubles as the check-in office and our kitchen. It often takes newcomers by surprise when they walk in and see my kitchen but we needed to get creative with our space. Some people wonder how we live in such a small place, but we don't find it cramped at all.

Everything has its place and my husband was very creative with the use of space. When we bring people through on a "tour" they are amazed at it all. Our laundry room (complete with a drop-down laundry drying rack) is also our pantry and clothes closets. When our grandsons visit, it is also a playroom. Since we operate a small motel, when the family visits, we simply close down and let them stay in our motel rooms. They really enjoy it, as do we!

Our building has been moved three times. It won't be moved now because it is on a proper foundation. When we bought it, teenagers had used it as a hangout and the walls were covered with graffiti. There was no electricity, plumbing, or heating. We call our cabin/house F.R.E.D., which stands for "freaking ridiculous economic disaster" because it needed so much work. The front wall was even unattached because a car had hit it decades before. When you closed the door the entire front wall moved. We had that fixed when we moved F.R.E.D. onto a proper foundation.

We have lived here since September, 2007, and hope never to move. We have raised-bed vegetable gardens in our backyard, fruit trees, and grape and berry bushes. We preserve our own food and hunt for grouse in the fall.

My husband always wanted to own a Beatty windmill. (His great-grandfather was the founder of a company in Canada called Beatty Brothers and they made windmills and farm equipment.) He managed to find one that was for sale and we moved it into our backyard. A few months later, while at the dump, Bob discovered a plane fuselage that was for sale. A home-built plane had crashed at the local airport and was stripped of its wings and anything of value. Bob bought the plane and proudly brought it into the backyard beside the windmill. I asked him what he planned on doing with it. He said he would put it back together (it was in three pieces), paint it, and hook it up to the windmill! I looked at him, wondering what he meant. By attaching the tail of the plane to the windmill, the wind blowing lifts up the tail of the plane and children sit in it while it moves up and down. We call it the "Flying Tigger."

I guess you need to be a little "different" to live the life we have chosen, but life in our small town of Coalmont is indeed very, very good!!

Floor Area: 800 sq. ft. / 74 m²

 www.mozey-on-inn.com

"The building was originally a carpentry shop with only two rooms."

"This lead to our decision to run a small, three-unit motel."

"I guess you need to be a little 'different' to live the life we have chosen."

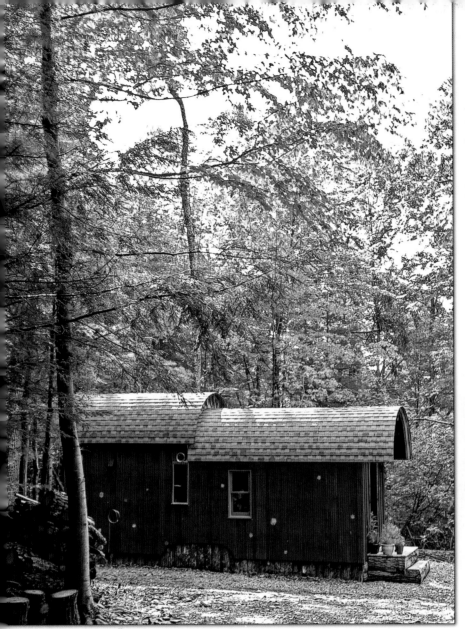

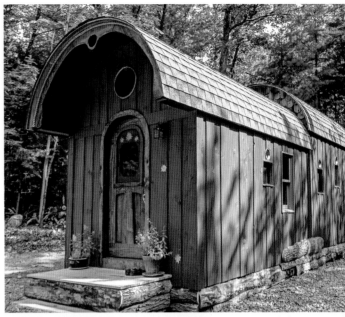

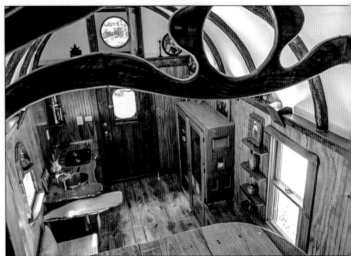

Old-Timey, Off-Grid Caravan
Nick and Aaron Troisi

"Our friend Tania sold her house and asked us to build her an old-timey caravan."

OVER THE YEARS, WE HAVE developed a deep admiration for small, deliberate living. We've been excited and inspired as the tiny house movement has swept the country, combining all the best elements of DIY, simple living, environmental consciousness, self-sufficiency, sustainability, and creative adventure.

Tiny houses are particularly intriguing to us, an imaginative father-and-son team with a combined 60-plus years of experience in design and construction, fine woodworking, and ceramic art. We've always been highly creative builders, and have developed a range of eclectic skills completing projects for schools, non-profits, museums, theaters, and wildly visionary clients.

We couldn't help but jump at the opportunity when our friend Tania sold her house and asked us to build her an old-timey caravan. We loved the experience of building our first off-the-grid tiny house on a trailer.

Building tiny houses brings together all of our eclectic skills and experience in a single project, from the design phase through to the finishing artistic touches. Also, building small fits well with our own personal philosophies and politics: sustainability,

ethical living, creative lifestyles, and progressive thinking.

Our Old-Timey Caravan is a fully custom home on wheels, a one-of-a-kind tiny house, practical and aesthetic from 24-foot trailer to 13-foot curved roof.

We built custom windows and doors throughout, as well as a hand-crafted floor, ceiling, loft, storage staircase, sleeping nook, composting toilet, shower, and live-edge organic table, countertop, shelves, benches, hangers, and artistic accents.

The Caravan is both off- and on-the-grid capable, with on-demand water from a 40-gallon tank, propane heat, both AC and DC (battery) power, and lighting from LED lights repurposed from automobile fixtures.

Floor Area: 289 sq. ft. / 27 m²

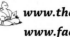 www.theunknowncraftsmen.com
www.facebook.com/
theunknowncraftsmen

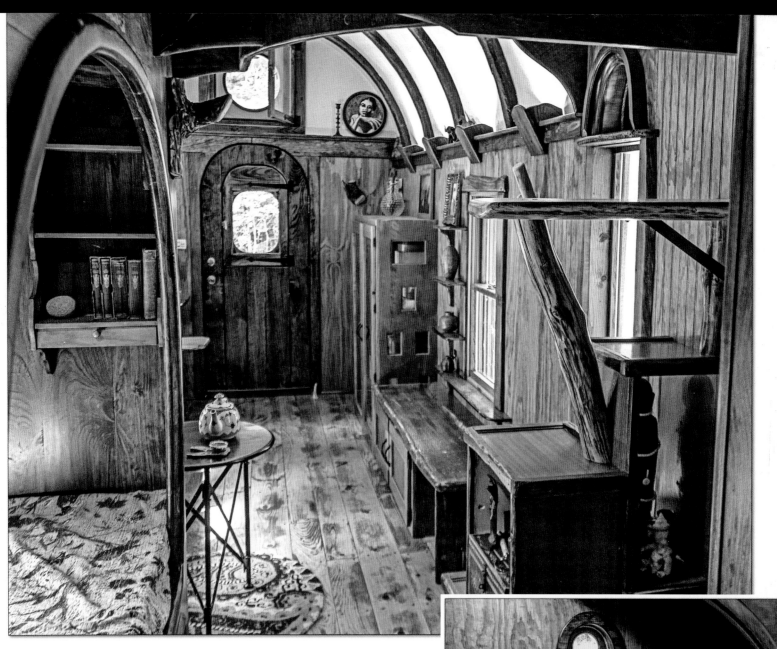

"The Caravan is both
off- and on-the-grid capable."

"We built
custom
windows
and doors
throughout."

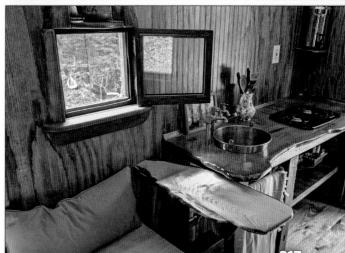

Houseboat in Southwest England

Erin MacAirt

MY NAME IS ERIN, AND I live on this boat, Jenny, outside Bristol in Southwest England. I am a printmaker and relocated here about a year ago. The boat is about 6 feet wide by 42 feet long, around 300 square feet of interior space.

There is a real sense of community in houseboat living; we all look out for each other.

For the first few months after moving in, I was using it as an art studio as well as for living. It was a bit tight — I'm messy when creating — but now I have a studio in Bristol.

Collecting wood and providing my own heat gives me a sense of self-sufficiency; it's really rewarding. This winter was cold, but I enjoyed gathering and chopping wood; it got to the point where my eyes would spot fallen trees in the woods every day; I'm getting my stock in for this winter already.

Moving from house to boat was a major downsizing project. I realized I really didn't need that much; it was liberating to lighten up on material possessions.

Also, a total bonus is being able to move your home!

Floor Area: 300 sq. ft. / 28 m²

 www.erinmacairt.com

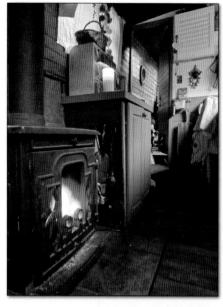

"It was liberating to lighten up on material possessions."

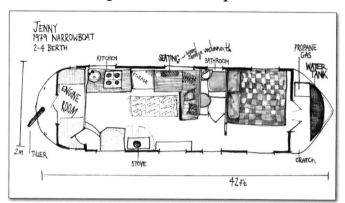

"Collecting wood and providing my own heat gives me a sense of self-sufficiency."

"Also, a total bonus is being able to move your home!"

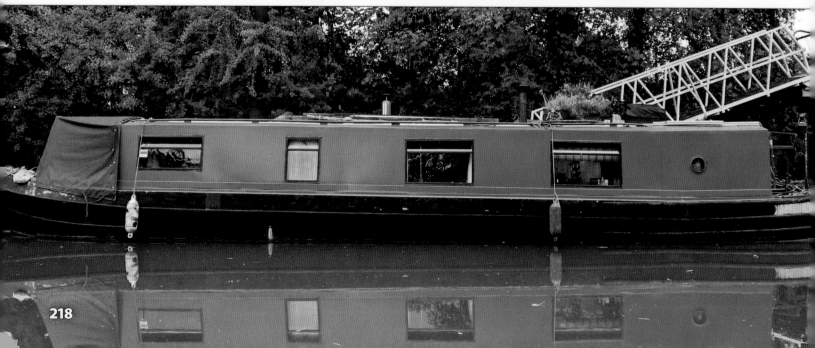

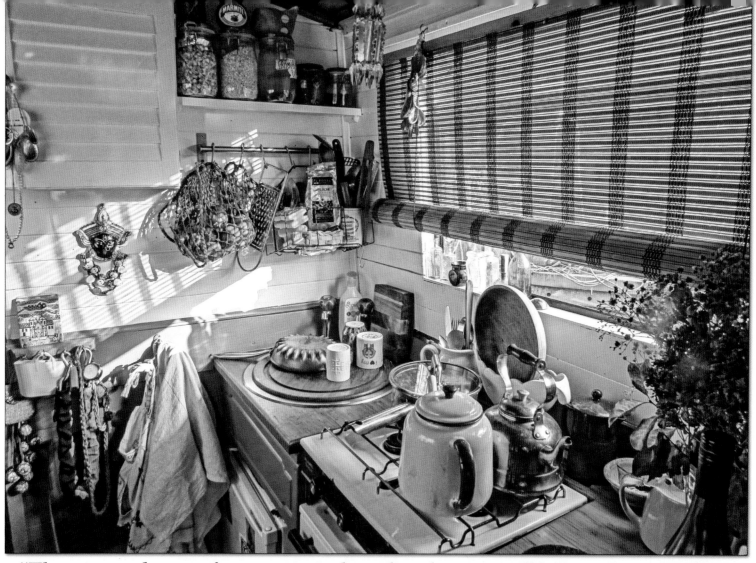

"There is a real sense of community in houseboat living; we all look out for each other."

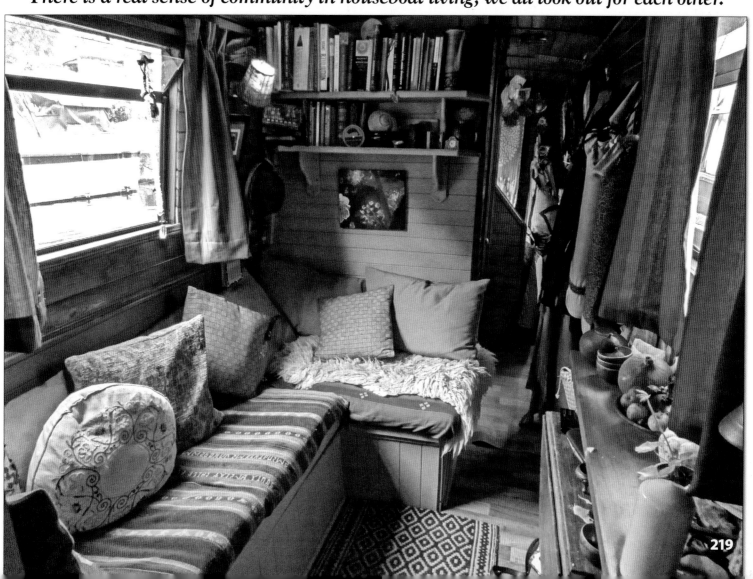

The Nesthouse in Scotland

Why small is sustainable!

Jonathan Avery

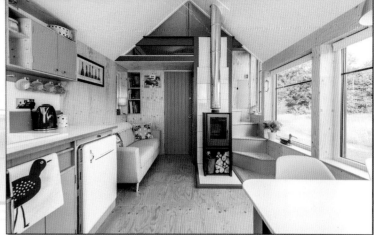

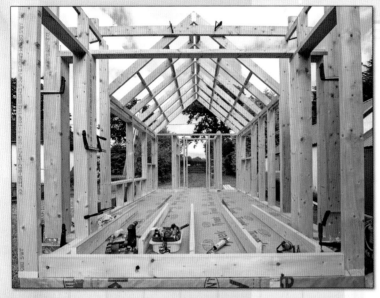

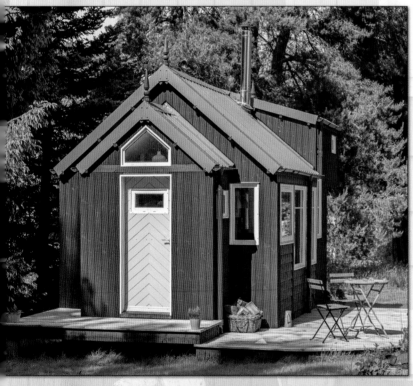

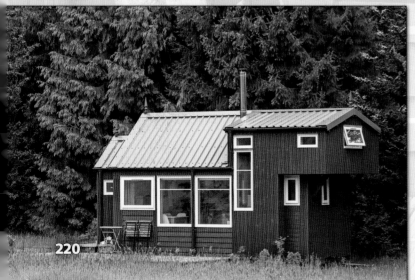

GROWING UP WITH A very practical Dad who built whatever we needed, like a kitchen or garage, gave me a practical streak, and I have been designing, making, plumbing, and wiring since the age of 10.

But if you are having trouble starting your build, here's my favourite Lloyd Kahn line from his talk in Kirkcaldy, Scotland, in 2016: "If you don't know how to do something, just start"!

That's just it; be brave and learn on the job. If you have a logical mind you really can do anything!

I have been a designer, photographer and furniture maker for over 30 years and have completed many builds and renovations, from cottages and houses to an 18th century threshing mill. As an avid reader of the U.S. magazine *Fine Homebuilding*, I became aware of calls for smaller, more sustainable homes, *e.g.,* Sarah Susanka's book, *The Not So Big Home*, amongst others. I came to love too, the U.S. tiny house movement, with its ethos of cute, self-built dwellings on trailers.

Then at the beginning of 2014 I had a light-bulb moment and realized that small houses brought together all my interests and skills: the physics of building design with the principles of sustainable living and the ability to concentrate a high degree of craftsmanship and architectural detailing into a small package.

I brought my lifelong passion for architecture and green design together and imagined a beautiful, small, wooden building with high-quality certified materials, offering complete protection from the environment whilst being light-filled, snug, independent, and moveable.

So my concept for a moveable, modular, small eco-house was born; I decided to call it the Nesthouse, using the analogy of a bird-nesting box: a compact, wooden, eco-friendly survival unit. This was the start of Tiny House Scotland, my business to design and build small-scale moveable homes in Scotland.

In the UK, road-legal towing restricts a trailer's width to 2.55m (8´4˝), which I found too restrictive internally, especially with good insulation, so I decided that the Nesthouse would have to be wider at 3.4m (11´2˝). This is not road-towable, but then we do not have the wide-open highways of the U.S.A. anyway; get a camper van if you want to tour.

The Nesthouse would still be built on a wheeled chassis so as to be moveable on-site but be delivered on a trailer.

Internally, it would be much more spacious and have a floor area of 25m² (270 sq. ft.), whereas most tiny houses on wheels are around 102m² (110 sq. ft.)

It could be on-grid or off-grid, and so well insulated that it would require little energy to run. The compact footprint is light on the land and doesn't require tons of concrete for a foundation and can be moved without leaving a trace.

After a lot of hand drawings and a full Sketchup 3D model, I started construction on August 1, 2015, and the structure was complete and being fitted out by Christmas that year. The Nesthouse has that quintessential "cabin in the woods" flavour, pioneering for the modern age.

> ## *"I have been designing, making, plumbing, and wiring since the age of 10."*

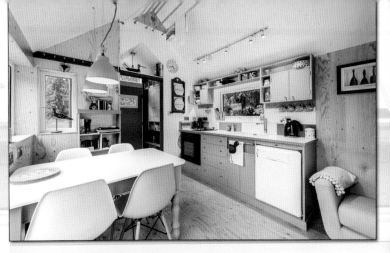

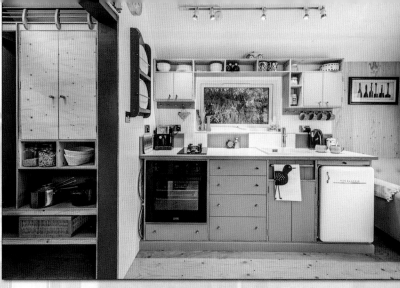

"The design is based around functional modules that are combined at the construction stage."

I have used many innovative techniques in its construction. Unlike traditional architecture, the shell is conceived as a whole, not a series of interconnected and differently structured walls, floor, and roof. The advanced framing techniques and heavily insulated, stressed-skin shell also has a further unbroken (apart from door and windows) outer shell of "outsulation," in which the windows "float." It is designed to be oriented with few windows on the north side and large ones for solar gain on the southerly elevation; a *brise soleil* will provide summer shading. A small, high-tech German HRV (heat recovery system) unit modulates any extremes of air quality, and a small woodstove provides winter comfort.

The design is based around functional modules that are combined at the construction stage so that form follows function. "Live" is the basic house-shaped module available in three sizes: 4.0m, 5.2m, and 6.4m (13′, 17′, and 21′); there are additional external modules which add functionality: "Entry," "Bathe," and "Sleep," a cozy sleeping loft reached by a compact, boat-style stairway.

Many people dream of living in a "cabin in the woods," but unfortunately there are no easy answers to the age-old issue of procuring land to live on. The difficulty of finding a plot in the countryside puts one in the position of competing for the rare commodity of a serviced plot at a price that reflects its

rarity locally. Finding a site requires creativity and lateral thinking and it must be said that agricultural ties with a small-holding or woodland manage-ment can be a useful angle.

Indeed, this was my main vision for the Nesthouse: full-time homesteading or a "micro living" ideal for singles or couples who want to live sustainably on their land or as an affordable starter home in urban or rural areas. Of course, the Nesthouse can just as easily be used as a studio, home office, or holiday rental, but I do believe that there is a greater purpose here: to provide affordable small housing units whether for a young person on a Scottish Island beset by the holiday-home phenomenon or a communal housing cooperative like a tiny house community.

This holistic approach to living in a small house on a small holding or small farm with varying degrees of self-sufficiency, or even just taking a conscious decision to live more simply and closer to nature whilst working from home, could mean you could live debt-free without a mortgage.

The need for sustainable small-living options for people who cannot afford £100k-plus for a house has to be a compelling argument in this era of housing shortage, not to mention the planet's need for us all to want and need less of its resources and to practice consumption awareness. I hope in a small way that my Nesthouse can address some of these issues!

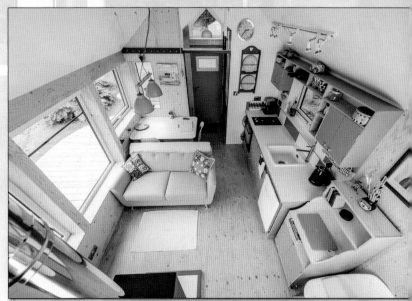

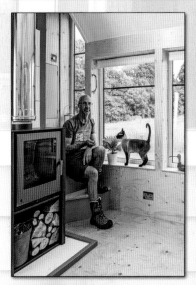

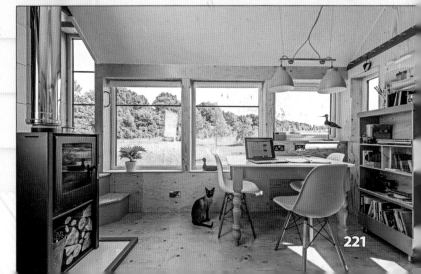

Floor Area:
As shown: 270 sq. ft. / 25 m²
Expandable to: 430 sq. ft. / 40 m²

www.tinyhousescotland.co.uk
www.jonathanavery.com

Credits

Editor and Layout: Lloyd Kahn
InDesign Layout and Photoshop: Rick Gordon
Contributing Editors: Evan Kahn, Lew Lewandowski, Lesley Kahn
Photoshop Assistance: Sean Hellfrisch
Proofreader: Marianne Rogoff
Office Manager: Mary Sangster
Cover Color Consultation: Kim Wylie, Kevin Votel, Elise Cannon,
 Publishers Group West

Printers: Paramount Printing Company, Hong Kong
Text Paper: 128 gsm Gold East Matt Art Paper

Production Hardware: Apple Mac Pro, NEC LCD3090WQXi
 wide-gamut monitor, Epson Stylus Pro 4900 12-color inkjet printer

Production Software: Adobe InDesign, Adobe Photoshop,
 Nisus Writer Pro, BBEdit, AppleScript

Cameras:
Olympus OM-D EM-1
Sony Cyber-shot DSC-RX100 II
Apple iPhone 5 and 6s Plus

On-the-Road Computer
11″ Apple MacBook Air

Editing Text
I edit contributors' text (heavily, if necessary) and write my own text
in Microsoft Word, write headlines and choose pull quotes, do a spell
check, and print it out in two- or three-column format.

Production Process
We continue to follow a process where I do initial layout by printing
out photos (six per sheet of paper), then adjusting the size on a
Brother MFC-9130CW copy machine. I cut out text with scissors,
then paste down photos, text, headlines, and pull quotes on layout
sheets with removable Scotch tape. I then mark the numbers of each
photo on these sheets, gather all of them as well as text in a folder
which I then put into Dropbox, to which Rick has access from his
working studio at home.

I do the layout two pages at a time, with no idea how they will all fit
together. During the process, things fall into place. It's a wonderful
thing to watch, as if the book is creating itself day by day.

It's an old-school, new-school process, where I believe we get the
best of both worlds, as opposed to doing layout on the computer
from the beginning: Analog, then digital.

As we go along, we print out reduced-size, two-page spreads on
plain paper. These go into a binder and I continually shuffle them
around, putting them in what seems like a somewhat logical order.

The next step is that Rick and I go through all the pages together
and make changes and corrections. At this stage, the manuscript
goes to our proofreader. Once the proofing corrections are made,
photos or colors adjusted as necessary, and we print out full-size
proofs on high-quality proofing paper.

These will be sent to the printer so that the press operators will
see what colors we want. The entire book is sent electronically to
the printers. I have always gone to the printers to do press checks
for color books on the first printing, but we now have such good
synchronization with Paramount Printing that I haven't felt it
necessary to go to Hong Kong for this one.

How we found these homes
Our large network of builders and homeowners sent us leads.
A number of these homes were inspired by our earlier books.
Eight of these came from *Mother Earth News* readers. Others came
from my own experiences, online exploration, travels, and friends.

All these stories and photos came from the builders, except for
ten by me.

- I have been working on this book for over a year — not 100% of
the time, but increasingly long hours each day as the process has
unfolded. I have folders of email correspondence back and forth
with some 130 contributors; in some of them there are 30–40–50
emails. A lotta emails!

- I'm so glad to have this project done. In the '60s, Jim Morrison of
the Doors said that only when they finished one record could they
go on to do the next one. That's true for us now, and I'm starting
to look around for what will be our next book.

Possibilities:

- A memoir of sorts, something like *50 Years of Natural Building,*
tracing my interest in building over the years, with photos
showing a journey in discovering buildings and builders.
Maybe I should call it *Builders.*

- *Trips,* a photojournalistic account of trips in the U.S.A.,
Canada, Europe, Mexico, South America, Southeast Asia,
China, and Hawaii

- *My America,* a chronicle of America and Americans, with
my photos from visits to 44 states over the years, and
six coast-to-coast car trips

- *Barns,* from a lifelong love and interest

What do you think?

–LK

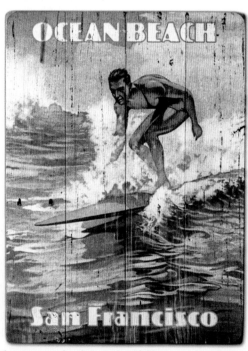

Old poster on display at the Cliff House, San Francisco

The Shelter Library of Building Books:
A Series

Shelter (1973)

Shelter II (1978)

Home Work (2004)

Builders of the Pacific Coast (1973)

Tiny Homes (1973)

Tiny Homes on the Move (1973)

Small Homes (1973)

These books are interconnected not only by interesting builders and buildings, but by a surprisingly large group of people who were inspired by one of our books to build their own homes, and who then sent us photos that appeared in later books. There's a thread of dreams generated, then brought into reality here.

- *Shelter* (1973)
- *Shelter II* (1978)
- *Home Work: Handbuilt Shelter* (2004)
- *Builders of the Pacific Coast* (2008)
- *Tiny Homes: Simple Shelter* (2012)
- *Tiny Homes on the Move: Wheels and Water* (2014)
- *Small Homes: The Right Size* (2017)

Each of these books has over 1,000 photos.
For details on our books, see ***www.shelterpub.com.***

Special Offers:
For three or more books, a 40% discount
For all seven books, a 55% discount
To order: ***www.shelterpub.com*** or call 1-800-307-0131

Ebooks: ***www.shelterpub.com/ebooks***
Home Work (iBooks & Kindle)
Tiny Homes: Simple Shelter (iBooks)
Tiny Homes on the Move (iBooks)

Shelter Online:
Shelter's Website: *www.shelterpub.com*
The Shelter Blog: *www.TheShelterBlog.com*
Shelter's Tumblr: *shelterpub.tumblr.com*
Shelter's Twitter: *www.twitter.com/shelterpub*
Shelter's Instagram: *www.instagram.com/shelterpub*

Lloyd's Instagram: *www.instagram.com/lloyd.kahn*
Lloyd's Blog: *www.lloydkahn.com*
Lloyd's Twitter: *www.twitter.com/lloydkahn*
Lloyd's Facebook Page: *www.shltr.net/facebook-lk*

If you ever need a helping hand,
you'll find one at the end of your arm.

—Old proverb